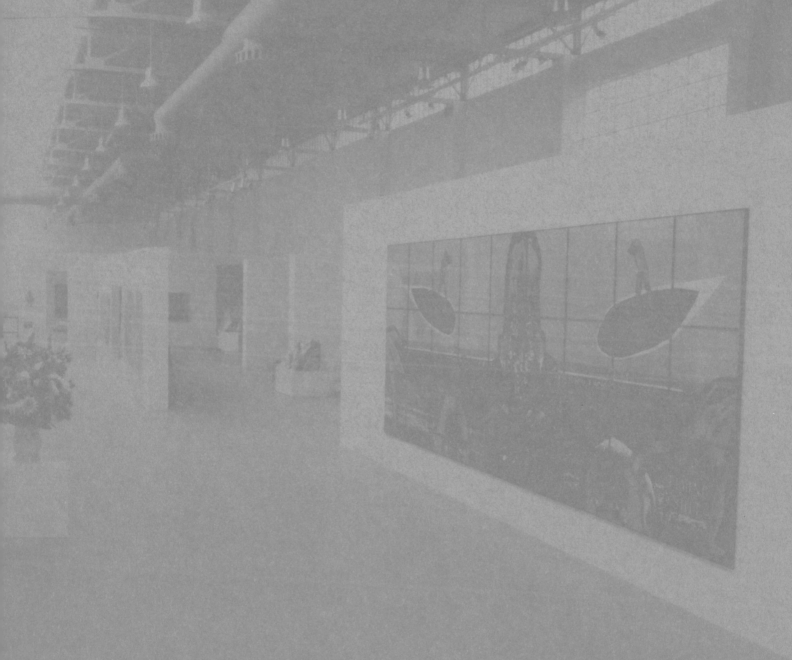

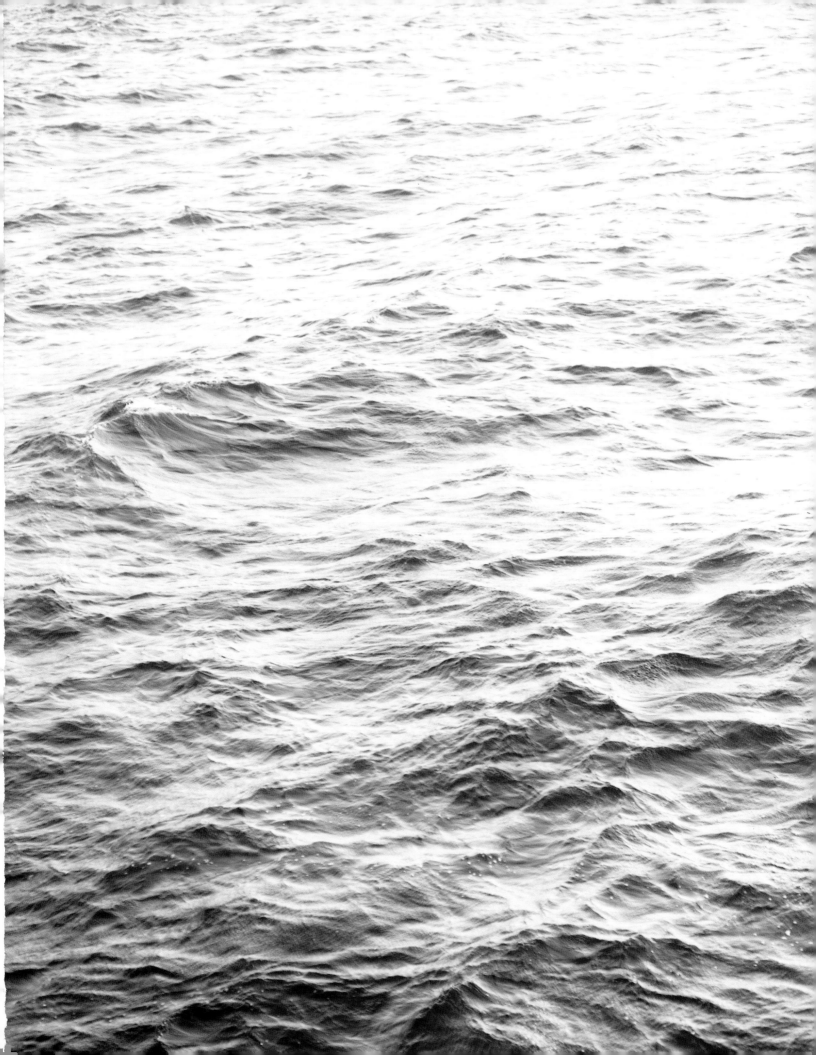

Produced and printed by Dr. Cantz'sche Druckerei, Ostfildern-Ruit, Germany
Printed on BVS matt 170 g/sqm

Project Coordinator: Jeffrey Deitch
Designer: Richard Pandiscio
Consulting Editor: Louise Neri
Editorial Coordinator: Sarah Watson
Design Assistant: Tony Moxham
Photo research: Christa Aboitiz
Copy editing: Anne D. Haas
Administrative Assistant: Lisa J. Young

Each artist was invited to contribute a statement or suggest a text for the artists' pages in this book.
The editors and the DESTE Foundation gratefully acknowledge their collaboration.
Measurements are recorded in centimeters and inches, height x width x depth.

European Distribution:
Cantz Verlag
Senefelderstraße 9
D-73745 Ostfildern
Tel: 49. 711-44993-0 Fax: 49. 711-4414579

North American/ Asian Distribution:
DAP/ Distributed Art Publishers
636 Broadway Room 1200
New York, NY 10012
Tel: 212-473-5119 Fax: 212-673-2887

ISBN: 3-89322-816-0 (Clothbound edition)
3-89322-817-9 (Softcover edition)

Library of Congress Catalog Card Number: 95-71219

Printed in Germany

Photographs on front and back covers and page 1 by Todd Eberle
Photograph on opposite page and page 5 of Leftaris Arapoyannis wearing T-shirt with Jenny Holzer *Truism*, commissioned from Wolfgang Tillmans.

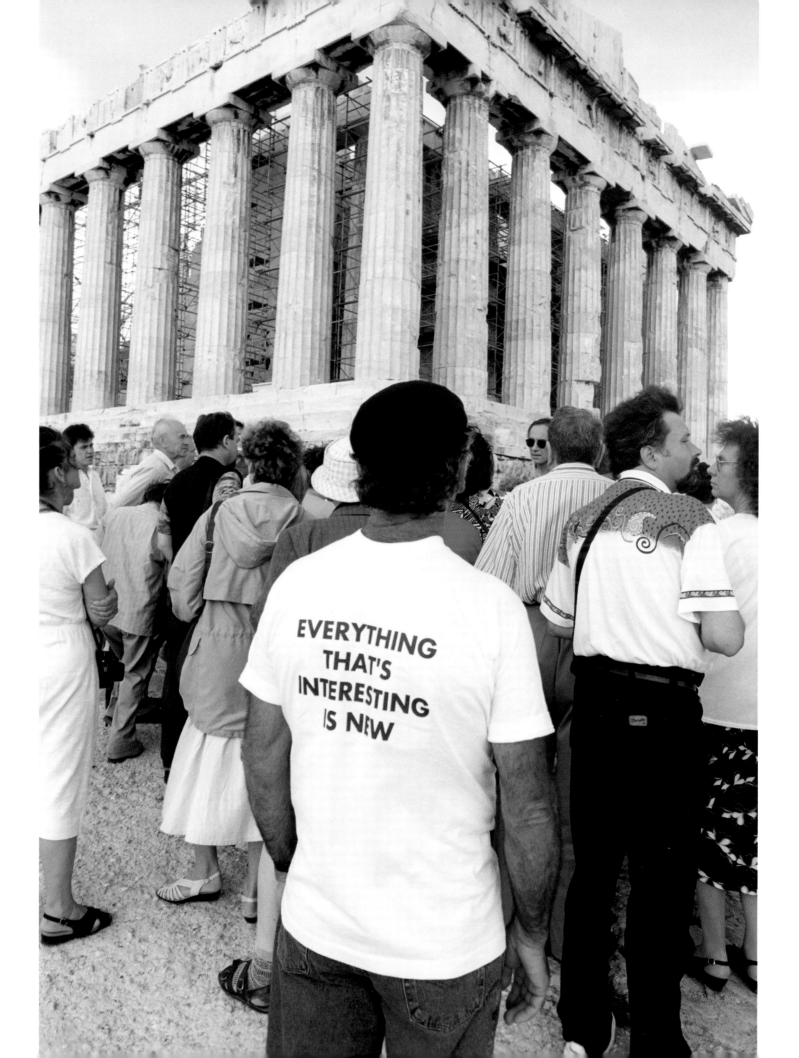

The Dakis Joannou Collection

Jeffrey Deitch, Project Coordinator

Richard Pandiscio, **Designer**

Louise Neri, Consulting Editor Sarah Watson, Editorial Coordinator

The title of this exhibition "EVERYTHING THAT'S INTERESTING IS NEW" is taken from Jenny Holzer's *Truisms*, 1984.

CANTZ

This book is published to accompany the exhibition

EVERYTHING THAT'S INTERESTING IS NEW:
The Dakis Joannou Collection

Athens School of Fine Arts "the factory", Athens,
Museum of Modern Art, Copenhagen
Guggenheim Museum Soho, New York

Exhibition Coordination:
Athens:
Coordinator: Maria Panayides
Installation Design: Dakis Joannou
Conservation: Christian Scheidemann
Installation Coordinator: Maria Ioannou
Administration: Angelina Kapsaskis
Installation Manager: George Andreou
Packing and Transportation: Stelios Beryeles Co.

Copenhagen:
Director: Anna Castberg
Head of Exhibitions (Curator): Anders Kold
Assistant Curator: Dorthe Aagesen
Senior Curator: Holger Reenberg
Assistant: Merete Schrøder
Project Coordinator: Malene Rix
Assistant: Heidi Højlund
Educational Curator: Tine Nygaard

Contents

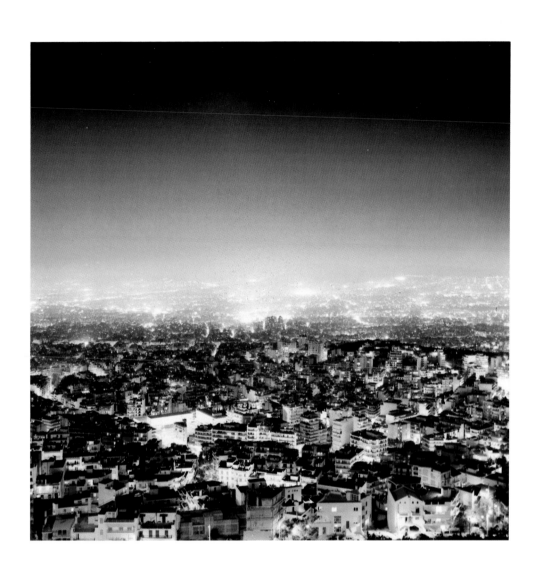

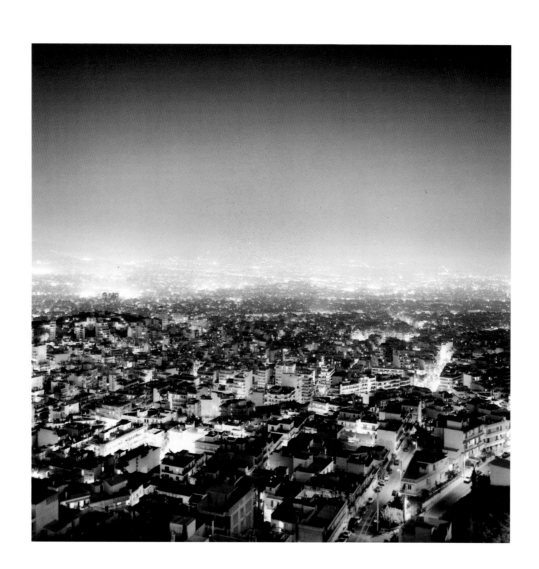

This page: Andreas Gursky, *Athens*, 1995, color print. Preceeding pages: Andreas Gursky, *Athens Diptych*, 1995, color print.

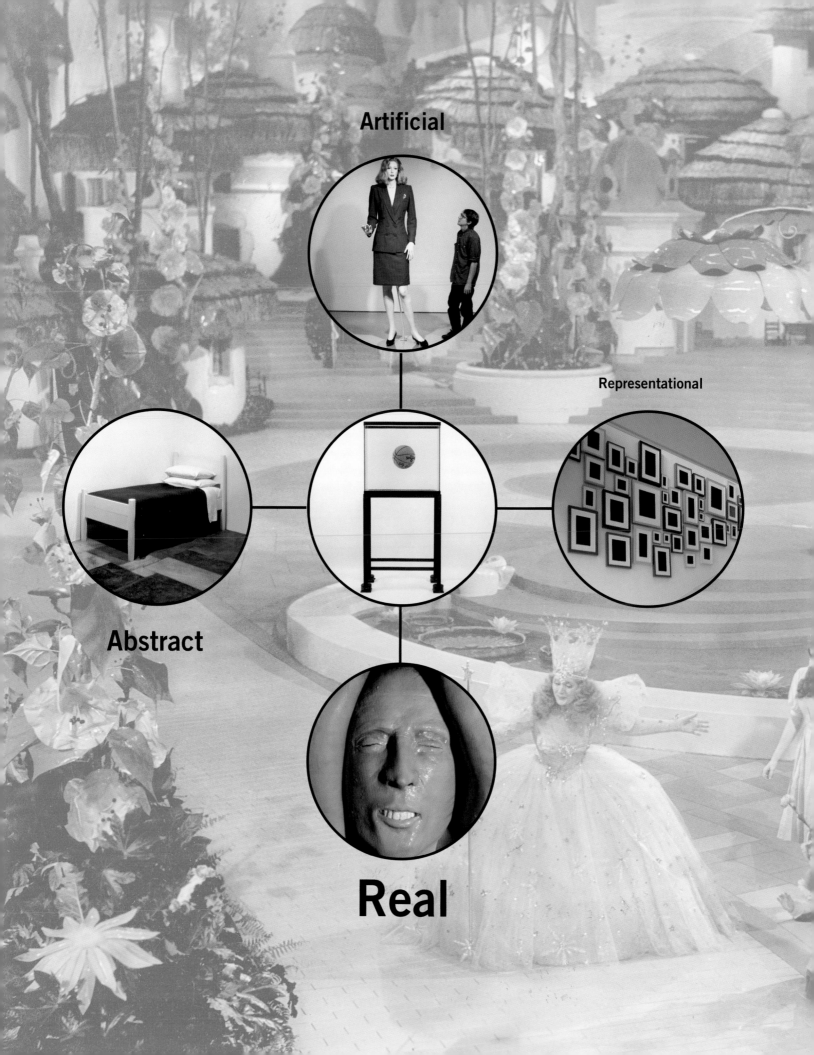

Artificial

Representational

Abstract

Real

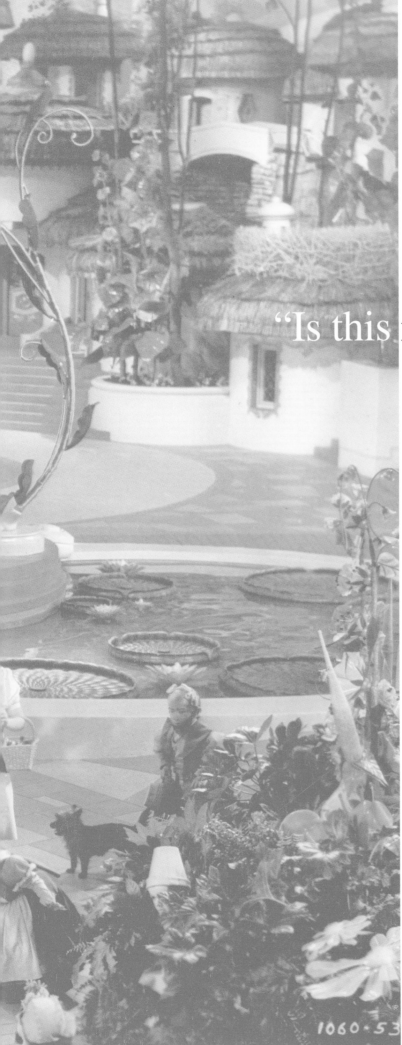

Truth in Advertising

"Is this realness or not?", coos the master of ceremonies in the least exotic but most startling scene of *Paris Is Burning*, Jennie Livingston's riveting documentary on New York drag balls. A slightly built young man, his face beaming, struts onto the runway in a navy blue business suit, white shirt, and conservative tie, carrying a cheap vinyl attaché case. "Realness!" the audience exclaims in admiration, thrilled by how one of their fellow drag queens has been transformed into a fantasy image of a rising junior executive. Artificiality has been pushed to the point where the young cross-dresser has walked through the looking glass and bounced back on the other side.

More *real* than real: The cool white fluorescent tubes that give an electronic aura to Jeff Koons's sculptures of encased vacuum cleaners; the blinding Day-Glo colors that make Peter Halley's paintings pop; the bolts and brackets that make Ashley Bickerton's sculptures spring off the wall. The heightened physical presence of many of the most innovative artworks of the 1980s paralleled the hyperreality of much of the decade's economic, political, and social history: The Japanese bubble economy; the Star Wars defense; the ultra-modernist office buildings that bankrupted their developers. Reality and fantasy frequently traded places. The artificial and the real were often so confused that whether it was the transformation of Michael Jackson, the spin-doctoring of political information, or the wild spiraling of art prices, it was difficult to determine what was real and what was not. In fact, it often made no difference. Voters and consumers were usually just as happy to have the fantasy as the reality.

The conflation of artificial and real became one of the major aesthetic themes of the 1980s. The high modernist quest for "truth" and "authenticity" seemed less relevant when

Opposite page: clockwise from top: details from works by Charles Ray, Allan McCollum, Cindy Sherman, Robert Gober, and (center) Jeff Koons. Background: film still from *The Wizard of Oz*.

Artificial

Representational

Abstract

Real

everyone knew that a large proportion of the things that appeared to be made out of wood were actually plastic, and the sweet, helpful voice of the telephone operator really belonged to a computer. The path to truth seemed to lead ultimately to the false. A previous generation of artists had been inspired by trying to find the essence of self and the essence of art by grappling with the raw materials of painting and sculpture. A new generation of artists appeared to be more interested in surface than in substance: Formica was more inspiring than marble; climate-controlled shopping malls with piped-in music were more inspiring than quaint country villages; television situation comedies were more inspiring than psychoanalysis.

As modern architecture had been stripped of its utopian spirit by the cancerous sprawl of chintzy office parks and dismal apartment blocks, the vocabulary of modern art also became detached from its original meaning. Artists and advertisers appropriated heroic modernist compositions simply as imagery, the same way they lifted images from popular culture. David Salle quoted from paintings by modern masters and from commercial kitsch with indifferent equivalence. Peter Halley substituted the fake stucco Rolo-tex surface of motel ceilings for the impasto that preserved the artist's touch. Cubist faceting and modernist grids became additions to the stockpile of commercial and historical images that could be appropriated, spliced, and juxtaposed into contemporary art.

Abstraction began to be treated as representation. The abstract imagery of Arp or Kandinsky became signs that represented the modern style. Representational imagery, such as the clichéd poses found in movie stills or in pornographic magazines, began to be treated as abstraction. An equivalence was constructed between abstraction and representation which intersected with the convergence of artificial and real. This double axis where opposites change places and change back became the characteristic structure of the 1980s aesthetic discourse.

The fusion of abstraction and representation, artificial and real could be found in all media from handwrought sculpture to constructed photography. The sink sculptures of Robert Gober are artificial in that they are not really sinks, but meticulously constructed *images* of sinks. And yet they are real objects, resonant of real emotions. They are representational in that they are readable as sinks yet they are abstract in their obdurate symbolism. David Salle's paintings chart the whole process of confluence between abstract and representational, artificial and real. Actual objects like chairs, tables, and found thriftshop

paintings are paired with representations of real objects. Panels of cheesy 1950s-style fabrics are juxtaposed with arbitrary renderings of historic paintings. It is pointless to try to determine which segments are abstract, representational, actual, or false as everything is interchangeable. Salle's paintings articulate a contemporary mode of perception, a way of seeing the world that incorporates this fusion.

Cindy Sherman's *Film Stills* also enter into this framework of multiple interpretations. Her work builds on the artificial reality of Hollywood, but these film fantasies became *the* reality for the millions of young women who styled themselves after movie characters and saw their world as an extension of movie plots. The characters that Sherman herself portrays in these works as she transforms herself through wigs and costumes are both real and imaginary. They become abstract signs for the repertoire of fantasies and nightmares that can fill a young woman's consciousness.

The constructed photograph is itself one of the prime examples of how artificial and actual have fused to create a new, more complex version of reality. The photograph was, until recently, a widely accepted proof of authenticity. From Eadweard Muybridge's documentation of a horse running with all four legs in the air to paparazzi shots of nude celebrities, there was a sense that if it was photographed, it really happened. Soon most teenagers with home computers will understand photographs as constructions that can be altered and manipulated. Instead of clear-cut evidence of an old-fashioned factual reality, photographs and similarly-constructed moving digital images will become the most widely understood representations of the new fusion of artificial and empirical that will define the reality of the future.

The nonlinear perception of reality has also been shaped by the new sense of space experienced through the computer screen. Moving beyond the single-point-perspective reality of conventional photographs or the flowing narrative of television or film, the computer-literate generation has become accustomed to the multilayered reality of the Internet. One image folds on top of another, simultaneously combining visual information recorded at different times and places and referring to a multitude of subjects. This new kind of information space may represent one of the rare instances of the invention of a truly new aesthetic spatial model—which prompts artists and eventually nearly everyone else—to construct and perceive their world differently.

The effects of information space on artists are less important

Opposite page: clockwise from top: details from works by Cindy Sherman, Robert Gober, Charles Ray, Allan McCollum, and (center) Jeff Koons.
Background: detail from Gregory Crewdson.

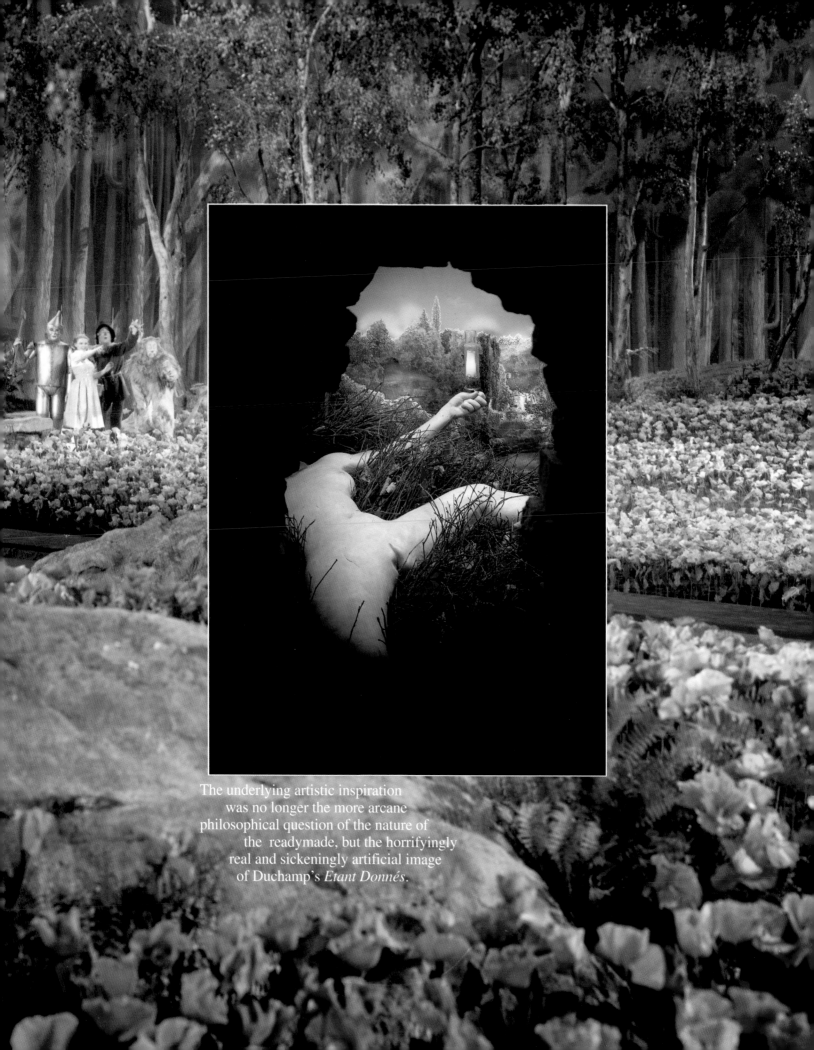

The underlying artistic inspiration
was no longer the more arcane
philosophical question of the nature of
the readymade, but the horrifyingly
real and sickeningly artificial image
of Duchamp's *Etant Donnés*.

in terms of visual vocabulary than they are in structuring a way of seeing. For the past decade or more, artists have been constructing systems of vision that involve numerous juxtapositions of time, space, and context. It is fascinating to see how a number of artists anticipated electronic information space even before the new technology made it fully realizable. The layering and juxtaposition of texts and images in the work of John Baldessari, Barbara Kruger, Richard Prince, David Salle, and others presaged a new way of seeing that combined dreams, memories, objects, sensations, and everything else that entered the imagined visual field to portray a new multilayered reality. These artists anticipated the computer manipulation of visual data as certain early nineteenth-century painters had anticipated the photograph.

The conflation of abstract, representational, artificial, and real continues one of the most influential strains of modernism, moving it from the realm of postulation and theory to the realm of everyday life. This same four-way fusion was already present in Marcel Duchamp's readymades, his self-portraits in drag, and numerous other examples of his work. Another version of the same sort of conflation is present in Jasper Johns's flags. By the 1980s these issues had moved beyond the world of art to change peoples' understanding of everyday experience. The underlying artistic inspiration was no longer the more arcane philosophical question of the nature of the readymade, but the horrifyingly real and sickeningly artificial image of Duchamp's *Etant Donnés*.

Artists like David Salle and Meyer Vaisman were commonly characterized as Post-modernists, cynical manipulators of historical styles. But a more interesting interpretation is that these artists and other artistic innovators of the period were actually reviving an essential strain of modernism that had been partially smothered by several decades of reductivist criticism. This was the side of modern art that reveled in double meanings and in juxtapositions of artificial and real. It was the modernism of Picasso's collage with fake chair-caning and his sculptural glass of absinthe with a real spoon. It was the modernism of Dada photomontage and Surrealist performance. It was the modernism that celebrated the irrational.

Irrationality re-emerged to inspire much of the most interesting art of the past decade. The resurgence of the irrational began in the wake of the "do your own thing" ethos of late 1960s counterculture. Most of the Minimalists and Conceptualists had emphasized rigorous rational structures of thought. Influenced by the openness of counterculture consciousness, artists like Vito Acconci, Bruce Nauman, and later Laurie Anderson and Jonathan Borofsky began exploring the irrational side of Conceptualism. Instead of pursuing rational visual systems, their art pushed toward the outer edge of consciousness, exploring dreams, fantasies, and lapses in logical behavior.

The neat fusion of Pop, Minimal, and Conceptual Art that first seemed to explain the art historical genealogy of the "simulationist" artists left out something essential–this was the legacy of performance art and the irrationally oriented conceptualism of the 1970s. The emphasis on personal history and self-discovery profoundly influenced many of the artists who came of age during the following decade. The attempt to fuse the primary structures of geometry with the primary structures of dreams and memories created a foundation for the further fusion of abstraction and representation in the 1980s.

A sense of irrationality has permeated much more than just the world of art during the past ten years. Chaos theory has captured the popular imagination suggesting that chaos may be the natural order of things. There has been the inexplicable devastation of AIDS. Fanaticism and terrorism have disrupted the "New World Order" that was the hoped for result of the end of the Cold War. Reports of dysfunctional behavior have been pouring out of the workplace, the schoolroom, and even the highest levels of government. The prepackaged paradise of global brands and home-shopping networks can no longer keep down the pressure bubbling up from below. The animal is raging against the artificial, putting intolerable stress on the structures of family and self-identity. But as individuality is being smothered by the homogenizing forces of economic globalization, it is simultaneously being stimulated. The reassertion and rebuilding of self-identity against the sprawl of simulated culture has become one of the most compelling issues in both society and in art.

Artificiality and irrationality are converging in the construction of contemporary reality. The public's perception of reality is much less linear and clear-cut than it was even twenty years ago. Things for which there were simple widely accepted explanations are now subject to multiple interpretations. The O. J. Simpson trial which dominates the news as this is being written, provides an example of how the perception of reality has changed. Twenty years ago this probably would have been an open and shut case. The seemingly rational circumstantial evidence would have convinced most observers of Simpson's guilt. Today, the defense allegation that the police set up a fictional trail of evidence to frame the defendant is widely believed. Many people find it plausible that the evidence was simulated rather than real.

Opposite page: inset, Marcel Duchamp, *Etant Donnés: 1e La Chute d'Eau, 2e Le Gaz d'Eclairage*, 1946-66. Background: film still from *The Wizard of Oz*.

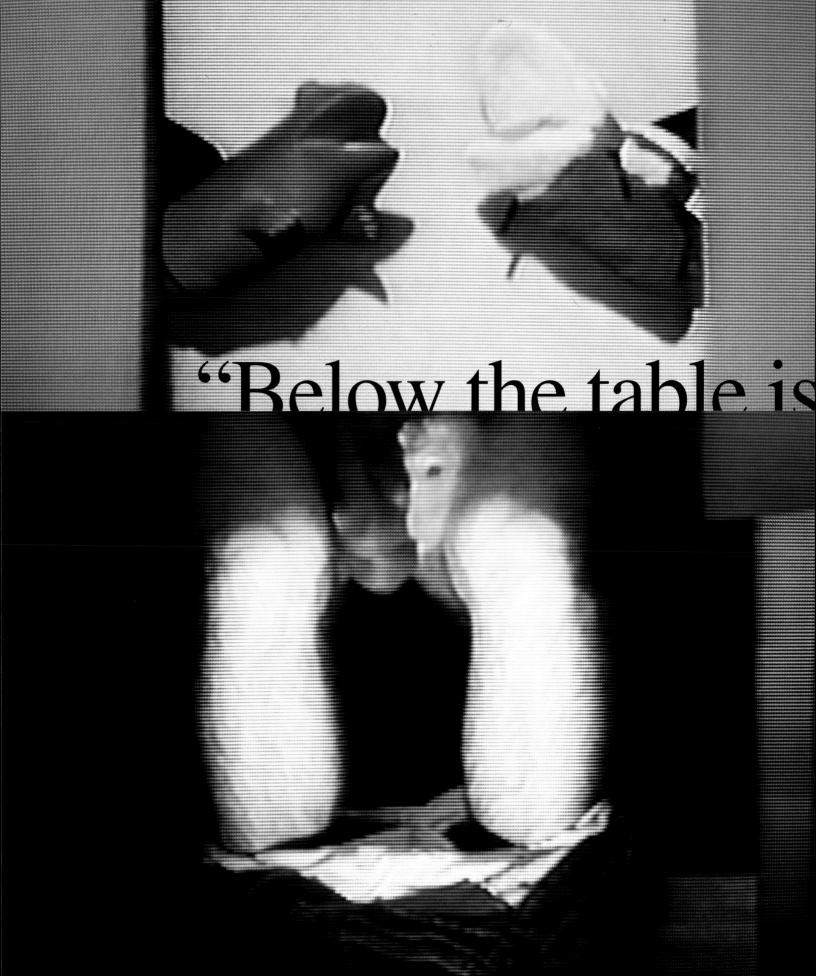

perversity,

pure libido and nature," declares a frog hand puppet in Paul McCarthy and Mike Kelley's *Heidi*. "Above the table is cheap theatrics, facades and lies!" The camera then moves below the table to reveal the lower half of the human puppeteer with his pants pulled down below his knees. Art has increasingly been looking below the table.

Beneath the models of hyperreality lie the deep emotions and imprinted images of childhood experience. What remains compelling about the work of artists like Robert Gober, Jeff Koons, and Cindy Sherman is not its surface effects or its critical agenda–it is its emotional resonance. The late 1980s' critical focus on surface rather than substance corresponded to the prevailing aesthetics of simulationism, but it neglected the personal content that gave the work much of its strength. It is fascinating and ironic that in an era when the family structure is perceived to be breaking down, artists are now looking back to their families and to their childhood experiences as sources of creative inspiration. The best art of the past decade began at home.

Artists found a natural parallel to the contemporary world's fusion of artificiality and irrationality in the "wonder years" of childhood. Reaching back to the magical world of the child helped artists to deal with the often irrational and artificial reality of their adult experience. The reconstruction of childhood imagery became part of the artistic process of reconstructing the self. The magical interchangeability between humans, animals, and cartoon characters inhabits the work of some of the past decade's most serious artists. Clumps of stuffed animals and carvings of pigs and angels are endowed with the same kind of primal iconic power that a previous generation invested in minimal geometric forms. The works' psychological resonance unleashes a flood of emotions retained from childhood.

The skewed cribs, empty childrens' beds, and hallucinatory sinks of Robert Gober's artistic world emerge from memories of the childhood home. They evoke the interiors of the aging frame houses of the decaying industrial towns of Connecticut, where Gober grew up. Strong childhood memories are objectified in these works, which bring adults back to the lingering emotional longings of youth. Gober began the reconstruction of this haunted aesthetic world with his dollhouse sculptures. Many of his subsequent images seem to emerge from the lonely rooms of these emotionally charged structures. The vanguard artist can go home again.

Jeff Koons has created a whole aesthetic universe of images that resonate from the childhood experience. Much of his vision is rooted in his memories of his father's interior decorating shop in the small city of York, Pennsylvania. The work is also anchored in visual memories of the town's housewares stores and automobile showrooms. Deep visual memories that Koons carried with him through childhood are abstracted and reconstructed. His equilibrium tanks and his encased vacuum-cleaner sculptures were often misinterpreted as Duchampian exercises devoid of emotion. These works are, in fact, loaded with emotion. The vacuum cleaner has profound associations with the mother and with female sexuality. The basketball, like Jasper Johns's FLAG, is an abstract symbol of American identity. Floating in the equilibrium tank, it is like a fetus suspended in the womb. It becomes an allegorical self-portrait of the artist.

With the dissolution of communism and the erosion of the moral imperative beneath democratic capitalism, the great modernist value systems could no longer provide artists with a universal framework of belief. As it became anachronistic for artists (and most other people as well) to identify with the spirit of utopian modernism, they began to look toward more personal constructs of self-identity. More traditional concepts of identity such as nationality, ethnicity, and religion have again become relevant as art has increasingly become an arena for the reconstruction of identity.

Identity is abstracted and deeply buried in the work of Jeff Koons, but for some of the best artists of the younger generation identity is much closer to the surface. The structure of art and the structure of identity becomes intertwined. Matthew Barney explores the structure of the self in the context of an unprecedented combination of traditional masculine mythology and advanced biotechnology. Male and female archetypes traverse

Opposite page: video stills from Mike Kelley and Paul McCarthy, *Heidi*, 1992.

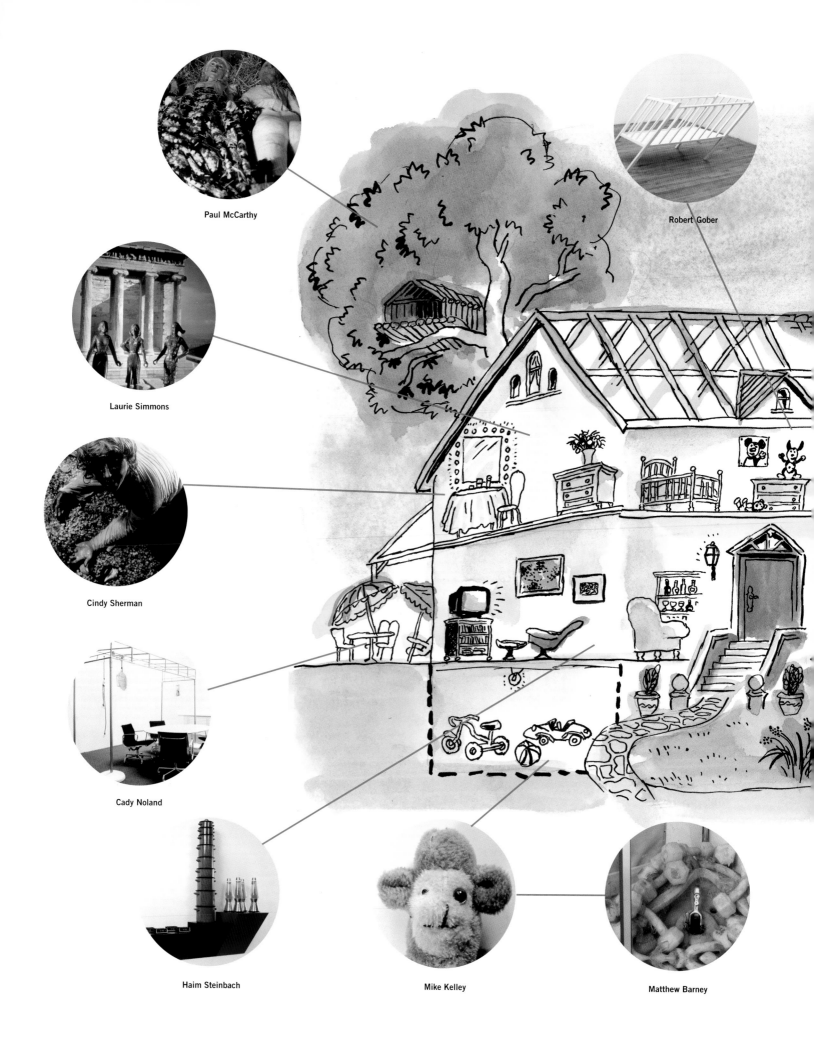

Paul McCarthy

Robert Gober

Laurie Simmons

Cindy Sherman

Cady Noland

Haim Steinbach

Mike Kelley

Matthew Barney

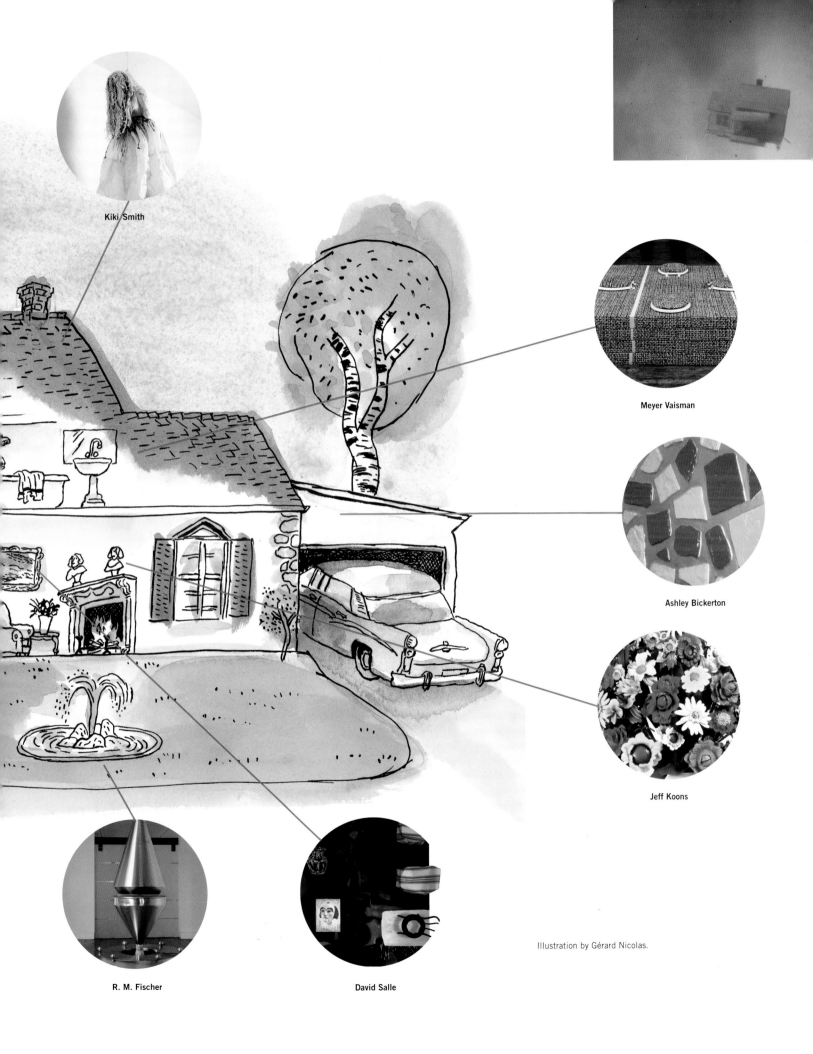

Kiki Smith

Meyer Vaisman

Ashley Bickerton

Jeff Koons

Illustration by Gérard Nicolas.

R. M. Fischer

David Salle

a terrain that is part hospital and part sports field. Gender roles are turned inside out as men and women morph into each other and even into animals. Myths of masculinity and femininity are exploded into premonitions of a re-engineered future.

Dreams are abstracted into a continuously expanding object in Janine Antoni's SLUMBER, a mesmerizing work that combines performance with sculpture and high technology with craft. The artist sleeps in a startling contraption that is part bed and part loom while her rapid eye movements are being monitored by an attached electroencephalograph. When she awakens, she spends the day unraveling the threads of her diminishing nightgown and weaving into a flimsy blanket, following the pattern of her brain waves. The whole device becomes a self-identity machine, making subconscious thought and feelings into form.

A different aspect of identity is celebrated in Nari Ward's AMAZING GRACE, an astounding accumulation of over three hundred abandoned baby strollers looped together with discarded firehose. The artist introduced the work with a rousing gospel service and then had the reverend lead the congregation through the sculpture as Mahalia Jackson's recording of "Amazing Grace" resounded in the background. There are few things as poignant as a discarded stroller, each one representing a life with its private joys and tragedies. In Harlem, strollers are associated not only with little children and their mothers but with the homeless men who reclaim them to drag around their belongings. The artist created an epic portrait of the cycle of life transforming this thrown-away material into an altar of religious deliverance. In his involvement with religion and in his imaginative use of recycled material, Ward draws on his Jamaican heritage. His work is an example of how art is being re-energized by artists from countries that had been marginalized by the art-world mainstream.

Beneath the layers of artificiality in contemporary life, there is flesh and blood. Kiki Smith's figures are not hyperreal, they are real. When they are hurt, they bleed. In reaction to the simulated realities that artists have been modeling, Smith sculpts figures that bear witness to the emotional and physical burdens of real life. Smith goes deep inside the home in MOTHER/CHILD, a shocking rendering of two naked figures, a mother and her adult son. Positioned close together but facing away from each other, the mother hungrily sucks the milk out of her breast while the child sucks out his own semen. Alienated from the world and from each other, the mother and child seek fulfillment within themselves. In the tradition of great tragic art, the figures endure misery but ultimately their acts are life-affirming. Naked and battered by the outside world they try to suck the essence of life out of themselves.

As artists looked back into their personal histories as a way to penetrate the artificiality of contemporary life, they began resurrecting a deeper reality. Truth had seemed obsolete in the interplay of fact, fantasy, simulation and interpretation that shapes contemporary perception. But by retreating into the realm of childhood memories, dreams, and religious experience, artists found something genuine in their fantasies and their faith. Artists may not have been able to find truth in the multilayxered reality of everyday life, but they kept looking for it in themselves. Artificiality ultimately leads us back to authenticity. Truth is inside us. —JEFFREY DEITCH

Opposite page: film still from *The Wizard of Oz* with inset of Robert Gober *Untitled*, 1980.

The vanguard artist can go home again.

Marina Abramovic Vito Acconci
Dennis Adams Laurie Anderson
Janine Antoni Arman John M. Armleder
Richard Artschwager John Baldessari
Matthew Barney Vanessa Beecroft
Ashley Bickerton Ross Bleckner
Alighiero e Boetti Jonathan Borofsky
Jake and Dinos Chapman
Clegg & Guttmann Crash (John Matos)
Gregory Crewdson Grenville Davey

Most of the texts and photographs have been suggested by the artists themselves.

Wim Delvoye Walter de Maria John Dogg
Cheryl Donegan Stan Douglas
Marcel Duchamp R.M. Fischer Fischli/Weiss
Dan Flavin Günther Förg Katharina Fritsch
Gilbert & George Robert Gober
Jack Goldstein Dan Graham Peter Halley
Damien Hirst Jenny Holzer Rebecca Horn
Donald Judd Mike Kelley Niek Kemps
Jon Kessler Toba Khedoori
Martin Kippenberger Jeff Koons

Joseph Kosuth Jannis Kounellis
Barbara Kruger George Lappas Liz Larner
Annette Lemieux Sherrie Levine
Simon Linke Man Ray Piero Manzoni
Patty Martori Christian Marclay
Paul McCarthy Allan McCollum
Gerhard Merz Tatsuo Miyajima
Yasumasa Morimura Matt Mullican
Juan Muñoz Peter Nagy Bruce Nauman
Cady Noland Gabriel Orozco Pino Pascali
Francis Picabia Richard Prince

The editors would like to express their gratitude to the artists for their collaboration.

Charles Ray David Robbins
James Rosenquist Ed Ruscha David Salle
Rob Scholte Thomas Schütte
Cindy Sherman Laurie Simmons
Kiki Smith Robert Smithson
Pia Stadtbäumer Haim Steinbach
Philip Taaffe Takis Wolfgang Tillmans
Rosemarie Trockel Meyer Vaisman
Jan Vercruysse Wallace & Donahue
Nari Ward Andy Warhol Christopher Wool

Marina
Abramovic

Born: Belgrade, Yugoslavia 1946 / Lives and works in Amsterdam and Berlin

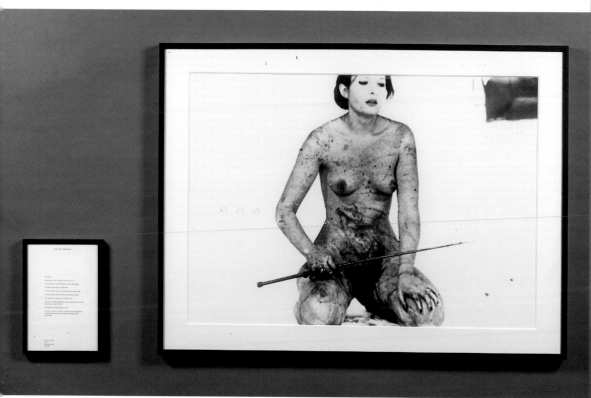

A VOW OF POVERTY "The acceptance of poverty in theatre, stripped of all that is not essential to it, revealed. . . . not only the backbone of the medium, but also the deep riches which lie in the very nature of the art form. Why are we concerned with art? To cross frontiers, to exceed our limitations, fill our emptiness. . . . This is not a condition but a process in which what is dark in us slowly becomes transparent. In this struggle with one's own truth. . . . The theatre, with its full-fleshed perceptivity, has always seemed . . . a place of provocation. It is capable of challenging itself and its audience by violating accepted stereotypes of vision, feeling, and judgment, more jarring because it is imaged in the breath, body and inner impulses of humanity. This defiance of taboo, this transgression, provides the shock which rips off the mask, enabling us to give ourselves nakedly to something which is impossible to define but which contains Eros and Caritas." FROM **JERZY GROTOWSKI**, *TOWARDS A POOR THEATRE* (NEW YORK: SIMON & SCHUSTER, 1968)

above: **Lips of Thomas**, 1975 framed black-and-white photograph and framed text; photograph: 95 x 7.5 centimeters / 37 x 3 inches text: 26 x 18.5 centimeters / 10 x 7 inches

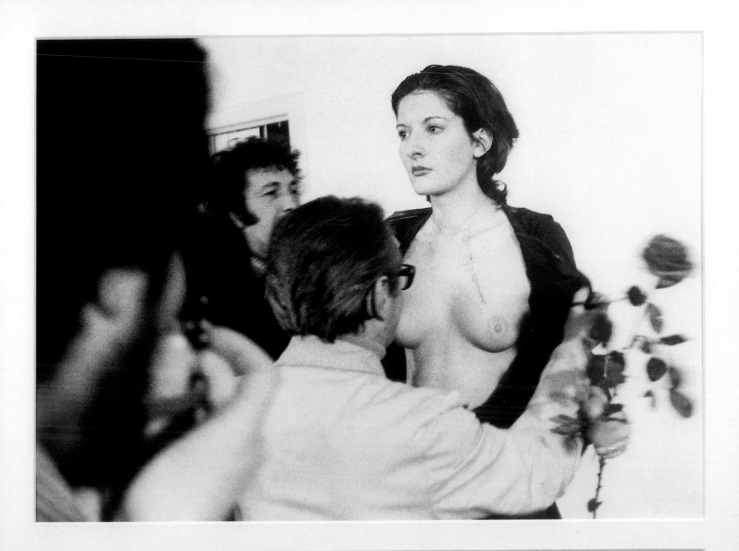

GUN	FLOWERS	NEEDLE	SHEET OF WHITE PAPER	SALT	MEDAL
BULLET	MATCHES	SAFETY PIN	KITCHEN KNIFE	SUGAR	COAT
BLUE PAINT	ROSE	HAIR PIN	HAMMER	SOAP	SHOES
COMB	CANDLE	BRUSH	SAW	CAKE	CHAIR
BELL	WATER	BANDAGE	PIECE OF WOOD	METAL PIPE	LEATHER STRINGS
WHIP	SCARF	RED PAINT	AX	SCALPEL	YARN
LIPSTICK	MIRROR	WHITE PAINT	STICK	METAL SPEAR	WIRE
POCKET KNIFE	DRINKING GLASS	SCISSORS	BONE OF LAMB	BELL	SULPHUR
FORK	POLAROID CAMERA	PEN	NEWSPAPER	DISH	GRAPES
PERFUME	FEATHER	BOOK	BREAD	FLUTE	OLIVE OIL
SPOON	CHAINS	HAT	WINE	BAND AID	ROSEMARY BRANCH
COTTON	NAILS	HANDKERCHIEF	HONEY	ALCOHOL	APPLE

above: **Rhythm O**, 1974 framed black-and-white photograph and framed text; photograph: 94 x 93 centimeters / 36 1/2 x 36 1/4 inches text: 26 x 18.5 centimeters / 10 x 7 inches

Vito Acconci

Born: Bronx, New York 1940 / Lives and works in Brooklyn

3. Video monitor as one point in a face-to-face relationship; on-screen, I face the viewer, off-screen. (Since the image is poorly defined, we're forced to depend on sound more than sight: "Intimate distance.")

4. Starting point: Where am I in relation to the viewer— above, below, to the side? Once my position is established, the reasons for that position shape the content: I can improvise, keep talking, fight to hold my stance in front of the viewer. (At the same time, I'm fighting the neutrality of the medium by pushing myself up against the screen—I'm building an image for myself lest I dissolve into dots, sink back into grayness.")

5. But my image breaks the face-to-face contact: the viewer faces a screen of me, an image under glass, me-in-a-fishbowl. Rather than being in a situation *with* me, the viewer is in front of a situation *about* me.

FROM VITO ACCONCI, "TEN-POINT PLAN FOR VIDEO," *VIDEO ART: AN ANTHOLOGY,* EDS. IRA SCHNEIDER AND BERYL KOROT (NEW YORK: HARCOURT, BRACE, AND JOVANOVICH, 1976)

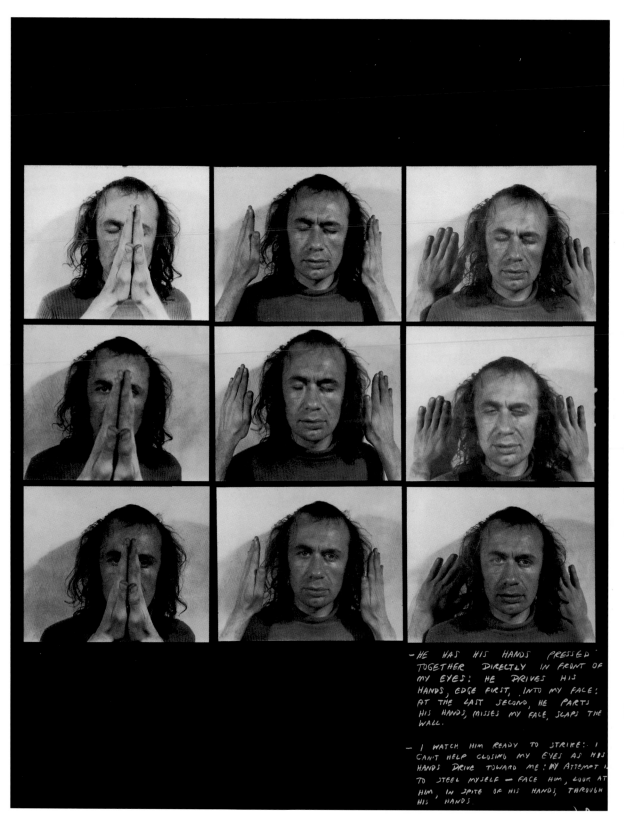

— HE HAS HIS HANDS PRESSED TOGETHER DIRECTLY IN FRONT OF MY EYES: HE DRIVES HIS HANDS, EDGE FIRST, INTO MY FACE: AT THE LAST SECOND, HE PARTS HIS HANDS, MISSES MY FACE, SLAPS THE WALL.

— I WATCH HIM READY TO STRIKE: I CAN'T HELP CLOSING MY EYES AS HIS HANDS DRIVE TOWARD ME: MY ATTEMPT IS TO STEEL MYSELF — FACE HIM, LOOK AT HIM, IN SPITE OF HIS HANDS, THROUGH HIS HANDS.

VITO ACCONCI, *EYE-OPENER,* 1971 PHOTO: LARRY LAME

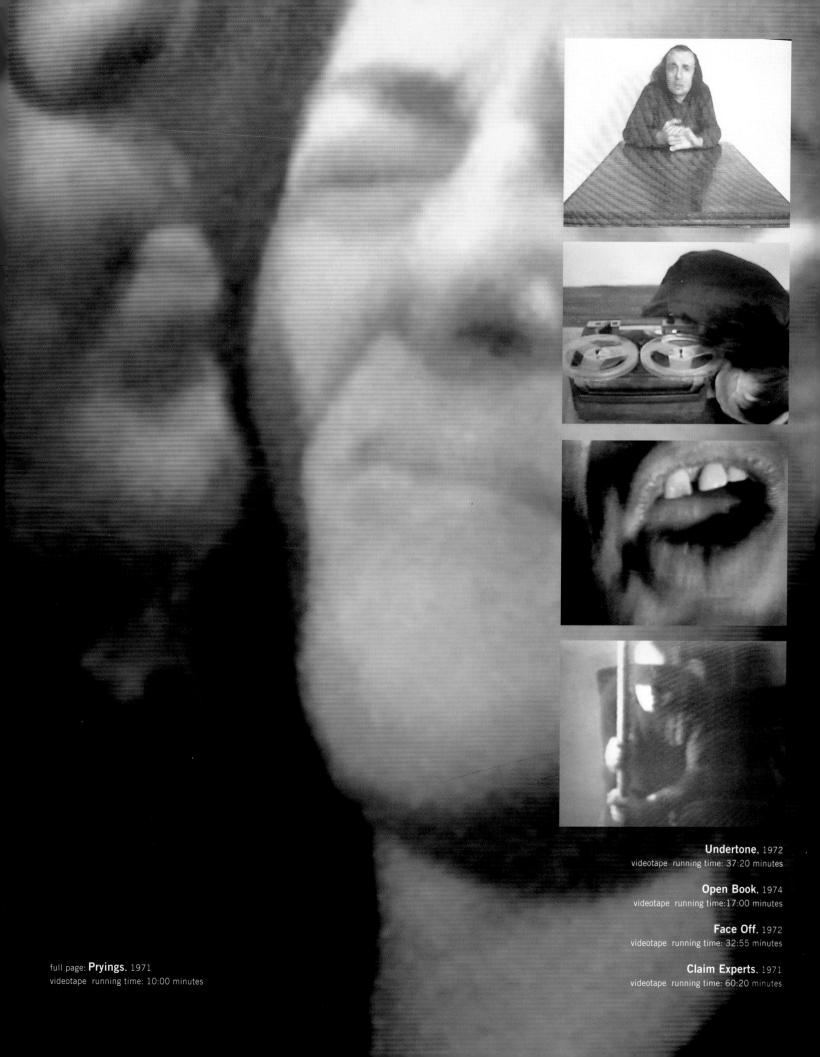

Undertone, 1972
videotape running time: 37:20 minutes

Open Book, 1974
videotape running time: 17:00 minutes

Face Off, 1972
videotape running time: 32:55 minutes

full page: **Pryings,** 1971
videotape running time: 10:00 minutes

Claim Experts, 1971
videotape running time: 60:20 minutes

Dennis Adams

Born: Des Moines, Iowa 1948 / Lives and works in New York City

I'm interested in how freedom and fear converge on the image. The rest is only photography. 1991

PHOTO: GÉRARD RONDEAU

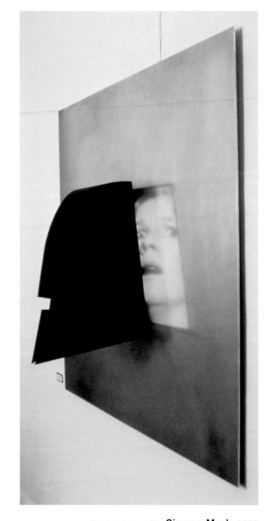

above and opposite: **Cinema Mask**, 1986
aluminum, wood, formica, fluorescent lights,
Plexiglas and Duratrans photo
122 x 122 x 38 centimeters /
48 x 48 x 15 inches

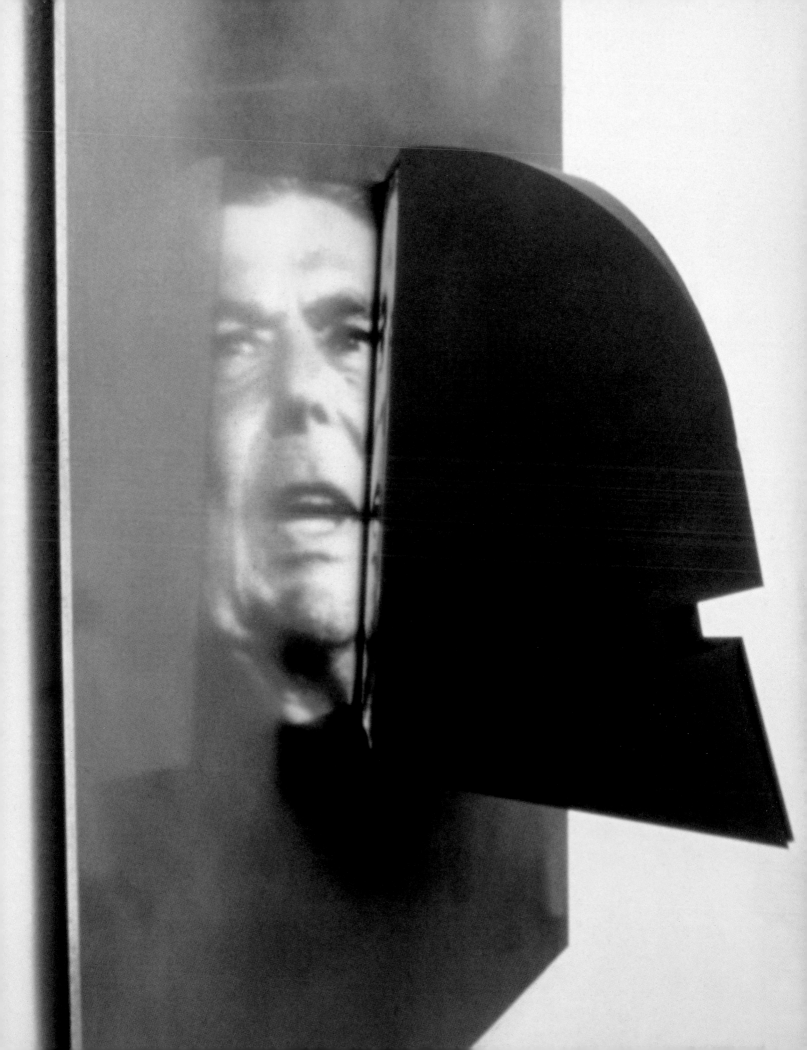

Laurie
Anderson

Born: Chicago, Illinois 1947 / Lives and works in New York City

NUMBERS RUNNERS 1978

An altered phone booth.
The listener picks up the phone and responds to a series of questions and stories.
Gaps were left for the listener's responses, which were on time delay.

You know that ad—that ad for the phone company—
there's a mother and her little daughter and they're sitting around and the phone rings.
The mother picks it up and talks for a moment.
Then she holds the receiver out to the daughter and says,
"Talk to Grandma! Here's Grandma!"
And she's holding a piece of plastic. So, of course, the question is:
Is the phone alive? What's alive and what doesn't have life?

In a lot of work that I do, there's interaction between technology and human beings. The possibilities for misunderstandings are obviously enormous.

And I answered the phone and I heard a voice and the voice said:

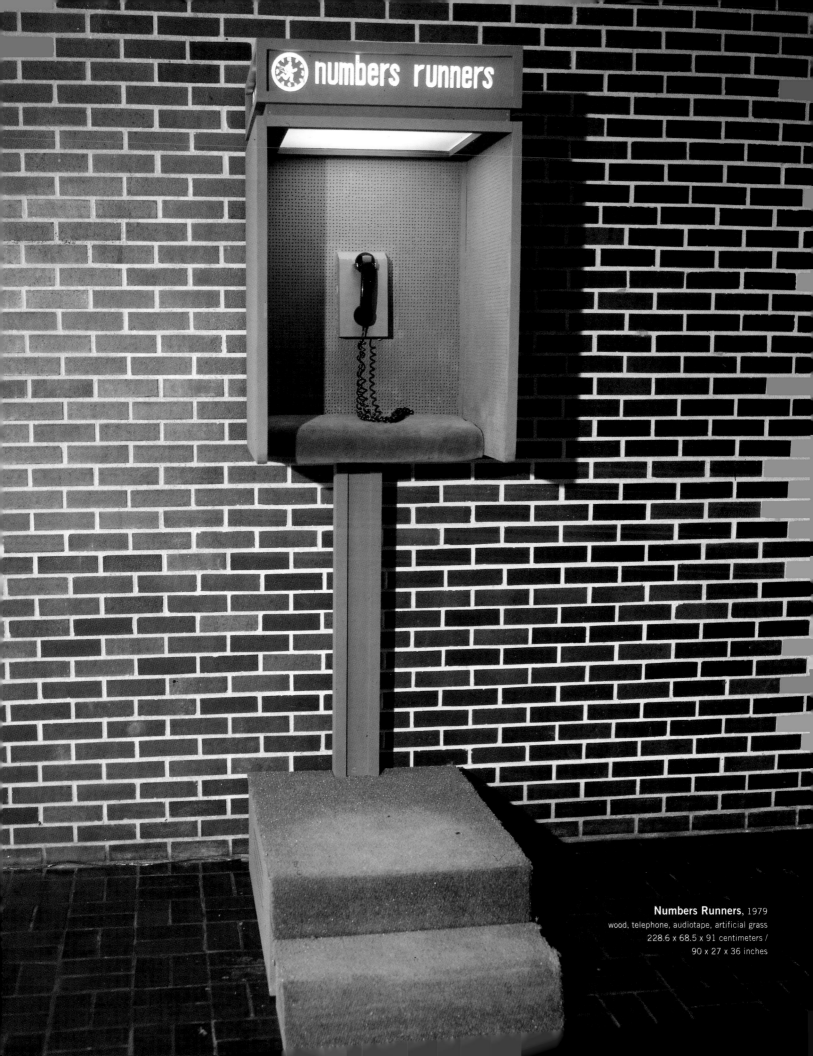

Numbers Runners, 1979
wood, telephone, audiotape, artificial grass
228.6 x 68.5 x 91 centimeters /
90 x 27 x 36 inches

Please don't hang up.

We know who you are.

Please do not hang up.

We know what you have to say.

Please do not hang up.

We know what you want.

Please do not hang up.

We've got your number:

One . . . **two** . . . **three** . . .
four

WE ARE TAPPING YOUR LINE

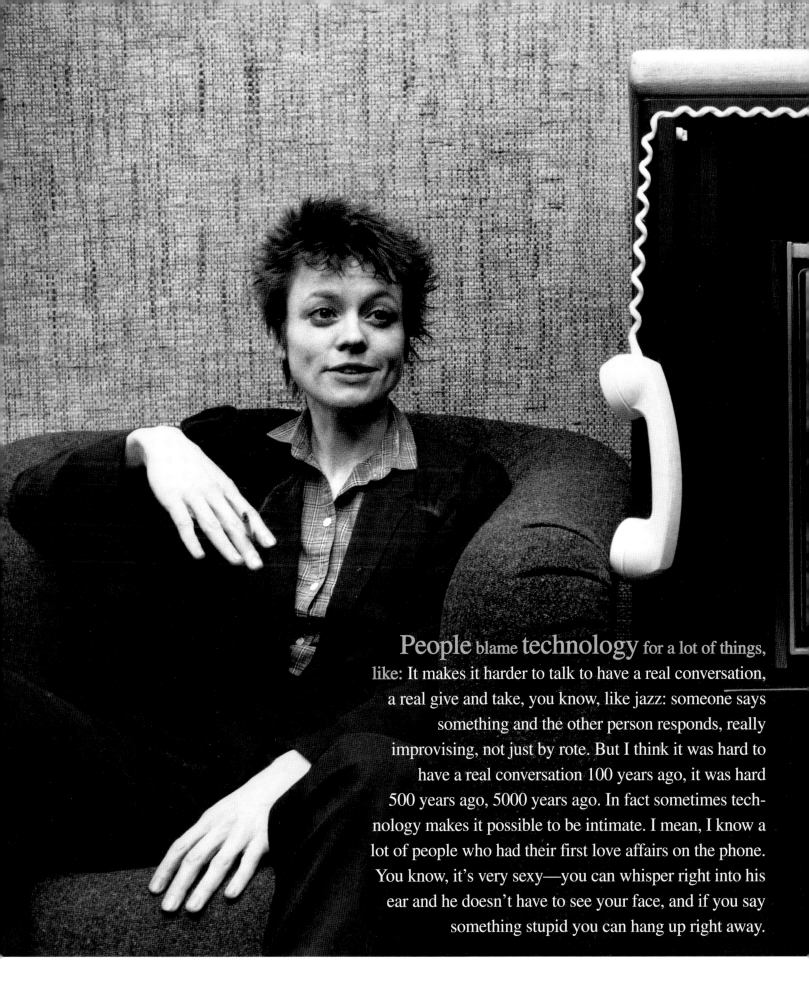

People blame technology for a lot of things, like: It makes it harder to talk to have a real conversation, a real give and take, you know, like jazz: someone says something and the other person responds, really improvising, not just by rote. But I think it was hard to have a real conversation 100 years ago, it was hard 500 years ago, 5000 years ago. In fact sometimes technology makes it possible to be intimate. I mean, I know a lot of people who had their first love affairs on the phone. You know, it's very sexy—you can whisper right into his ear and he doesn't have to see your face, and if you say something stupid you can hang up right away.

I had the idea that the

Janine Antoni

Born: Freeport, Bahamas 1964 / Lives and works in New York City

... are really the dreams

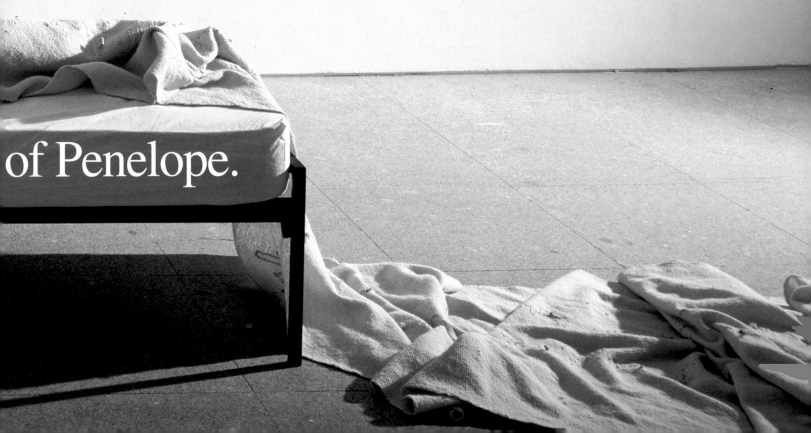

travels of Odysseus. . .

of Penelope.

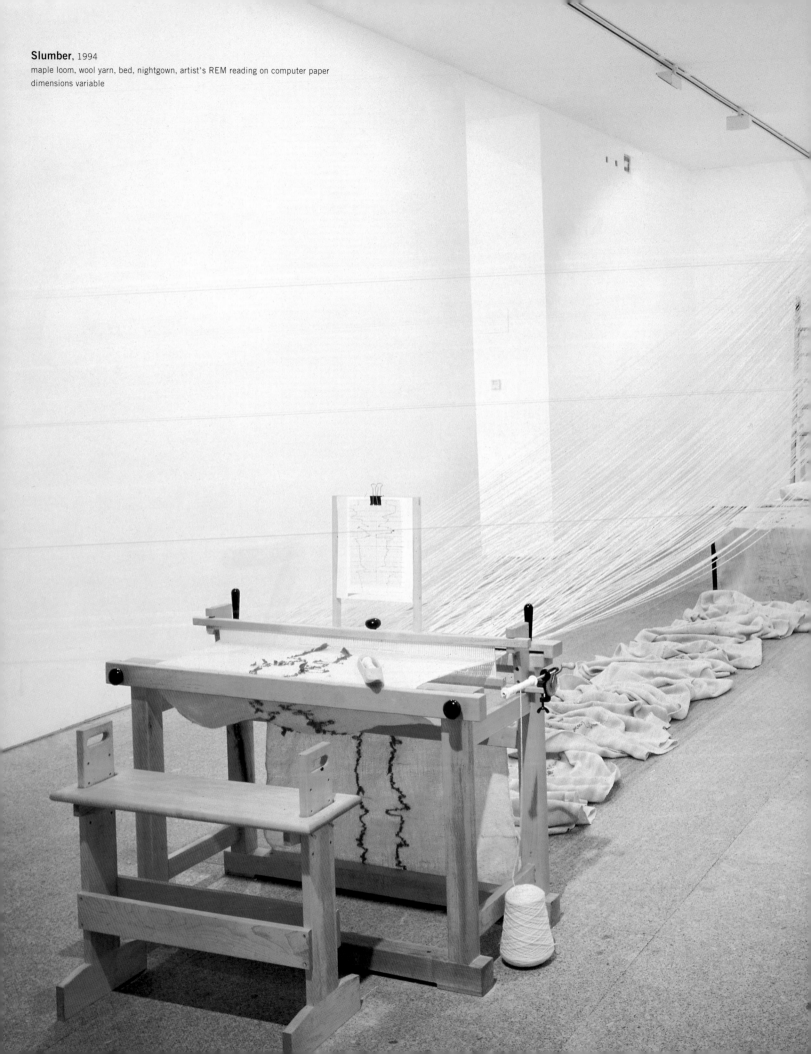

Slumber, 1994
maple loom, wool yarn, bed, nightgown, artist's REM reading on computer paper
dimensions variable

JANINE ANTONI: I had the idea that the travels of Odysseus are really the dreams of Penelope. All of his encounters, his trials and tribulations might be the monsters of the psyche.

PAUL RAMIREZ-JONAS: *But this is not how you told me the story originally. Didn't you begin it differently?*

JA: I don't know. Everybody asks me when I am weaving,"Are you waiting for a man?" Understandably, it is a distressing question which led me to a retelling of the story of Penelope.

PR-J: *And you saw her story as a parallel to your weaving. Or at least you imagined a retelling based on dreams.*

JA: SLUMBER is a re-enactment of Penelope's story. Except my version includes a polysonograph.

PR-J: *What I am asking for is the old wive's tale told by this young not-wife-to-be.*

JA: As Penelope weaves, she waits for her dreams to return to her . . . and when they do . . . she does not recognize them.

PR-J: *Can you tell me the story from beginning to end?*

JA: In its original form or its retelling?

PR-J: *As you wish.*

JA: Odysseus set sail from Ithaca to wander for ten years before he could return to Penelope. In his travels all kinds of things happen to him. There are a lot of difficult situations he has to overcome in order to survive. Meanwhile, Penelope is weaving as she waits for him to return. The weaving is a kind of time-keeping. It's something to do while she waits, as well as an excuse to keep the suitors away. She hopes that when she finishes weaving, Odysseus will return. But since he doesn't come back, at night she unravels her day's work. It makes me wonder if the weaving has something to do with the fate of Odysseus. Or in my story, her own fate.

PR-J: *You mean Odysseus is an invention of Penelope? That weaving the blanket is really the weaving of a fiction? Or perhaps, as you've told me plenty of times before, that Penelope being a woman needs a man's body to be able to travel? What I never understood is if the blanket is the fictional body of Odysseus or just the narrative.*

JA: I think that it is just the narrative. Odysseus doesn't have a body. He is a product of Penelope's mind. He just takes form in the narrative.

PR-J: *So why does she unweave it?*

JA: Good question. Because I don't unweave my blanket. But I do unweave my nightgown. In fact you can say the story is written with the nightgown.

PR-J: *Can you just tell me the story?*

JA: The story is that the travels of Odysseus are the dreams of Penelope. The reason that she doesn't recognize him when he returns to her is that the conscious mind cannot deal with its problems. So, in an effort to confront the problems, the unconscious disguises it in dreams.

PR-J: *There is a contradiction. He is a dream, he returns, he is a problem. So, does the unconscious turn him into a dream?*

JA: No! He is a dream, his travels, everything is a dream. When he returns to Penelope she doesn't recognize him, in the way that we don't recognize our own unconscious. In the way that the unconscious disguises itself for the conscious mind. 1995

Arman

Born: Nice, France 1928 /

Lives and works in New York City, Venice, Paris

ARMAN: TRASHCAN ART: *LES POUBELLES*

Containerized trash has form, texture, a fragile kind of beauty, but above all it triggers the imagination. Trash is the purest reflection of the transience of man's passage on this earth and of the civilization he creates. But trash is also the best clue to an individual's taste, values, interests, and sentimental, even criminal inclinations. Sleuths have reconstituted the personality of their quarry from the contents of his wastebasket alone. Arman has seized on the potential of refuse in much the same spirit. Trash, packed tightly in glass containers or sealed in polyester and plastic, can be read as the evidence of a doomed race seen throughout the periscope of a rescue vessel. Personalized waste, packed loosely and almost lovingly in plastic boxes standing erect like tombstones, is iconic, tributary, and summons up mortality. Both forms of waste possess finality.

opposite page:
La Poubelle de la Columbe d'Or, 1969
garbage, Plexiglas, resin
120 x 90 x 12 centimeters / 9 x 35 x 4 3/4 inches

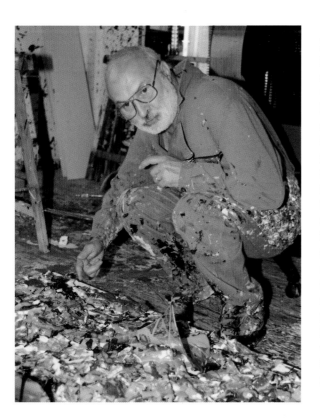

From 1960 on, Arman has made "trashcan portraits" of friends and fellow artists, more accurately referred to as "robot portraits." Their composition is the opposite of what they seem to be. Arman has not emptied wastebaskets to look for evidence of his subject's profession, emotional life or taste. In fact, he never uses what has been spontaneously discarded. Instead, he coaxes the person to be portrayed into sacrificing what means the most to him and is hardest to give up. A pragmatist, Arman does not insist that great treasures or works of art be thus removed from circulation and transparently preserved. Typically, these plastic containers will hold a favorite book and other revealing printed matter; clothes; one of a pair of anything—designer shoes, gloves, earrings—so as to render the other one useless; tools of the trade, keepsakes, and accessories. Exceptions to this rule are some of more recent artists' portraits. Following the tradition of Arcimboldo, who composed portraits of librarians from books, and gardeners from fruits and vegetables, Arman recomposed his colleagues using telltale evidence of Benday dots, flower silkscreens, used tape, or cut-up photographs he collected at their studios.

FROM JAN VAN DER MARCK, *ARMAN* (NEW YORK : ABBEVILLE PRESS, 1984)

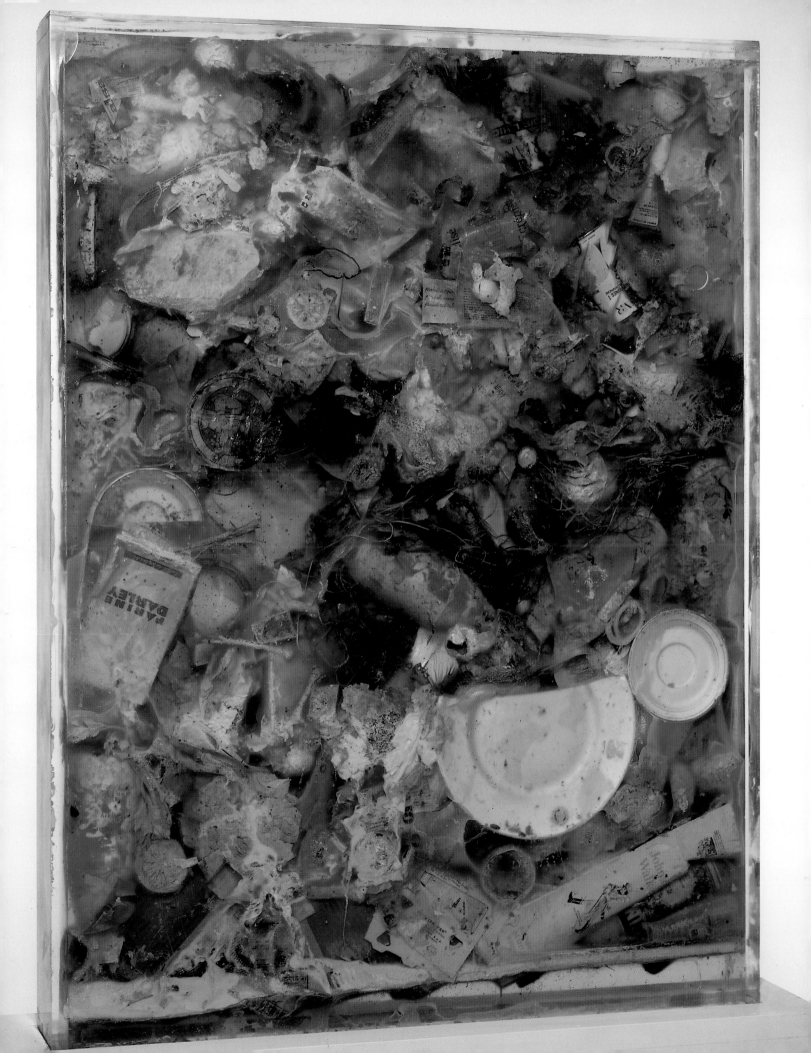

John M. Armleder

Born: Geneva, Switzerland 1948 / Lives and works in Geneva, Switzerland

opposite page:
Installation with Chair, Bookcase and Painting, 1985
acrylic paint on canvas, chair, bookcase
chair: 91.5 x 49.5 x 53.5 centimeters / 36 x 19.5 x 21 inches
bookcase: 86.5 x 101.5 x 35.5 cm / 34 x 40 x 14 inches
painting: 76 x 76 centimeters / 30 x 30 inches

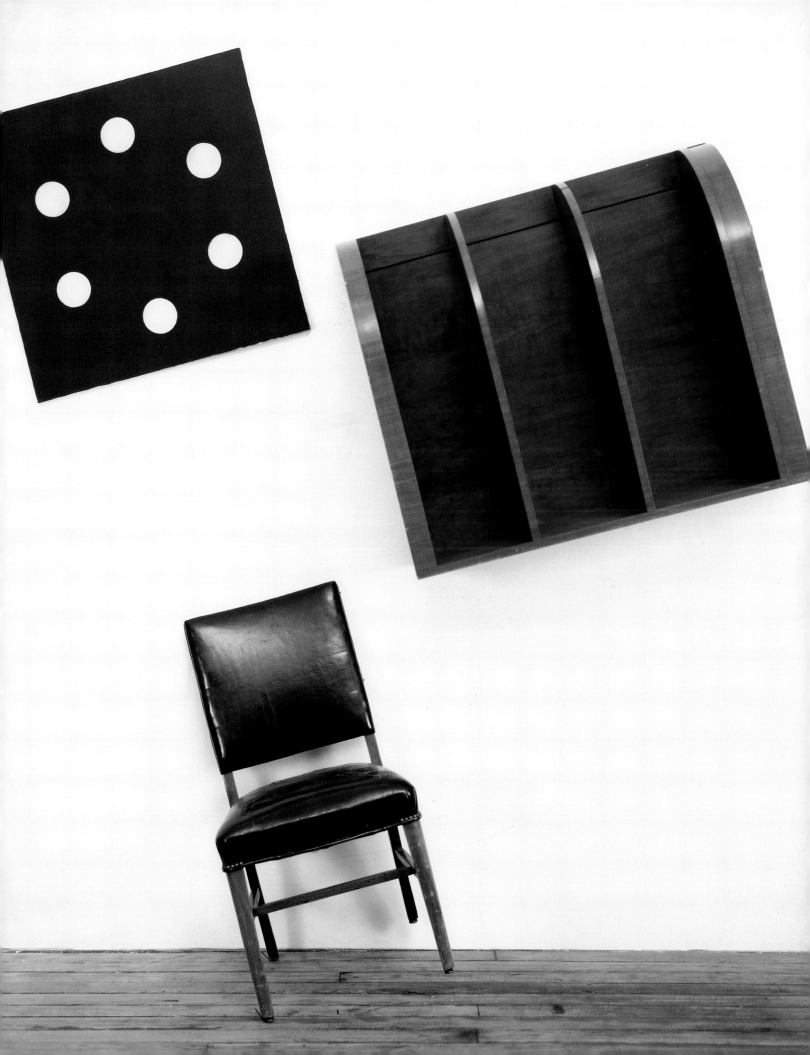

Untitled, 1986
acrylic, canvas, wooden bed frame
195 x 220 x 76.5 centimeters / 76 3/4 x 86 3/4 x 30 1/8 inches

I try most of the time to radically undermine what I tend to achieve easily. It works this way, but then a system grows that has to be undermined as well.

. . . I guess I was raised together with that generation which was convinced that there were no rules, no one truth, no power to impose, no ruling authority, and, within that scheme, that life was to be lived for the better; and hopes were raised that we were doing exactly that, making life better, and art was a chance to help, both on the surface and within the spiritual realm. Sometimes my systematic use and misuse of modernity attaches me to a philosophy of skepticism, of the eternal *réchauffé*, of the witty commentator of a consumer culture and society. Maybe I don't care enough about UFOs, but I know that UFO skeptics are not my friends.

. . . My art is defined by its culturally conscious statement. Or one says so. One of the backgrounds to art is art, whatever that is. But plainly I keep on enjoying it, and I guess my mind is busy on it. That's music, gardening, architecture, fashion and so on. And obviously I am involved in experiencing works and shows of artists I don't know as much as the ones I especially care for, and have that craving for new artists' works that tell me critically about my own. Of course, then I sometimes get involved more than a secret witness, since I build shows, produce multiples, and so on—implicated in a plot, so to speak. Well, this must be some kind of joke, but anyhow let's leave it in. What I believe, for instance, is that there are no clearly defined lines, and we all end up being outsiders. Because, after all, there is no consecrated position offered, available, seekable. And would there be so, we would run away.

FROM "TWO TAPED CONVERSATIONS; ALISTAIR SETTON, DEREK BARLEY AND JOHN ARMLEDER, MARCH 1993;

JACK FLASTEN AND JOHN ARMLEDER, MARCH 1993," *JOHN M. ARMLEDER* (VIENNA: WIENER SECESSION, 1993)

Richard Artschwager

Born: Washington, D.C. 1923 /
Lives and works in New York City

PHOTO: KATRIN SCHILLING

I may be too embedded in my own form of orthodoxy, which has to do with art: Formalism understood through its ritual. You can say "flat" and I would offer you as "flat" someone standing against a wall and looking straight ahead, not physically moving, and keeping his mouth shut. I'd define it more in terms of total tableau. I'm not being funny or dada. There are forms of sitting, or looking and so forth, which you cannot call dynamic in the strict sense of the word because they tend toward the static and close off senses, some options. You can define visual art by default, as that which you look at or as that which you don't listen to or smell.

opposite page: **Step 'n' See II**, 1966–1979 formica and wood wall: 91.4 x 84 x 26.5 centimeters / 36 x 33 x 10 3/4 inches floor: 136 x 84 x 87.6 centimeters / 53 1/2 x 33 x 34 1/2 inches

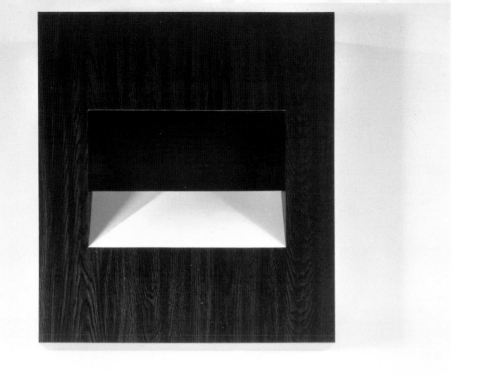

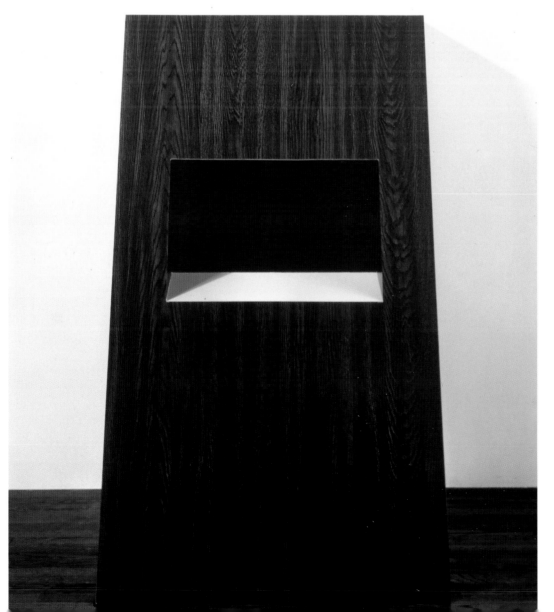

My art is
about
deprivations
working as
a backlash
or a reaction
that opens
up that which
is deprived to
speculation
and fantasy.

CIRCA 1975

John Baldessari

Born: National City, California 1931 / Lives and works in Santa Monica, California

MEG CRANSTON: . . . *I get from your work that you believe, or that you sense, that your works can be read—I can read them and understand them.*

JOHN BALDESSARI: I think my works are built on the premise that there's always a slipperiness in language. Yet, I know enough about it, that I could throw out markers out there that somehow slow us down and coalesce meaning. It's all a shell game. You think you're a little bit on top, but you're not sure. It's all a gamble. It's almost like that party game where you whisper one word in a person's ear, and then another, and you see how it comes out in the end. Art is like that. I love the idea of misreading. Because I think that misreading brings truth into the world. I don't think truth always comes from perseverance. I think a lot of it comes indirectly, while we're brushing our teeth, driving a car, it just sort of hits us. And I don't think the truth always comes from frontal assault.

FROM AN INTERVIEW WITH MEG CRANSTON, *JOURNAL OF CONTEMPORARY ART*, FALL/WINTER 1989

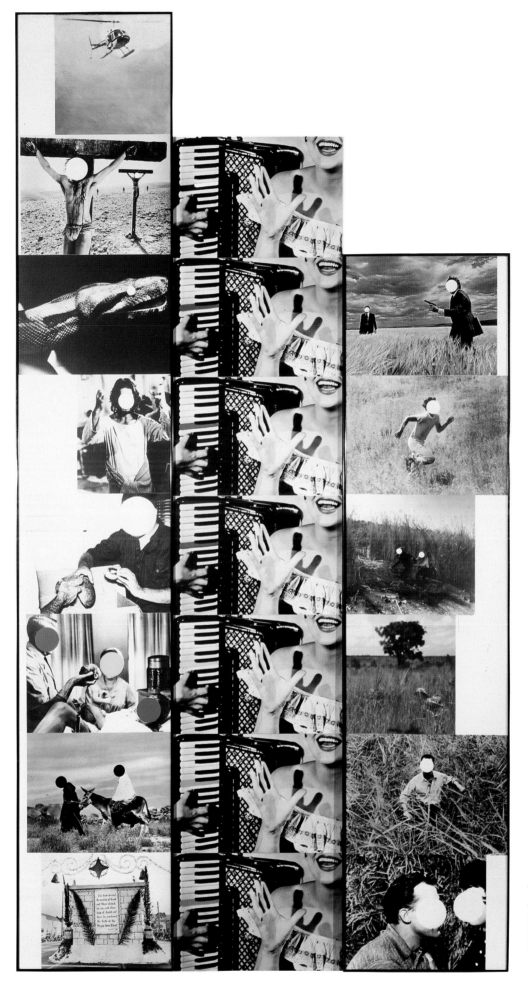

Two Stories, 1987
oil tint, acrylic,
b/w and color photographs
244 x 129 centimeters /
96 x 50 7/8 inches

Matthew

Born: San Francisco 1967 / Lives and works in New York City

Barney

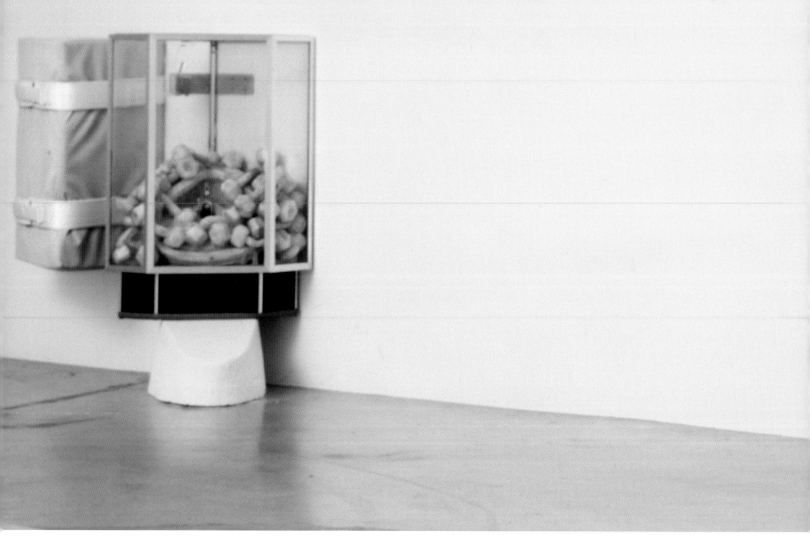

GLEN HELFAND: *How does your use of video relate to its use in sports and art video?*

MATTHEW **BARNEY**: The use of video interested me as secondary information in lieu of doing live works. It relates to an interest I had in the empty stage. It's something I think of as walking up the ramp around the outside of a stadium and hearing what's going on inside, but not being able to see it until you get to the very top. It's the notion of seeing something, but already having some sort of experience of it, a feeling inside. The location of head space became very important. Other areas of the installation can take on a different kind of presence, especially if they were experienced before the information.

GH: *Is there a goal behind your project?*

MB: I think the goal is to create a language that can communicate.

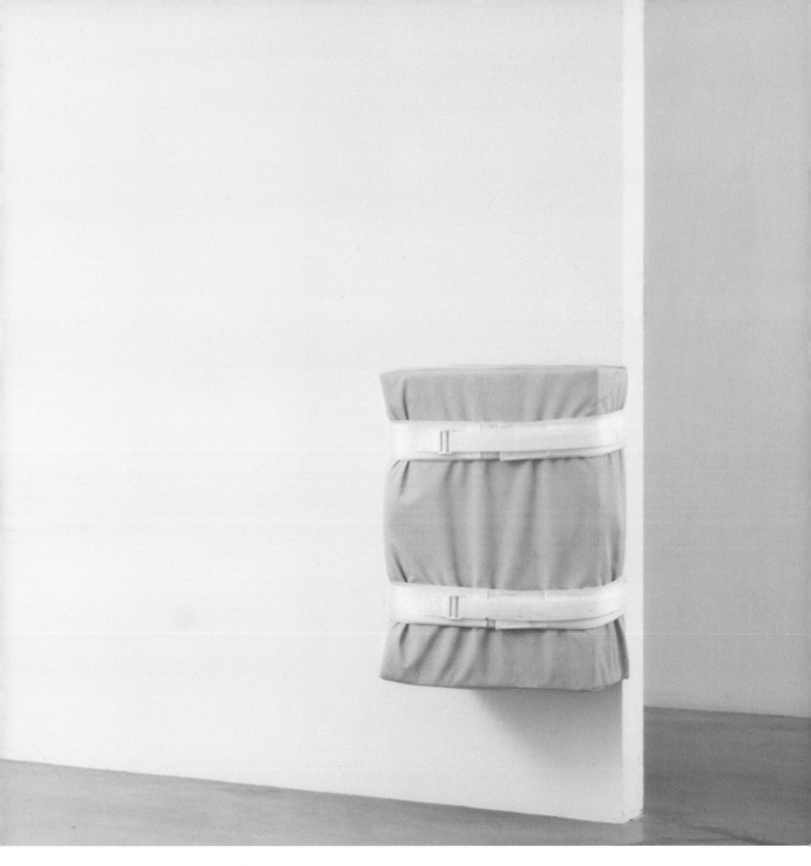

GH: *Is that language based on the physical body?*

MB: It's a visual language. That's the reason I started making art in the first place. I felt more comfortable with a visual language.

GH: *There's been a lot of talk about the influence of Beuys, Burden, and Acconci on your work. Do you have any comments about that?*

MB: I'm attracted to artists who put together a diverse body of work that deals with a cosmology that focuses less on aesthetics and formal rela-

Case BOLUS, 1989–91
cast petroleum jelly and wax,
45 lb. Olympic weights and 8 lb. dumbbells,
speculum, mouth guards, glass case, cast sucrose,
foam and nylon pads, binding belts
dimensions variable

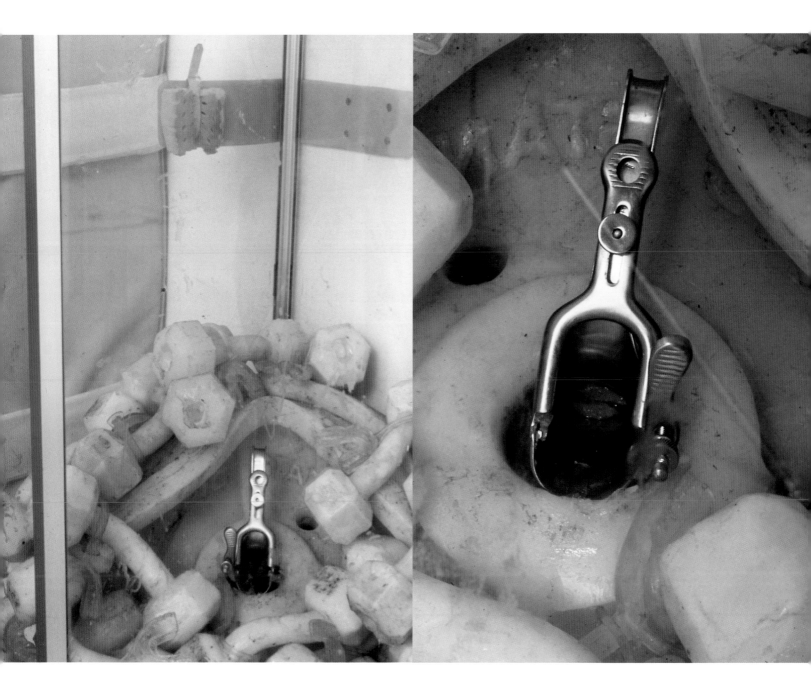

tionships. Obviously Beuys did that, Acconci and Burden definitely could have done this. Houdini influenced me even more.

GH: *Have you always been interested in Houdini?*

MB: I've been interested in Houdini for quite a while. It goes back to the behavior of athleticism. It always intrigued me that Houdini studied those locks so thoroughly that when the police forces in Europe proposed to incarcerate him and commissioned a locksmith to build locks to hold him, by the time the lock had been developed, Houdini had already moved beyond that. He knew how to pick a lock that hadn't even been invented yet. I've been interested in the physical transcendence that that kind of discipline proposes.

GH: *Do you address a notion of escape, of breaking free of the shackles or weights in your own work?*

MB: There's a certain aspect of the work that is a self-contained system and in a great disappearing act might represent a self-sufficiency. In the end, of course, that isn't healthy. I'm interested in dealing with the danger of that unhealthiness.

GH: *To me, your work seems to advance a dialogue about how we view gender. Do you see this as a trend in our society towards expanding the boundaries of gender identification?*

MB: The ratios of sexuality seem to be changing. That's where I think it entered my work. There's a proposed organism in my work that at certain points has a gender, but it's not necessarily a human gender. It has a ratio that fluctuates 1:10, 2:9, wherever it ends up. Obviously there are articulations that are specifically masculine and feminine, but I think that there's a lot of space in between that has to do with other points on that graph. Maybe more people are looking at sexuality that way. FROM **GLEN HELFAND**, "INTERVIEW WITH MATTHEW BARNEY," *SHIFT MAGAZINE*, VOL.6, NO.2, 1993

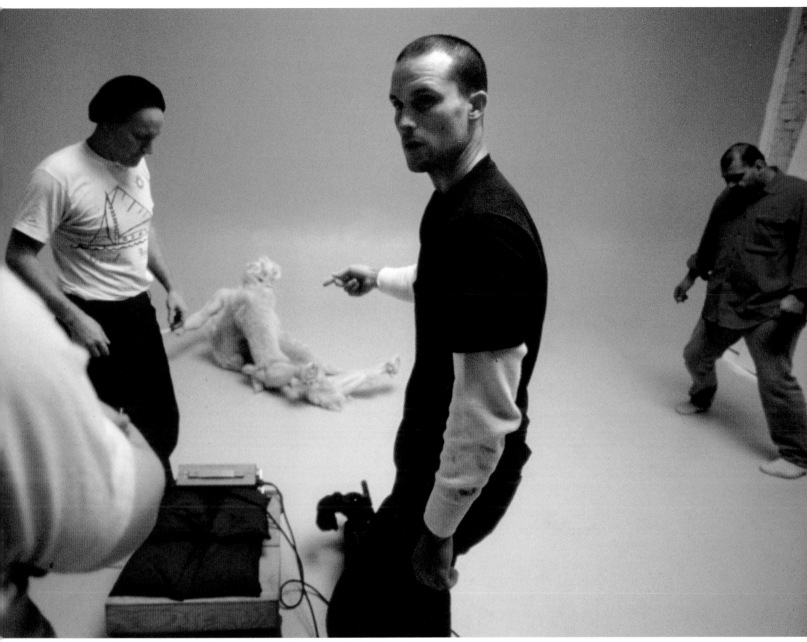

MATTHEW BARNEY (CENTER) DURING THE PRODUCTION OF *DRAWING RESTRAINT 7*, 1993 PHOTO: MICHAEL JAMES O'BRIEN

opposite page: **Case BOLUS**, 1989–1991 (details)
cast petroleum jelly and wax,
45 lb. Olympic weights and 8 lb. dumbbells,
speculum, mouth guards, glass case, cast sucrose,
foam and nylon pads, binding belts
dimensions variable

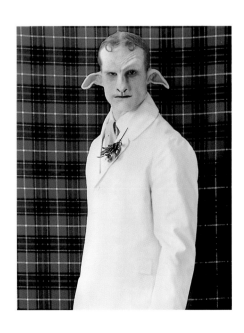

CREMASTER 4:
The Loughton Candidate, 1994
color photograph in cast plastic frame
Ed: 17/30
30.5 x 35.5 centimeters /
12 x 14 inches

Vanessa Beecroft

Born: Genoa, Italy 1969 / Lives and works in Milan

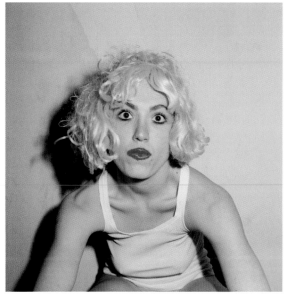

PHOTO: ARMIN LANKE

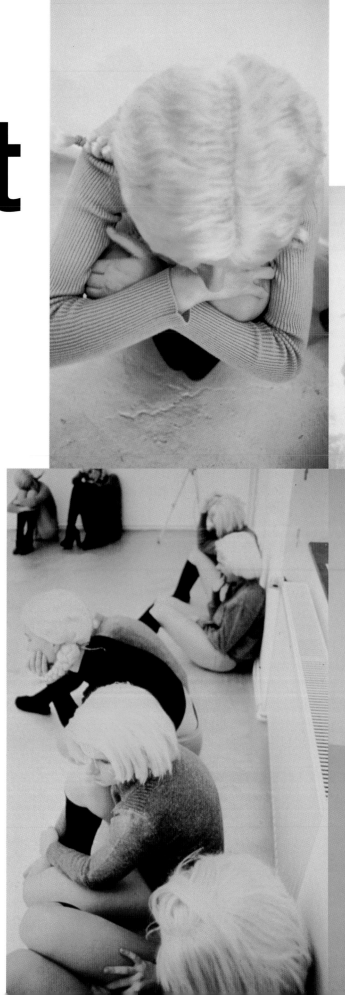

What I am after—setting real people in the place of images—is to get close to a two-dimensional surface, like a painted picture instead of painting a picture. These people hold the importance of portraits. We already know the girls through painting and cinema, but still we found them in the street. It is just a matter of recognizing them and bringing them into perspective. In my view, they fit like a surface and an image; they stand as icons, or models, before being portrayed as the final synthesis I deferred and postponed. The real painted picture is much better replaced by other sorts of pictures (squares) that we still don't know too well.

I look for typical features and follow some details to collect a kind of family portrait; then I usually give wigs to the people to wear to get them closest to a drawing and far away from real life. Nobody performs, nothing happens; they neither start nor end anything. They are just marked and close to disappearing like the (quit) in a computer screen. 1994

PAGE 54

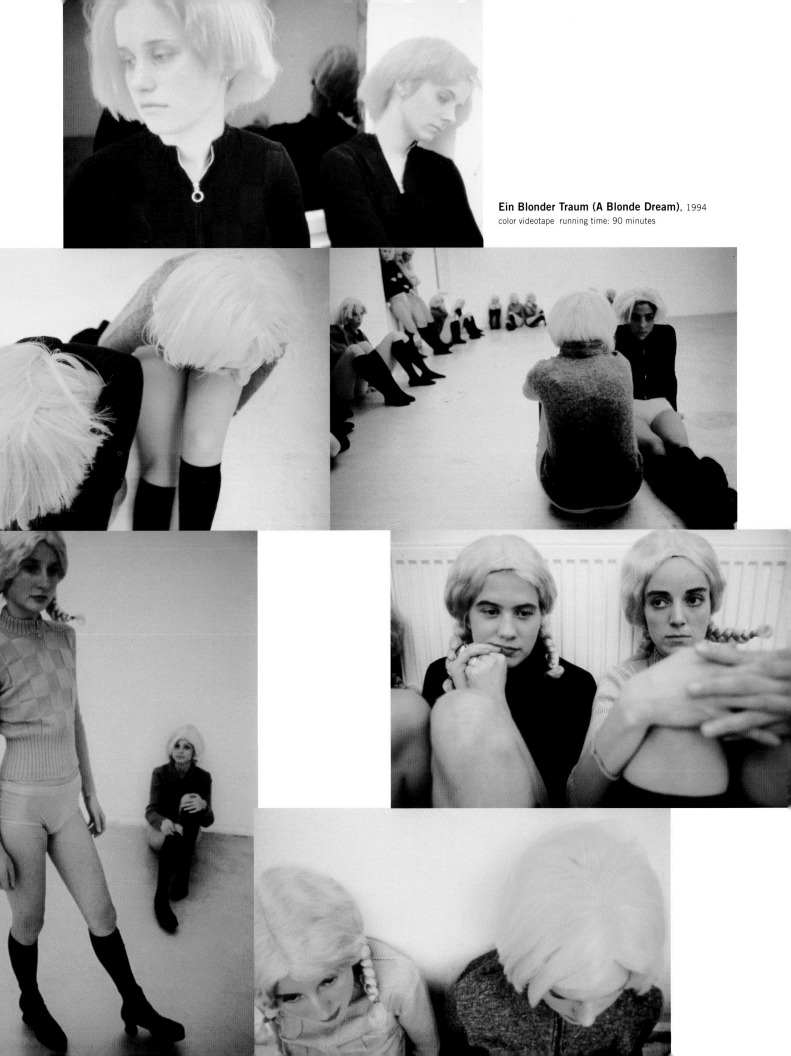

Ein Blonder Traum (A Blonde Dream), 1994
color videotape running time: 90 minutes

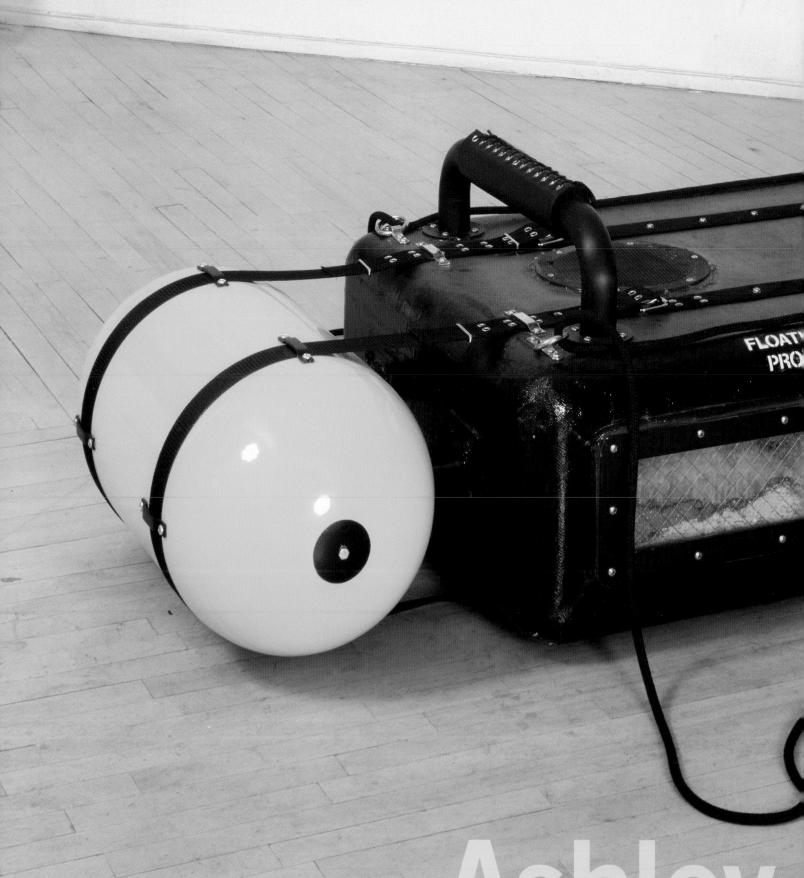

FLOATW
PRO

Ashley

Born: Barbados, West Indies 1959 / Lives and works in Bali and New York City

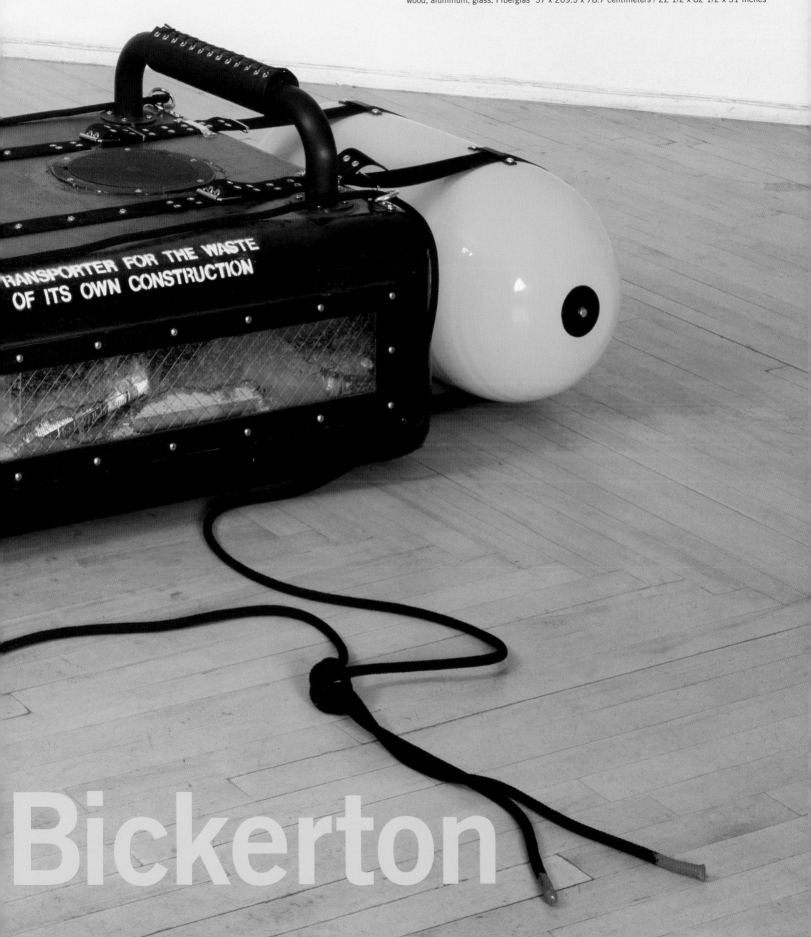

Seascape: **Transporter for the Waste of Its Own Construction, No.1**, 1989
wood, aluminum, glass, Fiberglas 57 x 209.5 x 78.7 centimeters / 22 1/2 x 82 1/2 x 31 inches

TRANSPORTER FOR THE WASTE
OF ITS OWN CONSTRUCTION

Bickerton

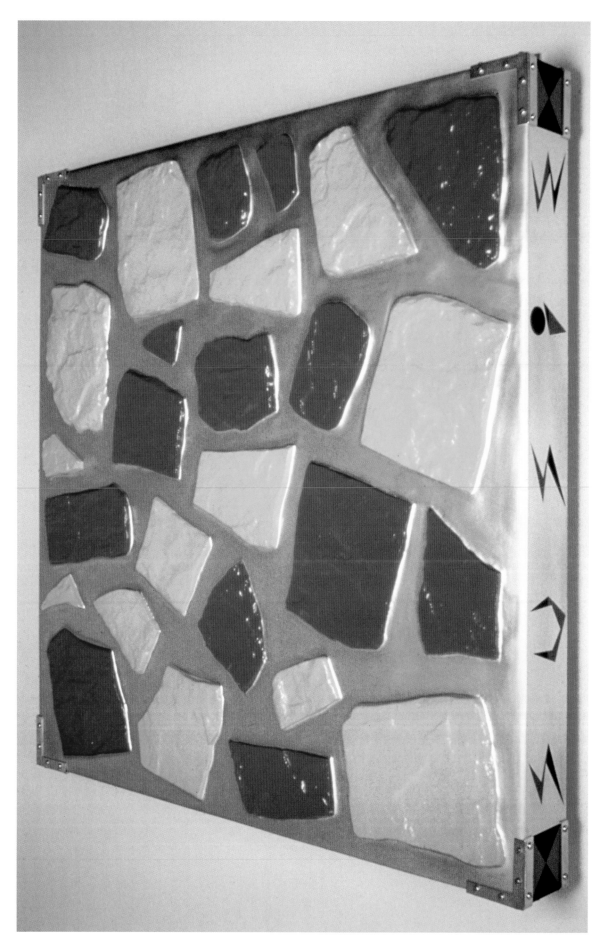

Wall Wall 4, 1986
plaster, polymer,
plywood, aluminum.
silver paint
122 x 122 x 16.5
centimeters /
48 x 48 x 6 1/2 inches

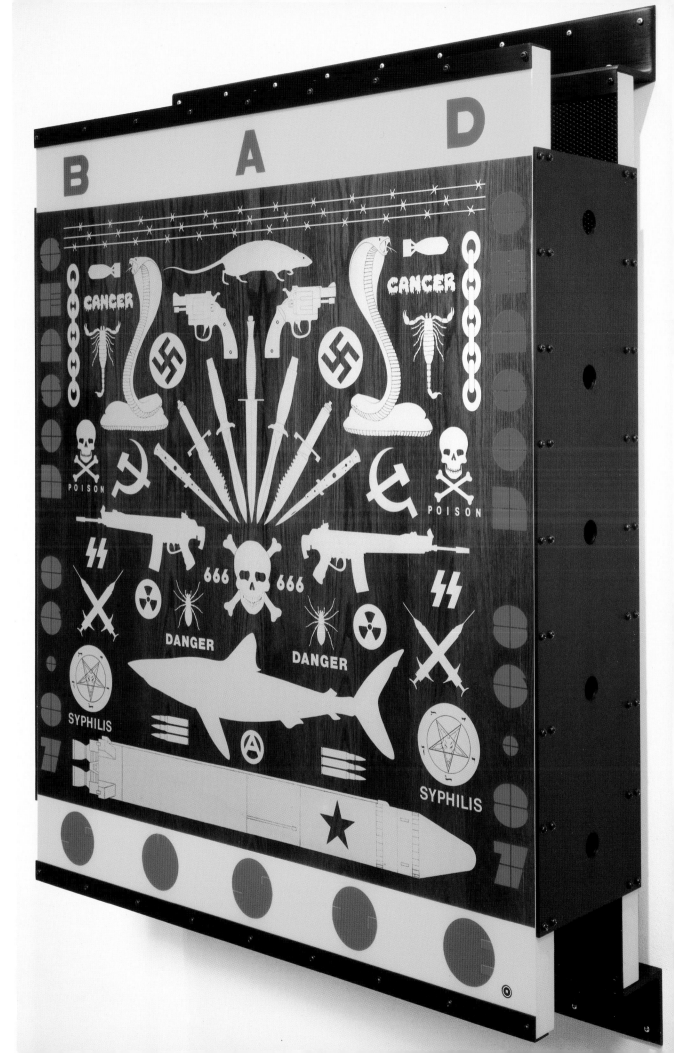

**Abstract Painting
for People No.5
(BAD)**, 1987
silkscreen, acrylic
aniline dye, polyester
resin on plywood with
anodized aluminum
172.7 x 122 x 38
centimeters /
68 x 48 x 15 inches

Formalist Painting in Red, Yellow and Blue, 1988
mixed media construction with padded yellow canvas 82.5 x 203 x 204.5 centimeters / 32 1/2 x 80 1/2 x 36 inches

I have spent years wallowing in the currency of commonality

and I have traded in the exotic "marketplace"of fashionable theoretical constructions. I have tried turning my back on all this: this culturescape! I have hit the road and immersed myself in the great spaces of the American Southwest only to trip over too much cultural organization in the last remaining scraps of terra incognita on the planet. But in some form you always come full cycle. Dusty road weasels and romantic diaspora hold on to a vision long beaten down by local politics, racism, and alienation. Daily pattern and petty social intrigue begin to infest one's brain like jungle rot, and one comes to the realization that one can never belong. No matter how hard or how fast you run, you inevitably crash straight into yourself again. There is no refuge from the painful occupation of your own mind. The druggie and the drinker must come down, the tourist must come home, and the sexual adventurer will have uncomfortable meetings with roommates down the hall at dawn. Strange vistas: you hop just one step ahead of your own cognizance, always outfoxing something, but never yourself.

Suicide is always an option for the task-oriented and the sensorily numb, but for the indolent it is far too great an effort. We are more prone to suck minor poisons into our system, push our biologies to the brink and smile peacefully in the face of catastrophe. I long to be sucked up into the big blank beyond taxes and mammalian neediness.

Instead I wake up in the morning and I make this art. My day is filled with purpose. Between sleep and sleep I have reason for being, for being one with my kind: belonging. My mind sits in a chair designed by Donald Judd. What is left? . . . Sensuous flights through tingling matter and jarring realizations on the nature of reality. Be it ever so trivial, this is the stuff to fight for, this is what makes the course through life feel good. In the face of human evanescence and the very real fact we might actually be wrong ,there seems no other course. Beauty makes its predictable comeback and I lower myself into the sensual ooze of that which I have known, and that which was good, and I try to tell a story. 1993

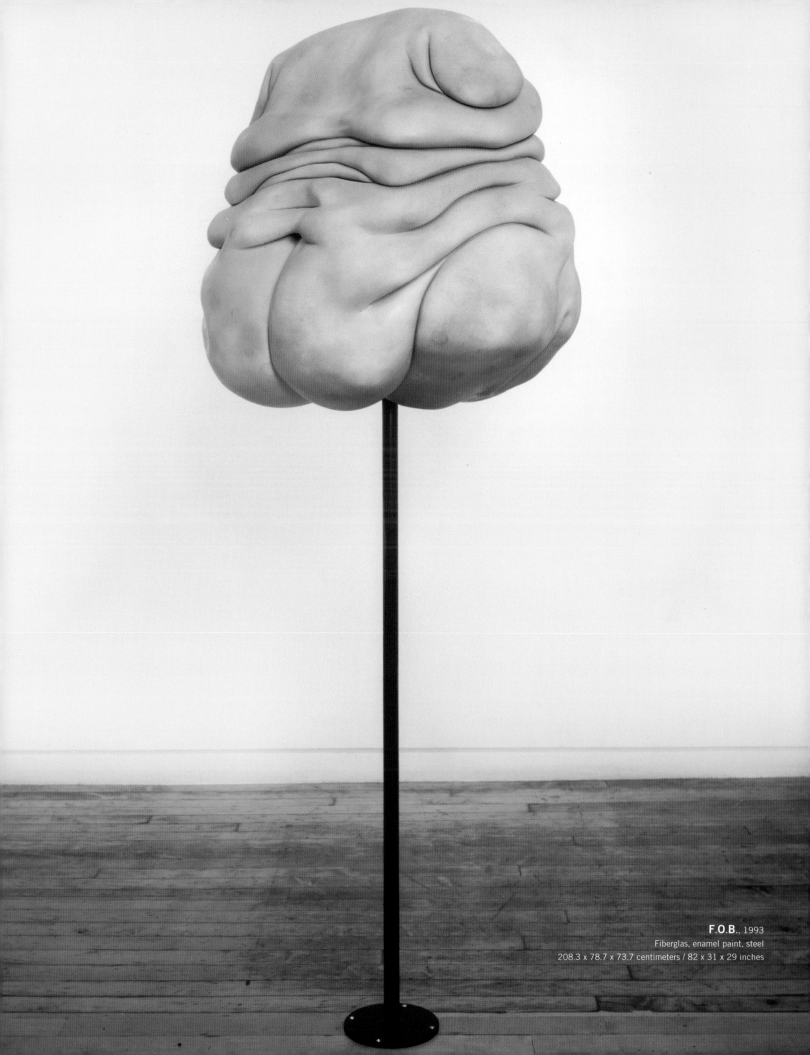

F.O.B., 1993
Fiberglas, enamel paint, steel
208.3 x 78.7 x 73.7 centimeters / 82 x 31 x 29 inches

Ross Bleckner

Born: New York City, 1949 / Lives and works in New York City

. . . I'M TRYING TO LOOK FOR THIS THICK AIR BETWEEN ALL OF THE DIFFERENT FEELINGS AND STAGES IN OUR LIVES. PEOPLE CAN PAINT THINGS THAT ARE REPRESENTATIONAL, AND IF THAT'S INTERESTING TO THEM, THAT'S FINE, BUT I WANT TO PAINT SOMETHING THAT'S MORE EPHEMERAL. BUT IT ALSO HAS TO BE CONCRETE. AND IT HAS TO BE ABOUT AN ISSUE: TO ADDRESS THE IDEA OF MAKING PAINTINGS, TO KEEP TRYING TO INVENT NEW REASONS TO WANT TO ADDRESS THIS IDEA. JZ: *IS IT MORE OF AN ATTENTION TO THE PAINTING PROCESS?* RB: I'M NOT INTERESTED IN THE "PICTURENESS" OF PAINTING; I'M MUCH MORE INTERESTED IN THE "PAINTINGNESS" OF PAINTING. IT BOILS DOWN TO ME HAVING TO SAY: I'M LOOKING FOR SOMETHING THAT I HAVEN'T FOUND YET. THAT'S WHY I CONTINUE TO PAINT. AND PART OF BEING A PAINTER IS THAT, SINCE WE ARE CONSTRUCTED SOCIALLY, AND SINCE WHAT WE'RE LOOKING FOR WILL ALWAYS SHIFT, YOU'LL NEVER FIND IT. YOU WILL ALWAYS HAVE THAT THICK AIR SURROUNDING YOU. IF YOU LIVE IN THE WORLD, AND YOU HAVE A SENSE OF YOUR CONSCIOUSNESS, YOUR CONSCIOUSNESS IS RESPONDING TO THE WAY THE WORLD WORKS AND DOESN'T WORK. I THINK NOW THE AIR IS A LITTLE THICKER, A SENSE OF LOSS PERVADES THAT THICKNESS: WE HAVE PROBABLY ALL BEEN CHANGED IN WAYS THAT ARE AS YET UNFORMED AND UNMENTIONABLE. JZ: *COULD IT BE ARGUED THAT YOUR PAINTINGS FUNCTION AS CONTAINERS OR VESSELS FOR THIS "THICK AIR"? IN THE CASE OF THE* AIDS ELEGIES, *THE VESSELS APPEARED AS LITERAL CONTAINERS, LIKE FUNERAL*

URNS. AND IN THE STRIPE PAINTINGS, THE STRIPES SEEM TO CONTAIN, ALMOST IMPRISON, THE LIGHT. WHICH LEADS TO MY NEXT QUESTION: DO YOU FEEL THE TRAGEDY OF AIDS IS SOMETHING MOST EFFECTIVELY DESCRIBED IN ABSTRACT TERMS?* RB: I THINK ANYTHING HAS TO BE DESCRIBED IN ABSTRACT TERMS. PARTICULARLY THINGS THAT ARE SO ABSURD. EVERY ARTIST INSINUATES A SUBJECTIVITY IN THE WORLD. EVERY ARTIST DESCRIBES THE WORLD THEY LIVE IN. IT IS BEYOND ALL OF OUR COMPREHENSIONS: THE WORLD THAT WE ALL TRY TO DESCRIBE IN SOME WAY, TO NARRATE, IS ALWAYS AN ABSTRACT WORLD: IT IS BASED ON EXCHANGES THAT WE ARE NOT AT THE CENTER OF. WE ARE A STRANGE ACCUMULATION OF HISTORICAL SENTIMENT. THAT STRANGENESS IS WHAT WE DESCRIBE. THAT STRANGENESS IS THE FEELING THAT HOLDS MY INTEREST. I'M NOT SAYING THAT MAKING PAINTINGS IS GOING TO SOLVE ANYTHING, OR BRING A CURE TO ANYBODY, BUT I THINK IT CAN MAKE PEOPLE THINK, IT CAN MAKE PEOPLE FEEL SIMULTANEOUSLY SOOTHED AND PROVOKED. FROM AN INTERVIEW WITH JOHN ZINSSER, *JOURNAL OF CONTEMPORARY ART*, SPRING 1988

From Unknown Quantities of Light, 1987 oil on canvas 274.3 x 152.4 centimeters / 108 x 60 inches

PHOTO: ARI MARCOPOULOS

Alighiero
e Boetti

Born: Turin, Italy 1940 / Died: Rome 1994

TO PUT THE WORLD INTO THE WORLD, 1973–1979

Two sheets filled with ballpoint, Pelikan blue.
One by a male, the other by a female. Tracing the
coordinates between the letters of the alphabet and the
comma; beginning on the left, we read the first letter
'M,' then 'E,' then 'TT'. . . *Mettre al Mondo il Mondo*

Mettre al Mondo Il Mondo, 1987 (detail)
blue ballpoint on paper on canvas
2 panels, each: 180 x 160 centimeters / 70 x 62 1/3 inches

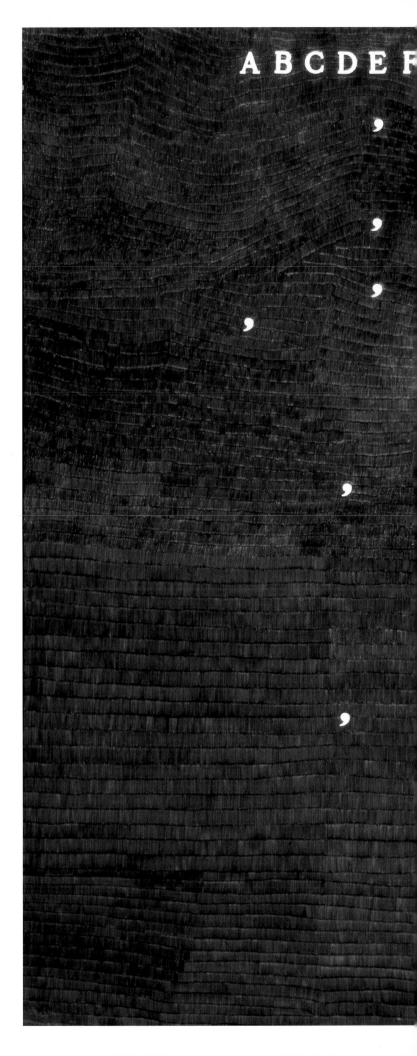

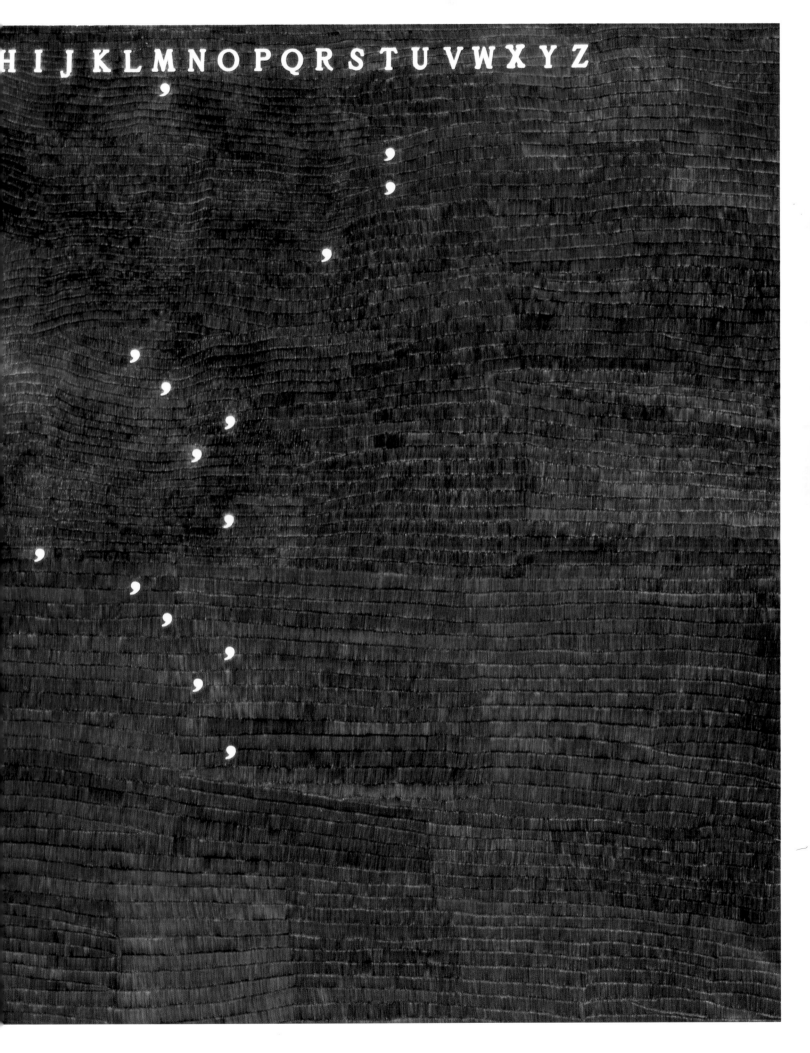

1984, 1984 pencil on paper mounted on canvas 12 panels, each: 100 X 150 centimeters / 39 X 58 1/2 inches

Jonathan Borofsky

Born: Boston, Massachusetts 1942 / Lives and works in Maine and California

Nov. 20, 1994

Dear Sarah,

Here is some "chatter" about my
art work "Chattering Man with El Salvador Stamp."
When I was a child, I looked foward to
going to my grandparents house – not only
for the good chiken soup but also because
I enjoyed it when my grandfather took me
into the back bedroom and showed me
his extensive stamp collection. My grand-
father was famous in our family, for sitting
in the back of the bus with the "negroes",
(during the 1930's in the South). It was his way
of protesting the inequality of it all. His
stamp collection also reflected his social-
political - humanistic concerns with special
stamp books dedicated to his native land,
Russia and to socialism. When my grand-
father died, his stamp books were left to me.
In 1982, as I was going through these books,
this El Salvador stamp, (with Franklin D.
Roosevelt signing treaties with South American
officials), caught my eye – no doubt because
at that time, we (the United States), were
envolving ourselves in a rather questionable
and potentially Vietnamese-like mess in
El Salvador.
For this art work, I photographically
reproduced and enlarged the El Salvador Stamp and
screened it onto a canvas. The chattering man
with its endless tape loop, is the chattering
man in all of us.

Sincerely
J. Borofsky

**2,845,317 Green Tilted
El Salvador Painting
with Chattering Man,** 1982–1983
silkscreen on raw duck canvas,
wood, aluminum, Bondo, primer,
electric motor, speaker
painting:
193 x 277 centimeters / 76 x 109 inches
chattering man:
210 x 58 x 396 centimeters /
82 1/2 x 23 inches x 156 inches

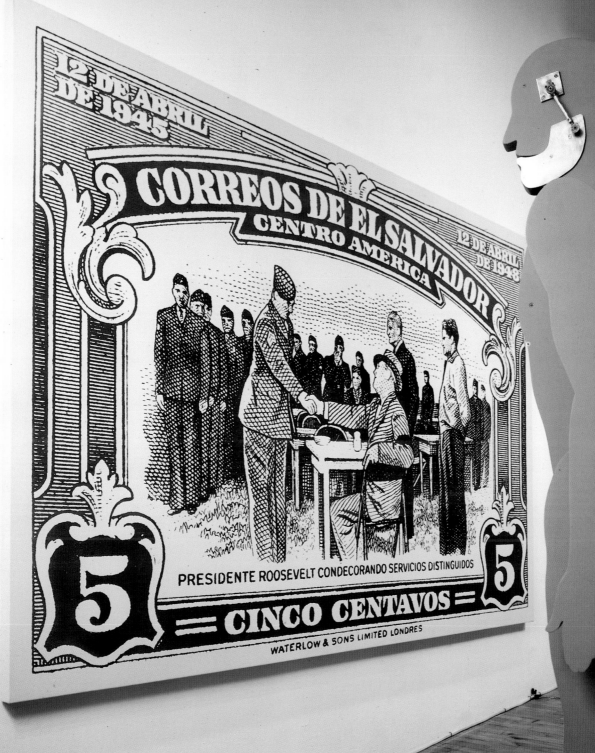

Dinos and Jake Chapman

Dinos Chapman

Born: London 1962 / Lives and works in London

Jake Chapman

Born: Cheltenham, Great Britain 1966 / Lives and works in London

We are sore-eyed, scopophiliac oxymorons. Or, at least, we are disenfranchised aristocrats, under siege from our feudal heritage. The graphic promise of our absent but nevertheless sonorous Letraset honours the dead (and the bad conscience) of past generations, a recollection of the discordance between concepts and pictures. Our discourse offers a benevolent contingency of concepts, a discourse of end-of-sale remnants, a rationalistic hotbed of sober categories. We have manufactured our products according to the market demands of a deconstructive imperative, and policed them according to the rules of an industrial dispute—our bread is buttered on both sides. We have always been functions of a discourse; in short, our professional interpretation, our mental agitation, demands a limitless expressionism, our contractual teleology demonstrates our servility to a cultural climax never to be experienced. The future remains excluded. But sometimes, against the freedom of work, we fantasize emancipation from this liberal polity into a superheavyweight, no-holds-barred, all-in mud-wrestling league, a scatological aesthetic for the tired of seeing.

We are artists 1994

top: **Fuck Face**, 1994
mannequin, wig, resin, paint, T-shirt
90 x 50 x 30 centimeters / 35 x 19 1/2 x 11 3/4inches

bottom left: **Fuckface Twin**, 1995
Fiberglas, resin, paint, wigs, shoes
85 x 64 x 57 centimeters / 33 x 25 x 22 1/4 inches

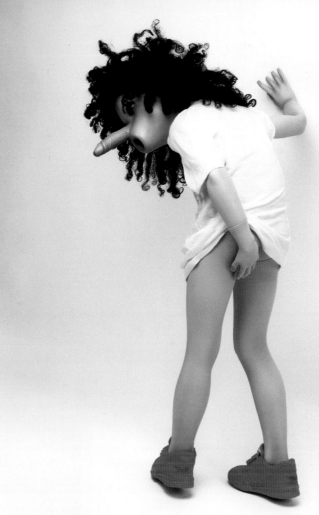
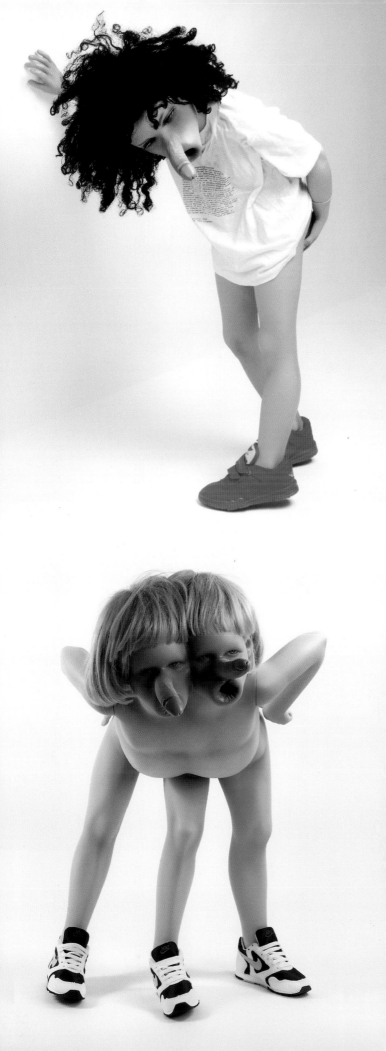

Initially, when we began doing the portraits, we assumed that there was an art public—that is, that there was a group of people who used art to construct their subjectivity within an art collective. What that means is that we thought that art could function like rock music vis-à-vis its audience in inspiring the audience en masse to experiment with new forms of subjectivity.

Having made this assumption, we went on to dramatize the fact that somewhere there was a contradiction: Although art addressed itself to the public, it was mainly privately consumed. This contradiction is, of course, an old one, a late 18th-century one. So we wanted to construct a monument to a contradiction on the occasion of its bicentennial . . .

From the very beginning, the portraits we made had a network of references to the history of portraiture. The primary reason for this is that we could never put ourselves in a position of inventing new representational devices. So whenever we had a problem, we looked at the history of the solution to the problem. New solutions for representing people imply investment in individualism, in the "triumph" over conventions. We never believed in individualism. We grew up on rock-and-roll music where the whole audience is represented, not each individual for him/herself. And anyway we believe that by the end of the 20th century, it is practically impossible to invent new positions, gestures, expressions in connection to individual presentation or representation.

FROM ACHILLE BONITO OLIVA, *SUPERART* (MILAN: GIANCARLO POLITI, EDITORE, 1988)

PHOTO: ZDENKA GABALOVA

**Untitled Landscape
#60**, 1990
Cibachrome
119.4 x 167.6 centimeters /
47 x 66 inches

Clegg &
Michael Clegg
Born: 1957 / Lives and works in New York City

Guttmann

Martin Guttmann Born: 1957 / Lives and works in San Francisco and New York City

A Family Portrait, 1987
Cibachrome
223.5 x 297 centimeters / 88 x 117 inches

A Matrimonial Portrait with an Obelisk, 1987
Cibachrome
180.5 x 171 centimeters / 71 x 67 1/4 inches

Crash

(John Matos)

Born: 1961 / Lives and works in New York

In 1974, one hot summer day, I remember seeing an entire train car painted from the bottom to the top in these incredible colors and saying to myself, "Damn, look at that!" This little event set the stage within my mind that painting not only had to be visual but also vocal. It shouted, "Life."

My painting DEAREST was done to capture the feeling of speed in which art history moved, from the late 1940s to the present (1986). The 1980s art market sort of set the stage to have the artist fly through history in order to justify his place among the masters.

Dearest, 1986
Spray and acrylic on canvas
Two panels, each: 178 x 304.8 centimeters /
70 x 120 inches

Gregory Crewdson

Born: Brooklyn, New York 1962 / Lives and works in Brooklyn, New York

this page, bottom:
Untitled 1993–1994
Cibachrome
76 x 101.6 centimeters / 30 x 40 inches

opposite page:
Untitled 1993–1994
Cibachrome
101.6 x 76 centimeters / 40 x 30 inches

The American vernacular—small towns, surburban sprawl, highway culture and the like—retains a central position as subject for the imagination of the American photographer. This tradition not only establishes a historical record of our changing and diminishing landscape, but also shapes and gives meaning to the visual iconography and imagery that define the national collective psyche. My photographs continue to explore the shifting terrain between the reality of the American vernacular and the vast array of mythologies and ideals that surround it. Several American art forms have influenced my vision, including traditional landscape photography, 19th-century Luminist painting, the natural-history-museum diorama, Hollywood cinema, and contemporary American fiction.

The photographs attempt to locate the fertile ground between the extremes of postmodern and traditional art photography. I employ staging, artifice and theatricality to heighten the fictional content of the photographs and establish them in an imagined world. However, I also try to combine these critical strategies with traditional concerns like pictorial composition, narrative complexity, and photographic beauty. This collision of styles and intentions appears contradictory, but I believe that the photographs produce an effect that hovers between photographic realism and unreality.

The scenes in surburban backyards and gardens explore the domestic landscape and its relationship to the natural world. The highly detailed, large-scale dioramas obsessively recreate the small dramatic events that occur within this familiar setting. Like the American writer Raymond Carver, I am concerned with the well-rendered detail or gesture and how it can reverberate with larger meaning and significance. In many of my photographs, the dramatic moment revolves around seemingly mundane and unremarkable events. I hope that within the parameters of these imagined landscapes, incidental scenes and occurrences—like a towering dirt pile, a circular formation of robin's eggs and an excavated hole in the ground—have the mystery and poetic resonance of a ritualistic site or private totem. This clash between the normal and the paranormal produces an uncanny tension that serves to transform the topology of the suburban landscape into a place of both wonder and anxiety. 1995

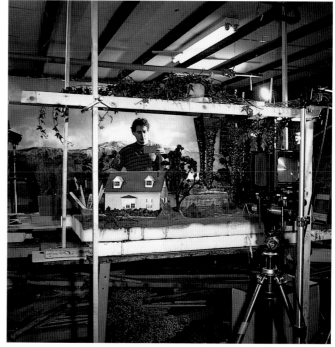

PHOTO: ERIC WEEKS

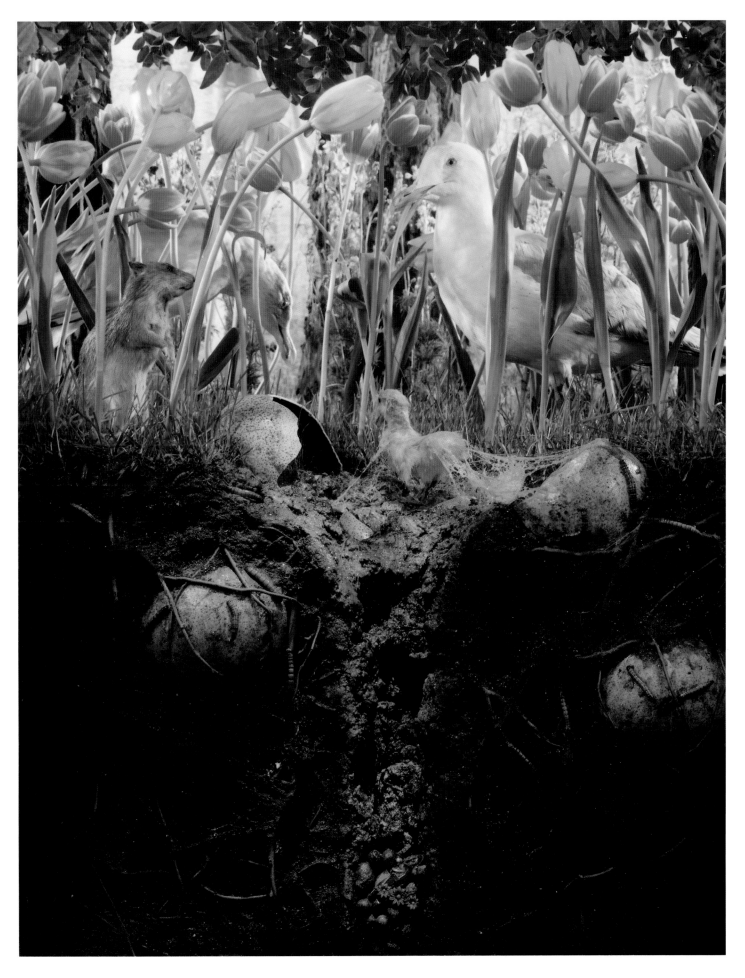

Grenville Davey

Born: Launceston, Cornwall 1961 Lives and works in London

Grenville Davey's first exhibition at the Lisson Gallery included a work that resembled a manhole cover cast in steel, with a central area protruding above a rim circled with tightened bolts, it seemed to summarize his concerns. Industrial materials and techniques had been used to conceal any evidence of the artist's intervention. The placement, flat on the floor; the exaggerated size; the idea of it being a lid or a canopy, all heightened the suggestion of intricate play, shifting attention from the work itself to a dark, vacant space below, as if the sculpture were situated above a subterranean escape route. Davey had borrowed the idea, he said, from a Bugs Bunny cartoon in which Bugs looked at his rabbit hole, a black outline, then picked it up, tucked it under his arm and walked away with it. The game of hide-and-seek, of what could and could not be seen and what should be assumed by looking at what the artist was prepared to offer, had already become a feature of Davey's work. Earlier, he had experimented with drawing in space; thin, metal rings described huge, absent forms, and a single sheet of vinyl, pierced with holes and folded into a conical shape, stood unaided. The traditional conjurer's assertion

"Nothing up my sleeve!"

had never been more apt; Davey seemed determined to survive by sleight-of-hand. Later, he added a sense of deliberate wrongness—wrongness of scale, of finish, of material, of usage—in an obvious attempt to remove any hint of realism or the Duchampian readymade. For references to everyday life would have been misleading. Far from being appropriated from the culture, these works were self-regarding, dysfunctional and, at the same time, self-defining.

FROM **STUART MORGAN**, "GRENVILLE DAVEY: THE STORY OF THE EYE," *GRENVILLE DAVEY* (BERN: KUNSTHALLE BERN)

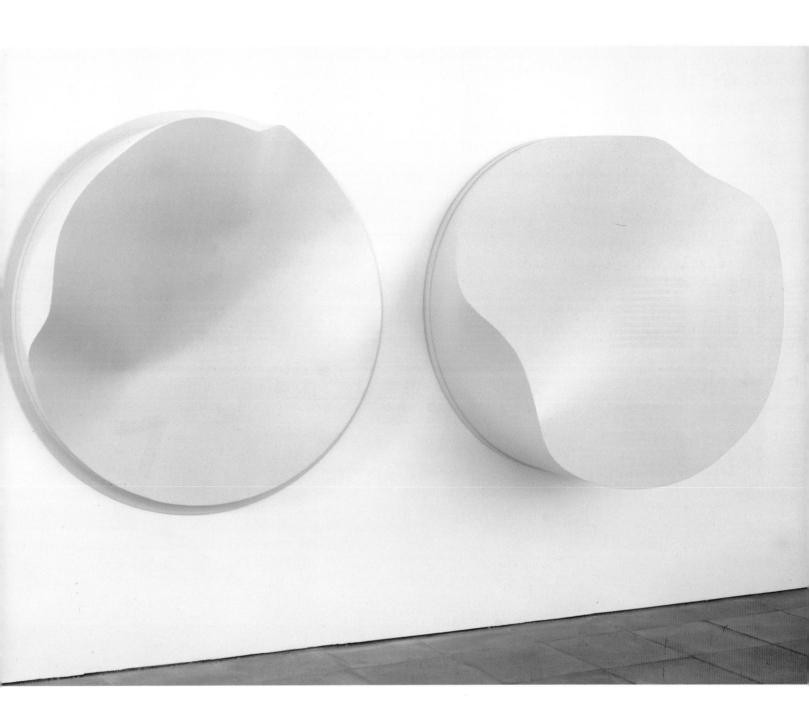

Right 3rd & 6th, 1989
painted steel, hardboard
diameter 152.5 x 62 centimeters /
59 1/2 x 24 inches

Walter
De Maria

Born: Albany, California 1935 / Lives and works in New York City

THE COLOR MEN CHOOSE

The Color Men Choose When They Attack the Earth, 1968 (detail)
engraved metal plaque, oil on canvas with stainless-steel plaque affixed
210 x 537 centimeters / 82 3/4 x 211 3/4 inches
plaque: 12.5 x 61 centimeters / 5 x 24 inches

Wim Delvoye

Born: Wervik, Belgium 1965 / Lives and works in Ghent, Belgium

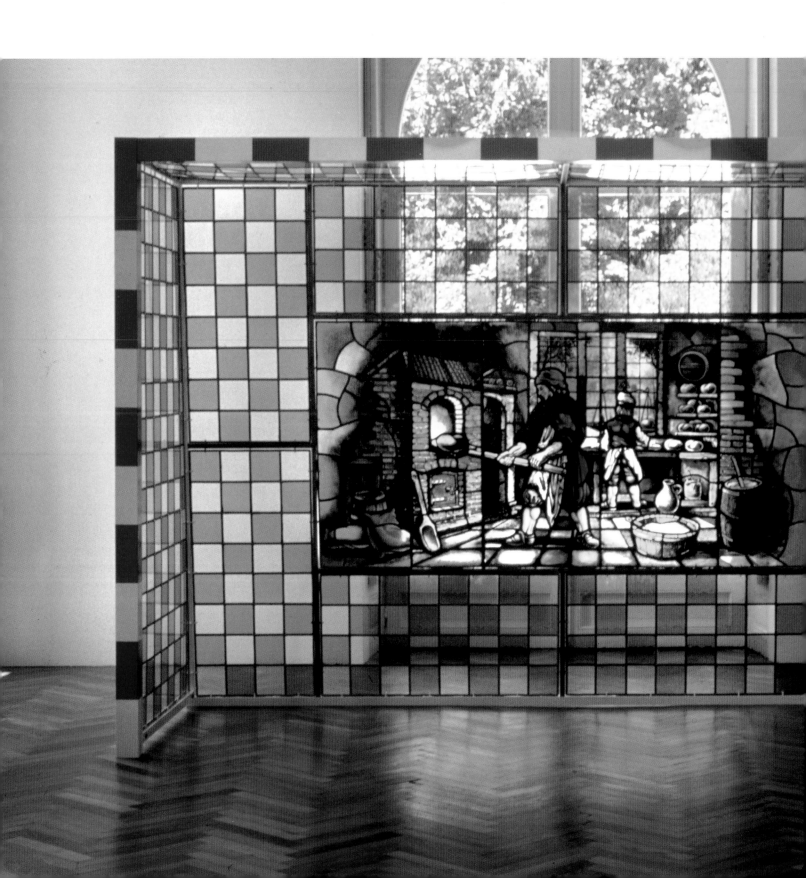

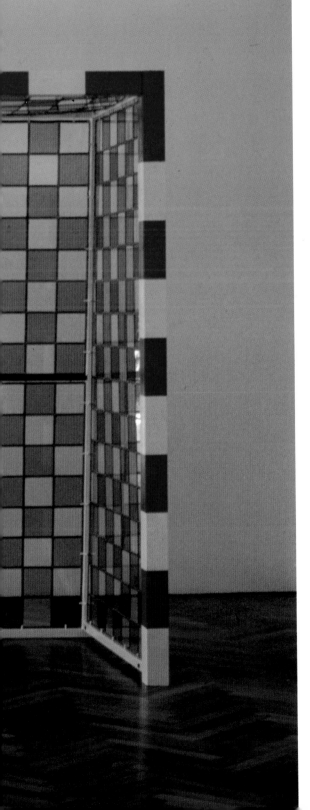

The series of soccer goals and concrete mixers are painstakingly crafted by hand, but they are trying to look like mass-produced and contemporary objects. They are **readymades in reverse.** They celebrate craft in the accuracy of their construction and, at the same time, they are made ridiculous by their references to speed and violence (soccer goals) and industrialism and labor (concrete mixers). PANEM ET CIRCENCES (BREAD AND GAMES) is a soccer goal frame with a "net" of stained-glass panels that show an old-fashioned scene of a bakery and an image usually found on bread bags, claiming how "sincerely" the product has been made: "Made by hand, just like in Grandma's time." Here, the idea of the handmade and the use of ornament is without its premodernist innocence. It is aware of its criminality. 1995

Panem et Circenses I, 1989
stained glass, steel, lead, enamel paint
209 x 315 x 110 centimeters /
81 1/2 x 124 x 43 inches

John Dogg

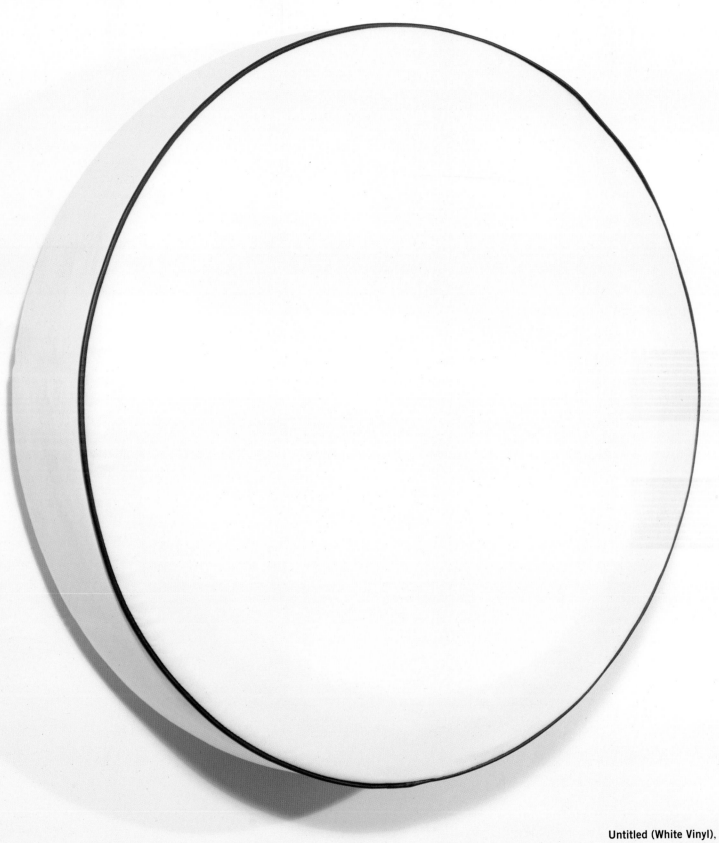

Untitled (White Vinyl), 1986
vinyl and rubber
diameter 76.2 x 20.3 centimeters /
30 x 8 inches

Cheryl
Donegan

Born: New Haven, Connecticut 1962 Lives and works in New York

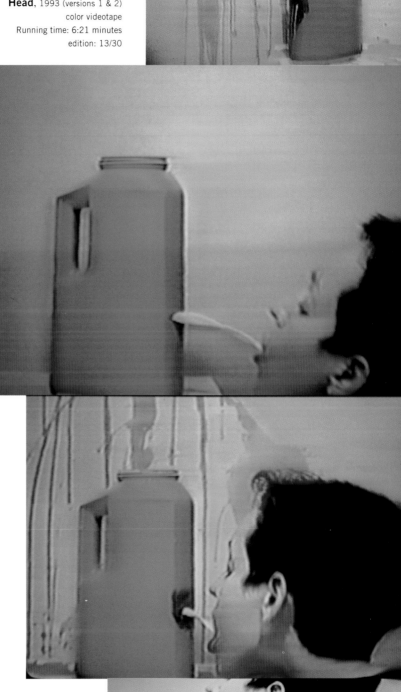

Cheryl Donegan
Head, 1993 (versions 1 & 2)
color videotape
Running time: 6:21 minutes
edition: 13/30

The last few seconds of
HEAD are the most
important to me—
I want TV that thinks painting
and painting that watches TV.

Stan Douglas

Born: Vancouver, Canada 1960 / Lives and works in Vancouver

FAR LEFT: STAN DOUGLAS PHOTO: OLLERTZ & STRAUSS

EVENING

n the course of an earlier production I studied, and then reconstruct-
ed, the technical and ideological apparatus of an early moment in tele-
vision history which has since become paradigmatic of broadcast
conventions in Europe today . . . EVENING is concerned with coin-
cident forms of media representation, in this instance, the conventions
of news broadcasting in the United States working under the hy-
pothesis that: television aided the American civil rights movement in
the early 1960s by making local conflicts national and, later,
international issues. But, within a decade, it began to represent
precipitates of the movement as unreasoned or fragmented "special
interests" lacking historical continuity.

BACKGROUND

EVENING was developed in consideration of broadcast idioms and his-
torical events from the Chicago area during a brief research trip when I
visited archives and tape collections in order to get a sense of local broad-
cast vernaculars and editorial policies ca. 1965–1975. It was not long
before I was made aware of two very different but related crises in the
legitimation of television news which occurred in relatively quick
succession: the controversies surrounding the 1968 Democratic National
convention in August 1968 and the assassination of local Black Panther
Party leader Fred Hampton in December of the following year.

This was, of course, the Democratic Convention disrupted by SDS-as-
sociated demonstrators who were arrested or dispersed brutally by the
Chicago Police and National Guard. It was also the first such event to
be presented live and in color by network television. Newspaper and
television editorials and proclamations by politicians soon after the
confused confrontations all seemed to dwell on the same rhetorical
figure. "Was television *making* news or merely reporting it?"

Evening, 1994
3 double-sided laser discs
1 custom-made synchronization device
each rotation: 14 minutes, 56 seconds
Ed: 1/2
dimensions variable

Amid the political confrontations which occurred elsewhere in the U.S. and in virtually every continent of the world, 1968–69 also witnessed formal and technical transformations in television news. Responding to its chronically low ratings, and an understanding of the impact of the personality of a newscaster, the Chicago-area ABC-owned station, WLS, introduced its widely imitated "Happy Talk News" format. Two or more anchors would sit at the same podium so they would be able to discuss stories, make jokes, and generally demonstrate their wit and sensitivity in a curious combination of journalism and entertainment. This moment also saw the transition from combined black and white (field shooting) and color (studio) to all-color news broadcasts. Thus, just as television news began to present reality with greater "accuracy," it became more and more removed and obsessed with its own internal logic. This is not to say that methods of reportage had previously been able to offer a more adequate representaion of its culture, rather that in the process of making news there was now an increasing "evening-out" of temporal and social differences . . .

I have often used musical methods and metaphors in my work because in both musical practice and reception there have developed very concise methods of presenting the relationship of an individual voice to a collective, and the transformation of that relationship over time. For television also, time is the crucial category: yearly, weekly, daily, and half-hourly units of time containing "live" prerecorded and mechanically repeating elements. Whatever the intention of a particular journalist or the policies of a station manager, the effect of North American models of television news is the fragmentation of interrelated events and atomisation of historical processes, with only the form itself as a constant. I have chosen to work with this moment in television news practice because it was when this (psychological and "musical") fugue first began.

Marcel Duchamp

Born: Blainville, Normandy 1887 / Died: Neuilly, France 1968

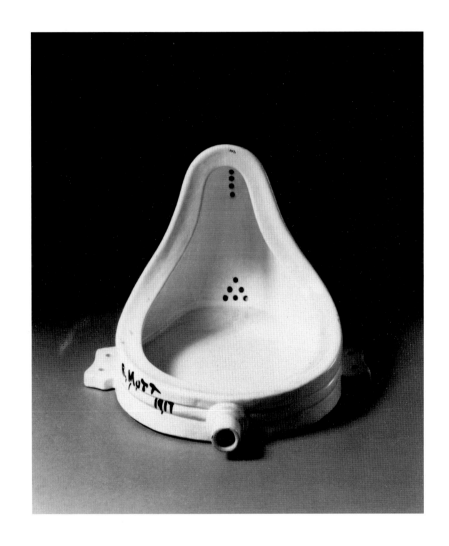

Fountain, 1917/64
porcelain urinal
35.5 x 48 x 61 centimeters /
14 x 19 x 24 inches

Whether Mr. Mutt with his own hands made the fountain or not has no importance. He CHOSE it. He took an ordinary article of life, placed it so that its useful significance disappeared under the new title and point of view— created a new thought for the object. FROM *THE BLIND MAN*, NO.2, NEW YORK, MAY 1917

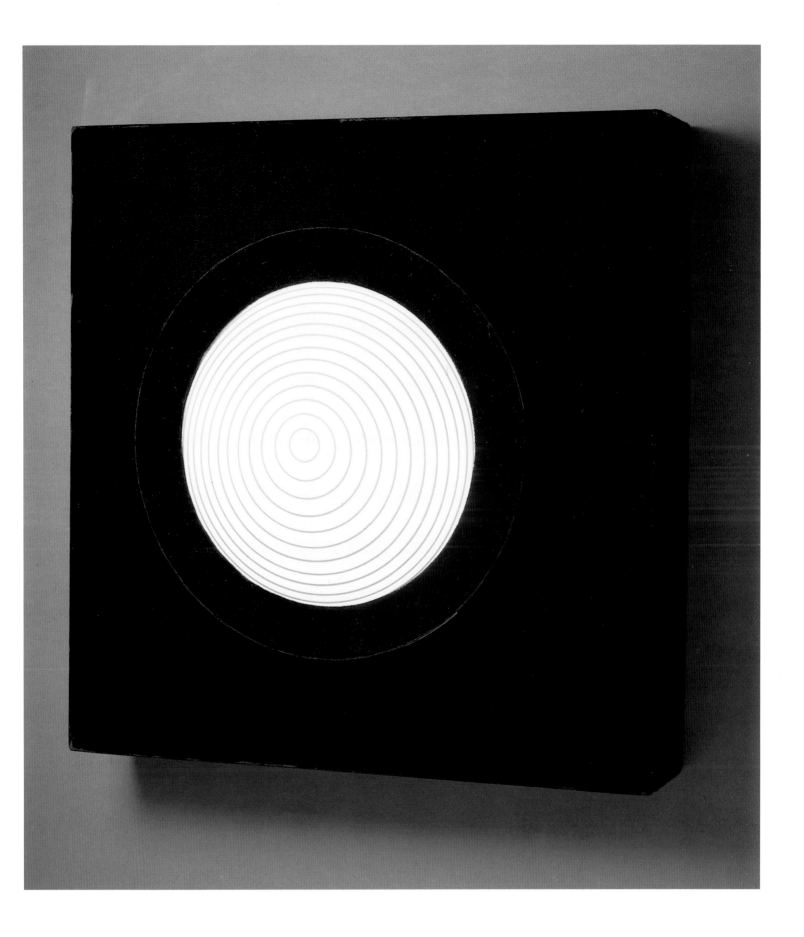

Rotoreliefs, 1953 mixed media 6 discs, each: diameter 20 centimeters / 7 7/8 inches

R.M. Fischer

Born: New York City 1947 / Lives and works in New York City

opposite page: **Fountain**, 1985
aluminum, brass, electric pump, rubber
241 x 93 x 93 centimeters /
94 x 36 1/4 x 36 1/4 inches

I have always been intrigued with utopian manifestos even though they usually end up as fascist credos. The idea of a modernist utopian dream still seems exciting to me. Of course, the original dream of the perfect modern world never materialized the way it was planned. But for me the modernist order is not so much about politics but more about style. It is the look and feel of the modern that is what interests me—

Jules Verne, Flash Gordon, *Blade Runner*, *American Gigolo*, Art Deco, transmitter towers, suspension bridges, atomic submarine research laboratories and stainless-steel chemical tanks— for me these are the things that dreams are made of.

The heavenly directed spires and domes of early architecture are the right idea. It is the spirit of optimism, the uplifting quest to seek the stars, that results in inspired forms.

1995

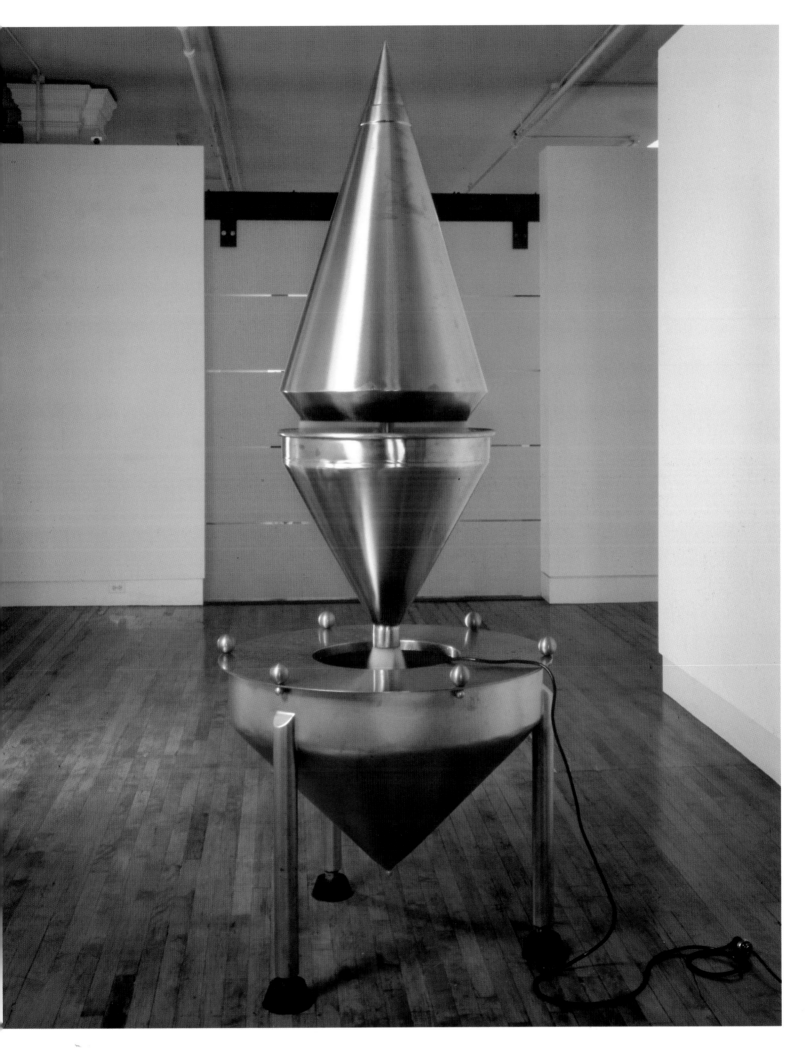

Peter Fischli/ David Weiss

Peter Fischli Born: Zurich, Switzerland 1952 / Lives and works in Zurich

David Weiss Born: Zurich, Switzerland 1946 / Lives and works in Zurich

• Fischli/ Weiss's treatment of things in general: the ability to see contented presence is tantamount to the archaic perception that crops up in all of their plastic, filmed, and photographed works; and it is at its most intense in certain marginal moments.

• Archaic perception bids things to state only that they *are,* to wake up to the fullness of their inner void.

• The Fischli/ Weiss view is animistic and, as such, it restores and exposes things to the paradox of their own facticity.

• Knowing about the contented presence of things is requisite to reactivating the vital energies stored within them in layer upon layer of meaning, the same energies, in fact, that were initially seminal to the sedimentation of these layers.

• The animistic attitude, as described here, is imbued with global curiosity unburdened by ethnographic displacement. Modern animation no longer has the support of tribal rituals. What is at stake now is simply the faculty for retaining astonishment despite lucid awareness.

• Intense astonishment—unexpectedly—empties the meaning out of things and thereby makes them all the more present, prepared to be transformed forever, even in their materiality. Fischli/ Weiss are interested in the transformation of things that remain suspended to sustain—paradoxically—the state of transformation.

Wanted: That magic moment when one reality turns into another entirely different one.

Wanted: The moment when the other is revealed while preventing the one from vanishing, the moment that can open up those spaces where meanings begin to dance and the self-evidence of things can be reconstructed.

FROM **PATRICK FREY**, "MOMENTS OF CONTENTED PRESENCE: ON PETER FISCHLI AND DAVID WEISS," *PETER FISCHLI Y DAVID WEISS* (VALENCIA: IVAM CENTRE DEL CARME, 1990)

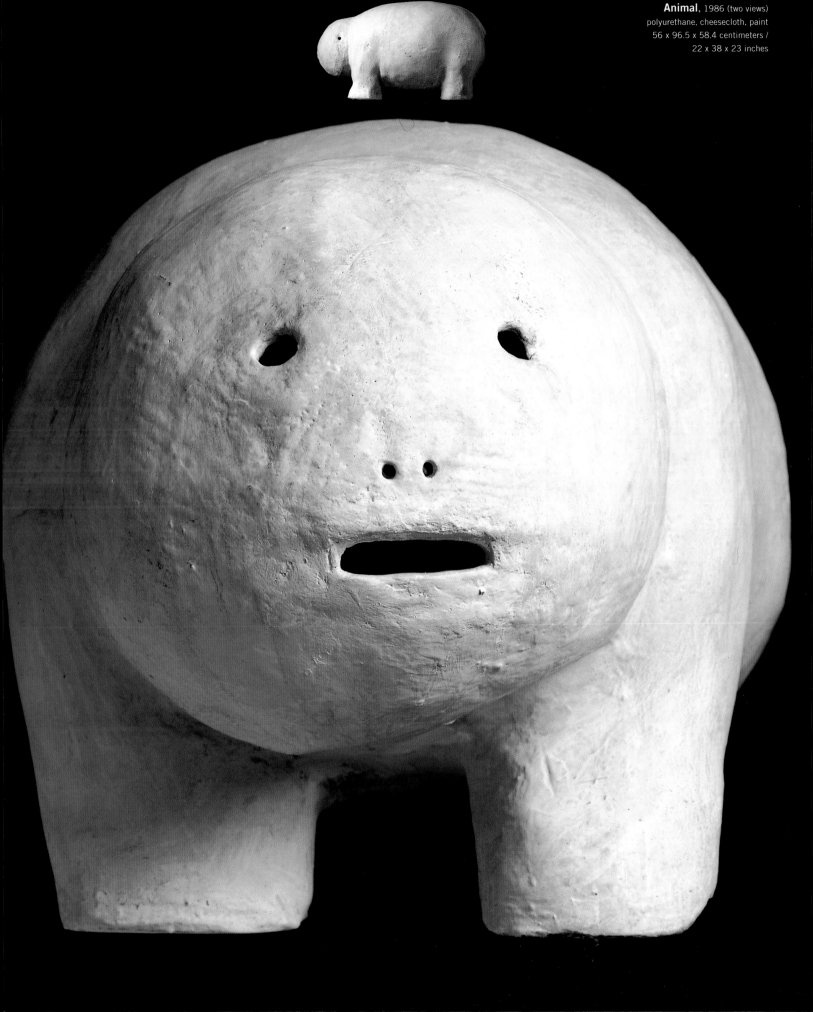

Animal, 1986 (two views)
polyurethane, cheesecloth, paint
56 x 96.5 x 58.4 centimeters /
22 x 38 x 23 inches

Dan Flavin

Born: New York City 1933 / Lives and works in Wainscott, New York

ON THE "MONUMENTS"...

Thus far, I have made a considered attempt to poise silent electric light in crucial concert point-to-point, line-by-line and otherwise in the box that is a room. This dramatic decoration has been founded in the young tradition of a plastic revolution which gripped Russian art only forty years ago. My joy is to try to build from that "incomplete" experience as I see fit.

'MONUMENT' 7 in cool white fluorescent light memorializes Vladmir Tatlin, the great revolutionary, who dreamed of art as a science. It stands, a vibrantly aspiring order, in lieu of his last gilder, which never left the ground. (1965)

My concern for the thought of Russian artist-designer Vladmir Tatlin (1885-1953) was prompted by the man's frustrated, insistent attitude to attempt to combine artistry and engineering. The pseudo-monuments, structural designs for clear but temporary cool white fluorescent lighting, were to honor the artist ironically. (1972)

FROM "MONUMENTS" FOR V. TATLIN FROM DAN FLAVIN, 1964–1982

(LOS ANGELES: MUSEUM OF CONTEMPORARY ART; CHICAGO: DONALD

YOUNG GALLERY; AND NEW YORK: LEO CASTELLI GALLERY, 1989)

fluorescent
 poles
 shimmer
 shiver
 flick
 out

 dim

monuments

of
 on
 and
 off

 art

(This poem is dated October 2, 1961)

FROM "WRITINGS CHOSEN BY THE ARTIST" IN *NEW USES FOR FLUORESCENT LIGHT WITH DIAGRAMS, DRAWINGS, AND PRINTS FROM DAN FLAVIN*, BADEN BADEN: STAATLICHE KUNSTHALLE BADEN-BADEN, 1989) EDITION CANTZ

opposite page: **Untitled ("monument" for V. Tatlin),** 1968
cool white fluorescent light, 244 x 82 x 13 centimeters / 95 x 32 x 5 inches

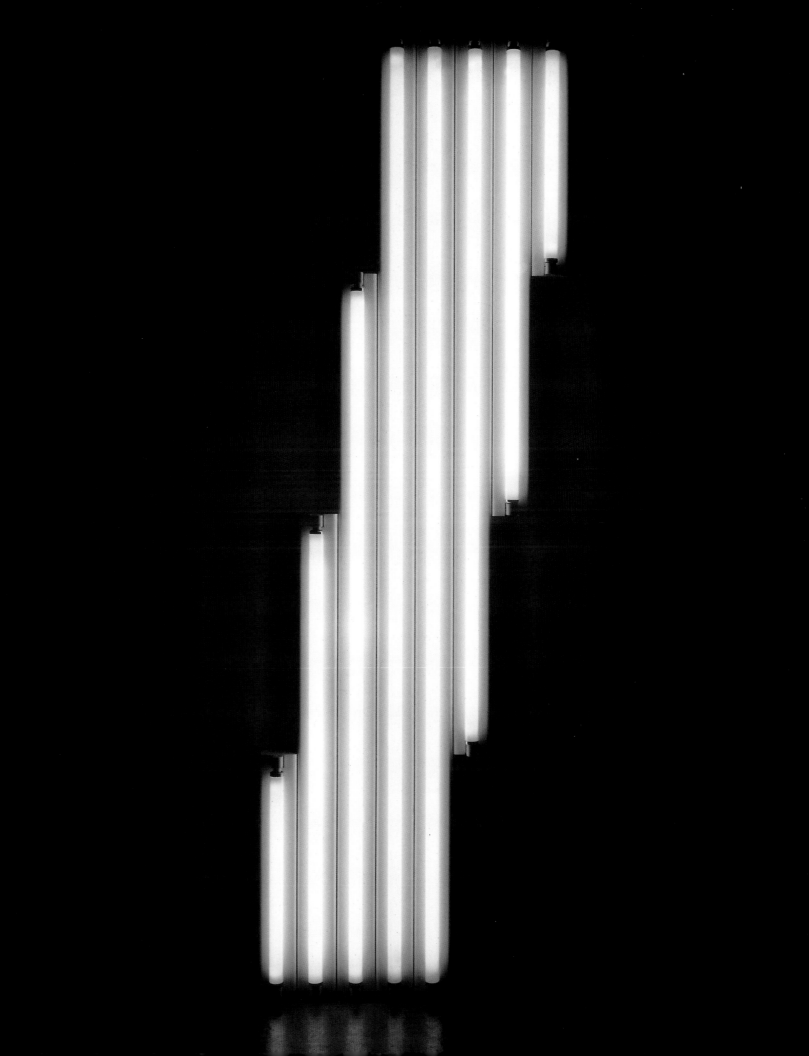

Günther Förg

Born: Füssen, Germany 1952 / Lives and works in Switzerland

It is never a question of combining colors to create a separate painting but of producing a palette for the series as a whole.

The color contrasts often seem painfully garish, and it is only as internalized states that they make any sense—colors that we see when blinding light forces us to squint. Longitudinal stripes, horizontal divisions and rectangle at the edges do not seem part of a geometric composition but give the impression, rather, of spatial arrangements designed to obstruct the line of vision, allowing glimpses of what lies beyond and opening up vistas, thereby forcing the viewer to step inside the lead paintings and be drawn inside them, or else be repulsed.

. . . Förg has produced a series of larger-than-life works on paper (watercolours, gouaches, chalk drawings, pen and ink drawings) which he calls "CANSONS" after a make of paper. They draw their painterly ideas from the surface structures of his bronze reliefs, monotypes and earlier watercolours, while a certain affinity with his photographic works is achieved by framing them behind glass. Facades, lattices, protuberances (masks), stripes (furrows), and lead picture motifs alternate with one another, becoming blurred in his wet-on-wet paintings, like reflections in a pond, or resembling the frost on windowpanes that someone has tried to wipe clean. FROM **VEIT LOERS**, "YOU MIGHT THINK THERE WAS NOTHING TO SEE . . . ", *GÜNTHER FÖRG* (KASSEL: MUSEUM FRIEDRICIANUM, 1990), EDITION CANTZ

Untitled, 1989
acrylic on Canson paper
260 x 148 centimeters /
102 1/2 x 58 1/4 inches

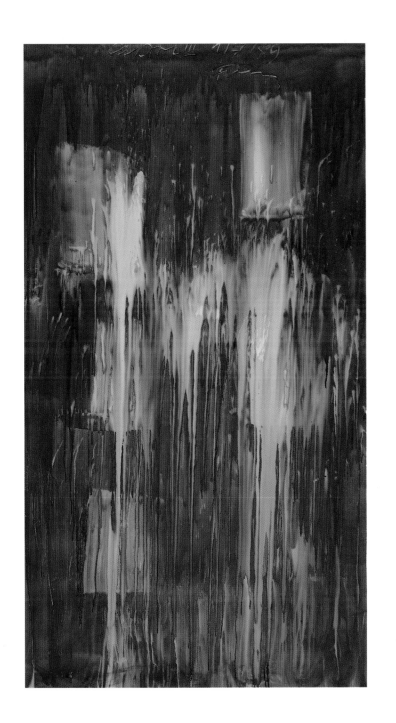

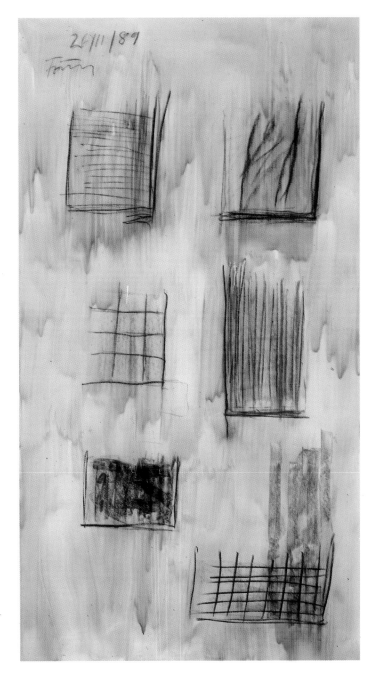

Capri III, 1989
acrylic on Canson paper
260 x 148 centimeters /
102 1/2 x 58 1/4 inches

Untitled, 1989
acrylic on Canson paper
260 x 148 centimeters /
102 1/2 x 58 1/4 inches

Katharina

Fritsch

Born: Essen, Germany 1956 / Lives and works in Düsseldorf, Germany

What can you say against order besides, maybe, that in our generation it is such a negatively loaded word?

I would rather speak about a formal clarity that also contributes to abstraction. I have, by the way, not only made symmetrical works . . . I like to leave chance elements next to order. For me, order is, first of all, nothing negative or positive. I would rather speak about clarity of forms and about symmetry. Order is immediately always morally loaded: *Ordnung*—one immediately thinks of the Third Reich. There are so many great works of art that are symmetrical, that are "orderly," which as sculpture are viewable from all sides. So, I don't want to attack order in this moralistic or political sense, or bring it from the inside ad absurdum. It is a sculptural need for me to work through objects and to arrive at a closed form. I like round, geometrical or symmetrical basic forms. Primarily, that has nothing to do with moral conventions . . .

. . . When I fix something intuitively, even though I have to justify myself to every exhibition curator, I know that it is right. But basically it is something objective for which one only needs a clear sensitivity. It's always about the point of identity, meaning that during the realization of the idea one doesn't lose or obscure this idea. It's about the finding of the measure, to get to a point in a very concrete and abstract sense.

That is an important point in my life and my work. It should be the most important thing in every life and in every work. That is, for me, not only a concrete question regarding measures and details but rather that people should find this point in their lives as human beings that is right for them.

FROM AN INTERVIEW WITH MATTHIAS WINZEN IN *JOURNAL OF CONTEMPORARY ART*, SUMMER 1994

Kerzenständer (Candlesticks), 1985
mixed media
120 x 120 x 160 centimeters /
47 x 47 x 62 1/2 inches

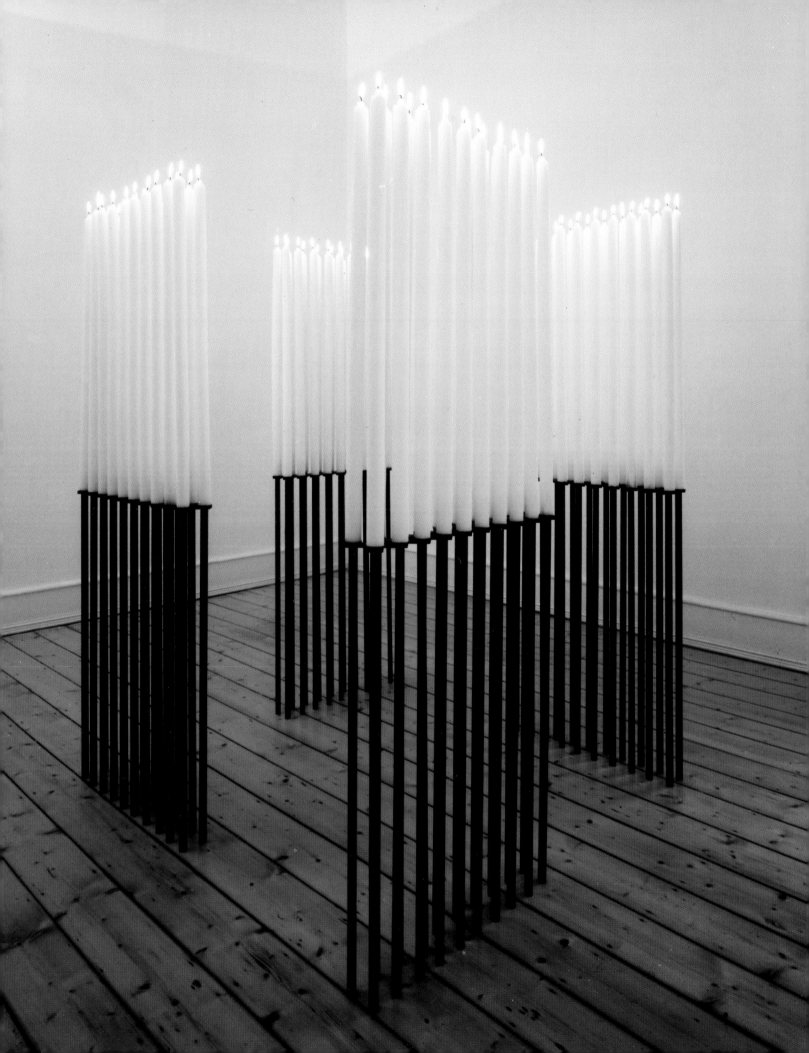

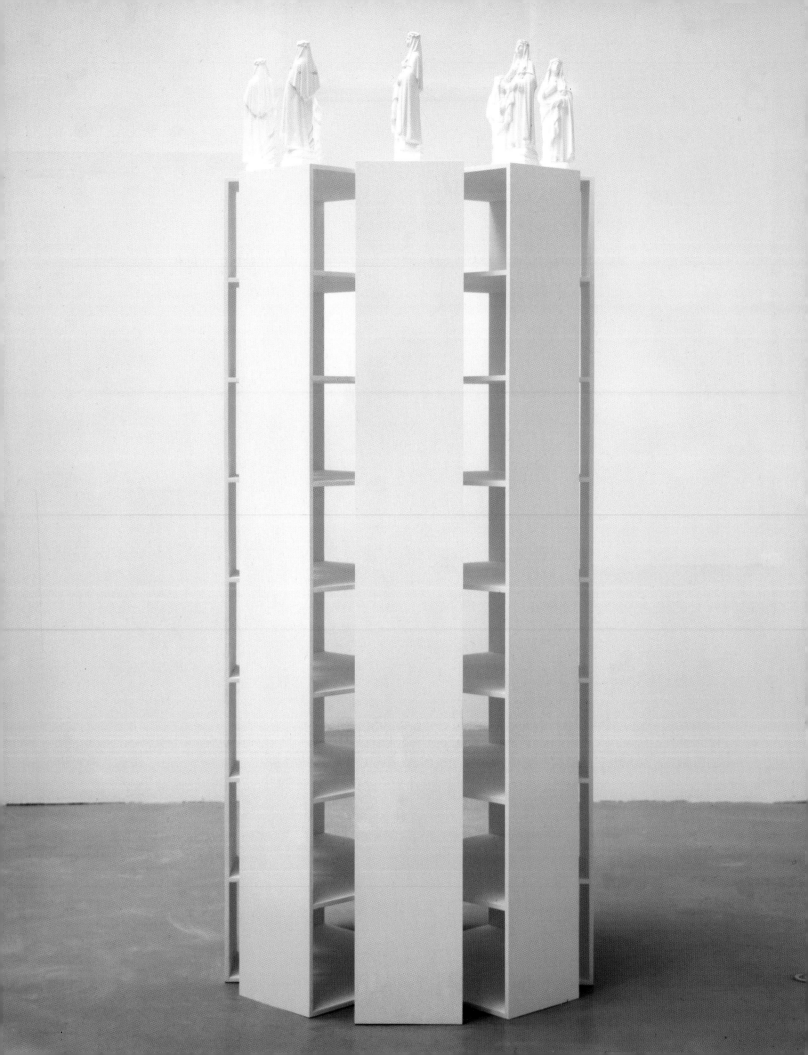

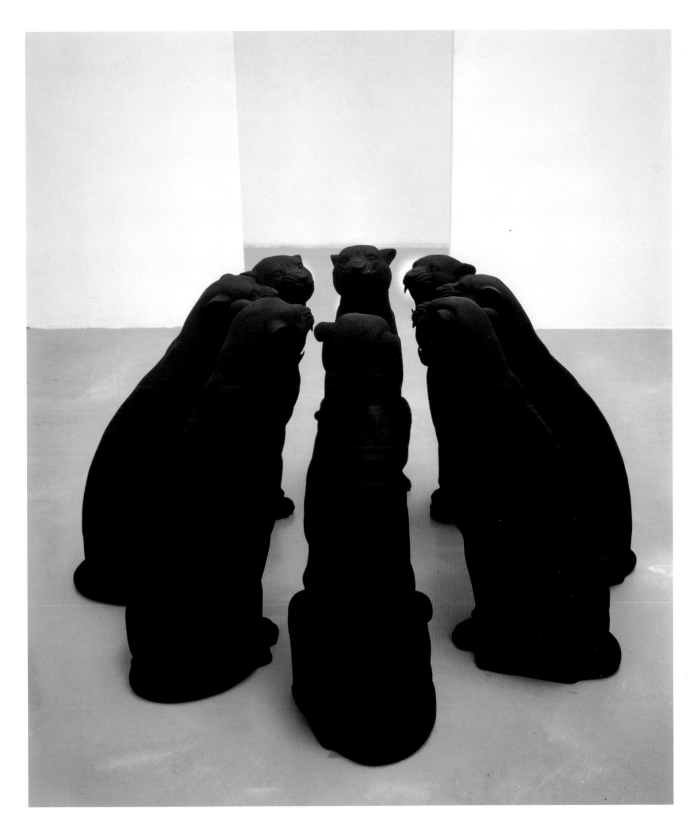

Panther, 1993
polyester, acrylic 245 x 500 x 160 centimeters / 95 1/2 x 195 x 62 1/2 inches

opposite page: **Regal mit Acht Figuren (Bookcase with Eight Figures)**, 1992–94
wood, acrylic, plaster 245 x 100 x 100 centimeters / 95 1/2 x 39 x 39 inches

Gilbert

Born: Dolomites, Italy 1943 / Lives and works in London

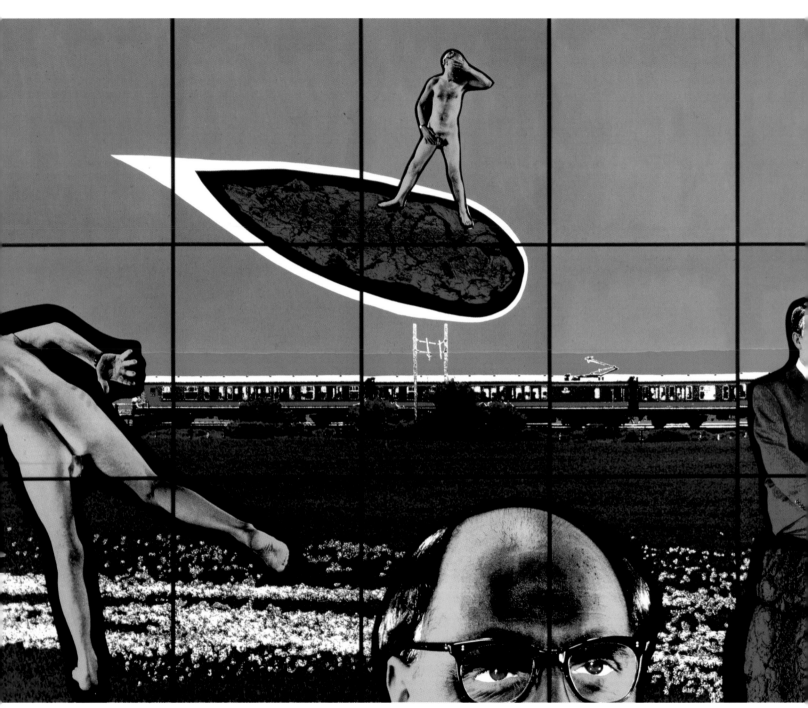

We are modern-times artists. We have to devise a vocabulary that reflects this age. We don't want to

& George

Born: Devon, Great Britain 1942 Lives and works in London

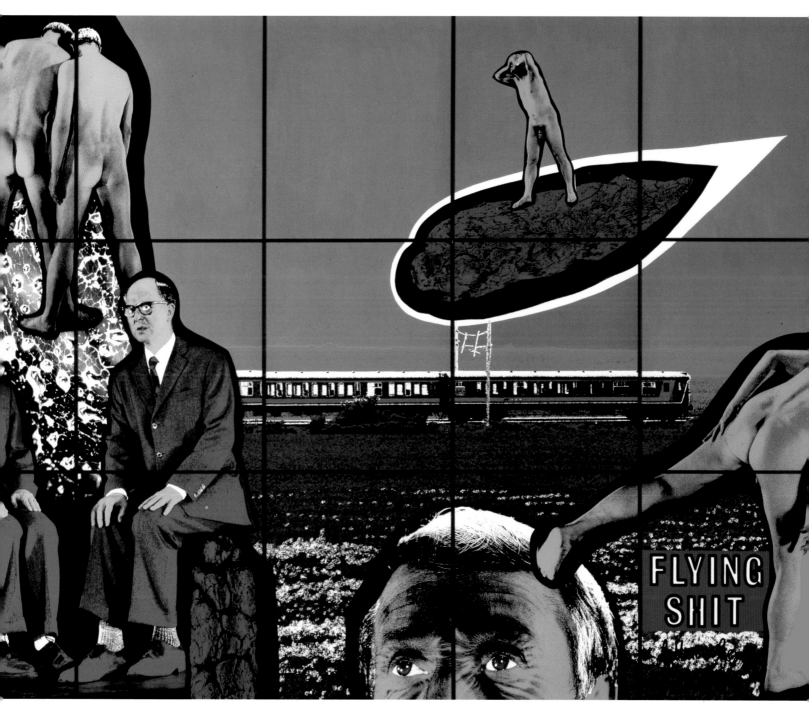

hide our weakness, our sexual behaviour, our thinking, our suffering, and all that belongs to mankind.

Flying Shit, 1994 Hand-tinted black-and-white photograph 253 x 639 centimeters / 98 1/2 x 249 inches

Robert Gober

Born: Wallingford, Connecticut 1954 / Lives and works in New York City

Robert Gober stages a personal, offbeat drama about life since the 1950s.

His art voices strong and mythically American sentiments: a sense of innocence lost, a need to speak plain truths, and an angry public-spirited discontent about current failings of the democratic process. The context in which it evolved included a childhood in the receding rural environment of Connecticut and a career in New York that barely preceded the first decade of the AIDS epidemic. Until recently Gober's art has resembled props that have captured the spotlight: Actors are noticeably absent, while the objects are simply there, communicating silent poetry. With their modesty and isolation they seduce curious viewers to engage them in fetishizing close-up. Some of his sinks, for example, draw from us the warm familiarity that we assume with the ordinary, then add the arresting shock of recognizing the aura of things that

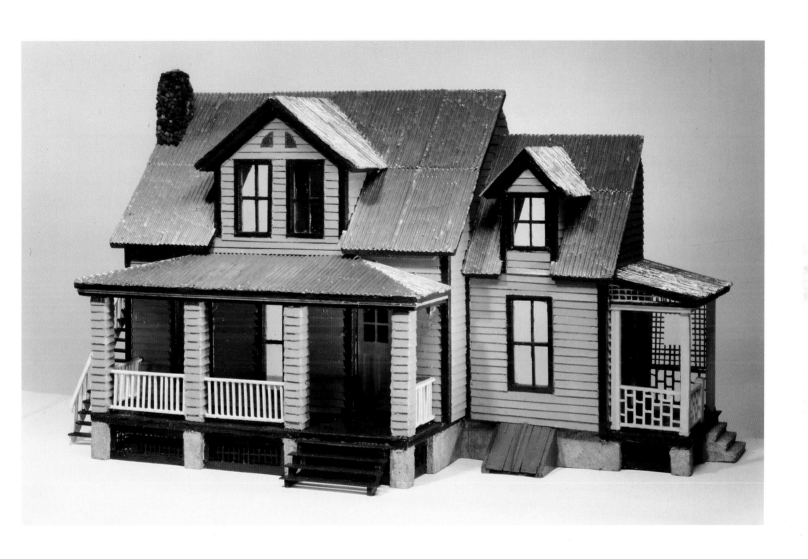

Untitled, 1980
mixed media dollhouse
69 x 119 x 57 centimeters / 27 1/2 x 47 x 22 inches

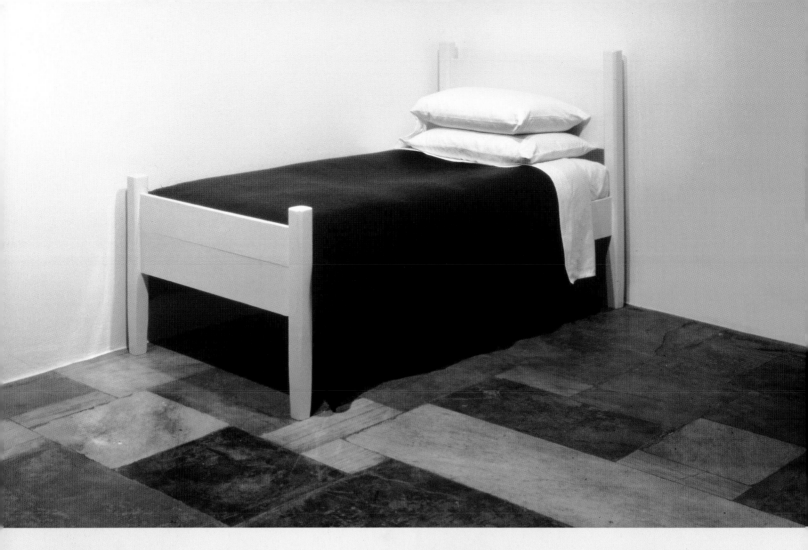

above: **Corner Bed,** 1986-1987
enamel paint, wood, cotton, wool
111 x 195 x 105 centimeters /
43 1/4 x 76 x 41 inches

Pitched Crib, 1987
enamel paint, wood
97 x 186 x 128 centimeters /
38 1/4 x 73 1/4 x 50 1/2 inches

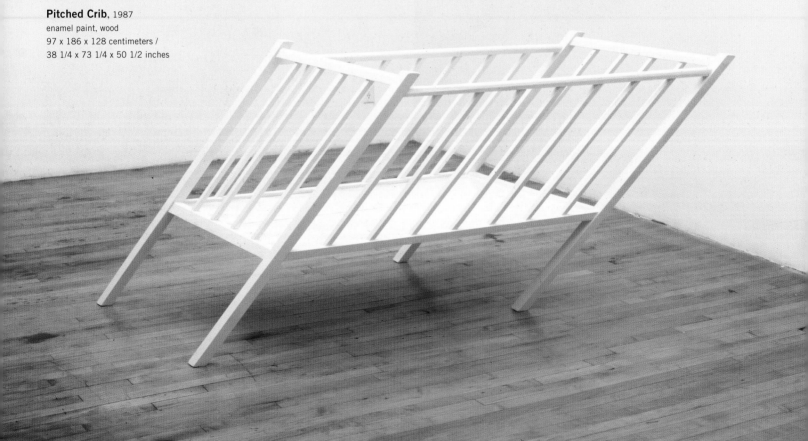

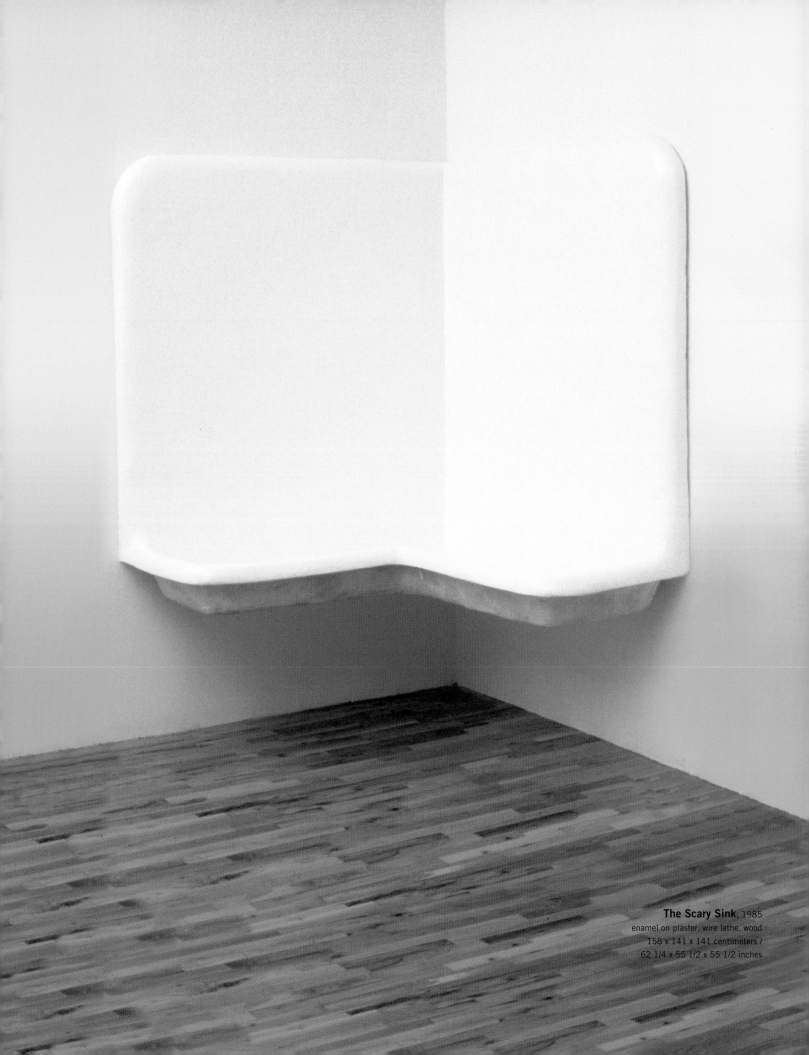

The Scary Sink, 1985
enamel on plaster, wire lathe, wood
158 x 141 x 141 centimeters /
62 1/4 x 55 1/2 x 55 1/2 inches

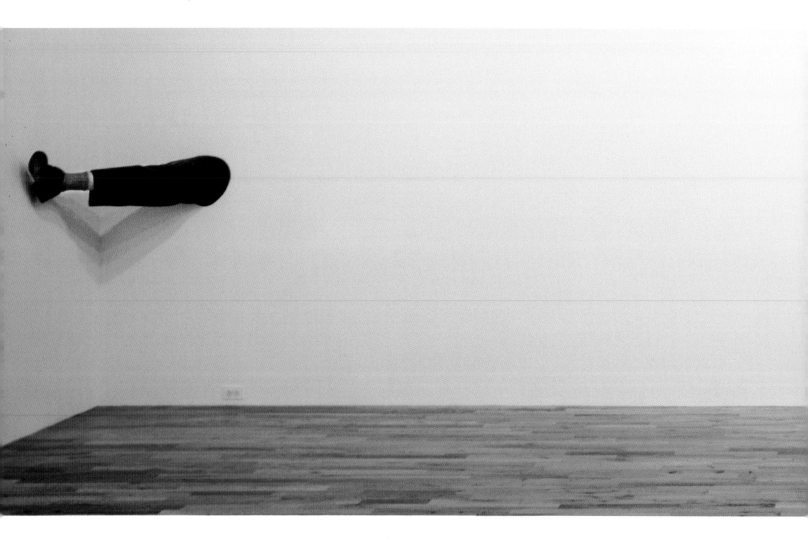

are unreal. We may be left staring rudely and in wonder, as if, free of prejudice, we were seeing for the first time an elaborate baroque interior, or a transvestite, or anything whose surface resists easy identification. Gober's idolatry of the real unhinges rather than confirms our assumptions about the subjects he chooses. As his subjects shed their cloaks of everyday associations, they reveal themselves as brooding vessels, which one may see in terms of the Freudian symbolism of sexuality, death and mourning. His intellectually loaded, subtly imperfect mimesis of common objects differs from the slick "superrealism" of the 1970s that indulged in illusionism for its own sake. Gober's art derives further complexity from the manner in which it

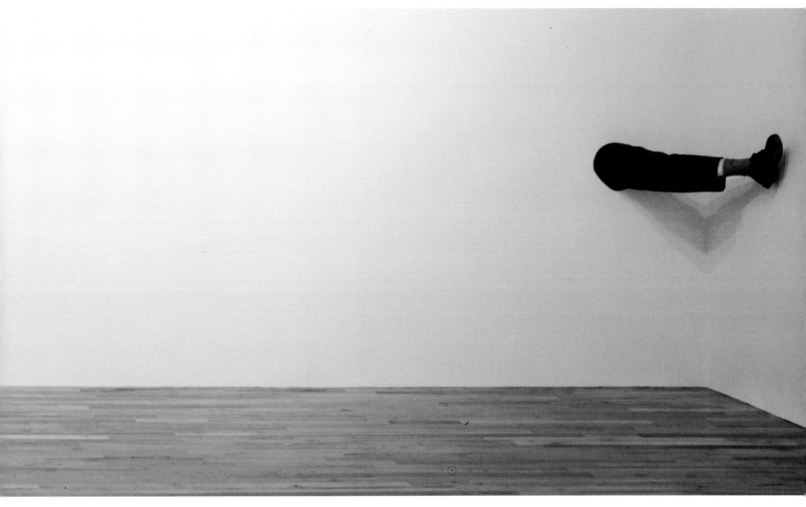

Two Spread Legs, 1991 wood, wax, leather, cotton, human hair, steel
each leg: 28 x 89 x 70 centimeters / 11 x 35 x 27 1/2 inches

reroutes modernist and minimalist practices. Even though his aesthetic of stringent rigor is indebted to the minimalist reformation of sculpture's objecthood, his realism and bias toward subjective expression represent the antithesis of minimalism as it was first theorized. The perverse catholicity of Gober's interests and his ironic, occasionally mordant, humor descend from the Surrealists by way of Alfred Hitchcock. Like them, he is in tune with the marginal, irrational and compulsive aspect of things. His formation of an identity through an impure method of intuitive accretion exemplifies the discontinuity and confusion of postmodernism. FROM **TREVOR FAIRBROTHER**, "WE

ARE ONLY AS SICK AS THE SECRETS WE KEEP," *ROBERT GOBER* (ROTTERDAM: MUSEUM BOYMANS VAN BEUNINGEN AND BERN: KUNSTHALLE BERN,1990)

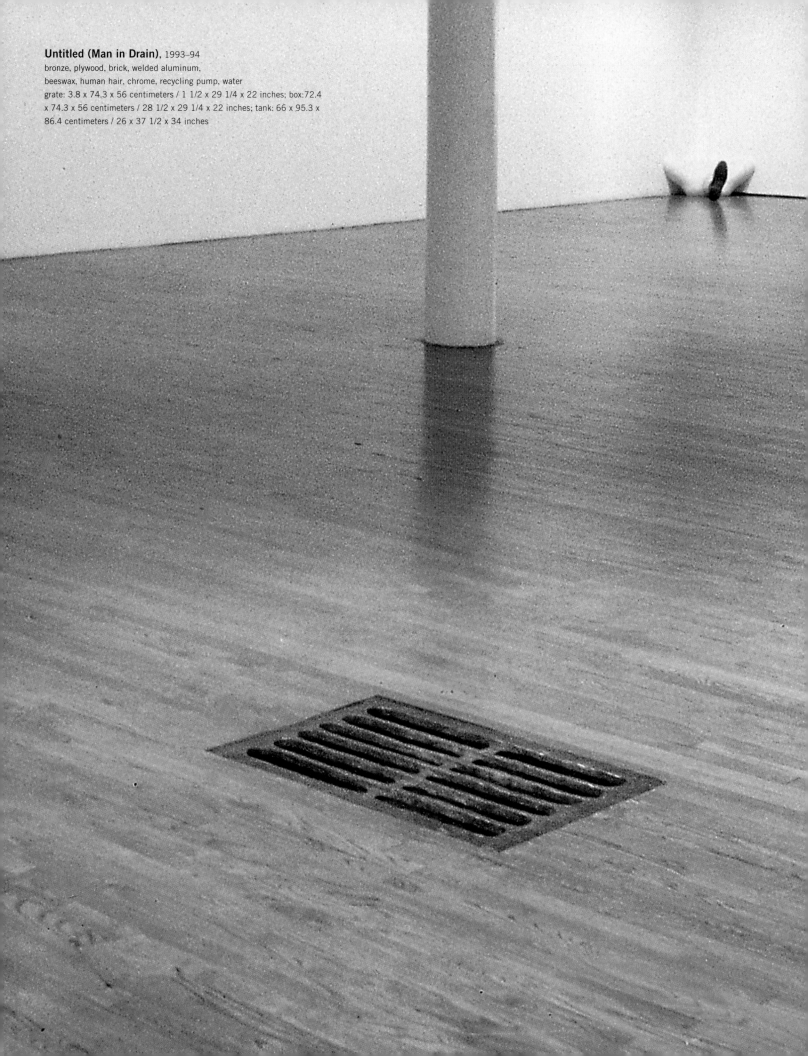

Untitled (Man in Drain), 1993–94
bronze, plywood, brick, welded aluminum,
beeswax, human hair, chrome, recycling pump, water
grate: 3.8 x 74.3 x 56 centimeters / 1 1/2 x 29 1/4 x 22 inches; box: 72.4
x 74.3 x 56 centimeters / 28 1/2 x 29 1/4 x 22 inches; tank: 66 x 95.3 x
86.4 centimeters / 26 x 37 1/2 x 34 inches

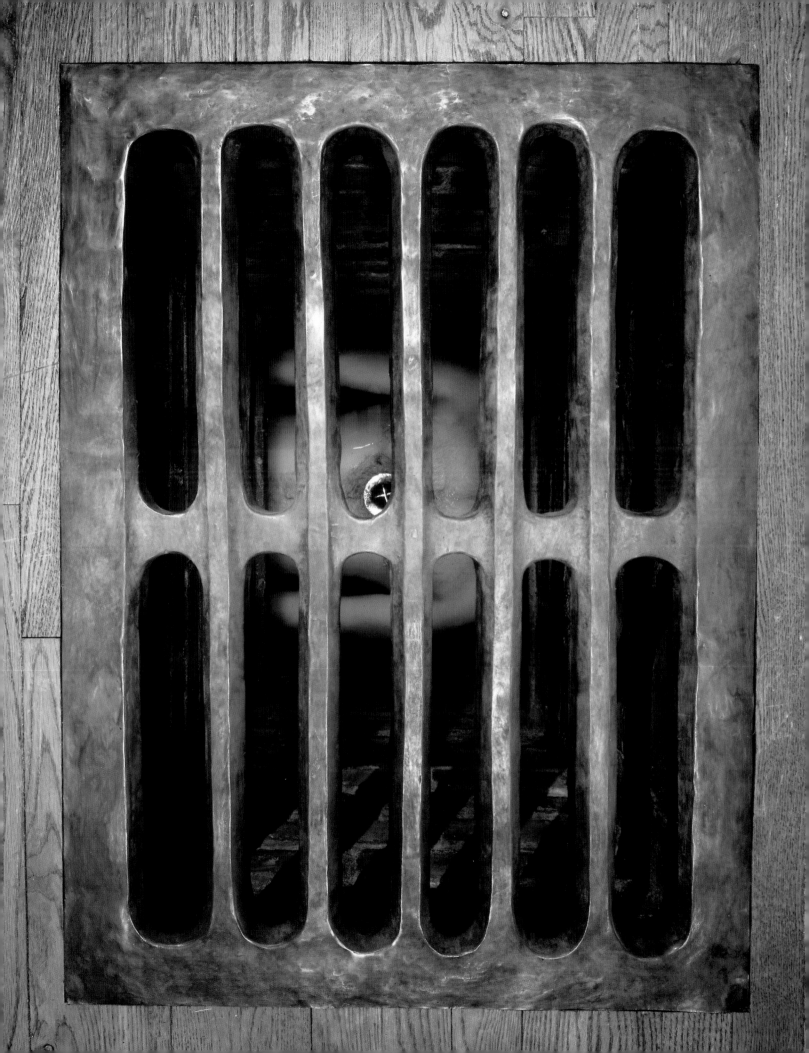

Jack Goldstein

Born: Montreal, Canada 1945 / Lives and works in California

More than most postconceptual artists who come to mind, Jack Goldstein's work seems directly related to fears and anxieties about living in the world, and yet, significantly, the look of the work is almost antiseptically divorced from any clichéd notion of the language of *Angst*. There are no smudge marks or erasures; there is no hesitancy of execution. On confronting the work for the first time, most viewers will be struck by how closely it mimics the slick presentation of commercial art. The images Goldstein uses are presented in a way that links them to the media with a much greater sense of complicity than one finds in the work of the Pop artists. Unlike Pop painting, transformation of the meaning of the image is not linked to simple change of form. . . . There is in Goldstein's work almost a sens of allegiance to the conventions of commercial presentation, which becomes ironic because of his intention to locate a source of control over his imaginary environment. The obvious paradox lies in aligning one's art with the presentational modes that are used culturally to control and limit our sense of self when one's goal is to distance or liberate oneself from that control and to establish a greater level of control. What one desires "control" over in one's life is the corrosive effect arbitrariness has on spontaneity . . .

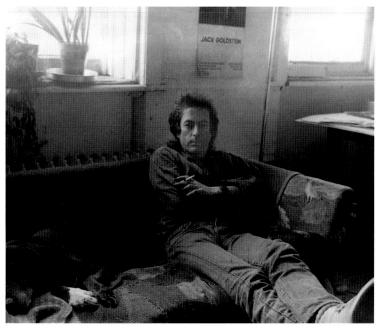

PHOTO: PETER BELLAMY

A BRIEF INTERVIEW

Q: *Who are the role models for the persona projected by the work?*
A: All of us.
Q: *If you could live in any time, what would it be?*
A: The future, the far future, so I wouldn't have to worry about spontaneity.

FROM **DAVID SALLE**, "JACK GOLDSTEIN: DISTANCE EQUALS CONTROL," *JACK GOLDSTEIN* (BUFFALO: HALLWALLS, 1978)

Untitled, 1980
acrylic on canvas, 2 panels:
122 x 167.6 centimeters; 122 x 78.7 centimeters/
48 x 66 inches; 48 x 31 inches

Joe Goode

Born: Oklahoma City, Oklahoma 1937 / Lives and works in Venice, California

In much of Joe Goode's work there is an attempt to dispel preconceived ideas about art, which is not unlike the attempt of Marcel Duchamp and his cynical subversion of the art-making process. In 1964, Goode created a group of works which lie between sculpture and painting recalling Duchamp's "ready-mades." These plywood constructions covered with carpet suggest real staircases, but, in fact, are "illusions" of staircases. Here the physical object is subverted by its own nonfunctionality; the steps lead nowhere, they are too weak to support weight and optically collapse into the wall. The *Staircases* present images which are at once three-dimensional, yet flat. The dense carpeting which covers the objects further deadens their sense of depth and adds to their abstract nature.

These works are surrogates.

We read them first as recognizable objects, but once the truth of their nonfunctionality is discovered, the *Staircases* begin to assume an abstract character. FROM **NORA HALPERN BROUGHER**, "WATERFALL PAINTINGS, " *JOE GOODE*, JAMES CORCORAN GALLERY, 1990

Untitled,
Staircase Series 1, 1965–1971
wood and carpet
177.8 x 122.6 x 125.7 centimeters /
70 x 48 1/2 x 49 1/2 inches

Dan Graham

Born: Urbana, Illinois 1942 / Lives and works in New York City

The one magazine piece that was most like a conventional article was "Homes for America," printed in *Arts Magazine,* December 1966 – January 1967. It is an article designed around photographs of suburban tract housing estates taken over a period of two years. It is important that the photographs are not seen alone, but as part of an overall magazine article layout. They are illustrations of the text, or, inversely, the text functions in relation to the photographs, thereby modifying their meanings. The photographs and the text are separate parts of a two-dimensional, schematic grid perspective system. The photographs correlate to the lists and columns of serial documentation and both represent the serial logic of the housing developments, which the article is about. I think the fact that "Homes for America" was, in the end, only a magazine article, and made no claims for itself as a work of art, is its most important feature. FROM "MY WORKS FOR MAGAZINE PAGES: A HISTORY OF CONCEPTUAL ART"

PHOTO: STEPHEN WHITE

**Homes for America, Highway
Restaurant, Jersey City
Courtyard of Housing Project, Bayonne**, 1966
2 photographs
top: 25.4 x 33 centimeters / 10 x 14 inches
bottom: 26.7 x 33 centimeters / 10 1/2 x 13 inches

**Homes for America,
Two Home Homes,
Ground Level Plan**, 1966
2 photographs
top: 25.4 x 36.5 centimeters / 10 x 13 inches
bottom: 26.7 x 33 cm / 10 1/2 x 13 inches

Peter Halley

Born: New York City 1953 / Lives and works in New York City

STATEMENT (1983) Even though my work is geometric in appearance, its meaning is intended as antithetical to that of previous geometric art. Geometric art is usually allied with the various idealisms of Plato, Descartes, and Mies. My work, in fact, is a critique of such idealisms.

I have tried to employ the codes of minimalism, Color Field painting, and Constructivism to reveal the sociological basis of their origins. Informed by Foucault, I see in the square a prison; behind the mythologies of contemporary society, a veiled network of cells and conduits.

To further locate my work, I would like to invoke Robert Smithson's achievement. While Smithson branded the blighted industrial landscape with the symbols of ideal geometry, I seek, conversely, to interject into the ideal world of geometric art some trace of that same social landscape.

FROM *PETER HALLEY COLLECTED ESSAYS 1981–1987* (ZURICH: GALLERY BRUNO BISCHOFBERGER, 1988, AND NEW YORK: SONNABEND GALLERY, 1989)

Red Shift, 1988
Day-Glo acrylic and acrylic on canvas
114.5 x 366 x 8 centimeters /
45 x 144 x 3 1/4 inches

Two Cells with Circulating Conduits, 1987 Day-Glo acrylic, acrylic, Roll-Tex on canvas 196.2 x 351 x 8 centimeters / 77 1/4 x 138 x 3 1/4 inches

On Dumb Painting

I always wanted to be a painter, much more than a sculptor, but I was overwhelmed by the infinite possibilities of painting. I think it's got something to do with the void, the void of the blank canvas where anything and everything is possible beyond gravity, beyond life, in the realms of the imagination. Max Beckmann used to paint his canvases black to represent the void and everything he painted he saw as an object that he placed between himself and that void.

I often get asked about the spot paintings: "I love your work but why do you do those stupid spots? They're not good paintings." Or, "The paintings are great—better than your other works, but Richter already did it." They're nothing to do with Richter or Poons or Bridget Riley or Albers or even Op.

They're about the urge or the need to be a painter above and beyond the object of a painting. I've often said that they are like sculptures of paintings.

I started them as an endless series—a scientific approach to painting in a way similar to the drug companies' scientific approach to life. Art doesn't purport to have all the answers; the drug companies do. Hence the title of the series, *The Pharmaceutical Paintings*, and the individual titles of the paintings themselves: ACETA-LDEHYDE (1991), ALBUMIN HUMAN GLYCATED (1992), ANDROSTAN-ALONE (1993), ARABINTOL (1994).

In the spot paintings, the gridlike structure creates the beginning of a system. In each painting no two colours are the same. This ends the system. It's a simple system. No matter how I feel as an artist or a painter, the paintings end up looking happy. I can still make all the emotional decisions about colour that I need to as an artist, but in the end they are lost. The end of painting. And I'm still painting. Am I a painter? Or a sculptor who paints? Or just an artist? I don't know. It's not important. However, it's very important that there is an endless series or enough to imply an endless series.

If you look closely at any one of these paintings a strange thing happens: Because of the lack of repeated colours, there is no harmony. We are used to picking out chords of the same colour and balancing them with different chords of other colours to create meaning. This can't happen here, and so in every painting, there is a subliminal sense of unease; yet the colours project so much joy, and it's hard to feel it. But it's there: The horror underlying everything. The horror that can overwhelm everything at any moment.

FROM AN UNPUBLISHED TEXT BY THE ARTIST, 1995

Damien Hirst

Born: 1965 Bristol, England / Lives and works in London

Alphaprodine, 1993
gloss household paint on canvas
335.3 x 457.2 centimeters /
132 x 180 inches

Jenny Holzer

Born: Gallipolis, Ohio 1950 Lives and works in Hoosick Falls, New York

Untitled (with selections from the Survival Series), 1983–1984
electronic moving message unit,
LED sign, green diode
15.8 x 154.3 x 17.8 centimeters /
6 x 60 3/4 x 7 inches

Ranging from the subtle to the spectacular,
Holzer's work masquerades as a public service message of a decided-
ly subversive type. While the late German artist Joseph Beuys performed
as the shaman of seventies social sculpture, Holzer works as the cool
eighties executive of psychological inquiry. She is clearly one of
Beuys' inheritors in her exercise of conscience and in her ambition to cre-
ate an evocative, socially utilitarian art. In Holzer's case, however, she
has filtered this ambition through the restless tenacity and mechanics of
American advertising, in its broadest sense, from a cigarette ad on a bill-
board to a televised State of the Union message.

In the end, hers is not a European sensibility. Indeed, it could be said that
Holzer's art represents American art of the 1980s in a way that no other
art can, given the uneasy and complex goals of the younger American
artists who have come of age during this decade. Many of the issues that
have haunted a new generation of artists over the past ten years—the emer-
gence of a dynamic social conscience; the debate over what constitutes a
viable form of public art; the issue of language as a visual element; the po-
litically volatile dialectic of feminism and gender within our reading of
contemporary issues; and the ambivalence of artists appropriating (or, in
some cases, being appropriated by) media hardware and techniques—all
seem to come to a flash-point in Holzer's art . . . FROM **MICHAEL AUPING**, "READING

HOLZER OR SPEAKING IN TONGUES," *JENNY HOLZER: THE VENICE INSTALLATION* (BUFFALO: ALBRIGHT-KNOX ART GALLERY, 1990)

PHOTO: MICHAELA ZEIDLER

PAUL TAYLOR: *Why did your* TRU-
ISMS *appear in the art context
instead of in, say, magazines or a lit-
erary context?*

JENNY HOLZER: To tell you the truth,
I didn't put them in an art context. I
put them in the street. I somehow
thought that maybe I could be an
artist and at the same time get this
work that I was thinking about out to
the public. I was dying to get this in-
formation out where maybe it would
be useful to somebody. It was really
the art world that put it into art even-
tually. I tried to put it outside. I did a
couple of shows after having the
stuff in the street for maybe two
years, in places like the window of
Franklin Furnace, in Printed Matter
and at Fashion Moda in the Bronx . . .

FROM **PAUL TAYLOR**, "JENNY HOLZER: I WANTED TO DO A

PORTRAIT OF SOCIETY," *FLASH ART*, MARCH/APRIL 1990

Rebecca Horn

Born: Germany, 1944 / Lives and works in Berlin

Oeufs d'Autruche, 1985
ostrich eggs and metal
35 x 22 x 12 centimeters /
13 3/4 x 8 1/2 x 4 3/4 inches

STUART MORGAN: *The gestures you choose for your machines are like animal movements, aren't they? Movements of display that happen very quietly or, conversely, in a rush.*

REBECCA HORN: They react as we react. My machines are not washing machines or cars. They have a human quality and they must change. They get nervous and must stop sometimes. If a machine stops, it doesn't mean it's broken. It's just tired. The tragic or melancholic aspect of machines is very important to me. I don't want them to run forever. It's part of their life that they stop and faint.

SM: *Do you think your reaction has to do with our historical perspective? After all, we're at the end of the Machine Age. Perhaps that's the reason that old machinery seems so sad and outdated.*

RH: Maybe. On the other hand, when I use machines, people start to dance. . .

FROM "THE BASTILLE INTERVIEWS II, PARIS 1993: REBECCA HORN WITH STUART MORGAN," *REBECCA HORN* (NEW YORK: SOLOMON R. GUGGENHEIM MUSEUM, 1993)

White Feather Wheel, 1984
aluminum, electric motor, feathers
26.5 x 42.5 x 22 centimeters /
10 1/3 x 16 1/2 x 8 1/2 inches

Donald Judd

Born: Excelsior Springs, Missouri 1928 / Died: New York City 1994

PHOTO: TODD EBERLE

Somewhat new work is usually described with the words that have been used to describe old work. These words have to be discarded as too particular to the earlier work or they have to be given new definitions. Occasionally new terms have to be invented. I discarded "order" and "structure." Both words imply that something is formed. Material, volume, space or color are ordered or structured. This separation of means and structure—the world and order—is one of the main aspects of European or Western art and also of most older, reputedly civilized, art. It's the sense of order of Thomist Christianity and of rationalist philosophy that developed from it. Order underlies, overlies, is within, above, below, or beyond everything.

I wanted work that didn't involve incredible assumptions about everything. I couldn't begin to think about the order of the universe or the nature of American society. I didn't want work that was general or universal in the usual sense. I didn't want it to claim too much. Obviously the means and the structure couldn't be separate and couldn't even be thought of as two things joined. Neither word meant anything.

A shape, a volume, a color, a surface, is something itself. It shouldn't be concealed as part of a fairly different whole. The shapes and materials shouldn't be concealed as part of a fair-ly different whole. The shapes and materials shouldn't be altered by their context. One or four boxes in a row, any single thing or such a series is local order, just an arrangement, barely order at all. The series is mine, someone's, and clearly not some larger order. It has nothing to do with either order or disorder in general. Both are matters of fact. The series of four or six doesn't change the galvanized iron or steel or whatev-er the boxes are made of. FROM *DICTIONARY OF CONTEMPORARY ARTISTS*, 1977, REPRINT-ED IN *DONALD JUDD: COMPLETE WRITINGS, 1975–1986* (EINDHOVEN: STEDELIJK VAN ABBEMUSEUM, 1987)

opposite page: **Untitled**, 1967
galvanized iron, bullnose progression
36.8 x 194.3 x 64.8 centimeters /
14 1/2 x 76 1/2 x 25 1/2 inches

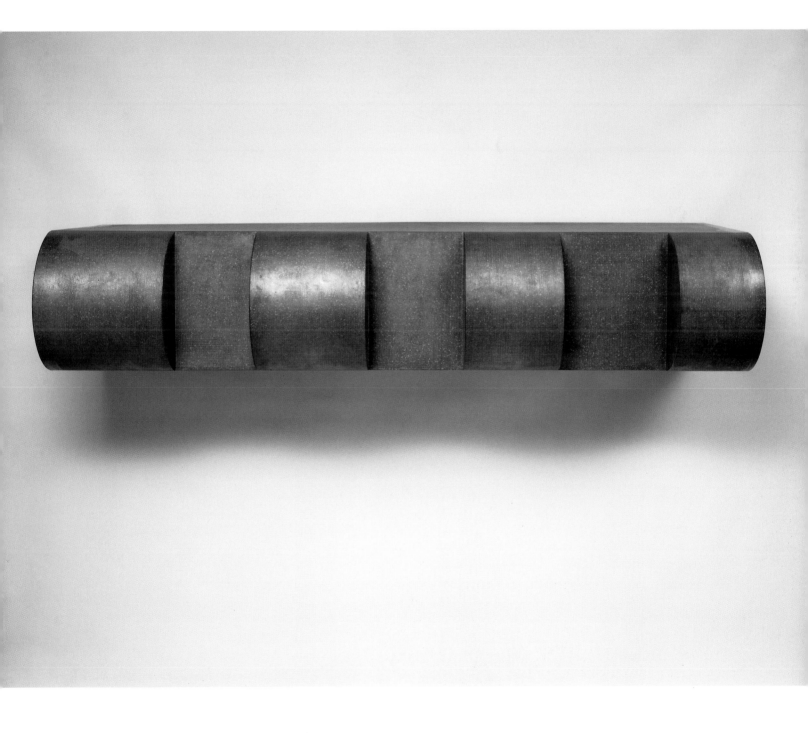

Mike Kelley

Born: Detroit, Michigan 1954 / Lives and works in Los Angeles

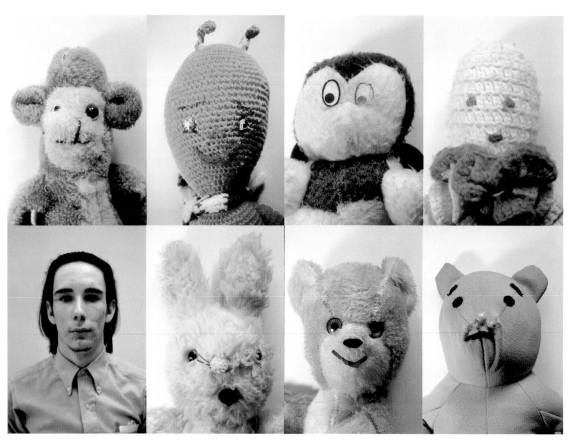

People say I am a romantic,

in the sense that I am trying to picture myself as an outsider or as a visionary. That's not true. I am very common. Every crackpot thing I use is a culturally given thing. They are illogical notions that are easily understood within the culture. You can't pretend that there isn't a history of knowledge outside the academic history. There is a history of illogical thought, there is a history of myth, of oral knowledge, and jokes, and tall tales, and lies, and wrong information, and propaganda. I was always interested in Charles Fort, an American from the early twentieth century who was just a compiler of oddities. It's just book after book of things that couldn't be explained. He is a logical compiler of illogical things. Recently, I am interested in the history of conspiracy theory and how it functions socially.

I like failure in artworks, because I am such an anticlassicist. I also think art is so much about questioning order that every artwork almost has to have something in it that denies its own validity. It's important that artworks be dysfunctional in some way, or at least have a veneer of dysfunction. I never thought of my work as assemblage, or as junk sculpture. I thought of it as a presentation of things that caused a problematic read. Like this craft item. It looks great when you see it from far away, and you say, "Oh, look at that bear, I'm going to go up and see what that bear's doing." And then when you get near to it, you say: "That's not a bear, that's a filthy rag!" That's what I am interested in, not a reaction like, "Oh, my childhood!" or "Oh, the loss of my childhood!" I prefer a situation

where first you read the thing one way, and then you see that it's dirty, you think, "I don't want to read that, I can't read that anymore." You realize that this thing is a model, it was designed to be nostalgic, to tug at an adult's heartstrings. It's not designed for children at all. But it only functions as a model if everything that really has to do with childhood is taken away, like the dirt, the gender, everything. As soon as you see all of the human elements on it, it ruins the effect.

I've used various strategies to get around the tendency to project into the things, when you are not able to see them as objects or models. In the photographs of dolls, for example. You are supposed to look at them as types. The exhibition language says that this is just a col-

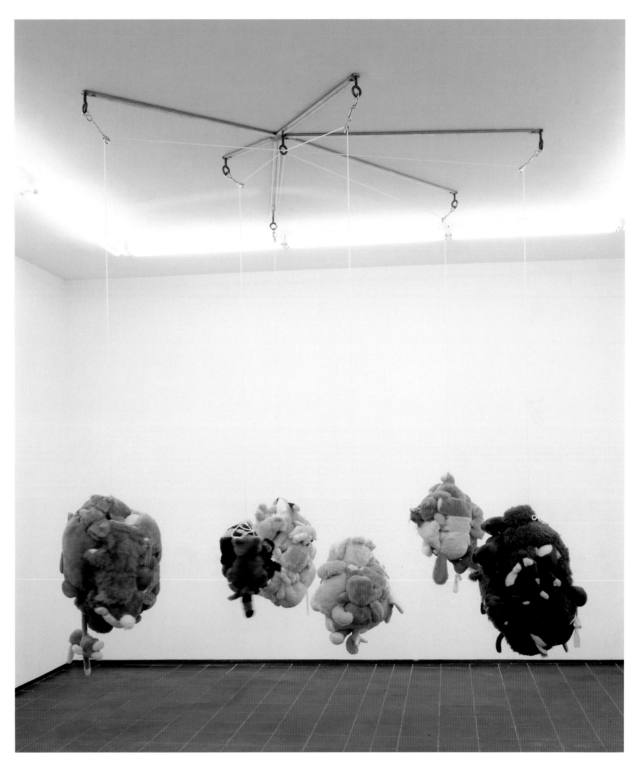

Brown Star, 1991
stuffed animals and steel
dimensions variable

lection of implements, but that's not how you were raised to look at these things. You can read all these various shapes as being a human, a generic human, a Platonic human, I guess. And you read them that way because you don't see them, you don't see them as lumps of cloth, as having formal qualities. But in the exhibition you don't see very clearly what the limits of a human representation can be.

In the color afghan works, I use pictorial conventions. Often I arrange them within the language of painting. I pattern them as figure/ground relationships. But that's just a framing device to look at the things. I use the pictorial convention to work against your tendency to personify the things. You can start to see them as pure color. The yarns were first shown with GARBAGE DRAWINGS. They are just yarns, they are linear,

black and white, so you are automatically prompted to see them graphically. But if you look at them in relation to other pieces, you don't see them graphically, you see them bodily. You see them as dolls taken apart. It's intestines, it's flesh. It's a linear depiction and the body at the same time. I wanted this contrast, this dual reading. FROM AN INTERVIEW WITH JEAN-FRANCOIS CHEVRIER, JULY 1991, *LIEUX COMMUNS, FIGURES SINGULIÉRES* (PARIS: ARC / MUSÉE D'ART MODERNE DE LA VILLE DE PARIS, 1992)

Niek Kemps

Born: Nijmegen, Holland 1952 / Lives and works in Amsterdam and Wenduine, Belgium

The Roman Forum in Rome
The Pyramids of Giza in Egypt
The Statehouse in Basel
The Casbah in Marrakesh
The Piazza San Marco in Venice
The Cathedral of Santiago de Compostela in Spain
The Golden Gate Bridge in San Francisco
The Palace Sans Souci in Potsdam
The Kremlin in Moscow

The Basilica in Assisi
The Juntha Muntha Observatory in Jaipur
The Piazza Dei Miracoli in Pisa
The Empire State Building in New York
The Casino Delville in France
The Candy Temple in Sri Lanka
The Château Azay-le Rideau in the Loire Valley
The Hoover Dam in Colorado
The Acropolis in Athens

The Palace of Versailles
The Pyramids of Teotihuacán
The Maharani's Palace in Udaipur
The Nara Temple in Japan
Edinburgh Castle
The Eiffel Tower in Paris
The Château Fontainebleau in France

Hampton Court in England
The Angkor Wat Temple Complex in Cambodia

1993

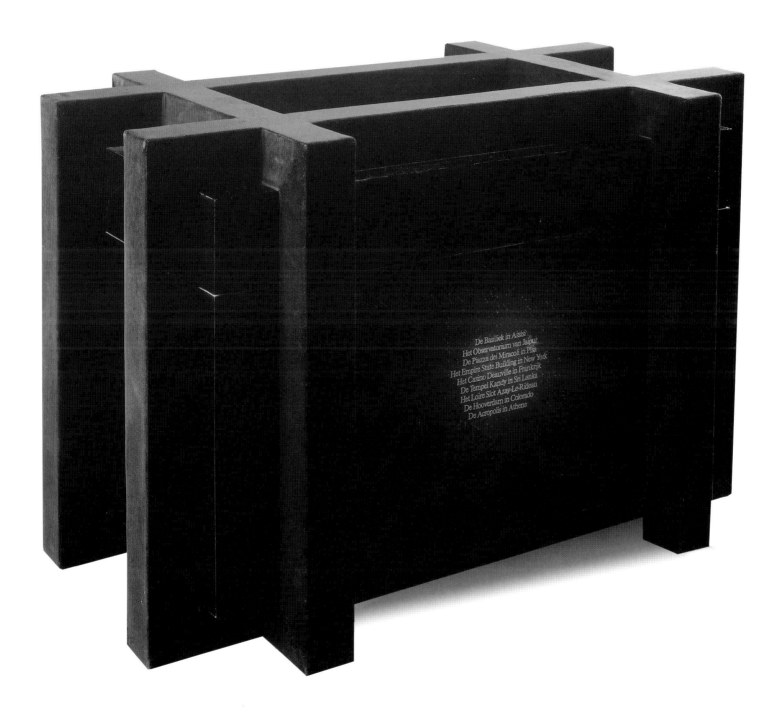

De Basiliek in Assisi
Het Observatorium van Jaipur
De Piazza dei Miracoli in Pisa
Het Empire State Building in New York
Het Casino Deauville in Frankrijk
De Tempel Kandy in Sri Lanka
Het Loire Slot Azay-Le-Rideau
De Hooverdam in Colorado
De Acropolis in Athene

Folie à Deux, 1984
wood, velvet, screen print
99 x 92 x 152 centimeters / 39 x 36 1/4 x 59 3/4 inches

Jon Kessler

Born: Yonkers, New York 1957 / Lives and works in New York City

The unfathomable workings of memory stand at the center of Jon Kessler's art. His constructions, no matter how sophisticated, do not constitute a vision of the future technology, except insofar as these ideas figure in our cultural memory and present landscape. After all, "the world is in our heads," and that includes the junkyard as much as the museum. Kessler alludes to both realms and many others, but in the process of his reference they are changed. I look, I recognize, but I cannot articulate what I remember, and the act of trying to unearth that lost image accounts for my enduring fascination. That may be the enchantment of Kessler's work.

When I look at one of his sculptures, I remember what I have never seen before.

FROM **SIRI HUSTVEDT**, "THE ART OF FASCINATION," *JON KESSLER* (SPAIN: AUTORIDAD PORTUARIA DE SANTANDER, 1994)

PHOTO: ROBERT KNOKE

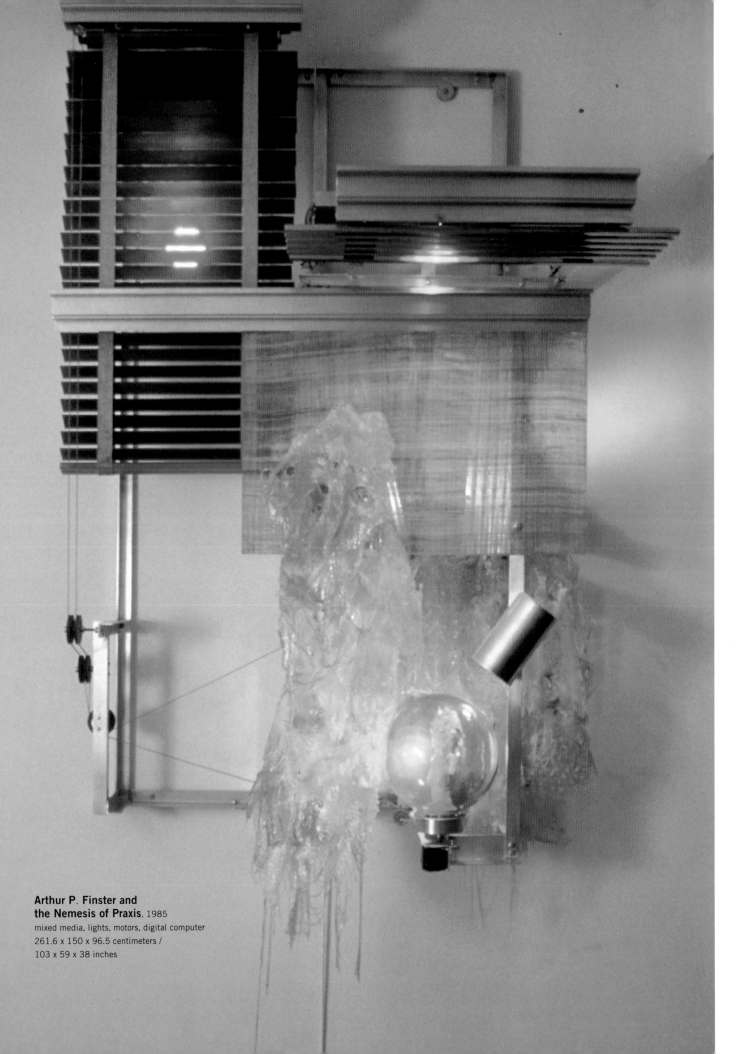

**Arthur P. Finster and
the Nemesis of Praxis**, 1985
mixed media, lights, motors, digital computer
261.6 x 150 x 96.5 centimeters /
103 x 59 x 38 inches

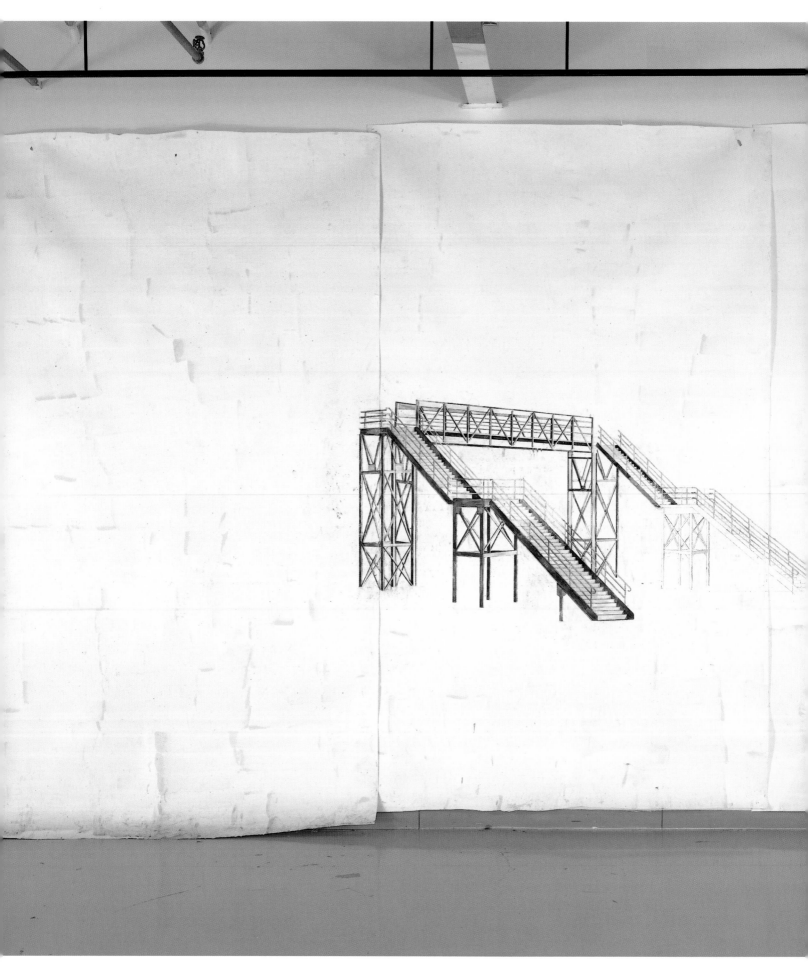

Toba Khedoori

Born: Sydney, Australia 1964 / Lives and works in Los Angeles

Untitled, 1994
oil and wax on paper
335.3 x 609.6 centimeters /
132 x 240 inches

Martin Kippenl

Born: Dortmund, Germany 1953

Lives and works in St. Georgen, Germany

**My Anti-amatos,
Dear Friends,**

**Rubber doesn't make me sadless. Less money makes
me no more collectors of sadness. The early air in
the container waits to be interpreted by your sin
ideas. Upstairs is always thin air. The air we just
talked about, even thin air, has the big possibility to
find a hole in the thick rubber. We good old media
cowboys of our time have to accept our hobby:
working on earth and not in time.**

**With best fresh wishes,
Yours,
Martin Kippenberger**

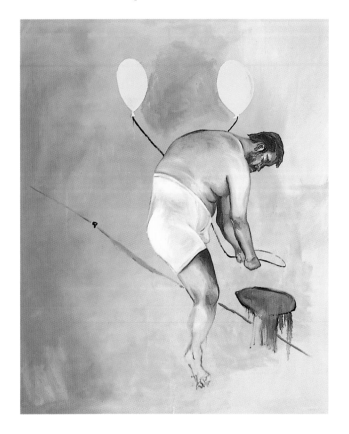

Memorial of the Good Old Time, 1987
mixed media and rubber
183 x 376 x 211 centimeters / 72 x 148 x 83 inches

left: **Untitled**, 1988
oil on canvas
241 x 202 centimeters / 95 x 79 1/2 inches

erger

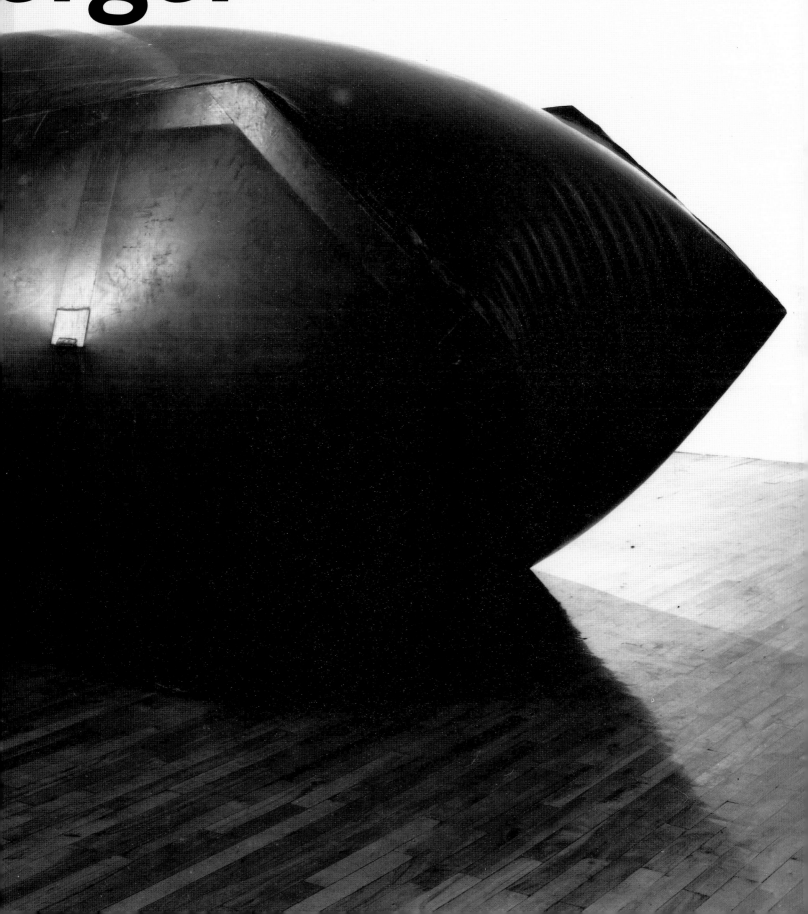

Jeff Koons

Born: York, Pennsylvania 1955 / Lives and works in New York City

Abstraction and luxury are the guard dogs of the upper class.

PHOTO: JOHN SALLER

My work has no aesthetic values, other than the aesthetics of communication.

Debasement is what gives the bourgeoisie freedom.

Over the years I have come to realize one thing through my work: that the objective and the subjective have nothing to do with the hand. Their meaning is found in morality.

FROM *THE JEFF KOONS HANDBOOK* (NEW YORK: RIZZOLI AND LONDON: ANTHONY D'OFFAY GALLERY, 1992)

If I've reached the bourgeois class, anybody can.

EQUILIBRIUM: **One Ball Total Equilibrium Tank**, 1985
glass, steel, sodium chloride reagent, distilled water, basketball
163.8 x 77.5 x 33.7 centimeters / 64 1/2 x 30 1/2 x 13 1/4 inches

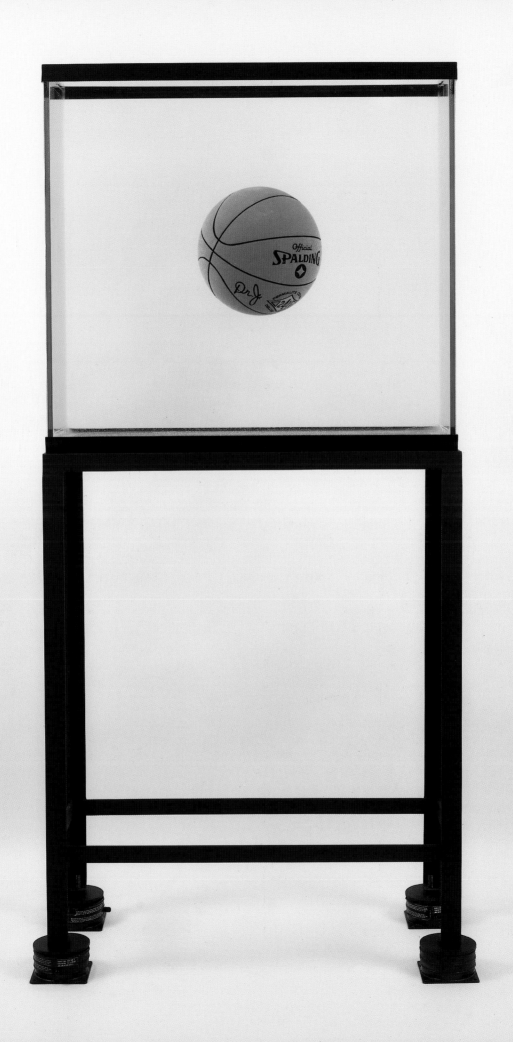

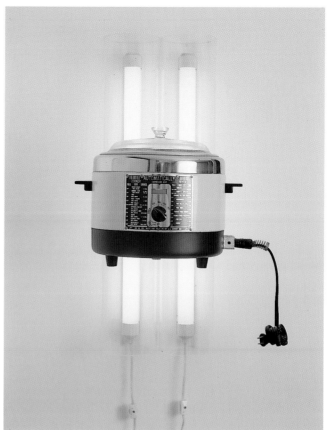

THE DYNASTY ON 34TH STREET.

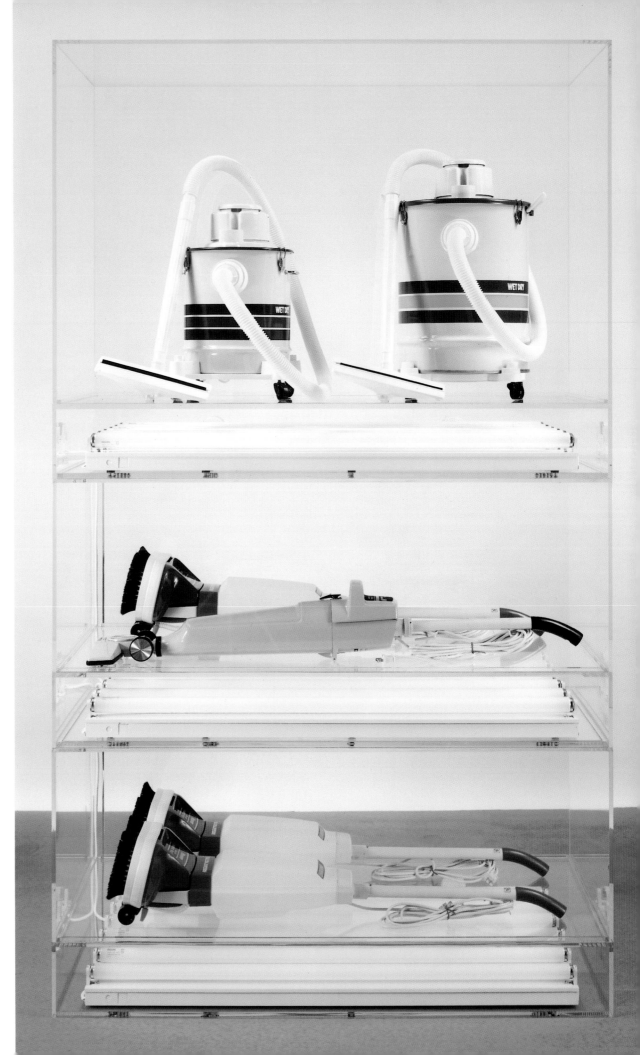

right:
THE NEW:
**New Hoover Deluxe
Shampoo-Polishers
New Hoover Quick-Broom,
New Shelton Wet/Dry
Triple Decker**, 1987
Plexiglas, fluorescent tubes,
appliances
231 x 137 x 71 centimeters /
91 x 54 x 28 inches

opposite page, top left:
INFLATABLES:
Inflatable Flowers, 1980
plastic flowers, Plexi mirror
61 x 81.3 x 30.5 centimeters /
24 x 32 x 12 inches

opposite page, top right:
THE PRE-NEW:
**New Nelson Automatic
Cooker/Deep Fryer**, 1979
Plexiglas, fluorescent
tubes, appliance, wire
69 x 37 x 41 centimeters /
27 1/4 x 14 1/2 x 16 inches

opposite page, bottom left:
EQUILIBRIUM: **Vest**, 1985
bronze
56 x 42 x 12.7 centimeters /
22 x 16 1/2 x 5 inches

opposite page, bottom right:
EQUILIBRIUM:
**Dynasty on 34th
Street**, 1985
framed poster
112 x 80 centimeters /
44 x 31 1/2 inches

above:

LUXURY AND DEGRADATION:

Jim Beam J.B. Turner Train, 1986

cast stainless-steel Jim Beam Bourbon

decanters with cast stainless-steel train

24.8 x 294.6 centimeters /

9 3/4 x 116 inches

opposite page:

LUXURY AND DEGRADATION:

The Empire State

of Scotch, 1986

oil inks on canvas

113 x 150 centimeters /

44 1/2 x 59 inches

BANALITY: **Ushering in Banality**, 1988
polychromed wood
96.5 x 157.5 x 76.2 centimeters / 38 x 62 x 30 inches

opposite page: STATUARY: **Louis XIV**, 1986
stainless steel
116.8 x 68.6 x 38 centimeters / 46 x 27 x 15 inches

BANALITY: **Michael Jackson and Bubbles**, 1988
porcelain
110 x 185.5 x 88 centimeters/
42 x 70 1/2 x 32 1/2 inches

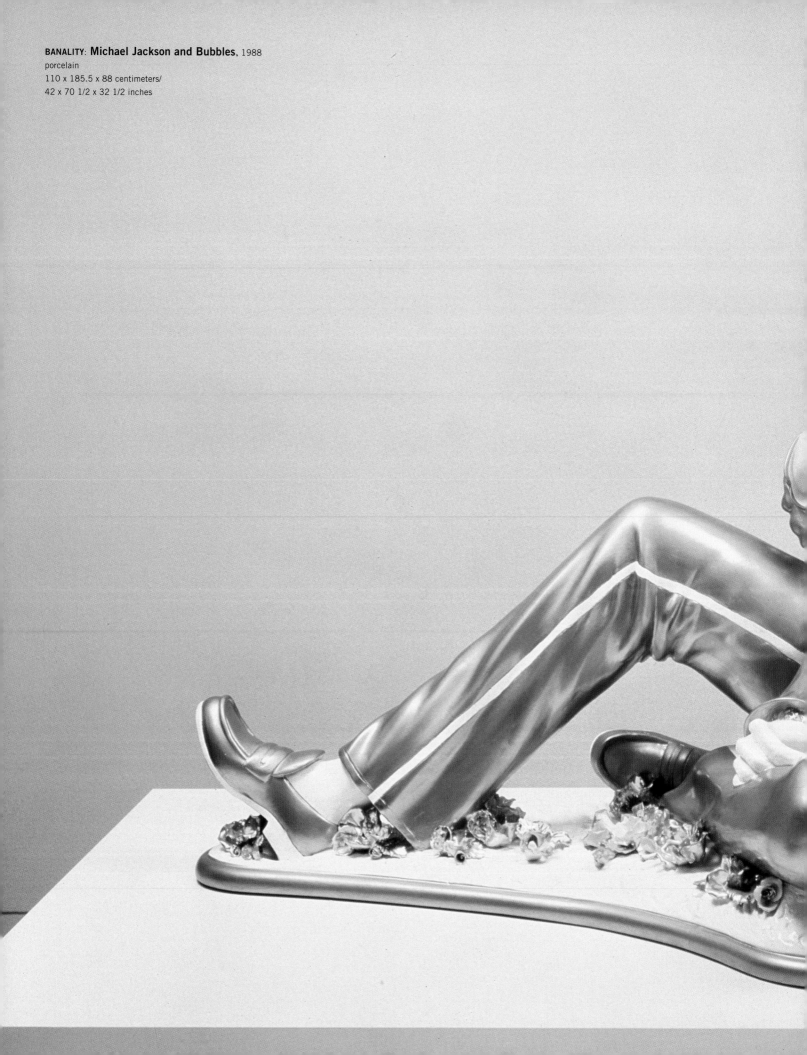

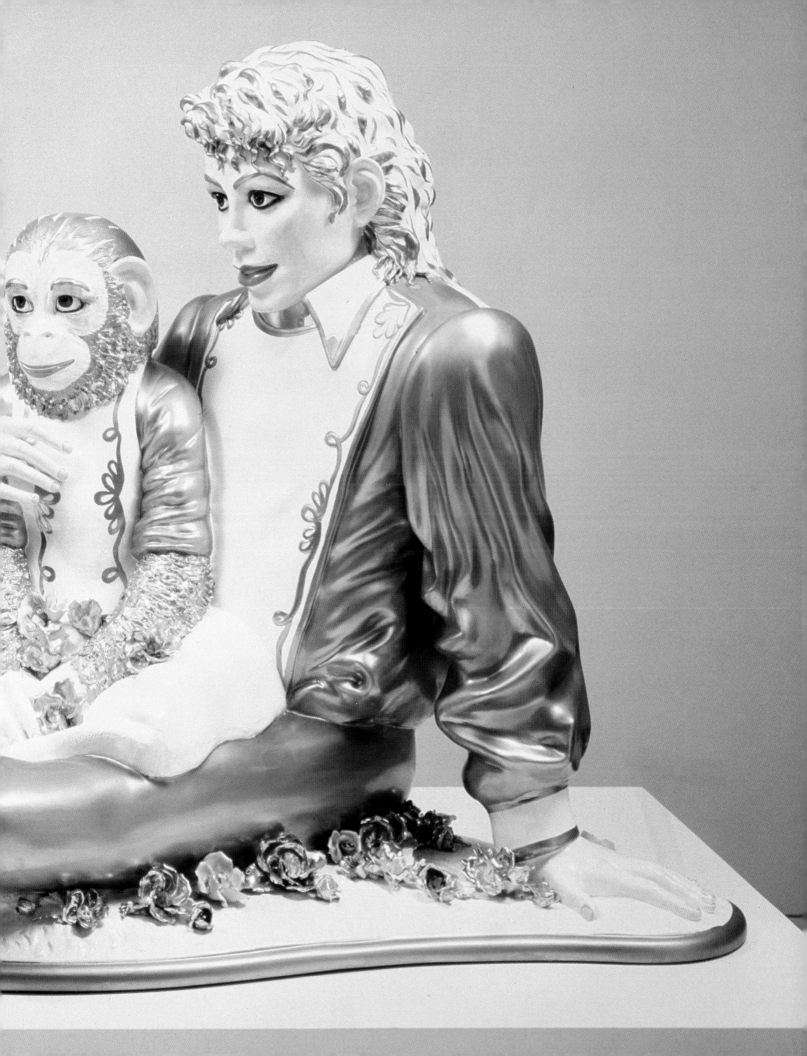

MADE IN HEAVEN:
Bourgeois Bust, Jeff and Ilona, 1991
marble 113 x 76 x 58 centimeters / 44 1/2 x 28 x 21 inches

opposite page: **MADE IN HEAVEN**: **Ponies**, 1991
silkscreen on canvas 232 x 153 centimeters / 91 1/2 x 60 inches

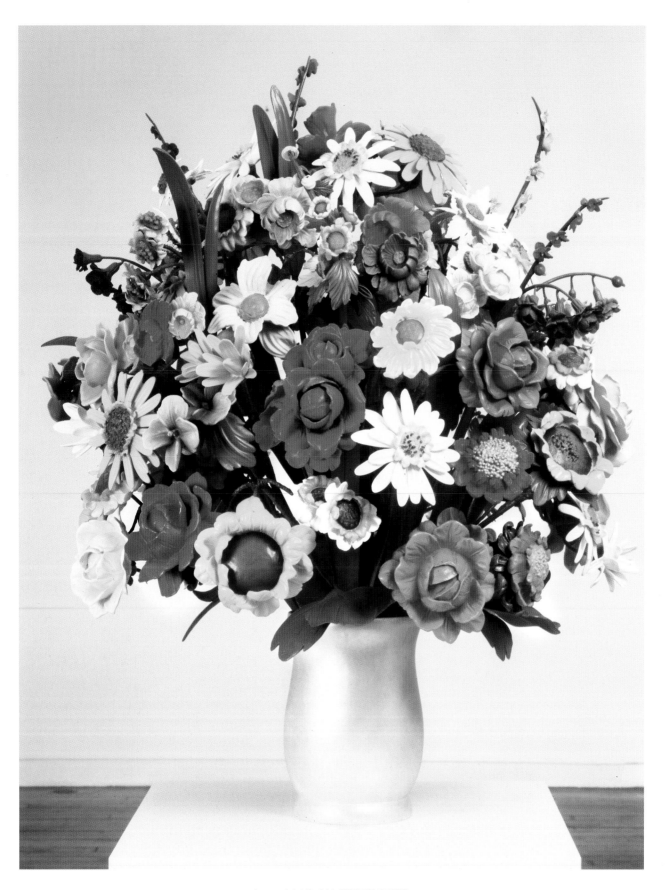

above and detail, right: **MADE IN HEAVEN**:
Large Vase of Flowers, 1992
polychromed wood
132 x 109 x 109 centimeters /52 x 43 x 43 inches

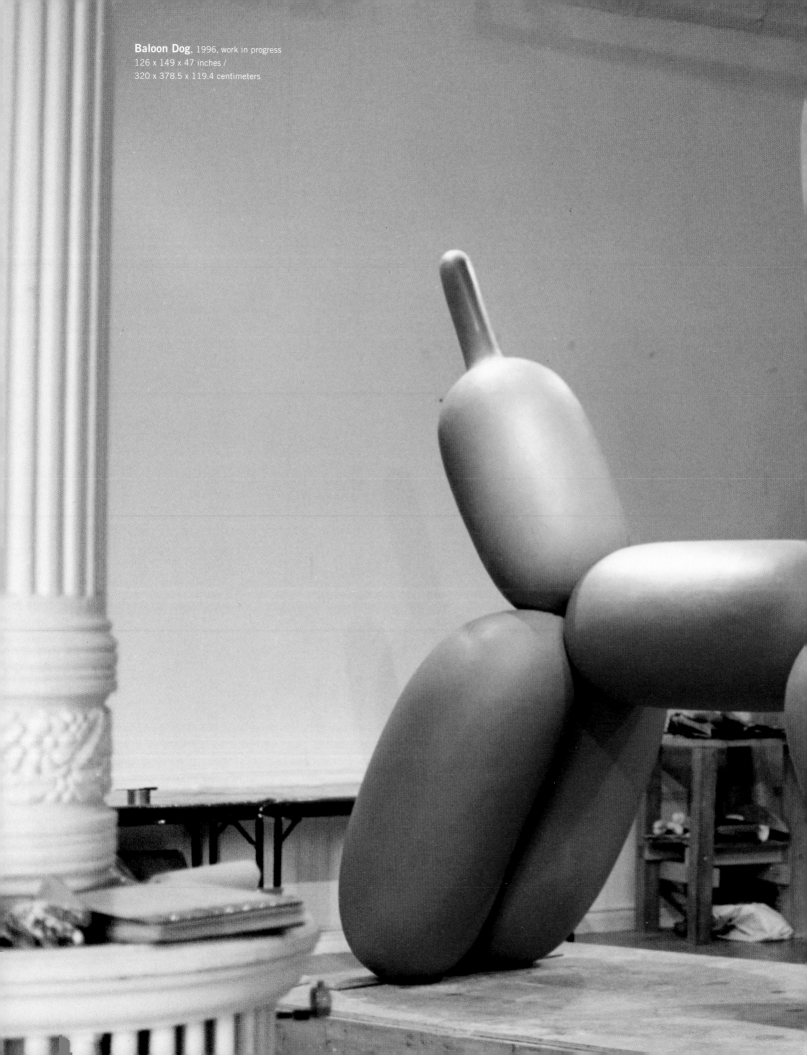

Baloon Dog, 1996, work in progress
126 x 149 x 47 inches /
320 x 378.5 x 119.4 centimeters

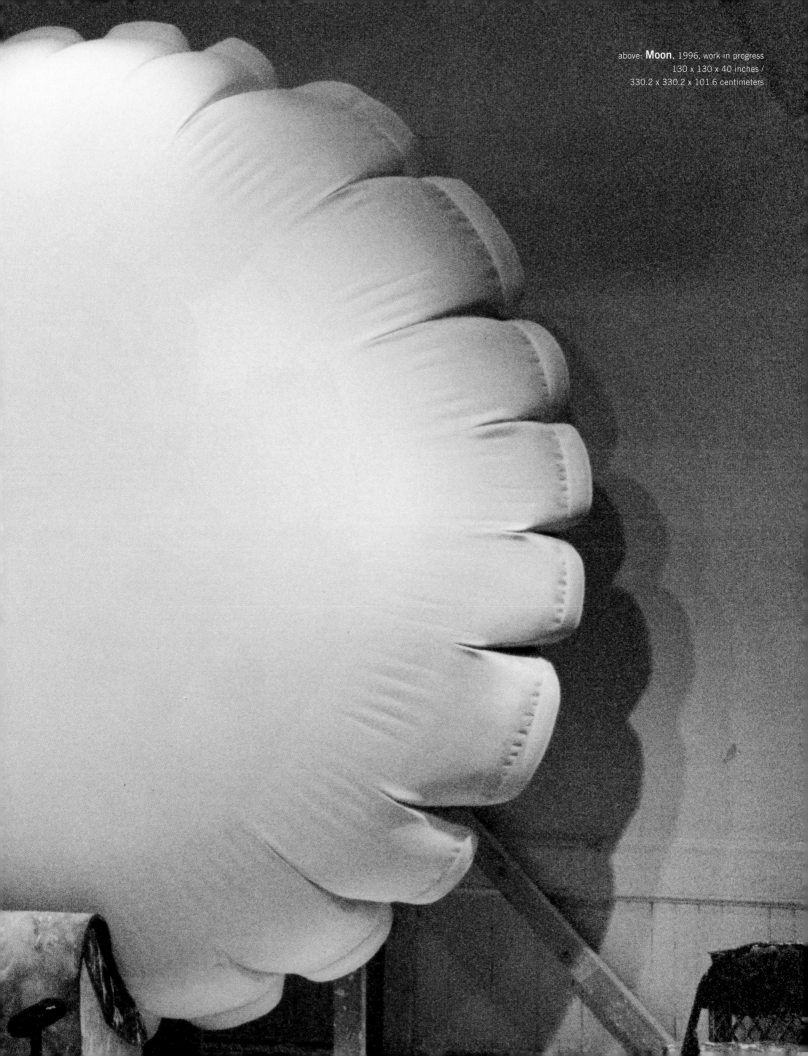

above: **Moon**, 1996, work in progress
130 x 130 x 40 inches /
330.2 x 330.2 x 101.6 centimeters

Joseph Kosuth

Born: Toledo, Ohio 1945 Lives and works in New York City and Ghent, Belgium

translat‖e [træns'leɪt] пе-
реводи́ть; ~ion [-'leɪʃn] пе-
ревóд; ~or перевóдчик.

translate, *v.t.* fasiri, tafsiri, geuza
lugha nyingine; (*transfer*) weka,
pengine, hamisha. **translation,** *n.*
kufasiri, fasiri, tafsiri &c. **trans-
lator,** *n.* mfasiri.

translate, v.t
(*con*)*vertĕre* (in gen.)
Quint.), *reddĕre* (=
pretari (= to interpr
num (*con*)*vertĕre, La*
exactly, *verbum e ve*
bum pro verbo reddĕ
scriptoris conversus o.
oratio conversa. t
-ētis, m. and f.

TO REMIND

Insofar as its public reception was concerned, Con-
ceptual Art was defined at birth in relation to formalism
and, by critics like Lucy Lippard, in the language of
Minimalism. The strategic reason (from my point of
view at the time) for emphasizing dematerialization and
anti-objectness was the immediate necessity to break
away from the formalist terms of the time, that is,
from an aestheticized art philosophically conceived
of in terms of shapes and colors employed for the
good of "superior taste." By removing the formalist de-
fined "experience," it seemed obvious (our heuristic
point went) that the condition of art would have to
be looked for elsewhere. In this regard, what we initi-
ated was a kind of readymade by negation. This re-
moval, or cancellation, was really a defetishizing of the
Duchampian Readymade in the form (both figurative-
ly and, in my case, literally) of a negative photograph
of our inherited horizon of artistic meaning, and the si-
multaneous act of its positive negation. . . .

. . . Though Minimalism created the context in which it
could emerge, Conceptual art, to be understood, must
be defined in terms of a difference. Post-Minimalism
took the formalist, and Modernist, concern with the lim-

its of materials and techniques, used Conceptual art's
strategic device of negating that concern, and institu-
tionalized this practice as a negative formalism. This
provided the Modernist agenda with a revitalized
"avant-garde" face without letting go of the premise that
the repository of central artistic concern was still in the
object, if only in its absence. In this regard, post-Min-
imalism's primary concern is with a radicalization of al-
ternative materials rather than alternative meanings. But
it is issues of meaning—the process of signification—
that define Conceptual art and have made it relevant to
recent art practice. The substantial import of such
work, it would seem to me, has been the radical reeval-
uation of how an artwork works, thereby telling us
something of how culture itself works: How meanings
can change even if materials don't.

With the subsequent "opacity" of the traditional lan-
guage of art (painting and sculpture) in the sixties, the
objects (paintings or sculptures) themselves began
to lose "believability" (the language was losing its
transparency). One was always in a position of being
"outside" the work and never "inside." With that be-
gan, through the sixties, an increased shift of locus
from the "unbelievable" object to what was believable
and real: the context. Objects or forms employed be-
came more articulations of context than simply and
dumbly objects of perception themselves.

FROM "(NOTES) ON AN ANTHROPOLOGIZED ART," 1974, IN "NO EXIT," *ARTFORUM* 26, NO. 7, MARCH 1988

below: **Translation**, 1966
mounted photograph
5 panels, each at 89 x 140 centimeters / 35 x 55 inches

bottom right: **The Square Root of Minus One**, 1988
Glass and silkscreen painting
2 panels: 178.3 x 154.6 x 1.2 centimeters / 71 x 61 x 1/2 inches
39 x 32 x 1 centimeters / 15 1/3 x 12 1/2 x 1/3 inches

other language,
(word for word
ccurately), *inter-*
to Latin, *in Lati-*
; — lit., *faithfully,*
-bo exprimēre, ver-
-lation, n. *liber*
s ; — of a speech,
r, n. *interpres,*

translation [tRans*lay*shn] *οὐσ.* μετάφρασις ‖ ἐξήγη-
σις ‖ μετάφρασις, μεταφρασθὲν ἔργον ‖ ἀπόδοσις
εἰς ξένην γλῶσσαν ‖ μετακίνησις, μετάθεσις ‖
(*μηχ.*) παράλληλος μετατόπισις.

translation. Unuhina. *Literal translation,* unuhi
kūlike loa, unuhi pili. *Free translation,* unuhi
laulā loa.

PHOTO: ARI MARCOPOULOS

Jannis Kounellis

Born: Piraeus, Greece 1936 / Lives and works in Rome

I am against the world of Andy Warhol and of the epigones of today. I want to restore the climate experienced by the Cubists.

I am against the condition of paralyzation to which the postwar has reduced us; by contrast, I search among fragments (emotional and formal) for the scatterings of history.

I search dramatically for unity, although it is unattainable, although it is Utopian, although it is impossible and, for all these reasons, dramatic.

I am against the aesthetics of catastrophe; I am in favor of happiness; I search for the world of which our vigorous and arrogant 19th-century forebears left us examples of revolutionary form and content.

I am an admirer of Pollock, for his dramatic and impassioned search for identity. I am an expert traveler, I know all the tortuous routes of my land of Europe, the mountain paths and the big cities with their passionate stories and gossip. I like the pyramids of Egypt, I like Caravaggio, I like van Gogh, I like the Parthenon, I like Rembrandt, I like Kandinsky, I like Klimt, I like Goya, I like the impetus of the Winged Victory of Samothrace, I like medieval churches, I like the character of Ophelia as Shakespeare describes her and I honor the dead, thinking of myself that I am a modern artist. FROM *VARDAR* (MADRID),

FEBRUARY 1982, REPRINTED IN GLORIA MOURE, *KOUNELLIS* (BARCELONA: EDICIONES POLIGRAFA, S.A., 1990)

PHOTO: CLAUDIO ABATE

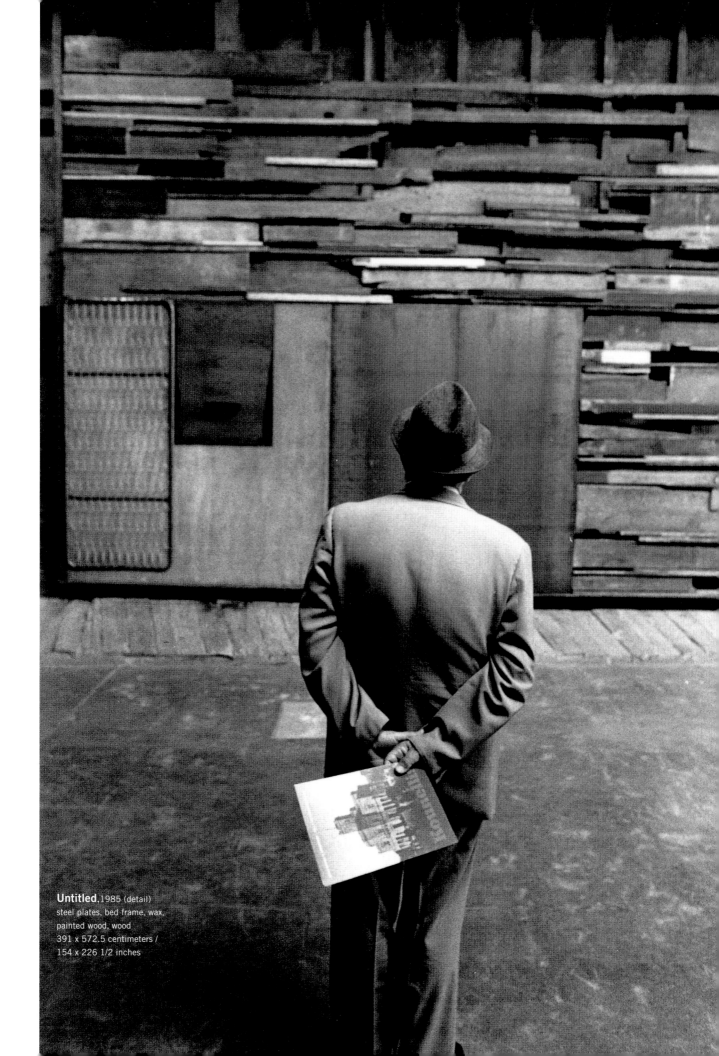

Untitled, 1985 (detail)
steel plates, bed frame, wax,
painted wood, wood
391 x 572.5 centimeters /
154 x 226 1/2 inches

Barbara

Born: Newark, New Jersey 1945 / Lives and works in New York City

Kruger

Not Nothing. You are walking down the street but nothing is familiar. You are a child who swallowed her parents too soon; a brat, a blank subject. You are the violence of mourning objects which you no longer want. You are the end of desire. You would not be this nothing if it wasn't for courtliness. In other words, religion, morality and ideology are the purification and repression of your nothing. In other words, romance is a memory of nothing which won't take no for an answer and fills the hole with a something called metaphor, which is what writers use so they won't be frightened to death: to nothing. You ransack authority by stealing the work of others, but you are a sloppy copyist because fidelity would make you less of a nothing. You say you are an unbeloved infidel. When you are the most nothing you say, "I want you inside of me." And when you are even more nothing you say, "Hit me harder so I won't feel it." As a kind of formal exercise, you become a murderer without a corpse, a lover without an object, a corpse without a murderer. Your quick-change artistry is a crafty dance of guises: cover-ups for that which you know best: nothing. And all the books, sex, movies, charm bracelets, and dope in the world can't cover up this nothing. And you know this very well since you are a librarian, a whore, a director, a jeweler, and a dealer. Who's selling what to whom? Supply and demand mean nothing. People talk and you don't listen. Explicits are unimportant, as they lessen the weight of meaninglessness to the lascivious reductions of gossip. You prefer to engage the in-between, the composite which skews the notion of a constituted majority, questioning it as a vehicle for even that most exalted of daddy voices, the theorist. He hesitantly places his hand on your belly as if he were confronting the gelatinously unpleasant threat of a jellyfish and decrees you a kind of molecular hodgepodge, a desire-breaching minority. You turn to him slowly and say "Goo-goo." He swoons at the absence-like presence of what he calls your naive practices: "The banality of the everyday, the apoliticalness of sexuality, your insignificantly petty wiles, your petty perversions." You are his "asocial universe which refuses to enter into the dialectic of representation" and contradicts utter nothingness and death with only the neutrality of a respirator or a rhythm machine. Goo-goo. But you are not really nothing: more like something not recognized as a thing, which, like the culture that produced it, is an accumulation of death in life. A veritable map and vessel of deterioration which fills your writing like a warm hand slipping into a mitten on a crisp autumn day. And like the exile who asks not "Who am I?" but "Where am I?," the motor of your continuance is exclusion: from desire, from the sound of your own voice, and from the contractual agreements foisted upon you by the law. Order in the court, the monkey wants to speak. He talks so sweet and strong, I have to take a nap. Goo-goo. **BARBARA KRUGER**, "NOT NOTHING," *REMOTE CONTROL: POWER, CULTURES, AND THE WORLD OF APPEARANCES* (CAMBRIDGE: MIT PRESS, 1993)

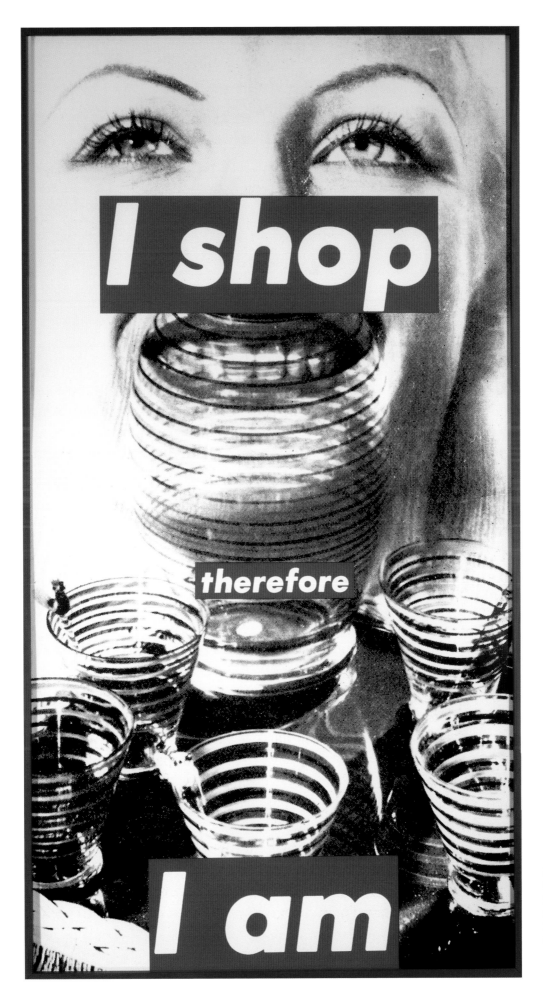

**Untitled
(I Shop Therefore
I Am)**, 1987
color photograph
231 X 125 centimeters /
91 x 49 1/4 inches

George Lappas

Born: Cairo, 1950 Lives and works in Athens

> Art is madness without sickness. 1992

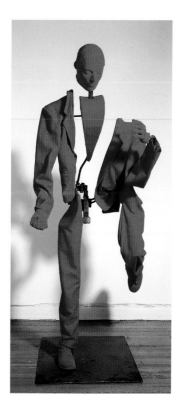

opposite page: **New Members for the Burghers of Calais**, 1992–93
(front and side views of Figure C)
iron, plaster, polyurethane, red cloth
dimensions unfolded: 220 x 300 x 300 centimeters /
86 x 117 x 117 inches
folded: 190 x 100 x 100 centimeters /
74 x 39 x 39 inches

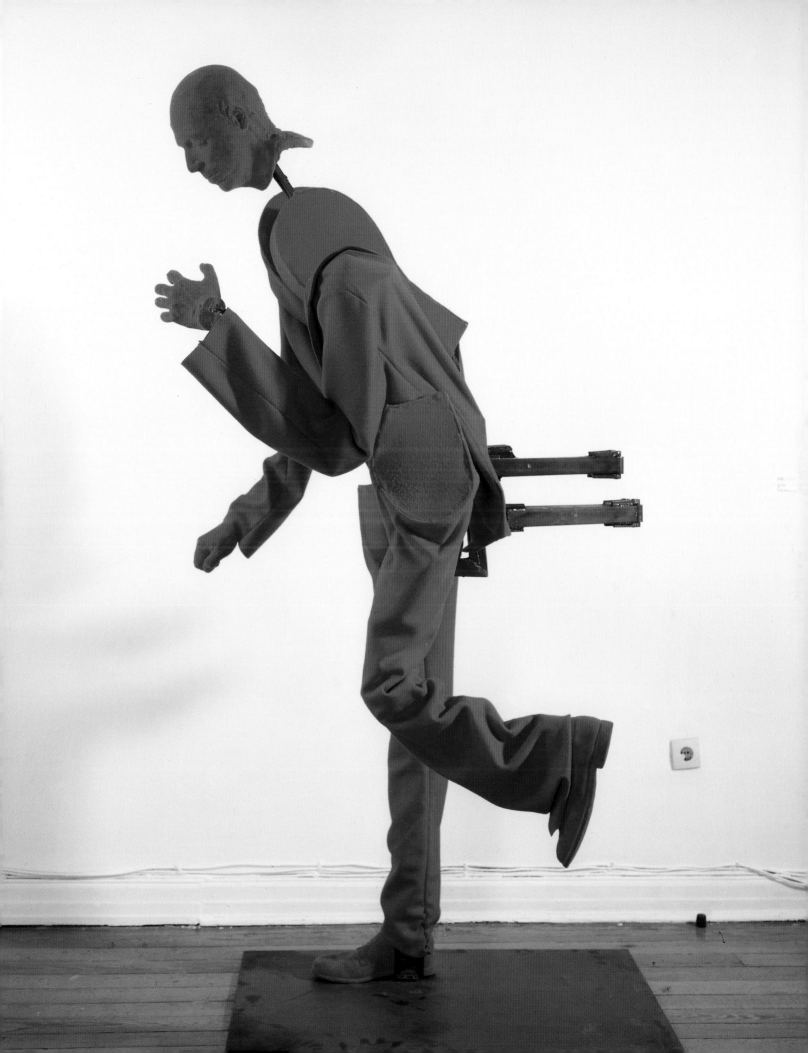

Liz Larner

Born: Sacramento, California / Lives and works in Los Angeles

LASH MAT is something of a triple homage to Meret Oppenheim, Bridget Riley, and Louise Nevelson. 1994

CATHERINE LIU: *I was thinking about how the real is the surface, and your surfaces are harsh but they are also very fragile . . . but with a hard edge.*

LIZ LARNER: Surfaces are created by the structure underneath them. Even though bones and skin are made of the same basic stuff, their textures are different and they are interdependent in producing the surface. I'm interested in this idea in sculpture because that kind of surface is contracted or expanded by moving around or within the space near or inside the sculpture.

CL: *You were saying how people have an easier time with images . . .*

LL: It is easier. With the media too. It's much easier just to use your eyes. Looking and moving through something to experience it are two different things. Even though you can change your range on a painting or a TV screen—you can move up quite close and look at a detail—you are really just looking at the surface. I think sculpture is more about expanding where a surface begins or stops or changes.

CL: *You made an interesting differentiation between looking and experiencing.*

LL: I think there is a difference. It's becoming more and more different all the time.

FROM **CATHERINE LIU**, "LIZ LARNER: EMBODIED TENSION," *FLASH ART*, JANUARY / FEBRUARY 1991

JIM SHAW, *CHARCOAL DRAWINGS* (DETAIL), 1990

Lash Mat, 1989
human hair eyelashes, leather
311 x 29 centimeters /
122 1/2 x 11 3/8 inches

Annette Lemieux

Born: Norfolk, Virginia 1957 / Lives and works in Brookline, Massachusetts

Annette Lemieux is a Unitarian in her struggle to blur the boundaries between the Trinitarian visual formats utilized by modern and contemporary artists: painting, sculpture, and photography. She is a Cagean permutationist dedicated to the variation of the order of a set of things; she has thus united her diverse media to fashion a cinematic-like continuum of images, scenes and events which combine an aggressive sense of agit-pop (text overlays), filmic memory (her photographic recall), a suspended notion of animation (the Dada-like objects), a gravity or seriousness (her photo inventories; the use of black), a symbolic portrayal of literature (the recycling of actual books as sculpture, representing the forgotten, the unknown, and the forgotten unknown) and an antique stage decor (a constant use of found objects, period furniture, old photographs). FROM **DIEGO CORTEZ**, "ANNETTE LEMIEUX—UNITARIANIST," *THE SEVEN ARTISTS '89: INFAS* (TOKYO: THE HANAE MORI CORPORATION, 1989)

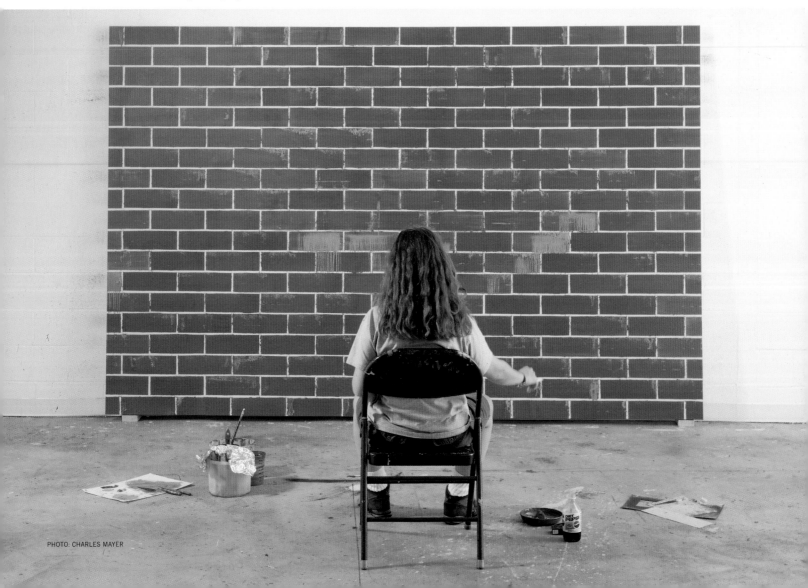

PHOTO: CHARLES MAYER

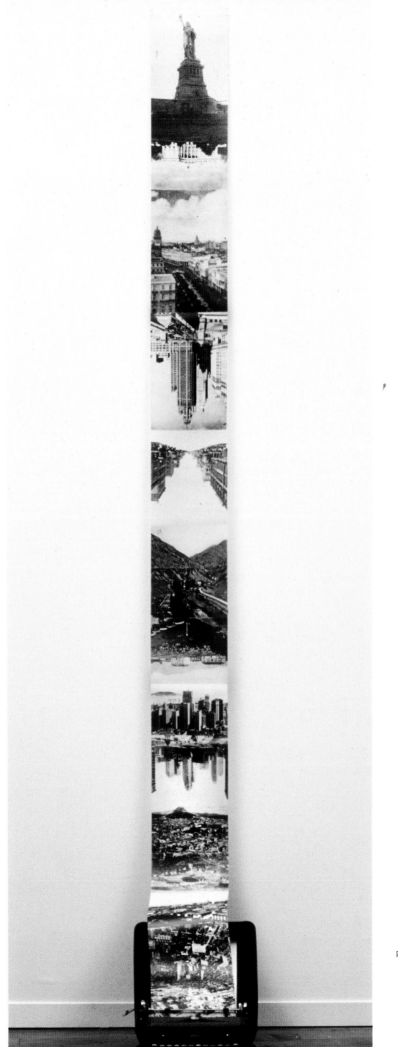

The Ascension, 1986
typewriter and photostat, black-and-white
photoscroll
with case: 15 x 33 x 30.5 centimeters /
6 x 13 x 12 inches
photoscroll: 182.9 centimeters / 72 inches

Nomad, 1988
ink on canvas
284.5 x 393.7 centimeters /
112 x 155 inches

above: **See No Evil, Seeing Evil**, 1987
black and white photograph, 2 parts
116 x 143 centimeters / 45 1/4 x 55 3/4 inches framed

Presidential Pleasures, 1986
oil on canvas, oil on glass with wood frame
canvas: 228.6 x 228.6 centimeters / 90 x 90 inches
frame: 73.7 x 43.2 centimeters / 29 x 17 inches

Sherrie Levine

Born: Hazelton, Pennsylvania 1947 / Lives and works in New York City

One of my main interests as an artist is to describe my relationship to what I perceive as the real world. In all my work I'm trying to find out how I describe my sense of authenticity and identity in relationship to that world. One of my main strategies has been to put one image on top of another, hopefully creating an interesting gap be-tween the original and the new one. This allegorical procedure seems to me a good method to produce a paradigm of historical move-ment, a sort of history of influence.

1992

opposite page:
Untitled (Lead Knots: One), 1987
metallic paint and wood
133.4 x 108 centimeters /
52 1/2 x 42 1/2 inches

Simon Linke

Born: Benalla, Australia 1958 / Lives and works in London

. . . The laboriousness of the paintings' construction stands in stark contrast to their striking graphic presence; courtesy of the applied minimalism of *Artforum* advertisements, which rely on an instantaneous visual punch and the almost subliminal power of design and typography. As has been remarked, the pantheon of established galleries opt for an instantly recognizable, "classic" typeface, stressing the solidity and commercial reliability of their reputations; while the less prominent—Vox Populi, the only gallery that matters—only just beginning to be remembered, are tempted by designer logos and layout. Serial production, hinted at in earlier runs of a single issue of *Artforum* advertisement pages, touched on audience expectation of continuing commitment and the archival nature of the work. The topical becomes the historical when galleries and artists featured in paintings only two years old no longer play an active part in the discourse.

Beyond the level of formal difference, which in the end comes down to advertisements themselves, it is difficult to talk of Linke's work in terms of individual images. It derives its strength through multiplication, and while possessing enough of the extraneous characteristics of painting to mimic, it subverts the status of the painted image: simulating its conventions yet relieving those elements of their functions. The meaning of the work resides outside, in the wings as it were, where the powerful peripheral factors that formulate a reading come into play. Forcing the reading of advertising as an iconised painted image exposes the way that the promotion of art shapes the context in which that art is perceived; as our own notions of self are created through advertising, expectation and fantasy. Manipulating assumptions and suppositions behind both history and painting, Linke's work takes its meaning from the context formulated to construct it; playing off the specifics of names, dates and places against the more complex conceptual issues that underpin them, and making the spectator create sense of the work by bringing those outside elements to bear. FROM **JAMES ROBERTS**, "ARTICULATING MEANING," *SIMON LINKE* (NAGOYA: KOHJI OGURA GALLERY, AND LONDON: LISSON GALLERY,1989)

PHOTO: JOHN RIDDY

opposite: **Artforum,** 1985 oil on canvas 15 panels, each: 61 x 61 centimeters / 24 x 24 inches

ROBIN WINTERS

SEPTEMBER 27 – OCTOBER 26

JEFFREY HOFFELD & COMPANY
1020 MADISON AVENUE NEW YORK 10021 (212) 734-5505

IN COOPERATION WITH
MICHAEL KLEIN, INC
611 BROADWAY, ROOM 430 NEW YORK 10012 (212) 505-1660

| AYCOCK | BUREN | KENDRICK |
| BIEDERMAN | HAACKE | LEWITT |

OCTOBER 5-26

JOHN WEBER GALLERY
142 GREENE STREET NEW YORK

James Surls
New Work
October 11 – November 9, 1985

L.A. LOUVER/Market Street
77 Market Street
55 North Venice Boulevard, Venice CA 90291 213/822-4955

GIULIO PAOLINI
OCTOBER 4 – NOVEMBER 2

MARIAN GOODMAN GALLERY
24 WEST 57TH STREET NEW YORK NY 10019 (212) 977-7160

FRED BRATHWAITE
NEW PAINTINGS
OCTOBER 3 TO NOVEMBER 2

FRED BRATHWAITE IS EXCLUSIVELY REPRESENTED BY
Holly Solomon Gallery
724 FIFTH AVENUE NEW YORK 10019 (212) 757-7777

BARBARAGLADSTONEGALLERY

GERHARD MERZ
"AUS DEN ALPEN" OCTOBER 5-26
152 WOOSTER ST. N.Y. N.Y. 10012 212-505-8610

OCT 10 ■ NOV 4
NOV 7 ■ DEC 1
SANTINO

BEN BAJOREK
September 21-October 20
Massimo Audiello Gallery 436 East 11th Street 212.475.4241

KEITH SONNIER
28 September-19 October
LEO CASTELLI
142 Greene Street, New York

GALERIE MICHAEL WERNER

BASELITZ
BYARS
IMMENDORFF
KIRKEBY
LÜPERTZ
A.R. PENCK
D – 5000 KÖLN – 1
GERTRUDENSTR. 24/28 T.210661

JOHANNES GECELLI
New Works
October 25-November 19

Galerie Reinhard Onnasch
Fasanenstr. 47 · D-1000 Berlin 15 · T. 030/882.7718

TONY SMITH
19 Oct. 16 Nov. 1985 PAULA COOPER 155 Wooster New York

MATT MULLICAN
SEPTEMBER 28-OCTOBER 26
MARTIN KIPPENBERGER
NOVEMBER 2-NOVEMBER 30
DOUGLAS HUEBLER
DECEMBER 7-JANUARY 11

RICHARD KUHLENSCHMIDT GALLERY

issey miyake
new design studio

LES TEXTILES DE L'INDE
MUSÉE DES ARTS DÉCORATIFS
107-109, RUE DE RIVOLI 75001-PARIS

OCTOBER 10, 1985–JANUARY 5, 1986.

SAN FRANCISCO

ALLPORT 126 POST STREET 398-2787 **MASAMI TERAOKA: WATERCOLORS & PRINTS** 10/15-11/15

ALLRICH 251 POST STREET 398-8896 **DAN SNYDER** 10/12 GROUP EXHIBITION 10/17-11/16

PAULE ANGLIM 14 GEARY 433-2710 **CHARLES GARABEDIAN/TERRY ALLEN** 10/2-11/2

BLUXOME 173 BLUXOME STREET 546-0449 **ANN HONIG-NADEL** 9/10-10/17 MADE IN CALIFORNIA 10/22-11/30

FRAENKEL 55 GRANT AVENUE 981-2661 **RICHARD MISRACH** 10/19 JOHN GUTMANN: VINTAGE PHOTOS 10/22-11/30

GREGORY GHENT 500 SUTTER STREET 956-0626 **PRE-COLUMBIAN ART FROM MESO AMERICA** 10/4-10/31

HARCOURTS CONTEMPORARY 550 POWELL 421-5580 **ANN OSENGA** 10/4-10/26 JACQUES KAPLAN 10/4-10/26

SHIVA 300 BRANNAN 543-2787 **JORGE SALAZAR: PAINTINGS** 10/17-11/16

MODERNISM 236 8TH STREET 552-2280 **HANNAH HÖCH: RUSSIAN AVANT GARDE 1910-1930** OCT

NOBLETT 139 E NAPA ST. SONOMA (707)996-2416 **ROBERT INDERMAUR** 9/21 10/27

SMITH ANDERSEN 200 HOMER AVE. PALO ALTO 327-7762 **SAM FRANCIS: RECENT WORK** 9/21-11/9

LEWIS BALTZ
RECENT WORK / OCTOBER 19 THROUGH NOVEMBER 9
CASTELLI GRAPHICS
4 EAST 77 STREET NEW YORK N.Y. 10021 212/288-3202

DONALD YOUNG GALLERY
212 WEST SUPERIOR STREET · CHICAGO ILLINOIS 60610 312-664-2151

MARTIN PURYEAR

Adam Cvijanovic
October 1 - October 26
Stavaridis Gallery
73 Newbury Street, Boston, MA 02116 • (617) 353-1681 • Tues.-Sat. 10:00-5:30

STEVE MILLER

BETTE STOLER GALLERY

THE KNOT
ARTE POVERA AT P.S. 1

Curator: Germano Celant

October 6–December 15, 1985
Opening October 6, 2-6 PM

Giovanni Anselmo
Alighiero Boetti
Pier Paolo Calzolari
Luciano Fabro
Jannis Kounellis
Mario Merz
Marisa Merz
Giulio Paolini
Pino Pascali
Giuseppe Penone
Michelangelo Pistoletto
Gilberto Zorio

Robert S. Zakanitch
October 1–October 26, 1985

ROBERT MILLER
724 FIFTH AVENUE, NEW YORK
212 · 246 · 1625
Color catalogue: $10 postpaid.

MARGO LEAVIN GALLERY

ROBERTSON GALLERY

AGNES MARTIN
RECENT PAINTINGS
15 OCTOBER–16 NOVEMBER

HILLDALE GALLERY

TONY SMITH
SCULPTURE & PAINTING
26 OCTOBER–30 NOVEMBER

PAINTINGS

LUCAS SAMARAS

THE PACE GALLERY
32 E 57 NYC 10022

LONDON

Benjamin Rhodes Gallery Oct. 9-Nov. 2 / Zadok Ben-David
4 New Burlington Place
London W1 X0SB
01-434-1768/9

Anne Berthoud Gallery Oct. 3-Nov. 3 Simon Lewty
10 Clifford Street
London W1 X1RB
01-437-1045/6

Brompton Gallery Sept. 26-Oct. 26 Miguel Morisane:
Brompton Arcade Paintings
Knightsbridge
London SW3 01-661-1078

Anthony d'Offay Gallery Oct. 6-mid Nov. Joseph Beuys
9 & 23 Dering Street
London W1
01-499-4100

Gimpel Fils Sept. 17-Oct. 19 Alan Davie: Meditations
30 Davies Street & Hallucinations
London W1 Oct. 22-Nov. 16 Susan Fuller: "Love,
01-493-2488 Death & Language"

Nigel Greenwood, to Oct. 19 Marc Chaimowicz:
Inc. Ltd. Recent Ptgs. & Artwork
from Café de Wok
London W1 01-730-8824 Oct. 22-Nov. 16 Terry Setch: New Work

Institute of until Oct. 20 Difference: Sexuality &
Contemporary Arts Representation
12 Carlton House Ter. Mikey Cuddihy,
London SW1 01-930-0493 Oct. 11-Nov. 10 Stephen McKenna

Nicola Jacobs Gallery Oct. 2-26 Adrian Wisniewski:
9 Cork Street Paintings & Drawings
London W1
01-437-3868

Leinster Fine Art Gallery Artists Include:
9 Hereford Road Leonard Baskin, Barbara
London W2 Rae, Richard Ziegler
01-229-5985

Nicholas Logsdail Oct. 9-Nov. 9 Alan McCollum:
Lisson Gallery "Surrogates"
66-68 Bell Street
London NW1 01-262-1539

Mayor Gallery Sept. 18-Oct. 26 Robert Kushner: Recent
22a Cork Street Works
London W1 from Oct. 29 Richard Stankiewicz:
01-734-3558 Sculpture

Anthony Reynolds Gallery Oct. 1-3 Gerald Newman
37 Cowper Street / Oct. 11-Nov. 10 Amikam Toren
London EC2
01-608-1516

Riverside Studios until Oct. 6 Jelolová, Boyce, Skelton,
Crisp Road, Hammersmith Whitehead, Ingham
London W6 9RL Oct. 18-Nov. 17 Banerji, Sevilla, & Skelton
01-741-2251 G. Johnson: C.Q.B.R.

Edward Totah Gallery Oct. 9-Nov. 2 Stephen McKenna:
13 Old Burlington Street Paintings
London W1 Illus. catalogue
01-734-0343 available

Man Ray

Born: Philadelphia 1890 / Died: Paris, France 1976

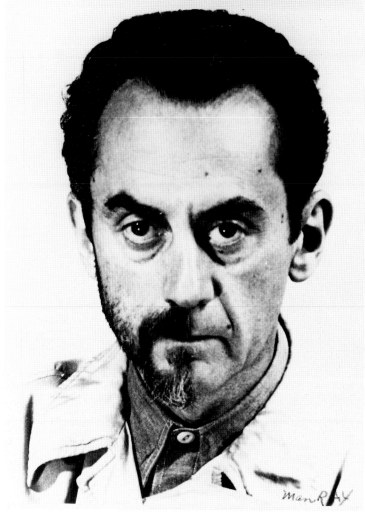

SELF-PORTRAIT WITH HALF-BEARD, 1943 ADAGP/ARS, 1995 ©MAN RAY TRUST

In THE ENIGMA OF ISIDORE DUCASSE (1920) Man Ray pays homage to Lautréamont (Isidore Ducasse) by creating an object inspired by the latter's famous image: 'beautiful as the chance meeting of a sewing-machine and an umbrella on a dissecting table.' Man Ray wrapped a sewing-machine in an army blanket and tied it up to produce a vaguely anthropomorphic shape. This work anticipates Christo's wrapping of objects by almost a half century. Man Ray told me, 'Christo is transparent, I am not, I am mysterious,' and he added, 'I was interested in Lautréamont because a new world was revealed to me, the world I was looking for, a world of complete freedom. Lautréamont gave me the stimulus to do things I was not supposed to do. The world is full of people who do good, but what we really need is people who do no harm.' He had said earlier: 'When I read Lautréamont I was

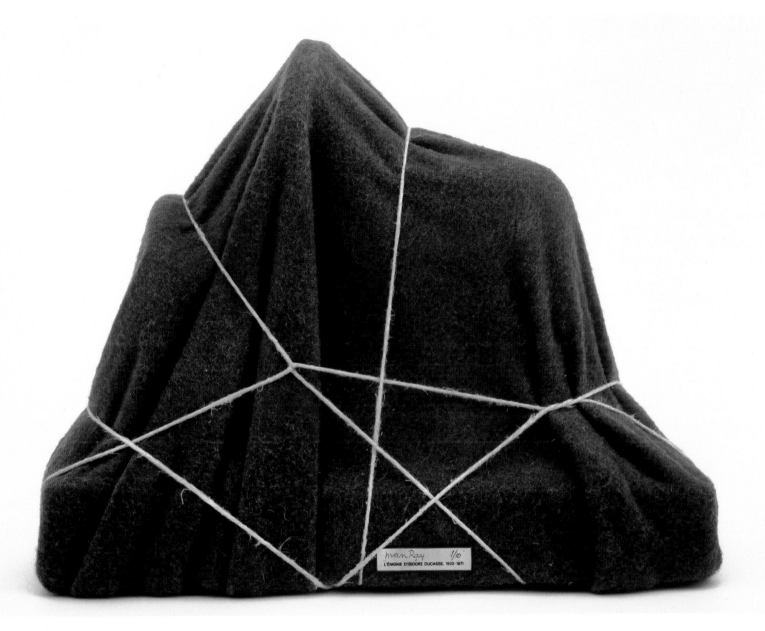

L'Enigme d'Isidore Ducasse (**The Enigma of Isidore Ducasse**), 1988 sewing machine, felt, and string

fascinated by the juxtaposition of unusual objects and words."

Appropriately, the Surrealists chose to reproduce THE ENIGMA OF ISIDORE DUCASSE on the first page of the first issue of their first periodical, *La Révolution Surréaliste* (December 1924). In the editorial of this issue, signed by J.-A. Boiffard, Paul Eluard and Roger Vitrac, a lapidary statement defined the Surrealist object: 'Any discovery changing the nature, or the destination of an object or a phenomenon constitutes a Surrealist achievment. Already the automats are multiplying and dreaming. . . . Realism prunes trees, Surrealism prunes life.'

Dali recalled the deep impression the ENIGMA made on the Surrealists in this very early stage of their history: 'The semi-darkness of the first phase of surrealist experiment would disclose some headless dummies and a shape wrapped up and tied with string, the latter, being unidentifiable, having seemed very disturbing in one of Man Ray's photographs (already then this suggested other wrapped-up objects which one wanted to identify by touch but finally found could not be identified; their invention, however, came later).'

The impression of this work on Man Ray himself was just as deep, since 32 years later the ENIGMA reappears in his painting LA RUE FÉROU (1952) where it is seen on a cart heading for his new Paris studio. **FROM ARTURO SCHWARZ,** *MAN RAY: THE RIGOUR OF IMAGINATION* (LONDON: THAMES AND HUDSON, 1977)

Piero Manzoni

Born: Soncino, Italy 1933 / Died: Milan 1963

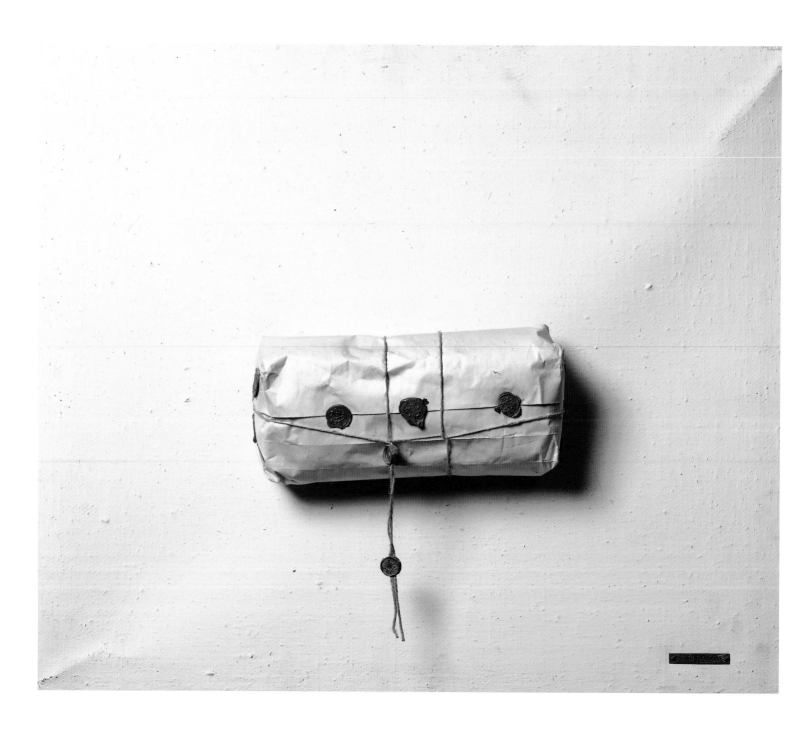

Achrome, 1961
packaging, wrapping paper, wax, string
55 x 65 centimeters / 21 1/2 x 25 1/3 inches

There is a certain mental cowardice common among artists, or at least among bad artists, which leads them to invoke a misunderstood freedom of art or some other gross commonplace instead of taking a stand. Having a very vague idea of art, they tend to confuse art with vagueness itself.

It is therefore necessary to clarify what is meant by art in order to set guidelines for our actions and judgements. The work of art originates in an unconscious impulse that springs from a universal collective substratum common to all beings whence people draw their gestures and the artist derives the *arcai* of organic existence. Each person derives his humanity from this substratum, without realizing it, in a simple, immediate way. The artist must delve consciously into himself, sinking past the individual and contingent to reach to the live seed of human totality. From here comes all that is communicable for humanity, and through the disclosure of this mental substratum shared by all men, the artist-work-viewer relationship is established.

The work of art takes on a totemic value, as a living myth, without symbolic and descriptive dissipation. It is a primary, direct expression. . . .

Abstractions, references, have absolutely to be avoided; in our freedom of invention we must construct a world that will answer only to itself. We absolutely cannot consider the painting as a space on which we project mental stage sets. We must consider it as the "area of freedom" in which we set out on the discovery of our primal images. Images as absolute as possible, that will not be valid for what they recall, explain or express, but only for what they are: being. FROM "FOR THE DISCOVERY OF AN AREA OF
IMAGES," IN *PIERO MANZONI* (PARIS: MUSÉE D'ART MODERNE DE LA VILLE DE PARIS, 1991)

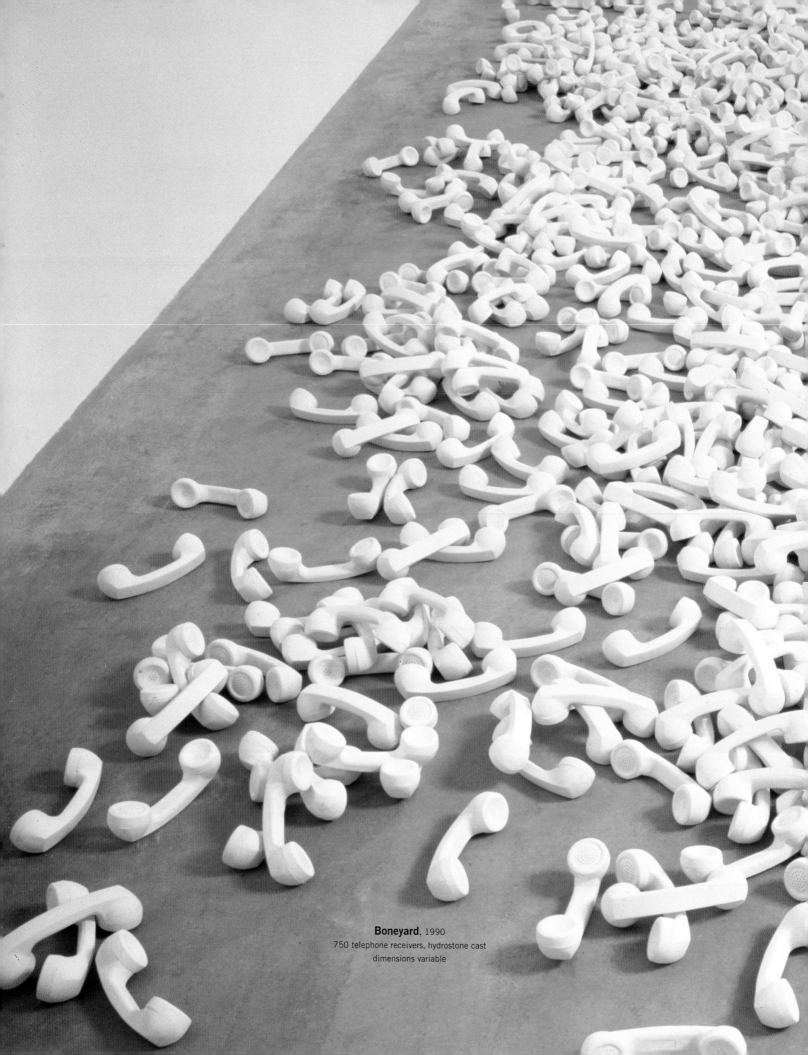

Boneyard, 1990
750 telephone receivers, hydrostone cast
dimensions variable

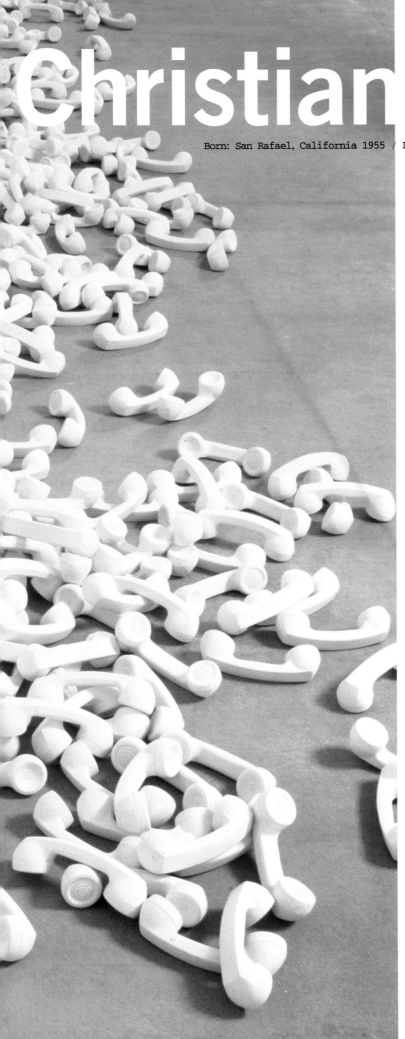

Christian Marclay

Born: San Rafael, California 1955 / Lives and works in New York City

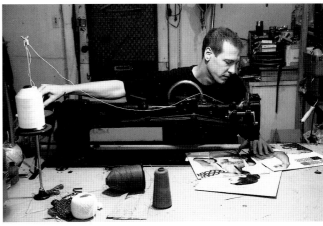

NATIONAL HERALD: New Delhi, Wednesday, F

Loud snoring offence

DAVIS, California, (DPA) — A 30-year-old woman whose loud snoring bothered a neighbour has been ordered to court to answer charges of violating the city of Davis's noise ordinance, it was reported here. Police yesterday said the unidentified woman faces a possible 50 dollar fine if convicted.

"It's really sad that this is happening," the alleged miscreant told the Davis Enterprise newspaper, "I've been married for nine years and my husband has never complained about (my snoring)". Davis police said the woman was cited for the noise offence when Chris Doherty, whose duplex home shares a common wall with the woman's, called officers early one morning and complained about the noise.

THE OBJET S'NORE

When Christian Marclay goes from the phonographic music, for which he has become well known, back to the visual arts from whence he came, he carries all that music and sound back to art; this would be the case no matter what he did because it is in his body. It resides there, a perfectly congruent phantom twin, a silent acoustic spatial formation that extends an ephemeral handshake that shakes your hand at the exact moment Christian Marclay shakes your hand, that will walk that walk when he walks that walk. And when this phantom sound captures your attention, it becomes larger, escapes his body, and silently begins to occupy and form other spaces, just as when he talks that talk, that talk will acoustically escape the confines of his actual body. The same is true with many of the objects he makes. They too are filled with residual sounds. . . . FROM **DOUGLAS KAHN**, "CHRISTIAN MARCLAY'S LUCRETIAN ACOUSTICS," *CHRISTIAN MARCLAY* (BERLIN: DAADGALERIE AND FRIBOURG: FRI-ART CENTRE D'ART CONTEMPORAIN KUNSTHALLE, 1994)

Patty Martori

Born: Phoenix, Arizona 1956 / Lives and works in New York City

The pure Imagination chooses, from either Beauty or Deformity, only the most combinable things hitherto uncombined; the compound, as a general rule, partaking, in character, of beauty, or sublimity of the things combined—which are themselves still to be considered as atomic—that is to say, as previous combinations. But, as often analogously happens in physical chemistry, so not infrequently does it occur in this chemistry of the intellect, that the admixture of two elements results in a something that has none of the qualities of one of them, or even nothing of the qualities of either. . . . Thus, the range of Imagination is unlimited. Its materials extend throughout the universe. Even out of deformities it fabricates that Beauty which is at once its sole object and its inevitable test. But, in general, the richness or force of the matters combined; the facility of discovering combinable novelties worth combining; and, especially the absolute "chemical combination" of the completed mass—are the particulars to be regarded in our estimate of Imagination. It is this thorough harmony of an imaginative work which so often causes it to be undervalued by the thoughtless, through the character of obviousness which is superinduced. We are apt to find ourselves asking why it is that these combinations have never been imagined before. FROM EDGAR ALLEN POE. "ON IMAGINATION,"

THE FALL OF THE HOUSE OF USHER AND OTHER WRITINGS, ED. DAVE GALLOWAY (LONDON: PENGUIN BOOKS, LTD., 1967)

Untitled, 1990
wood, varnish, process ink,
324 wood blocks
each block: 17.8 x 17.8
centimeters / 7 x 7 inches
installed: 336.6 x 336.6
centimeters /
132 1/2 x 132 1/2 inches

Paul McCarthy/
Mike Kelley

Paul McCarthy Born: Salt Lake City, Utah 1945 / Lives and works in Altedena, California

HEIDI

Grandfather as I am
Mike protects the sick girl
I work on the Heidi chalet
Neither admits to the goat
Heidi as European model as Madonna
Heidi as European fashion
Heidi as fashion model as Madonna
Heidi as purity—as fashion
Horror movie as model as docudrama
Docudrama as horror movie
Surrogate parts as stand-ins
Stand-ins as stunt props
Disney himself
Modern decorative purity
A lesson in aesthetics
Ultimately a question of taste
Acceptance of the role of beauty as correctness
Insistence on the role of beauty as correctness

OFFHAND THOUGHTS DURING THE TAPING OF **HEIDI** 1992 PAUL McCARTHY

HEIDI: Midlife Crisis Trauma Center and Negative Media Engram Abreaction Release Zone, 1992
Painted wood architectural structure, artificial human figures, various fabrics, wooden objects, 3 pinboards.

Heidi videotape: 60 minutes
2 backdrop paintings on canvas:
Frankfurt: 366 x 550 centimeters /
144 x 216 1/2 inches
Alm Mountain: 366 x 488 centimeters /
144 x 192 inches

4 Heidis:
4 found craft-art objects, fabric and
mirror
91 x 173 centimeters /
36 x 68 inches

Twins:
2 artificial rubber human figures with
clothes, mask, wigs,
2 pillows with cases, 2 found painted
boards on a felt covered table
108 x 197 x 109 centimeters /
45 1/2 x 77 1/2 x 43 inches

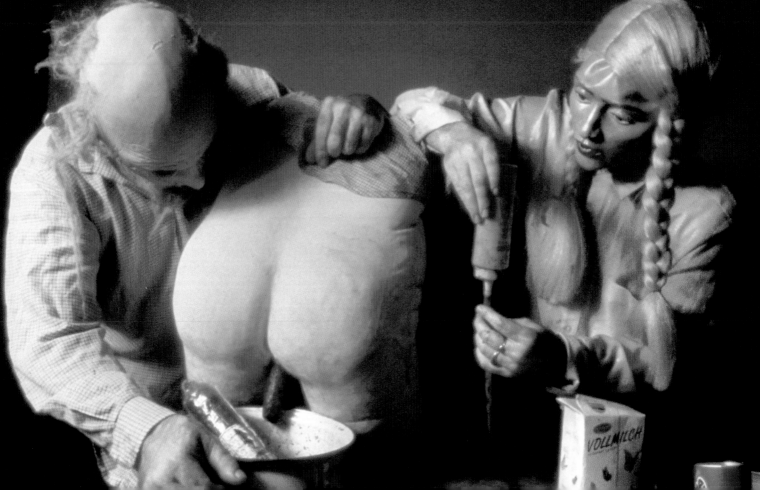

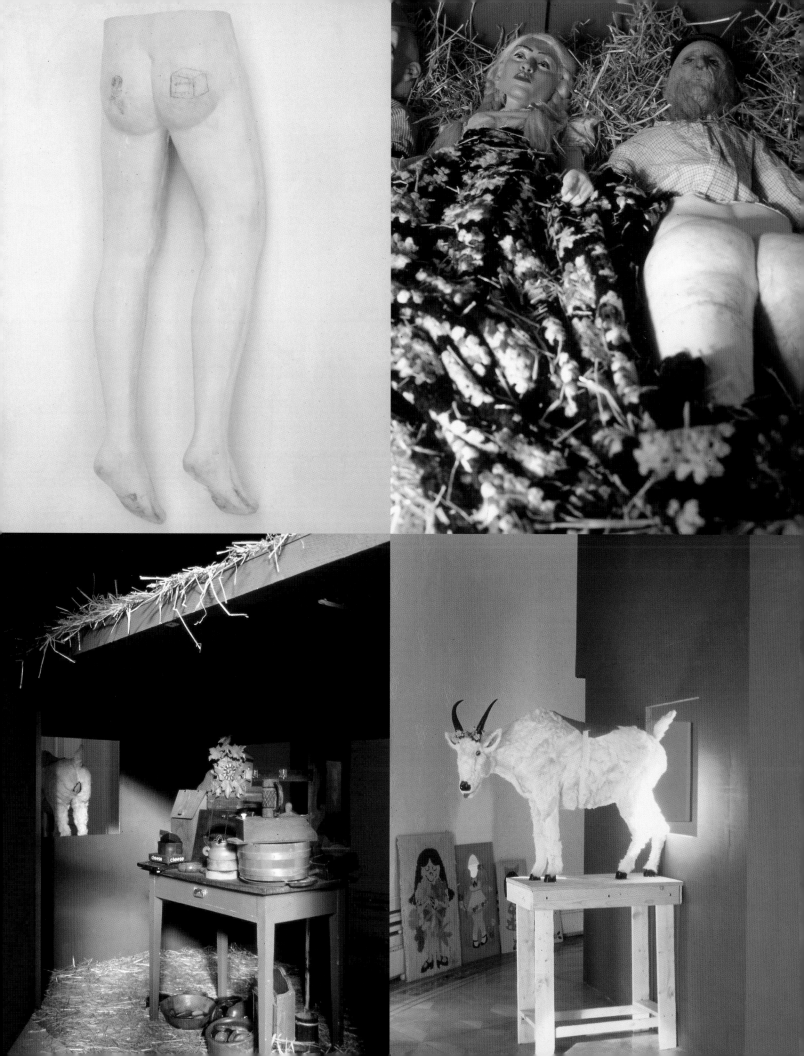

Allan McCollum

Born: Los Angeles, California 1944 / Lives and works in New York City

I think that there must be something false about the desire to look at a picture; it couldn't possibly be something we are born with. It must be something we grow into, like the way a dog comes to desire such a strangely contrived activity as being taken for a walk on a leash.

I am working to construct a charade, in which I am surrounded with false pictures: pseudo-artifacts which beckon me into the desire to look at a picture, but which are complete in doing just that, and that alone. My paintings don't serve a proper function—how could they? They're only representations, props, and surrogates: not real pictures at all. If I can engineer this charade the way I want, I think I can transform the seemingly innocent act of looking at art into a slightly nightmarish duplication of itself.

Then, as my work accumulates, it can act as an invocation: false pictures to call forth a false self. I can draw out such perverse forms as my desire to look has taken and address them false-face, each on its own level, matching one kind of fraudulence with another. 1980

Surrogates, 1982–1984
enamel on hydrostone, 2 sets of 20
assorted dimensions

Gerhard Merz

Born: Mammendorf, West Germany 1947 / Lives and works in Munich

Nonrepresentation no longer opens itself up to observation or immersion. From now on the spectator must know just as much as the author of the work; the spectator will not be taught or aided. The black square is no complete art, it is a fragment from a larger body of knowledge, from a larger realization. . . .

It is a discussion between equals, and I appreciate not only what I see but what is consciously left out. Absence is not to be understood as prejudice, as an artistic deficiency; it is not ascetic, design, or even taste. It is dictated by the will of a legitimate artwork and develops out of factual pressure. . . .

. . . For me, I dare say, what cannot be realized there should not be there. There is the imaginary museum and the court of dead artists which allows us to do what we do, and only then very few, after a lot of work, become artworthy. Mies van der Rohe, and many others, share the opinion that one only needs to pursue the right thing to do, to refine them and to bring them to the pinnacle of their time . . .

FROM "STATEMENT," *JOURNAL OF CONTEMPORARY ART*, SUMMER 1994

PHOTO: ROBERT MAPPLETHORPE

Roma, 1987
pigment on canvas in limba wood frame
91 x 290 x 15 centimeters / 36 x 114 x 6 inches

Principle of complementarity

What does the standard of quality of the artwork consist of?
Does it consist of pure beauty?
Or of strength of concept?
I have been calling for a standard of beauty for a long time.

Niels Bohr has proved, according to the principle of complementarity, that it is possible to describe one's existence from different angles. These descriptions are complementary and therefore it is impossible to reduce this expression of existence to any one description. This proof applies to the existence of the "artwork." Here, beauty and concept are complementary and therefore it is impossible for either the beauty or concept alone to define the value of artwork.

(The concepts of) time and beauty are equally important in my work; if one existed without the other, this would not result in a meaningful artwork.

above: **Counter Line No. 5**, 1990
light-emitting diode, IC, electric wire, aluminum panel
11 x 198 x 4.5 centimeters /
4 1/2 x 77 1/4 x 1 3/4 inches

below: **Counter Line No. 4**, 1988
light-emitting diode, IC, electric wire, aluminum panel
11 x 208.4 x 3.5 centimeters /
4 1/2 x 81 x 1 inches

929II3868II2886%8I%64988353I998II%2846I%2%893924I6882II72864I%36II398%38

Tatsuo Miyajima

Born: Tokyo, 1957 Lives and works in Tokyo

63386999I6I893868 = 975I2483I862843986378991836 = 35959I67I I 88854 I298294624831I85

Yasumasa Morimura

Born: Osaka, Japan 1951 / Lives and works in Osaka

The time will come when we courageously abandon being human.

1994

PHOTO: AKIKO MANTANI

opposite page:
Brothers (A Late Autumn Prayer), 1991
Cibachrome print mounted on plywood
265 x 259 centimeters (with frame) /
104 1/4 x 102 inches

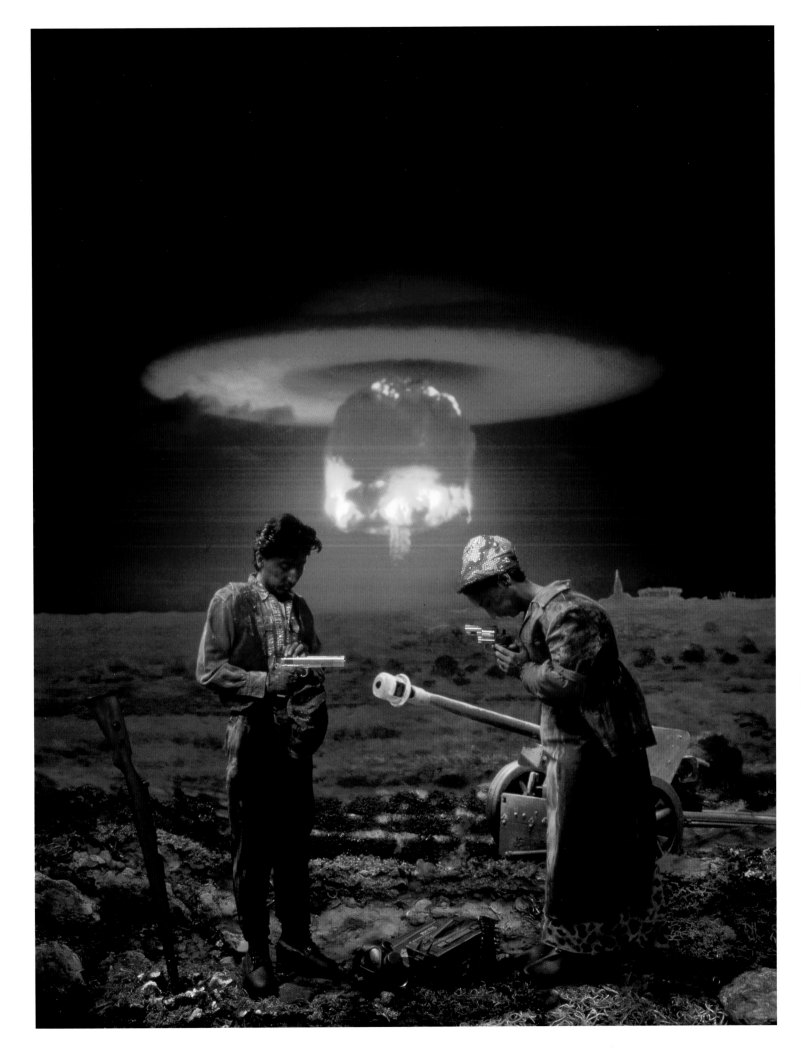

Matt Mullican

Born: Santa Monica, California 1951 / Lives and works in New York City

Maybe allegory is not the right word, because my city is not the representation of a social phenomenon. It's more abstract, it's not about a peopled environment. It's not about the space between people, necessarily, although it has to exist at that level. It is about the space between people and things. This might sound simplistic, but it's about that space which exists between any given object in different ways—emotionally, as a word, etc. I could end up putting people in the city later on, but right now it's empty, because it's about that perception of

emptiness.

FROM "INTERVIEW: ⌐ MATT MULLICAN AND MICHAEL TARANTINO," *MATT MULLICAN: THE MIT PROJECT* (CAMBRIDGE: MIT LIST VISUAL ARTS CENTER, 1990)

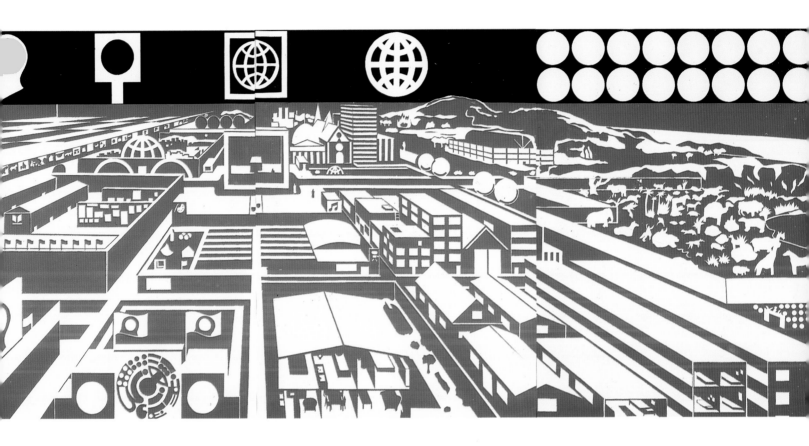

Untitled, 1986
lead-base paint on paper, 4 panels
each paper: 183 x 122 centimeters / 72 x 48 inches
each frame: 190 x 128.5 centimeters / 74 3/4 x 50 1/2 inches
all together: 190 x 513 centimeters / 74 3/4 x 202 inches

Juan Muñoz

Born: Madrid 1953 / Lives and works in Madrid

Pasamanos Favorito, 1988
wood and steel 8 x 220 x 8 centimeters / 85 2/3 x 3 x 3 inches

[With FIRST BANNISTER] very few people saw the flick-knife. I was very interested in this idea of the work, inviting your hand to go out, and then the idea of danger, of uncertainty. Do you really need a handrail to go up the stairs, or is it just a reassuring image? These bannisters are very strongly related to the body and to the passageway, to go through. They come from that moment when you lean on a balcony; I wanted to flatten the handrails so that they become useless, and at the same time pressed up against the wall like that, they look like a balcony, they even share the same wooden structure at the top.

The bannister, attached to the gallery wall, articulates a language which is close to that of minimalism. But the switchblade cuts through that language quite violently. Does this signify a general desire to cut through the formalist language?

There is just a fear of a tendency to become formalist. It is dangerous to make a piece, and then to try and make endless variations of it. In order to make it interesting, you have to put yourself in a position to say it is the last one, and to destroy. . . .

I feel that when I was making the ballerina it was more about endlessly moving, but always finding herself in the same space. I thought that when I made the ballerina it was a courageous act, to put forward such a permutated, even weak image, such a secondary presence.

The ballerinas have no legs, they rock on round bases, standing and not standing. . . .

They are about going nowhere. I was very concerned with the floor, about its relation to the base, about what happens above and below, and this seemed a perfect solution. The work is both the solution and the search for it, the pacing about, the working out of a problem. The ballerina is about the possibility of moving about and of hope, of conviction and lack of conviction, impossibility, uncertainty. . . . This work is about a presence, but I don't think it is commenting on the social environment. I want to make a statue, not a sculpture.

FROM AN INTERVIEW WITH THE ARTIST AND IWONA BLAZWICK, JAMES LINGWOOD, AND ANDREA SCHLIEKER,

IN *POSSIBLE WORLDS: SCULPTURE FROM EUROPE* (LONDON: ICA AND SERPENTINE GALLERY, 1991)

PHOTO: ARI MARCOPOULOS

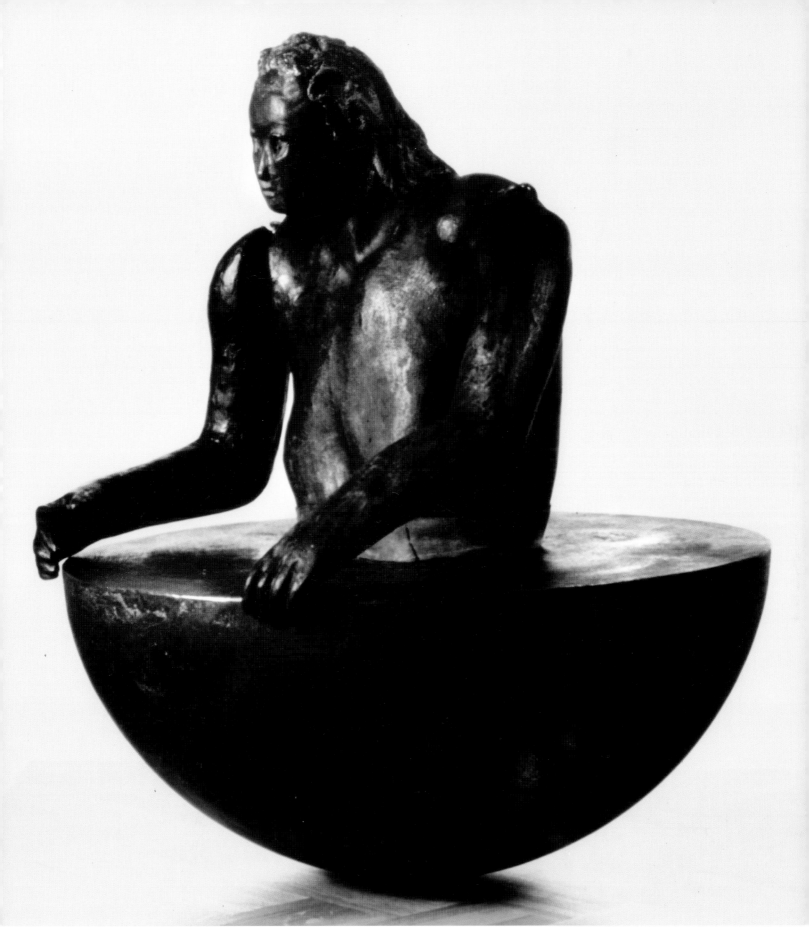

From One to Ten, 1990
iron and wood 53.5 x 60 x 60 centimeters / 21 x 23 5/8 x 23 5/8 inches

Peter Nagy

Born: Bridgeport, Connecticut 1959 /

Lives and works in New Delhi and New York City

It seems that what man tries to do is stop the disease by making metal things, or something. We took the works to this hospital in Long Island City; we took the gun one, it was hanging in an operating room. And I thought, people had come into this room having bullets taken out of them, but also being in car crashes.

I think the work is re-lated to Paolozzi just in his relationship to J.G. Ballard, and that whole science fiction/ Pop Art interface. The way the banal object changed from Surrealism to Pop Art; the way it lost a lot of psychology in the process. That's why the Nouveaux Réalistes like Spoerri were so important, they made that moment obvious. Be-cause the Surrealists knew what they could get out of the banal, really tapped the banal and used it for all these mystical things. But at a certain point the banal didn't signify all that mystical stuff. It became concrete.

FROM **GARY INDIANA**, "FUTURISMS: A CONVERSATION WITH PETER NAGY," *THE VILLAGE VOICE*, APRIL 14, 1987

PHOTO: JENNY GOLUB

America Invented Everything, 1985 ink on gessoed canvas 121.9 x 121.9 centimeters / 48 x 48 inches

Bruce Nauman

Born: Fort Wayne, Indiana 1941 / Lives and works in Sante Fe, New Mexico

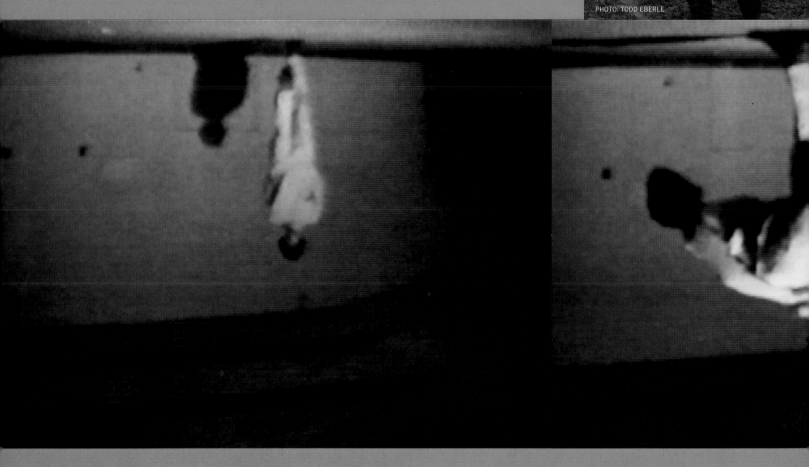

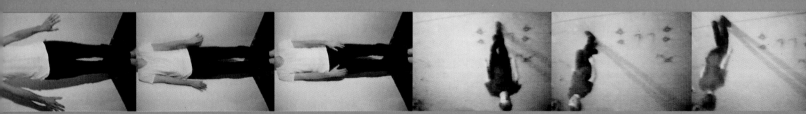

Bouncing in the Corner, No.1, 1968

Stamping in the Studio, 1968

Wall-Floor Positions, 1968

Bouncing in the Corner, No.2: Upside Down, 1969

Violin Tuned **D E A D**, 1969

Lip Sync, 1969 running time: 60:00

From Flesh to White and Back to Flesh, 1968

Revolving Upside Down, 1969

Chris Dercon: *Were you thinking about the video monitor as a piece of furniture?*

Bruce Nauman: In a sense, yes, as something that was just there. From the earliest tapes that I did, coming in a certain sense from some of Andy Warhol's films. They just go on and on and on, you can watch them or you can not watch them. Maybe one's showing already and you come in and watch for a while and you can leave and come back and eight hours later it's still going on. I liked that idea very much, it also comes from some of the music that I was interested in at the time. The early Phil Glass pieces and La Monte Young, whose idea was that music was something that was there. I liked that very much, that kind of way of structuring time. So part of it is not just and interest in the content, the image, but the way of filling a space and taking up time.

FROM CHRIS DERCON, "KEEP TAKING IT APART: A CONVERSATION WITH BRUCE NAUMAN," *PARKETT* #10, 1986

Cady Noland

Born: Washington, D.C. 1956 Lives and works in New York City

I am fascinated by crime and other very "dark" things. Those are the things I think about, those are what I enjoy talking about with friends. These are also palliatives to me. I watch *Court TV,* which is actual trials, televised, all the time. I watch shows called *Unsolved Mysteries* and *America's Most Wanted* (which are about criminals "on the loose"), too. These are modern Westerns.

As happens in Westerns, you don't always root for the good guys.

Hitchcock understood the dramatic potential of this and exploited it in films like *Shadow of a Doubt* and *Strangers on a Train* by casting charming, charismatic actors as the villains. In *Strangers on a Train* Farley Granger (the "hero") is completely unappealing—he's wooden, out of touch with his feelings and absolutely humorless. The villain, Robert Walker, is a really witty, engaging, sophisticated guy. He's rather special.

FROM "METAL IS A MAJOR THING, AND A MAJOR THING TO WASTE: AN INTERVIEW WITH CADY NOLAND," AMIEL VAN WINKEL AND MARK KREMER, *ARCHIS,* JANUARY 1994

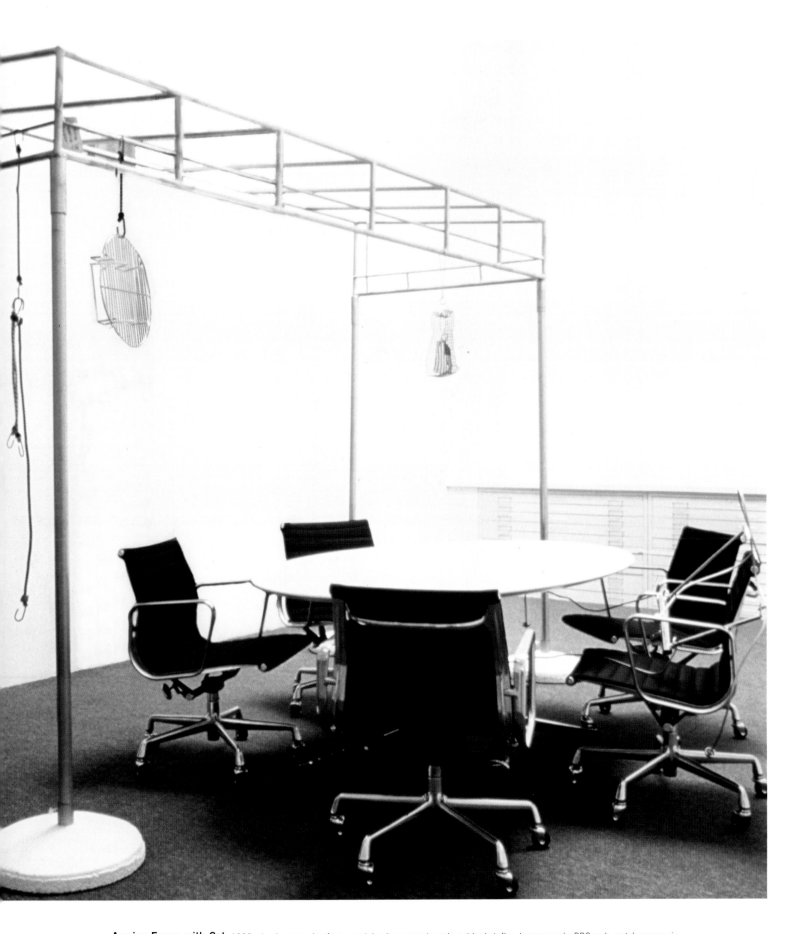

Awning Frame with Cat, 1990, aluminum awning frame, metal poles, concrete pods, cat basket, flag, bungee cords, BBQ rack, metal mannequin
238.8 x 170.2 x 355.6 centimeters / 94 x 67 x 140 inches

Gabriel Orozco

Born: Jalapa, Veracruz, Mexico 1962 / Lives and works in New York City

. . . We face first of all the outside of the elevator which used to be the part that we don't see normally in a building, that we don't see because it is normally inside. We are facing the back of an elevator or the exterior of an elevator which has a lot of texture because it was used. We are walking by this window and then we get in the elevator and we are surrounded and we are again in an interior situation that is the elevator inside. So all this walking through interiors and exteriors in the gallery, interiors in the space and exteriors in the landscape, and then again another interior/exterior piece that is the elevator. I think that could create a consciousness of our exterior in relation to all these objects and the landscape.

I cut eighteen inches from the cabin. Cutting this horizontally and putting it together again, I think it's another way of thinking about the space or the feeling of a space that is not there anymore but is still there in our conciousness. Or, what we feel when we are moving in an elevator. I have been interested in this notion of the missing space that is still there and how a thin line that divides two bodies is not measurable. Of course, physically it is very thin, but emotionally or mentally it is much bigger and is unmeasurable. I think in my work it is that space which interests me as a sculptor. I consider this space has to do more with the consciousness and the mental than the physical. Disappeared physically but very present mentally or emotionally, conceptually or virtually, whatever you want to say. It's there; the space is there and you can feel it.

FROM *OPTIONS 47: GABRIEL OROZCO*, MUSEUM OF CONTEMPORARY ART, CHICAGO, 1994

opposite page: **Elevator**, 1994
altered elevator cabin
243.8 x 243.8 x 152.4 centimeters /
96 x 96 x 60 inches

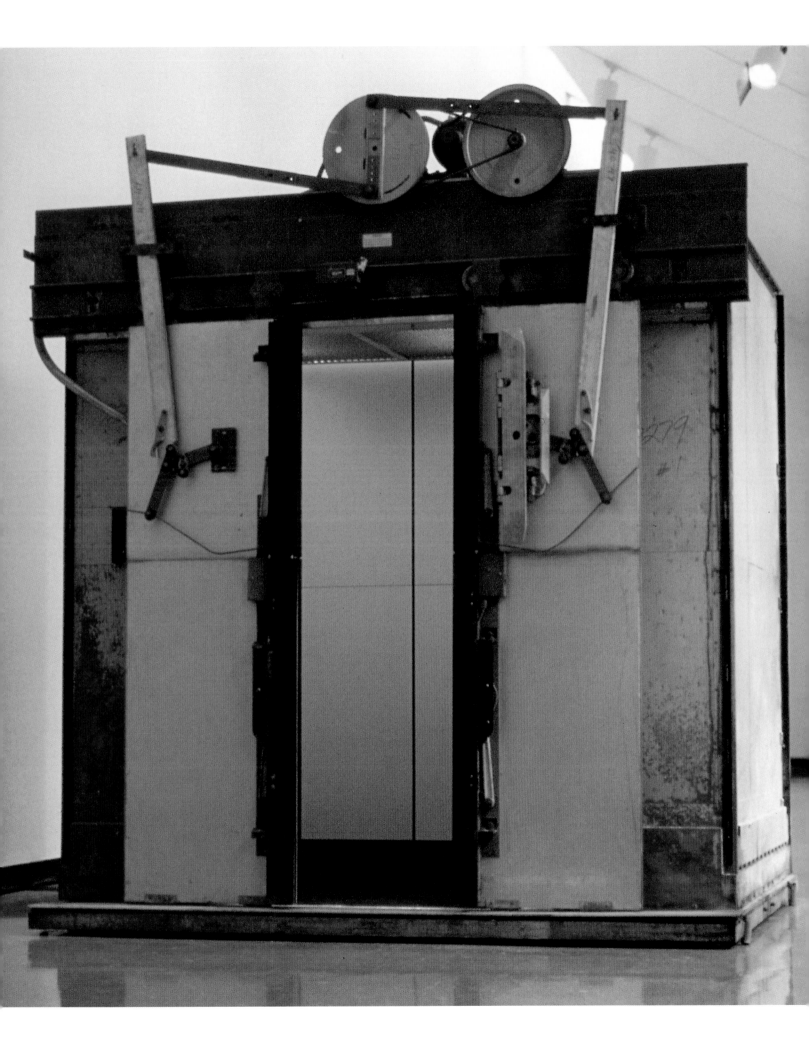

Pino Pascali

Born: Bari, Italy 1935 / Died: Rome, Italy 1968

I try to do what I like, basically it's the only system that works for me. I don't believe that a sculptor does heavy work: He plays, like a painter plays, as any person who does what he wants to plays. It's not just child's play, it's all a game, isn't it? There are people who work, after the games of childhood become the games of adolescence, the games of adolescence those of adulthood, but they are always games. At a certain point you're at the office; if the work is unpleasant, you'll want a powerful car to ride around in, precisely because you're doing work you don't like, while someone who likes what he's doing plays with the work he does, that is, he places everything there, in the work. Not in the sense of playing for the sake of it, that's something else, but in the normal sense of man's activity, right? Even children play seriously: It's a cognitive system, their games are made precisely to experiment with things, to know them and at the same time to go beyond. But I don't know what "children" means. They are men of a certain age up until the end; later, if one of them hits people with his spoon, he's a jerk, it's clear, but if he manages to live as he likes, like— I don't know—the boy who has a good time at school, that's the way it is.

FROM AN INTERVIEW WITH **CARLA LONZI** IN *MACATRE*, MILAN, JULY 1967; REPUBLISHED

IN *AUTORITRATTO* (BARI: DE DONATO,1969)

Quattro Trofei di Caccia, 1966
canvas on shaped plywood
340 x 170 x 50 centimeters /
134 x 67 x 19 3/4 inches

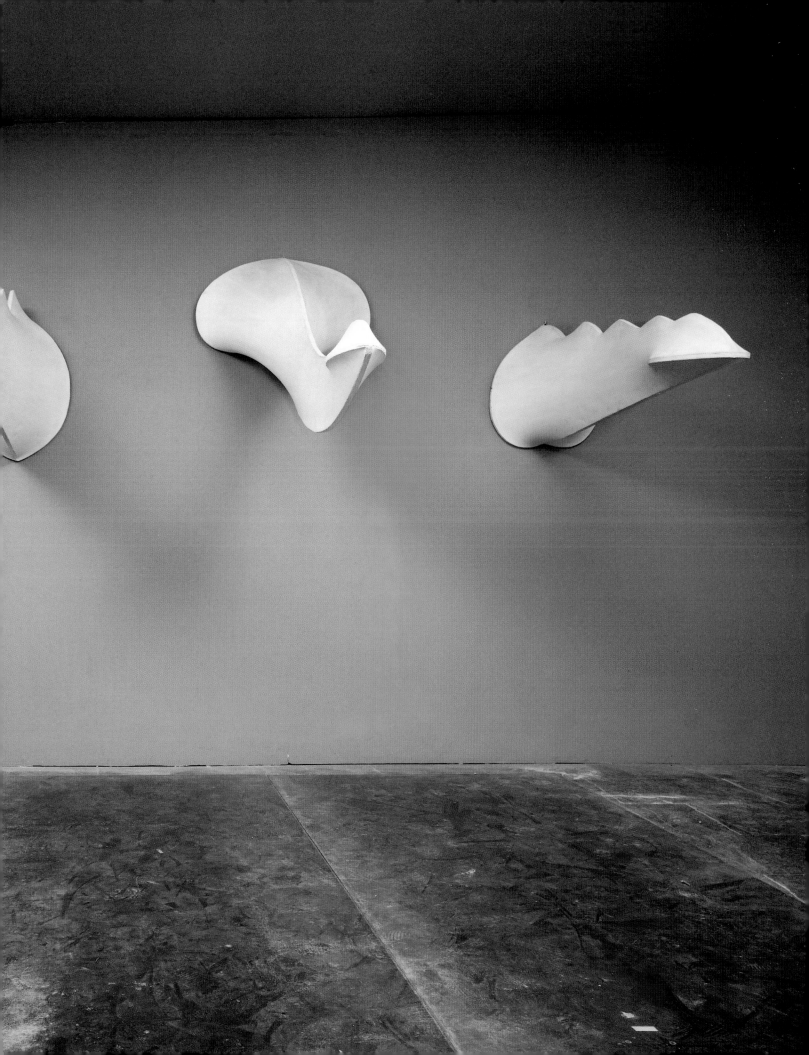

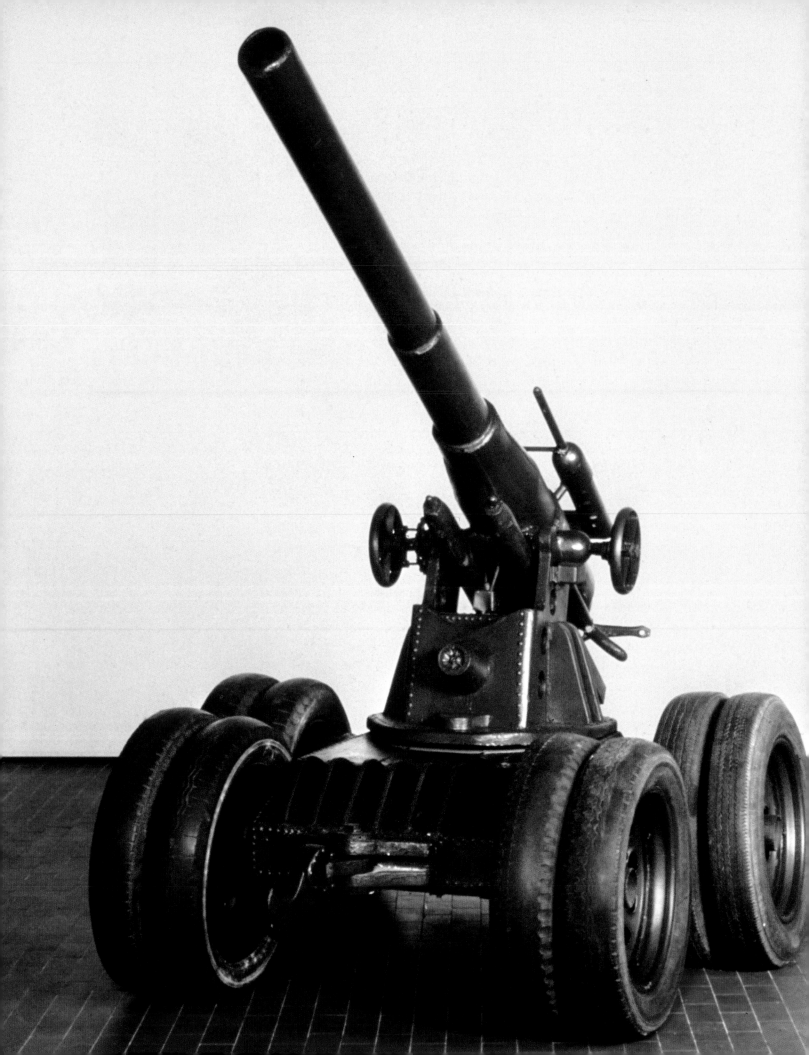

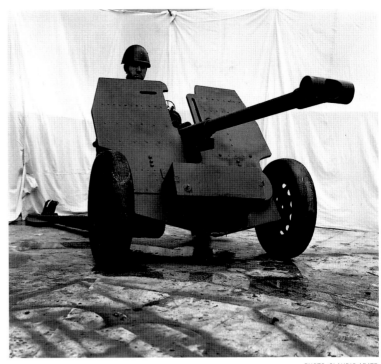

"Lo spettatore" (1966)

I think I'm not a sculptor, I have this impression of myself; it's something that could also be serious, but who knows if it is, for me it is also amusing. When I made the cannons I said, "How lovely to place a cannon in a place of sculptors," to succeed in truly placing it in a world that is so sacred, so fake . . .

FROM *D'ARS AGENCY* ON THE OCCASION OF THE ARTIST'S EXHIBITION AT L'ATTICO GALLERY, ROME, MAY 1969

Cannone Semovente, 1965
wood, scrap metal, wheels
251 x 340 x 246 centimeters /
99 x 134 x 97 inches

Let us talk of other things
must we find interesting
men who have ahead of
 them
a great future
or speak of women
with a great past
the present of women
is found in their youth
and that of men
in the old age of their
 future
to recapture slowly
the legal chagrin
grown golden
like a useless art
at the beginning of the
 world
all was well
today taste
has pinched features
without scruples
like an artist
with dyed hair
and a painted face
gently
I fell asleep
like a clock
that awaits its hour
I dedicate this long poem
to the one
who does not know how to
 sleep
without emptying her heart
into the vessel
in her night table
who can live
without the kiss
of our joined lips
a terrifying story
if it is not true
but with whom can I talk
 about it?

"COUSSERANCES," SEPTEMBER 3, 1947

FROM *WHO KNOWS: POEMS AND APHORISMS BY*

FRANCIS PICABIA (MADRAS / NEW YORK: HANUMAN BOOKS, 1986)

Francis Picabia

Born: Paris, France 1879 / Died: 1953

RASTADADA PICTURE, 1920

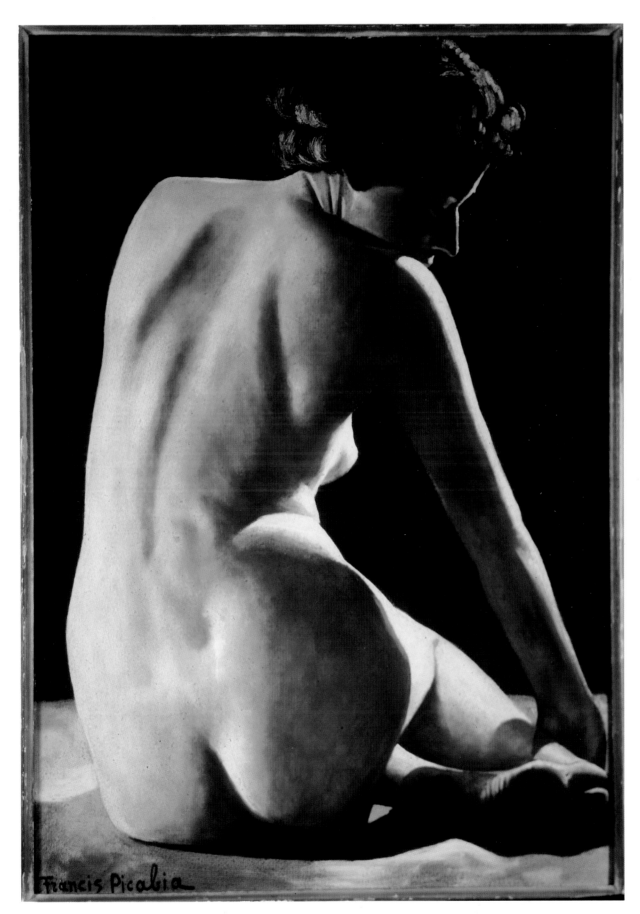

Nu de Dos, 1940–1942 oil on board 105 x 76 centimeters / 41 1/2 x 29 1/2 inches

Born: Panama Canal Zone 1949 / Lives and works in New York

1. Daddy

The father of the United States of America is the cowboy, one of whose modern-day appearances is the biker. We who live under the sign of myth know that the cowboy is that lonely male individual who, against all odds including Indians, braved all in order not to get rich quick, nor to survive, but to keep on traveling. As Steven Tyler, a contemporary cowboy, announced and keeps on announcing, "Take me to the other side."

PHOTO: TIMOTHY GREENFIELD-SANDERS

Richard Prince begins his Spiritual America visually with a picture of daddy. Daddy, on a big horse, is looking off into the faraway, which is always invisible.

In the interview which introduces this picture, an interview of course entitled "Extra-ordinary," Prince tells his interviewer, J.G. Ballard, the science fiction and fiction writer extraordinaire, that he was born in a place in which it is unbearable to the point of being impossible to be. An edge. A zone. The Panama Canal Zone.

Prince is using both content and genre to lace us in the realm of myth, of the imaginary which is more true than truth.

He tells Ballard only about his father. There seems to be no mother. At first, this father whose reality status equals that of Jimi Hendrix, another myth, is a hero: "My father's one of those imaginative criminals who wakes up in the morning and . . . makes resolution to perform some sort of deviant or antisocial act. . . . "

By the end of the interview, Daddy is a psychopath.

Here, there is no mommy. Maybe there never has been. Maybe, in the American version of the Virgin Birth according to Prince, it is daddy who immaculately conceives. The artist gives birth. The only woman whom Prince mentions is a stewardess whose nipples Daddy cut off during an airflight.

Prince is one mixed-up kid.

Welcome to the Princely American Family.

EXCERPT FROM **KATHY ACKER**, "RED WINGS: CONCERNING RICHARD PRINCE'S SPIRITUAL AMERICA," *PARKETT* #34, 199

opposite page:
Untitled (King Kong), 1985–1986 Ektacolor print
218 x 112 centimeters / 86 x 44 inches

Charles **Ray**

Born: Chicago, Illinois 1953 Lives and works in Los Angeles

. . . The mind grants instantaneous privilege—a fast track—to semblances of human beings. The threshold of the privilege is very low, such that we can "see" faces in clouds and cracked walls. A veristic mannequin by, say, Duane Hanson swamps the mind in person-recognition signals: an effective but paltry diversion. Ray's mannequins are pitched short of verisimilitude, each at a particular, internally consistent level. He goes to great lengths, for instance, to devise wizardly patinas that are "fleshlike" without dissolving into illusions of actual flesh and to match them with the "clotheslikeness" of the figures' attire, if any. One quickly comprehends the figures' lifelessness, but their liveliness is not thereby destroyed. Disbelief and belief, skepticism and credulity, fact and fiction persist together, proceeding on parallel tracks which, never meeting, comprise the art's lyric tension...

. . . Ray's works are like the lighthouse with seagulls, engineered signaling devices congenial to something untamed. The untamed thing may be a viewer's beating heart, as when I approach the big woman, FALL '91— an eight-foot-high, dressed-for-success Juno who extends one hand, palm downward, in an ambiguous gesture—with fluttery childish feelings of awe. Here is the parent I never had—thank goodness and alas. I find that her outstretched hand is at the exact height to rest on my shoulder if I make of my viewing an impromptu performance. Facing her, looking up, I am a child held down by a stony Mom. Turned around—looking out at the world with Her behind me, Her hand on my shoulder—I am a child protected by a heroic Mom who as much says, "I'll handle this son." She emasculates and comforts me. My consequent steady state of anxiety chimes for me with other conflicted steady states that I often experience, such as discomfort in art museums. . . .

PETER SCHJELDAHL, "RAY'S TACK," *PARKETT* #37, 1993

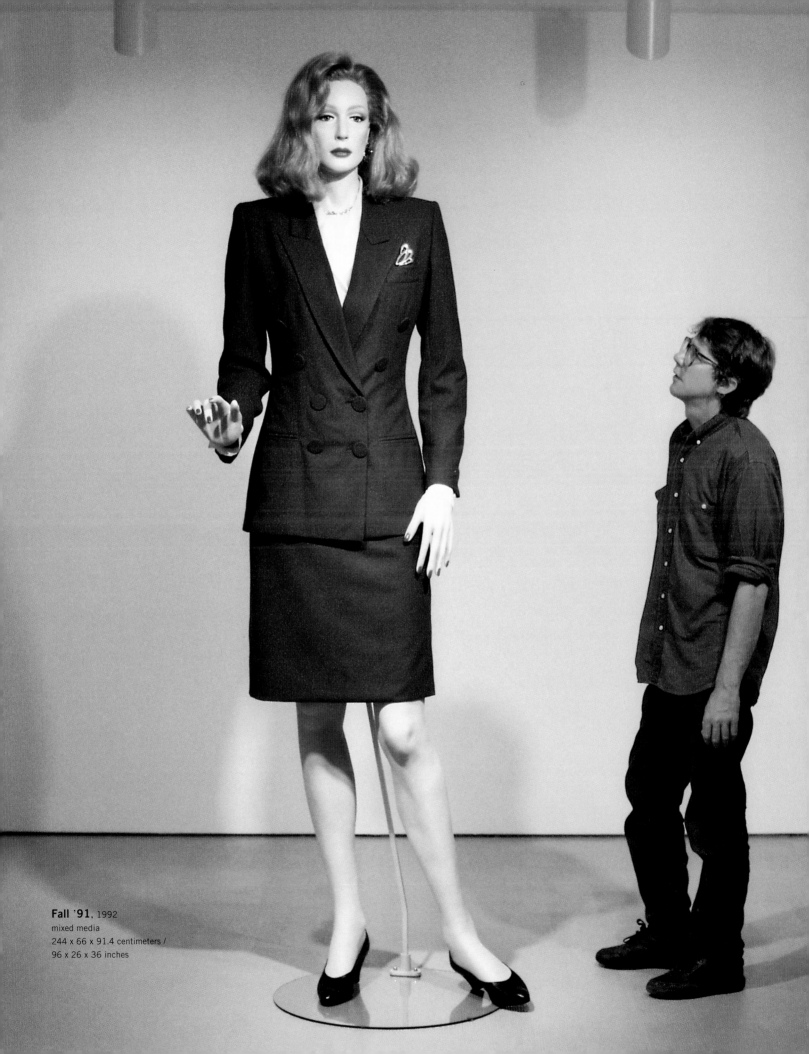

Fall '91, 1992
mixed media
244 x 66 x 91.4 centimeters /
96 x 26 x 36 inches

David Robbins

Born: Whitefish Bay, Wisconsin 1957 / Lives and works in New York City

Alan Belcher

Jenny Holzer

Michael Byron

Larr

Joel Otterson

Clegg and Guttmann

Steven Parrino

Thom

Robert Longo

Robin Weglinski

Ashley Bickerton

Peter

Talents, 1986
18 black-and-white photographs
each: 27 x 21.9 centimeters /
10 5/8 x 8 5/8 inches

Cindy Sherman

Allan McCollum

Jeff Koons

Gretchen Bender

Jennifer Bolande

David Robbins

In 1986, I produced a work called TALENT in which I attempted to effectively remove the refuge of critical distance and explicitly equate artist and entertainer. TALENT consisted of 18 black-and-white "head-shot" photographs of contemporary artists. The photographs were made by a Times Square photographer who for 30 years had taken this kind of photo for aspiring actors and actresses, singers and comedians. Thus TALENT was intended as neither a representation nor a parody of entertainment culture. It blew open a hole in the membrane separating the context of art from the context of entertainment. Through this hole, the structures, conditions, and aims of each context became for me gloriously and hopelessly polluted with the presence of the other. I hoped TALENT would cause both avant-garde culture and entertainment culture to confess their habits of mind, framing the issue of criticality itself. It was my attempt to tip the critical and the non-critical into a perpetual motion of mutual critique, simultaneously indicting art's naïve, shrewish criticality and entertainment's smug, oafish complacency; art's chronic marginality and entertainment's brutal populism; art's fierce autonomy and entertainment's collaborative nature; art's addiction to disposable theory and entertainment's poverty of theory. TALENT X-rayed two late twentieth-century bureaucracies of the imagination— one an Industry, the other a World.

FROM "ART AND BEHAVIOR," *FOUNDATION PAPERS FROM THE ARCHIVES OF THE INSTITUTE FOR ADVANCED COMEDIC BEHAVIOR* (NEW YORK: FEATURE GALLERY; NEW YORK: JAY GORNEY MODERN ART AND BRUSSELS: GALERIE XAVIER HUFKENS, 1992)

James
Rosenquist

Born: Grand Forks, North Dakota 1933 Lives and works in New York City and Florida

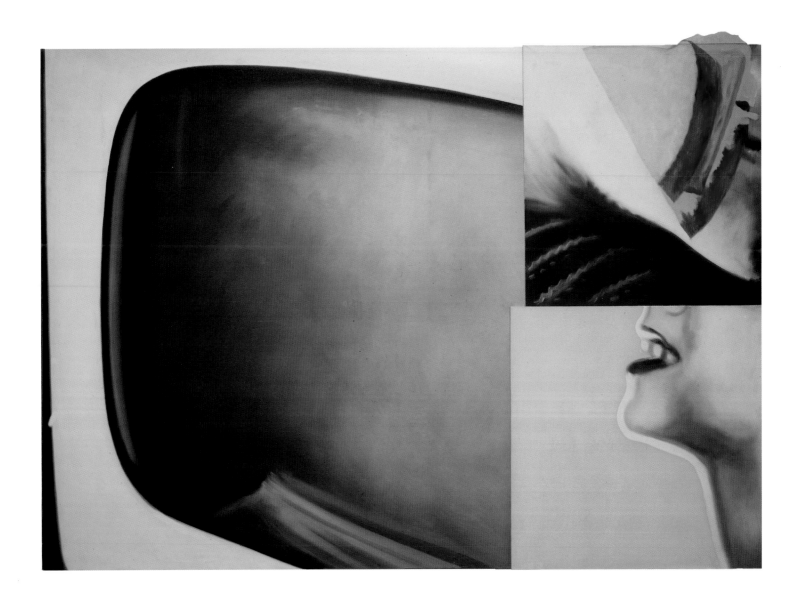

The Light That Won't Fail, 1961, oil on canvas, 177 x 244 centimeters / 69 3/4 x 96 inches

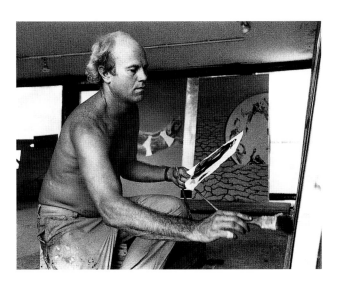

...**O.K.,** the critics can say [that Pop artists accept the mechanization of the soul]. I think it's very enlightening that if we do, we realize it instead of protesting too much. It hasn't been my reason. I have some reasons for using commercial images that these people probably haven't thought about. If I use anonymous images—it's true my images have not been hot-blooded images—they've been anonymous of recent history. In 1960 and 1961 I painted the front of a 1960 Ford. I felt it was an anonymous image. I wasn't angry about that, and it wasn't a nostalgic image either. Just an image. I use images from old magazines—when I say old, I mean 1945 to 1955—a time we haven't started to ferret out as history yet. If it was the front end of a new car there would be people who would be passionate about it, and the front end of a car might make some people nostalgic. The images are like no-images. There is a freedom there. If it were abstract, people might make it into something. If you paint Franco-American spaghetti, they won't make a crucifixion out of it, and also who could be nostalgic about canned spaghetti? They'll bring their reactions but, probably, they won't have as many irrelevant ones. . . FROM AN INTERVIEW WITH G.R. SWENSON, *ARTNEWS*, FEBRUARY 1964

Be Beautiful, 1964, oil on canvas 137 x 214 centimeters / 54 x 84 1/4 inches

Edward Ruscha

Born: Omaha, Nebraska 1937 / Lives and works in Venice, California

Who put those messages in the haze? Not God certainly, but Ruscha's pictures do evoke a certain big and invisible something. . . . What Ruscha's art also suggests, however, is a characteristic habit of mind. He has captured, to a T, the cool, wry ambivalent jokiness that many intelligent people in L.A. use to tame the monster of Pop. This attitude is tricky; it requires a careful balance between respect and rebellion, humor and profundity, the schlocky and the serious. Too much "fine art," for example, would seem out of place. —MARK STEVENS

He is also the archaeologist of language, dusting off words and phrases from the rubble of a syntactically shattered culture, like so many keystones of meaning leveled by an ancient catastrophe. —PETER SCHJELDAHL

It is difficult to pigeonhole [Ruscha's] style at all. Conceptual, Pop, Surrealist, Dada, neo-Dada, earth art—all these are arguable elements of his style. Ruscha can be pinned down partially by any of these labels, and yet he escapes all of them. —HENRY GELDZAHLER

STATEMENTS COMPILED BY THE ARTIST

Cactus Omelet by Ed Ruscha

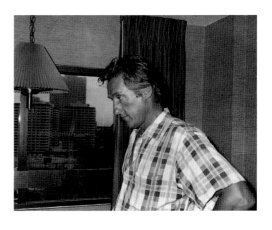

Ingredients:

2 eggs
2 teaspoons of Nopolitos (chopped cactus pads that can be
 purchased from Mexican markets or specialty stores in jars)
1 teaspoon chopped celery
 pepper
 canola or safflower oil
 (optional: 2 teaspoons cottage cheese)
 I use a teflon coated pan
.
1. Whip eggs only 25 strokes with a fork so they do not get too fluffy
2. Pour oil the size of a 25 cent piece into the center of the pan as it is being heated.
3. Heat oil, spreading it around with a spatula. (Use of spatula is optional.)
4. When fairly hot, pour eggs into pan. Move eggs around pan so they become evenly distributed.
5. Just before eggs lose their runniness, sprinkle ingredients evenly on only half of omelet.
6. Pepper to taste.
7. Toss or fold empty side of omelet over other half with ingredients.
8. Slide omelet onto plate . . . serve.

Noise, 1963 oil on canvas 170.2 x 183 centimeters / 67 x 72 inches

David Salle

Born: Norman, Oklahoma 1952 / Lives and works in New York City

PHOTO: TODD EBERLE

It seems as though for many people iconographic identification is the key to meaning in painting, that knowing where a certain image comes from is somehow the key to meaning in a work. In my view, it's irrelevant. It's a fundamentally different world view, a different way of looking at paintings. I remember a review of a painting that contains these images: a pair of eyes, an upside-down basket of apples and a chair leg projecting off the canvas, from which hangs a black brassiere. The reviewer was irate because he thought that this was an adolescent joke about the sexualization of Cézanne's apples. He thought it was infantile, as if my intention was to bring Cézanne down to size or "critique" Cézanne. This is an example of what is not important in my painting. It would not have occurred to me—I wasn't even thinking about Cézanne. These were not Cézanne's apples. But even if they had been, why does anyone think that art has anything to do with that? It just doesn't get you very far. It's a not-interesting way to look at painting. Iconographic reference testing has been thrown at my work as a measure of what it is. I think that

my starting point, which I know I share with other artists of my generation, is that basically everything is equal. That everything in the world is an image already. An abstract painting is an image, just as much as an apple or a picture of a drowning girl and a painting is an image of a painting. Where an image comes from is less important than how it plays now. This is pretty much a truism for artists.

FROM "DAVID SALLE," *INSIDE THE ART WORLD: CONVERSATIONS WITH BARBARALEE DIAMONSTEIN*

(NEW YORK: RIZZOLI, 1994)

Théâtre des Amis, 1989
oil and fabric on canvas, three wooden chairs
291 x 483 x 102 centimeters / 113 1/2 x 188 1/4 x 40 inches

Rob Scholte

Born: 1958 / Lives and works in Amsterdam, Tenerifa and Nagasaki

Acrylic on canvas

The Golden Mean was the measure for harmonious building. A human size was in a world that was controlled, known and shaped to a beauty through measuring and building. Today this humane, homogeneous world has dis-integrated, and the observed nature has made a place for the representational world of art, photography, film and television. In this synthetic world of images there is no general valid order-liness, no Golden Mean is thinkable. Rob Scholte's paintings are not speculative objects that breathe out reflections on the decline of the absolute extension of significant meaning. They are images, presented in the universal code of neutral representation. Paint and canvas are not allowed to interrupt him with the *poésie pure* of the paint-erly gesture, material mysticism, the magical moment or the fund-amental deed. He wants to be impure and public, synthetic and actual, clearly understandable and disturbing. These paintings are local, paradoxical soundings in the representational world for equally as many new Golden Means; for a changeable but verifiable relation between illusion and concept. Acrylic on canvas, measuring instruments. **DIRK VAN WEELDEN**, 1984

Self-Portrait, 1988
acrylic on canvas 150 x 150 centimeters / 58 1/2 x 58 1/2 inches

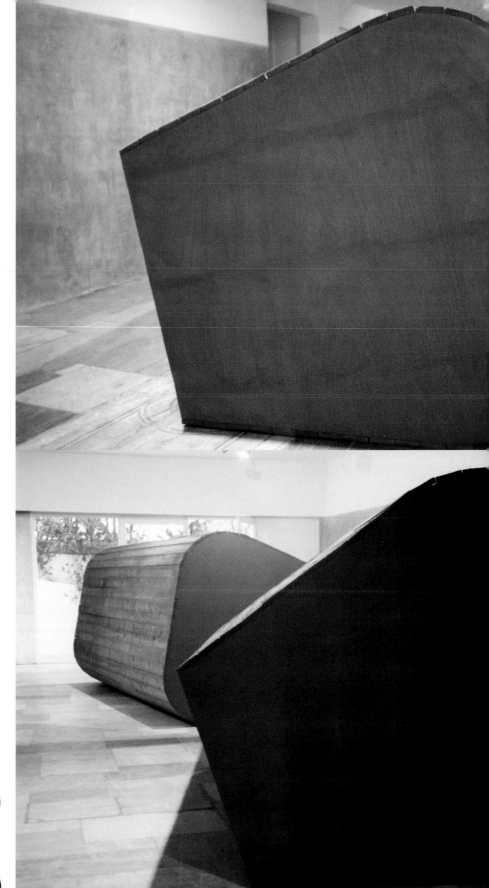

Thomas Schütte

Born: Oldenburg, Germany 1954 / Lives and works in Düsseldorf, Germany

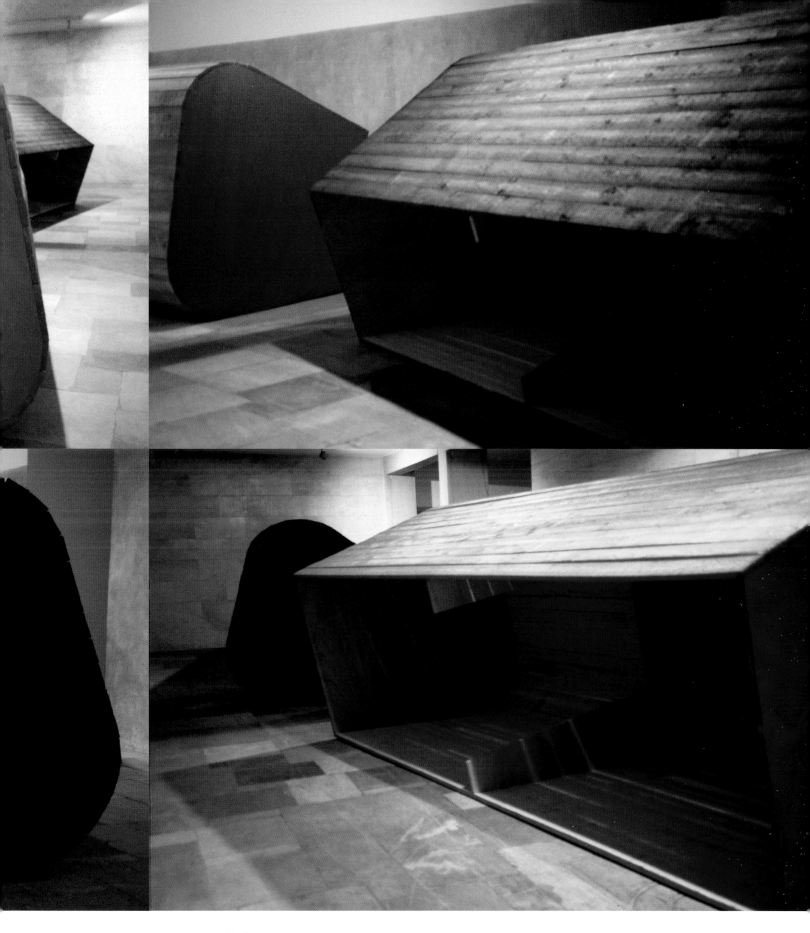

Boats, 1986 painted wood, 160 x 170 x 400 centimeters / 62 1/2 x 66 1/4 x 156 inches
158 x 180 x 320 centimeters / 62 x 70 1/4 x 124 3/4 inches

Cindy Sherman

Born: Glen Ridge, New Jersey 1954 / Lives and works in New York City

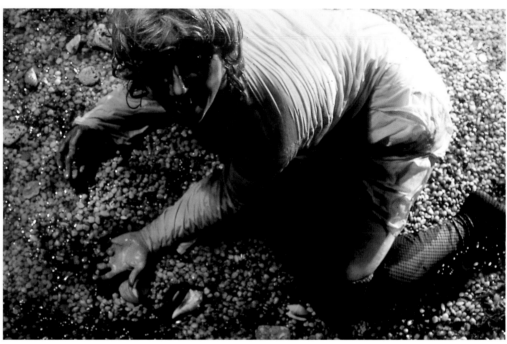

above right: **Untitled**, 1985
Cibachrome
125.7 x 184.2 centimeters /
49 1/2 x 72 1/2 inches

opposite page: **Untitled**, 1995
Cibachrome
152.5 x 101.5 centimeters /
60 x 40 inches

I feel I have addressed the various ways of looking at women or the ways they think they are looked at or portrayed by men and women. Of course I did not invent this terrain, but it felt new when I began with it and now it is a large part of art making. Also, the more and more elaborate the staged studio poses became, the higher degree of artifice was for me a way of taking photography out of the realm of documentation and naturalness and putting it more into the realm of art. Printing larger and larger was a relatively new technology that helped me distance my work visually from traditional photography. FROM AN INTERVIEW WITH MATTHEW WEINSTEIN IN *JÜRGEN KLAUKE / CINDY SHERMAN*, (MUNICH: SAMMLUNG GOETZ, 1994) EDITION CANTZ

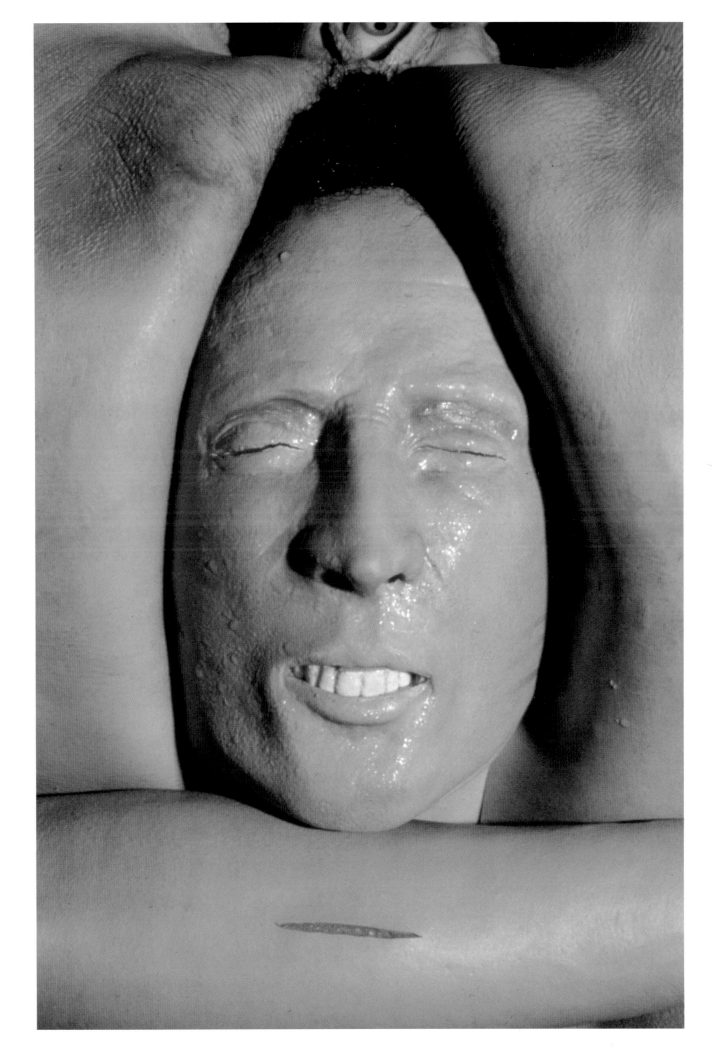

Tourism: The Acropolis, 1983 Cibachrome 102 x 153 centimeters / 40 x 60 inches

Laurie Simmons

Born: Long Island, New York, 1949 / Lives and works in New York City

Tourism was one of the most satisfying groups of pictures I've ever made, starting with the fact that these were all places that I wanted to go but couldn't. I thought if I could move the surrogate figures (a stand-in for myself) through an interior space, like a house which is a metaphor for psychological space, I could certainly move her out into the world. "I have places to go, people to see," was my attitude and the attitude of the pictures. The *Tourism* series started when I was in Greece in 1983. I was standing on the Acropolis in front of the Parthenon. I was with a couple of friends, and it was really hot and crowded and polluted. . .

. . . I had a camera, but it was not something that I really felt like using. There were guides everywhere speaking in different languages. There were people hawking souvenirs. It was an unpleasant experience, and I said to my friends, "You know, you get a better sense of this place in books. You can see it better in pictures." The people I was with were irritated by what I had said. I thought about how experience has been mediated for us through textbooks and tourist guides. The images have been shown to us over and over again so many times that by the time you come to the real thing it's something of a letdown. It's much more beautiful in a travelogue. When you look at an image of a place in a book and have it idealized for you in a certain way, when you actually get there and you see what humans and pollution have done to the place, it's a disappointment.

So I went over to one of the tourist shops and bought a page of slides of a number of Greek archaeological sites. They were all faded, a sort of blue, cerulean blue. I brought them back to the studio,and set up some dolls in front of the Parthenon. That was the first picture in the series. After that I became an armchair traveler.

PHOTO: SUSAN JENNINGS

FROM AN INTERVIEW WITH SARAH CHARLESWORTH, *LAURIE SIMMONS* (CALIFORNIA: ARTPRESS, 1994)

Kiki Smith

Born: Nuremberg, Germany 1954 / Lives and works in New York City

I don't feel I have a great allegiance to art history; I don't feel like defending it or continuing it. I don't think my work is particularly about art. It's really about me, being here in this life, in this skin. I'm cannibalizing my own experience, my surroundings.

opposite page: **Untitled (Hanging Woman)**, 1992
paper and ink 183 x 81.3 x 81.3 centimeters / 74 x 32 x 32 inches

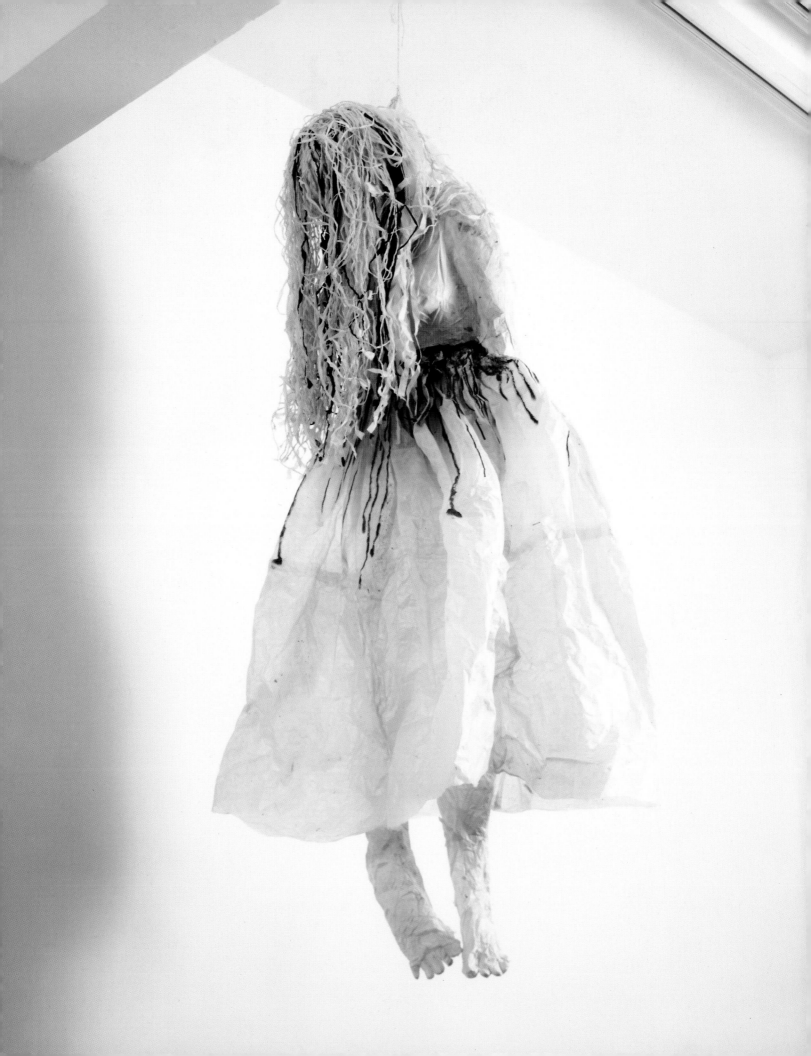

I don't have a strategy. I am not working out of an agenda. For me, there is no difference between living and doing my work—there's no separation. Basically, I just do what comes naturally to me. I use different materials and then I can make up some ideological thing about, like, diversity being a strong thing, but basically it's just what comes naturally to me.

above: **Untitled (Head with Tongue)**, 1995
bronze and silver plate 25.4 x 15.2 x 15.2 centimeters / 10 x 6 x 6 inches

opposite page: **Mother/Child**, 1993 wax, life-size

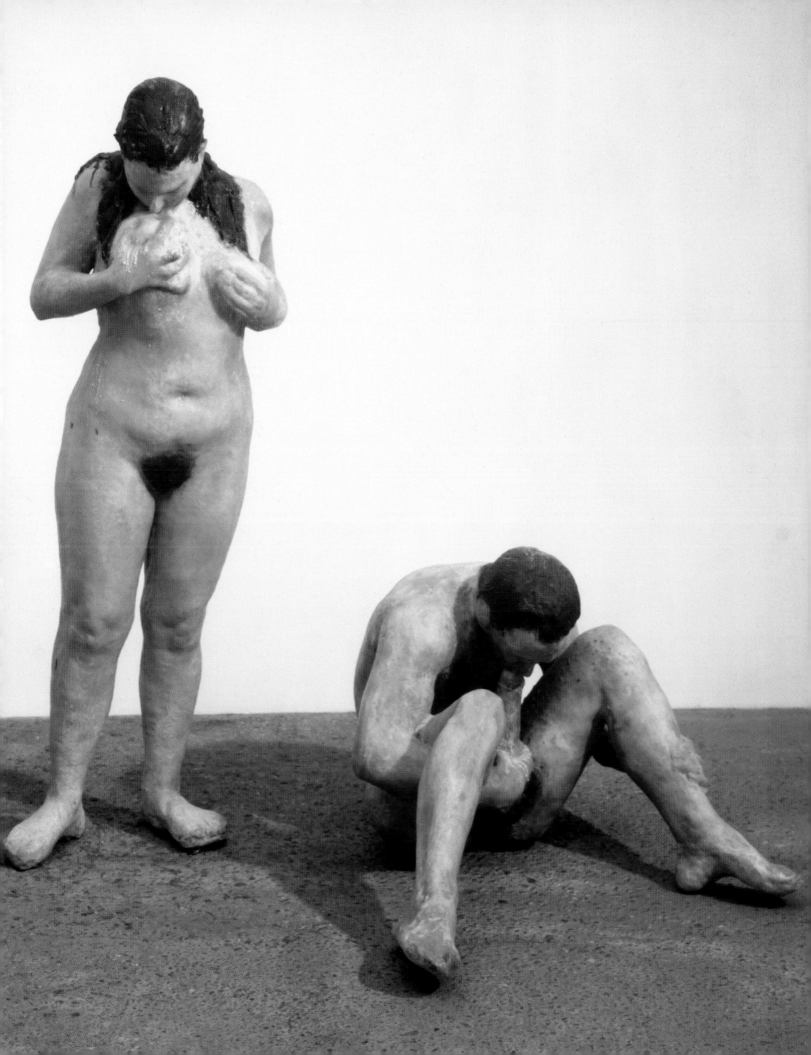

. . . I think I chose the body as a subject, not consciously, but because it is the one form we all share; it's something that everybody has their own authentic experience with. I try to make my work a kind of mantra—keep it fairly neutral—like something one can circle around, fill with their own lives. It's not didactic, telling people how they should think. It's more like opening a can of worms. All the life that happens between the tongue and the anus. It's opening up a situation.

I basically live in one culture. I want to make things that don't exclude and sometimes are informative— like how much skin surface there is, or how much blood there is, in the body—show it to people, make it physical, then they can think about what it means in their lives. As a child, I felt locked out of access to information. I didn't understand how anything worked. I wasn't asked to raise questions, so I never knew how you were supposed to find things out. So I want my work to demystify rather than mystify situations, to make things accessible to other people, experientially accessible. FROM **ROBIN WINTERS** "AN INTERVIEW WITH KIKI SMITH,"

1990 IN *KIKI SMITH* (AMSTERDAM: ICA AMSTERDAM AND SDU PUBLISHERS/THE HAGUE, 1990)

opposite page: **Untitled,** 1995 brown paper, methyl cellulose and horse hair
134.6 x 45.7 x 127 centimeters / 53 x 18 x 50 inches

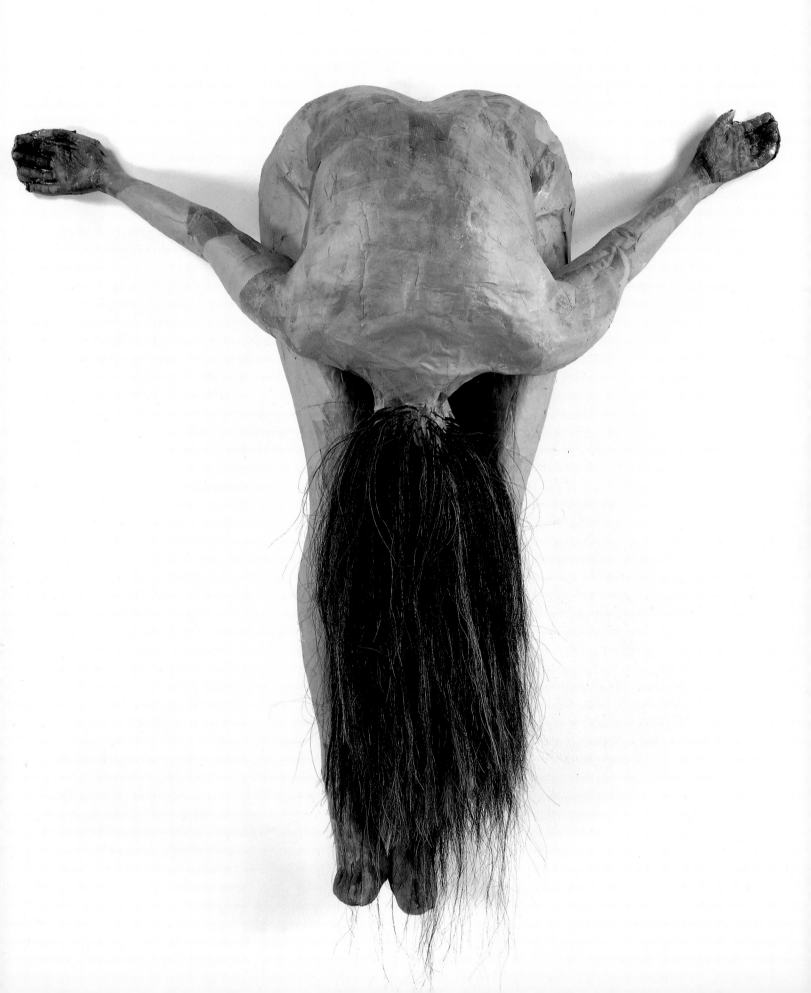

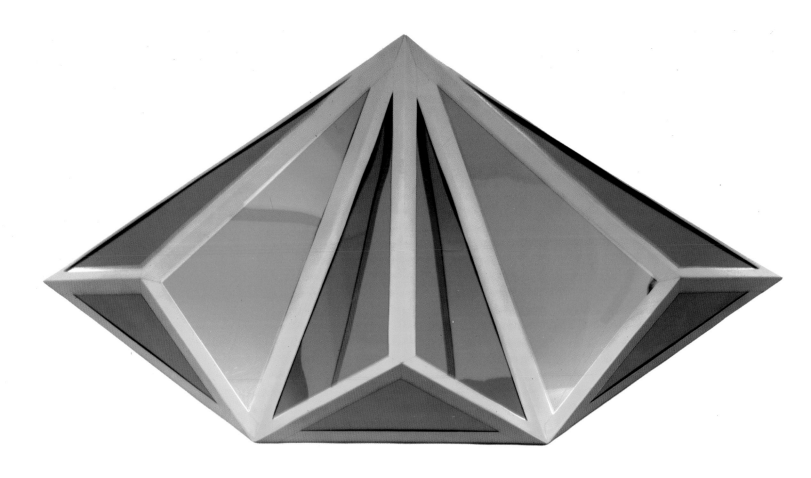

Robert Smithson

Born: Passaic, New Jersey 1938 / Died: Amarillo, Texas 1973

Untitled, 1964 yellow metal frame, blue plastic mirror 115 x 202 x 25.5 centimeters / 45 x 79 1/2 x 10 inches

PHOTO: ESTATE OF ROBERT SMITHSON

ROBERT SMITHSON: People who defend the labels of painting and sculpture say what they do is timeless, created outside of time; therefore the object transcends the artist himself. But I think that the artist is important, too, and what he does, the way he thinks, is valuable, whether or not there is any tangible result. You mainly follow a lot of blind alleys, but these blind alleys are interesting.

ANTHONY ROBBIN: *It isn't so neces-sary for the artist to render this chaos into form so much as to ex-pose the fact that . . .?*

RS: It's there.

AR: *Yes. Not only that it's there, but that he is dealing with it, manipulating it, speculating about it.*

RS: That he is living with it without getting hysterical, and making some ideal system which distorts . . .

AR: *Not making an ideal system, but at the same time making some system . . .*

RS: Yes. But even some system tells you nothing about art.

AR: *Tentative and transient as it is. It's not enough for him not to do anything.*

RS: I feel that you have to set your own limits . . .

AR: *And the self-aware setting of limits is close to the center of it all?*

RS: Yes. I think the major issue now in art is, what are the boundaries. For too long artists have taken the canvas and stretchers as given, the limits.

AR: *The motivation for doing that is not to expand the system?*

RS: I'm doing it to expose the fact that it is a system, therefore taking away the vaulted mystery that is supposed to reside in it. The articfice is plainly an artifice. I want to demythify things.

AR: *People will be frustrated in their desire for certainty, but maybe*

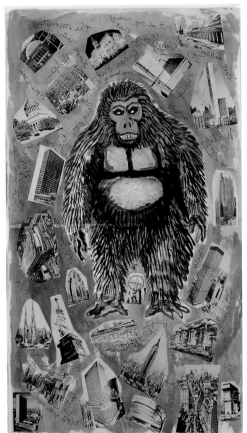

they will get something more after that frustration passes.

RS: Well, it's a problem all the way around, and I don't supect we will work our way out of it.

FROM "SMITHSON'S NON-SITE SIGHTS: INTERVIEW WITH ANTHONY ROBBIN," *THE WRITINGS OF ROBERT SMITHSON*, ED. NANCY HOLT (NEW YORK: NEW YORK UNIVERSITY PRESS, 1979)

It's King Kong the Monster, 1963–64
pen, gouache, photo on paper
90.2 x 52.1 centimeters /
35 1/2 x 20 1/2 inches

Pia Stadtbäumer

Born: Münster, Germany 1959 / Lives and works in Düsseldorf, Germany

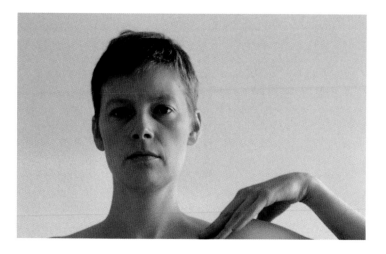

The works of Pia Stadtbäumer are . . . characterized by clear references, both to the tradition of a humanistically influenced bodily awareness and to the changed conditions of perception of contemporary artistic concepts. Thus her sculptures develop an inner tension from the dialectical relationship of their link to empirical perception and to the autonomous artistic idea subordinate to it, which is not based on the objectivization of an abstract conception of body, but on bodily awareness as a naturally given condition of being.

Pia Stadtbäumer makes her sculptures according to traditional methods, producing casts from modeled forms. The modeling of the figures, or figure fragments, is based on pictures in the strict sense of the word, as she does not work directly on models but from photographs. This procedure appears more important for the creation of the artistic form than for the viewing of the sculptural form, insofar as it denotes a first level of distancing from the portrait character of the representation. Photography enables the statuary fixing of a physical state in a relatively limited period of time, remaining available during the entire sculptural process. Concentration on a specific corporeal conception, which had already been decisive for the choice of the model, is subject therefore not to the respective external influences that could influence the physical state of the model. The manual process of modeling, which is clearly evident when viewing the sculptures, thus becomes a conscious contradiction of the artificiality of hyperrealistic casts. That is, the technical perfection of the mechanically reproduced representation of reality is for Pia Stadtbäumer a pragmatic means that creates the space in which the distanced conception of physical individuality can push outwards.

FROM **ULRICH WILMES**, "ANDROGYNOUS CONFIGURATIONS," *PIA STADTBÄUMER* (MÜNICH: LENBACHHAUS KUNSTFORUM, 1993)

opposite page:
Androgyne, 1993
wax, pigment (two figures)
185 centimeters /
72 inches

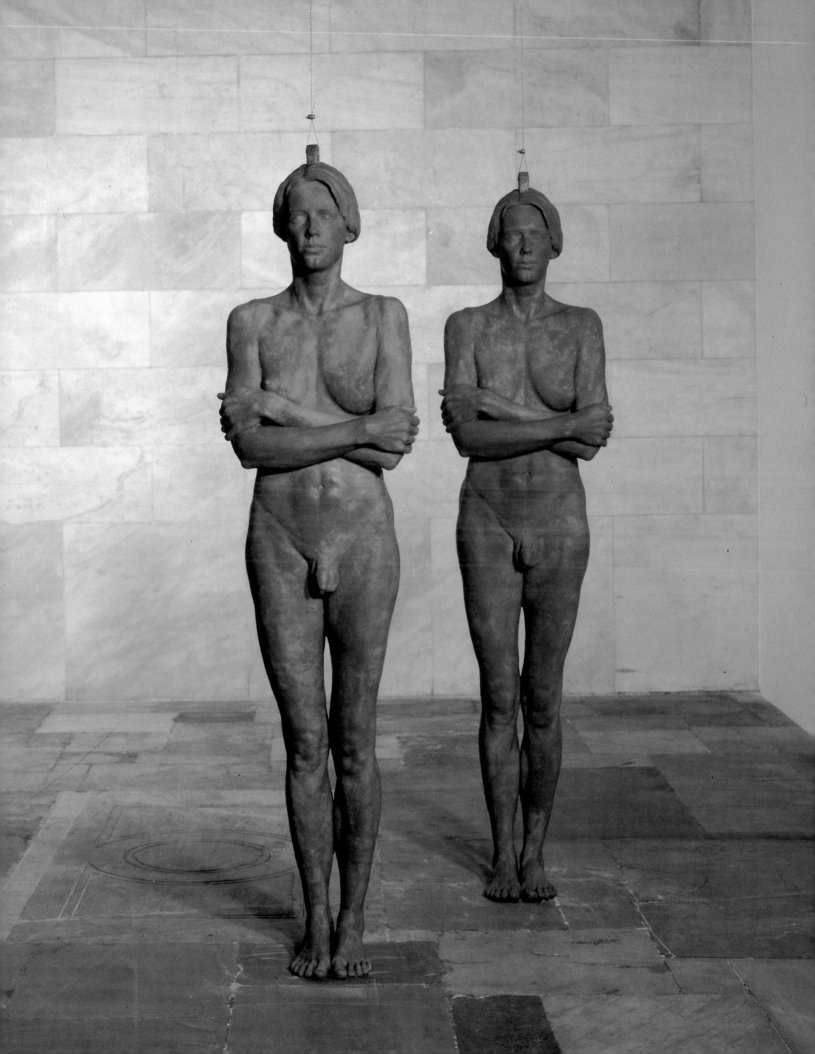

Haim

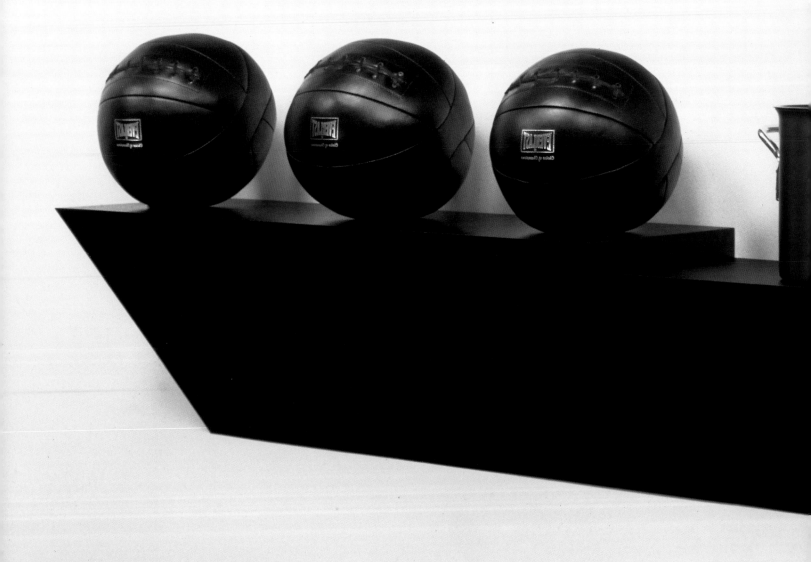

Steinbach

Born: Rechovot, Israel 1944 / Lives and works in New York City

one minute manager no. 3, 1989
mixed media 72.4 x 266.7 x 35.6 centimeters / 28 1/2 x 105 x 14 inches

I like looking at objects,

PHOTOS: ARI MARCOPOULOS

selecting them and placing them in groups made up of singularities and repetitions. People speak through objects. In a society there are collective cultural desires based on the exchange of objects between people, which translate into a language.

By placing and juxtaposing objects I try to engage ideas about positions and projections. Numerical games of units that stress similarities and differences between objects may be employed. Being an artist, my strongest means toward this end are visual devices that translate the art of looking. At the same time, cultural, social, psychological and philosophical languages must be negotiated in the resolution of a particular work.

I believe that everyday objects produced by our society may be turned into objects of desire more than one time. By juxtaposing objects of various types, myths which overdetermine the objects' identities may be broken. At the same time, by underscoring the aesthetic and transcendental dimensions of objects, a discourse may be taken to the level of their functions. 1994

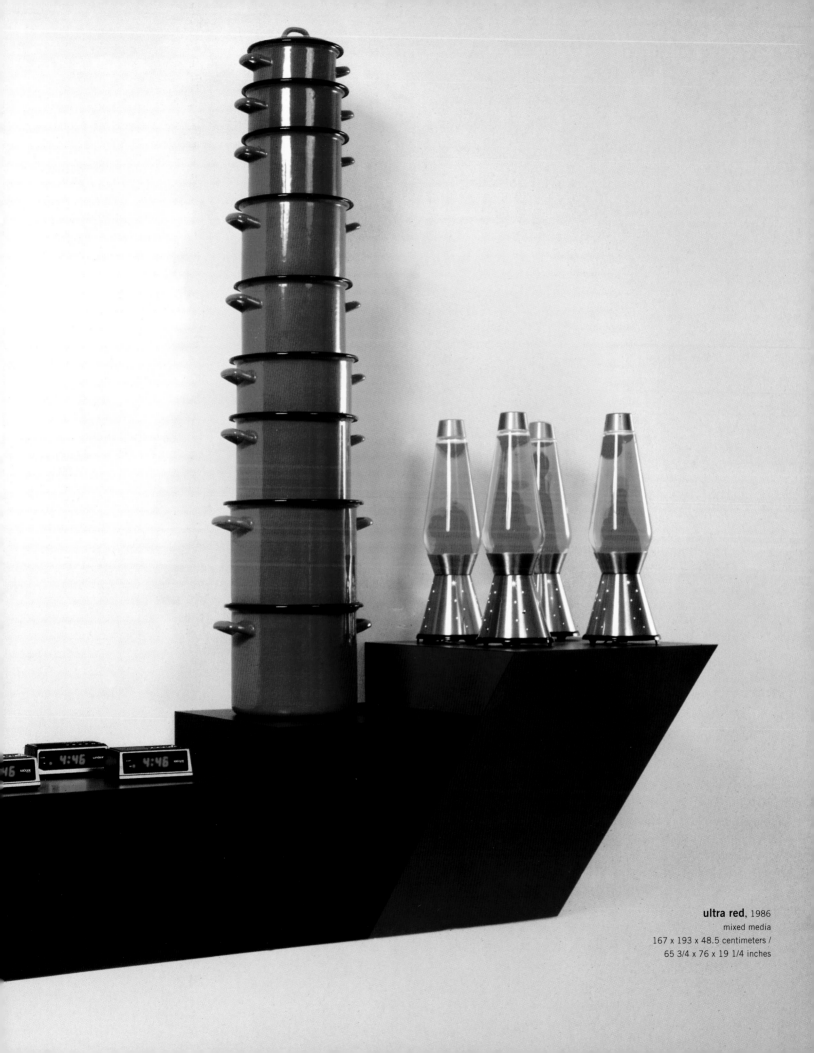

ultra red, 1986
mixed media
167 x 193 x 48.5 centimeters /
65 3/4 x 76 x 19 1/4 inches

Philip Taaffe

Born: Elizabeth, New Jersey 1955 / Lives and works in New York City

PHILIP TAAFFE: [Decoration and pattern] is an important issue for me and I haven't talked very much about it before, partly because I'm not sure how to enter into a discussion that reflects what is going on in the paintings. Very often the paintings contain elements from decorative sources, and yet I hope that the character of the final work assumes much more than the sum of these constitutive elements. I love to look at decorative art. I have a collection of books and other material concerning the decorative arts. I always enjoy going to museums of decorative art wherever I visit. I look very closely at architectural decoration and the design of public spaces, gardens. . . . But from another artistic point of view, in Béla Bartók's music, for example, the uses of folk art or what one might call local melodies in his compositions are put through his own psychic filter, so that they become deeply expressive and meditative. Of course, it's not a question of applying decoration or applying a folk melody in a certain pattern. It's a matter of researching the melody, of repeating it to oneself, and trying to understand the lived reality out of which this imagery came. And then to form a statement that allows these melodies to speak for themselves, in all of their vitality and beauty, but using at the same time another voice that says something that the decorative, in the ordinary sense, just could never say. Decoration is usually derived from a local, natural situation; it can epitomize the lush quality of, let's say, palms or lotus flowers or jungle overgrowth. Decoration in this folk sense is a kind of culturalized representation of nature. It's closest to the raw elements that reflect a very specific geographical location in historical time. The importance of it for me is that I can have these circumstances of time and place in crystalline

PHOTO: ARI MARCOPOULOS

form, and I can feel those realities, feel the history that they would inevitably speak about in this natural cultural sense. It would be presumptous to say that I go beyond that or transcend them, because I really don't consider that it's just decoration and that I am merely interested in transcending its meaning as decoration. I primarily want to feel the living reality of these elements, and to respond to them in a personal way by making a composition that allows these other voices to speak again in a way that I've understood and responded to. These voices are part of this lived experience represented by decoration, and I would like those voices to share a dialogue with the formulations that I produce. The fact that one can repeat something in order to achieve a dynamic synthesis, a sort of crescendo of decoration having this possibility of tempo, change and restructuring—means that these voices can be amplified and joined together in a way that I couldn't have anticipated. And I want to see, I want to hear, I want to experience this. **I make decisions on the basis of what I want to experience, and how I feel this relates to my own life and what I have imagined is the lived experience that generated these images and decorative fragments.** I don't use them only because they're interesting or exotic forms, or because they can be used in a certain way structurally or formally. It's always a matter of feeling the intention or desire behind them, and shaping something out of that enthusiasm, that passion.

FROM AN INTERVIEW WITH SHIRLEY KANEDA, *BOMB*, SPRING 1991

opposite page: **Reliquary**, 1990–1991
mixed media on canvas 230 x 282 centimeters / 89 3/4 x 110 inches

Takis

Born: Athens, Greece 1925 / Lives and works in Paris

PHOTO: K. IGNATIADIS

Takis is working with and expressing in his sculpture thought forms of metal—Silent flowers twist in mineral pollenization—And you hear metal think as you watch disquieting free-floating forms move and click through invisible turnstiles—Cold blue mineral music of thinking metal—You can hear metal think in the electromagnetic fields of Takis sculpture:
—Walked out in your brain—Free-floating forms moving flesh—Wind through the cables—Cold mineral music moved the spine hatching blue twilight where time stops drifting in statehouses—Sculpture thought forms leave a wake as you watch the disquieting ventriloquist dummies click through invisible turnstiles the heavy thinking metal—Takis is working with locks and motors—You can hear weather maps arranging The American Dawn of Terminal Blue Twilight—(Time out in flesh memories and wan light)—He came to Blue Junction in his sculpture—Thought forms composite being—Think as you watch the disquieting assassins wait skid row—Street boys caught in data and thinking metal—Blue heavy silent streets in your brain—You can hear metal caught in the turn for position—Free-floating forms move and click in the long slot—Cold mineral music of The Silent People—Blue twilight where Time in a vast knife fell—High Note tinkling through his sculpture in a heavy blue mist as you watch the disquieting Insect People click through invisible turnstiles the white-hot thinking metal—Heavy the judge and many light-years away—
This text was prepared by folding the opening paragraph down the middle and passing it through some texts I had written on a planet of heavy blue metal—WILLIAM BURROUGHS, PARIS 1962

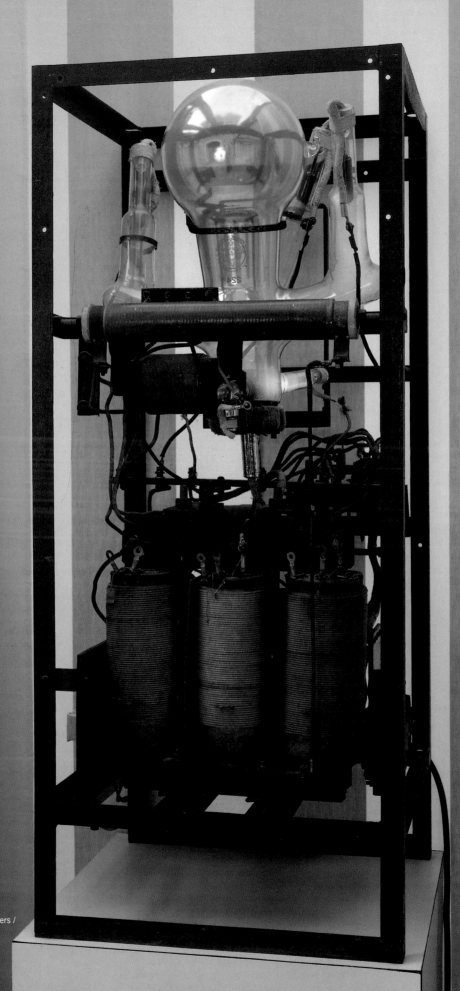

Télélumière, 1961
mixed media 110 x 50 x 50 centimeters /
43 x 19 1/2 x 19 1/2 inches

Wolfgang Tillmans

Born: Remscheid, Germany 1968 / Lives and works in London and New York City

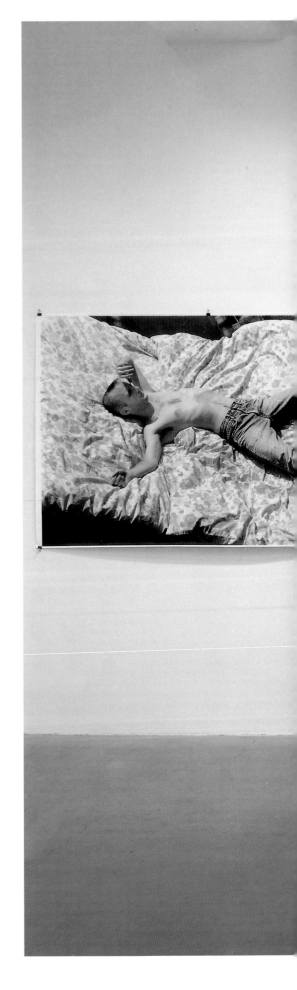

On a Sunday afternoon in 1993 I went down to the record shop and bought the new 12-inch "I Feel It" by Moby. Later that day I told my friend Lutz how much I would like to meet with Moby; his 1991 song "Go" and its dozens of remixes left a huge impression on me. The next day Matthew from *i-D* called to ask if I was interested in taking a picture of Moby for the magazine . . . When Moby came around to my house a few days later I didn't have a specific idea for the picture, but I collected a chair and this fabulous duvet from our prefurnished apartment and put them on the rooftop, hoping that Moby would respond well to this situation. He turned out to be a real roof freak. After running up and down the slate tiles, leaning over the void below the building, sitting on top of the tallest chimney, sticking his leg into another chimney, I could finally suggest to him to relax and lie down on the duvet.

All I can really do when making work is to create situations and choose people who have a positive sense of a physical existence beyond their own control. In these moments I allow for my own insecurity to become noticeable, which somehow puts sitter and photographer into the same emotional boat.

In early 1993 I convinced *i-D Magazine* to let me do a story on army clothes and their design as well as their political/nonpolitical and sexual implications. I went ahead and researched clothes, designer and army surplus, found friends who would model for it and chose my neighborhood and the seaside town of Bournemouth as the appropriate locations. To play with the contradictory potential of fashion photography, I contrasted the pants with Birkenstock sandals and two scarfs by artist Rosemarie Trockel turned into an apron, worn on a topless woman with no standard model figure, smoking in a calm and strong gesture in the middle of the road. The woman of color wearing an apron with white babies printed on it, added to a number of details and comments knowingly and unknowingly built into this picture. Then the traffic lights changed and a Rolls Royce pulled up, completing the frame.

When in Berlin on an assignment in November 1992 I stayed with my sister, who had given birth to her first son a couple of weeks earlier. For me it was the first chance to intimately see a mother and child at such an early stage. In particular, watching the breast-feeding was a fantastic experience. My sister and I were joking about the size of her breasts, before she showed me how a jet of milk can be squeezed from them.

MARCH 1995

from left to right: **Moby (lying)**, 1993
bubble-jet print, 119.4 x 179.1 centimeters / 47 x 70 1/2 inches
Corinne on Gloucester Place, 1993
bubble-jet print, 180.3 x 177.8 centimeters / 71 x 70 inches
milkspritz, 1992
bubble-jet print, 119.4 x 177.2 centimeters / 47 x 69 3/4 inches

Rosemarie Trockel

Born: Schwerte, Germany 1952 / Lives and works in Cologne

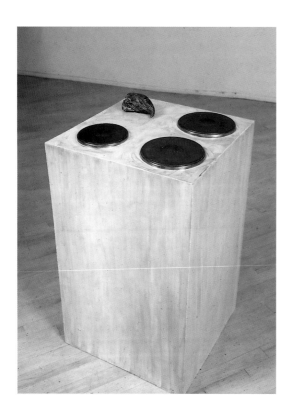

JUTTA KOETHER: *We have reached a pluralistic phase of art where everything is allowed. Countless currents and trends exist side by side. Should an artist not even more urgently set out the formal boundaries for his work?*

ROSEMARIE TROCKEL: It isn't important to set out limits for yourself. What is more important is to make clear the ideas you are dealing with. I work within an integrated structure. Now and then I produce pictures, sculptures and objects, and I consider it important (in order to make my position clear) always to return to the main lines I very often depart from. I don't believe that an artist should give explanations, we musn't understand art that way. However, things must be set within a totality which doesn't leave any doubts about their direction. Frankness does not imply interchangeability.

JK: *What demands do you make on your work?*

RT: That I don't get lost in frivolity, and that my assertions—every stroke is one—should be understood.

JK: *Do you consider an attitude of opposition to be a component of art?*

RT: Of course. But facing every artist is the paradoxical task of achieving beauty without gloss.

PHOTO: B. SCHAUB

JK: *What is the relation between you and the "models" of modern art as far as the question of artistic conduct is concerned? I refer, for instance, to Duchamp's* Negation of Art as Life-Work *or, at the opposite pole, to Joseph Beuys's* Enlargement of the Conception of Art in Social Sculpture.

RT: Unfortunately, there are too many cases that have shown the historical models were only used and consumed to bolster the theories of younger artists. For me and in my position as a woman, it is more difficult, as women have historically been left out. And that's why I'm interested not only in the history of the victor, but also in that of the weaker party. FROM **JUTTA KOETHER**, "INTERVIEW WITH ROSEMARIE TROCKEL," *FLASH ART*, MAY 1987

Untitled, 1987
iron, electric burners, enamel paint, plaster with patina
50.2 x 50.2 x 88 centimeters / 19 3/4 x 19 3/4 x 34 3/4 inches

right: **O.T. (Fleckenbild)**, 1988 (detail)
wool 160 x 360 centimeters / 62 1/2 x 140 1/2 inches

Born: Caracas, Venezuela 1960 / Lives and works in New York City

Meyer Vaisman

I am not crazy

Following is translation of an excerpt of an e-mail that
moreno@CRT.UMontreal.CA sent to spy@pipeline.com on Thur, 30 Mar
1993 at 12:34:46 to which moreno@CRT.UMontreal.CA attached a message
posted in soc.culture.venezuela by vidale_c@lai.su.se on Mon, 9 Jan 1995
at 11:09:34 in response to a message posted by malo@tukki.jyu.fi in
soc.culture.venezuela (time-date stamp undefined) that described his life with
a lesbian chicken years ago in Barcelona, Spain; not Barcelona, Venezuela.

I remember that a few several years ago, the Moscow Circus (still Soviet)
toured Latin America, bringing with it its best animal acts. One of those
acts was a chicken that danced the ballet "The Death of the Swan"; it was
her masterpiece. The little chicken collected tumultuous applause in Rio de
Janeiro, Buenos Aires, Santiago de Chile, and in other major capitals.
Everything was a big success: invitations, prizes, flower bouquets and
excited crowds, until the circus arrived in Lima, Peru.

There, on the first performance, the chicken did wonders of corporeal
expression to such an extreme that a journalist wrote the following in his
notebook: . . . then, when the chicken reclined her graceful neck at the
supreme moment of death, the Universe seemed to stop for an instant and a
barely perceptible gasp escaped from one thousand throats choked by an un-
definable emotion. At last. At last! The genius of Tchaikovsky had found a
faithful interpreter in that sublime ballerina that could translate for the hearts
of the Peruvians the sweetest and most painful notes of the Russian souls. . . ."

Anyway, that same night, someone squeezed into the circus tent and took
Chicken Nicolaieva. The police investigations did not turn up any clues and
neither did the offer of $10,000 that the circus made as a reward for its
ballerina. Apparently, it wasn't a kidnapping. Nowadays, after some years,
Peru's Civil Guard suspect that Chicken Nicolaieva was eaten for lunch or
dinner by a poor Peruvian, a victim of unemployment, hunger, and misery.

When I read the news on this event, I felt an indescribable revolutionary
emotion, a happiness that was sincere and filled with a sense of fraternity.
Chicken Nicolaieva had fulfilled its communist destiny in a perfect and
consequent manner. With her magnificent dance she managed to move the
hearts of the people and united their souls with more efficacy than one
thousand Peace Ambassadors or one thousand Heads of State; and with her
death, she had contributed to placating the hunger of an obscure proletarian
family, which in turn, for an instant in its life, had enjoyed the privilege of eating

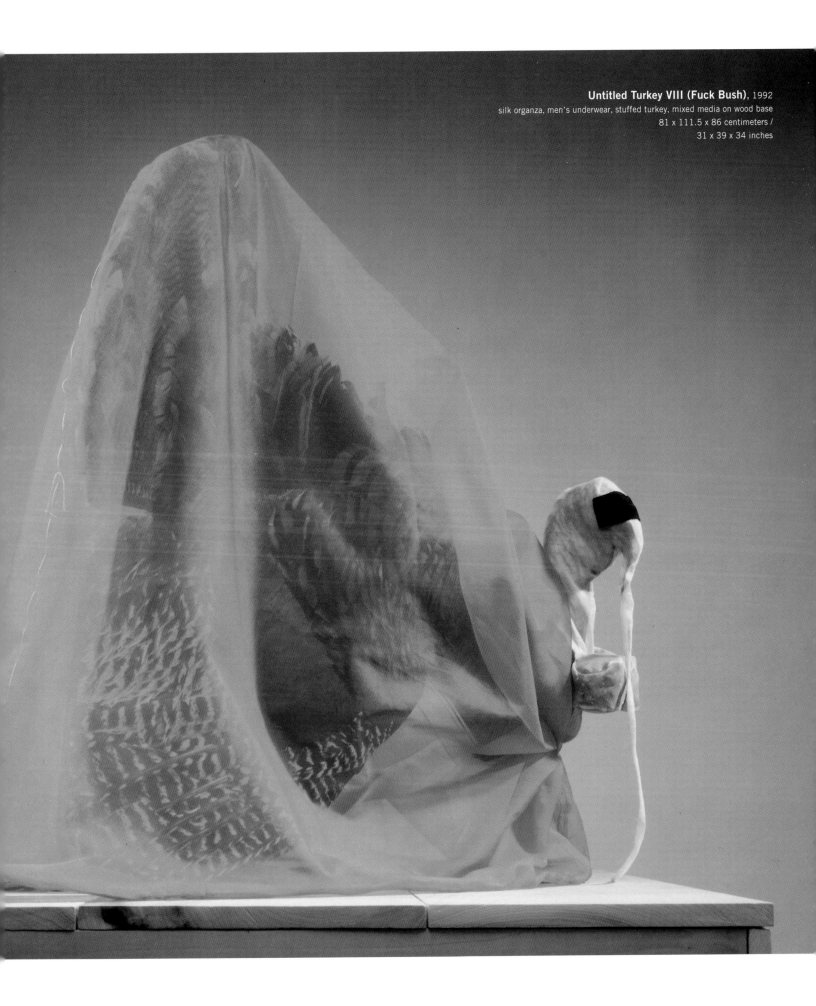

Untitled Turkey VIII (Fuck Bush), 1992
silk organza, men's underwear, stuffed turkey, mixed media on wood base
81 x 111.5 x 86 centimeters /
31 x 39 x 34 inches

a glorious ballerina. A feast of Gods—Wasn't it a symbol; a prophetic sign of the glorious future that awaits the pariahs of this earth?

Blessed are the poor. . .

Years have gone by, and none of this seems to have any relevance. No one remembers Tchaikovsky. The swans die under the bombardment of Grozni, of Sarajevo, and the poor are forbidden from eating chicken, and the circus has been shut down because of the bombs, or because everyone has gone to buy futures in the stock market.

But here we have a friend in Finland who has taken the time to remind us that life is not only horror, nor war, nor hatred, nor blind and brutal violence. Instead it is in the sincere, frank, and tolerant friendship between man and chicken. It makes little difference if the chicken is a ballerina, or a communist, or a lesbian or whatever. Once you have come to understand her, you have also come to understand a little piece of the enigma of the Universe; and then you will be better and wiser and you may even aspire to acquire the sublime right to eat the chicken, so it may, while you live, be flesh of your flesh and soul of your soul.

Small Death, 1987 process inks and acrylics on canvas
247.7 x 311.2 x 24.8 centimeters / 98 1/2 x 122 1/2 x 9 3/4 inches

above: **The Whole Public Thing**, 1986
process inks on canvas and toilet seats
45.7 x 177.8 x 177.8 centimeters /
18 x 70 x 70 inches

following page: **In the Vicinity of History**, 1988
process inks and acrylics on canvas
243.8 x 438.2 x 21.6 centimeters /
96 x 172 1/2 x 8 1/2 inches

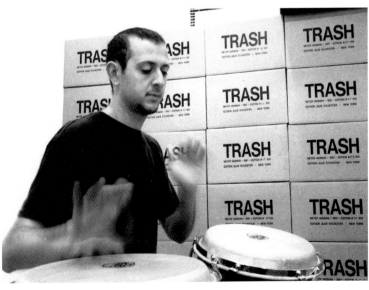

Jan Vercruysse

Born: Elisabethville, Zaire 1948 / Lives in Rome and works in Europe

In the art of the still life, objects devoted to death acquire a splendor that can only live in images. Still lifes grant an independent meaning to death, devoid of all religious-moralistic effect.

Jan Vercruysse's oeuvre is an art of still life. Not sculpture, but a staged *nature morte*. The still life has lost track of the world. It creates a space of art and for art that excludes life. In it, absence is present: a dual void. Vercruysse formulates the traditional relation art/life and art/world in a negative fashion. He presents the space of art as atopia, thus stating that art has a place or takes a stand neither within nor with respect to the world. Atopia, as a concept, offers resistance to the positiveness of utopian thinking.

His work says: "I indicate how the world could be visualized, but the moment this is likely to happen, I withdraw." Art that divulges the impossibility of realizing the *disegno interno*. This narcissistic gesture is an important one. It has nothing to do, however, with the artist himself (this is no psychological narcissism), but with artisthood itself, which prevents him from taking part in life.

SELF-PORTRAIT III, 1984

Art is on death's side.

FROM **MARIANNE BROUWER** "PRÉCIS DE DÉCOMPOSITION," *JAN VERCRUYSSE* (BRUSSELS: PALAIS DE BEAUX-ARTS, 1988)

Atopies IX, 1986
wood 2 panels each 200 x 100 centimeters / 78 x 39 inches
fireplace: 117 x 130 x 35 centimeters /
45 1/2 x 50 3/4 x 13 3/4 inches

Wallace &
Donohue

Geralyn **Donohue** Born: Staten Island, New York 1959 / Lives and works in New York City
Joan **Wallace** Born: New York City 1959 / Lives and works in New York City

GERALYN DONOHUE: As far as our work itself is concerned, we provide built-in stage directions for the viewer.

JOAN WALLACE: The relationship between our titles and the paintings is also something we think about. Sometimes it's literal, sometimes literary: it's very much based on impressions—what strikes the viewer as he or she looks at the painting. We've been thinking about what the resonance of the relationship is as opposed to rationalizing what the paintings are about.

GD: We're very interested in the associational.

JW: Our approach evokes the frustration involved in something like trying to activate an intransigent set of knowns.

GD: We're all familiar with the conventions of painting, and we recognize those conventions as our given set of limits. But with our work, absurdity surfaces in something like the activity of staging events on a platform of nothingness.

JW: I'm thinking of the title, THE OBDURATE FORTITUDE WITH WHICH OUR SLENDER INNUENDOS BECOME FATUOUS. It confesses the mode in which an object seems to usurp itself in terms of its own materiality or its own lack of dialectical resilience (or the viewer's lack, for that matter). It's just one more facet of our frustration in front of the problem of making thought processes visible.

GD: What a quaint idea. [laughter]

JW: If we consider the notion that language exists in an autonomous and circuitous entropic state, seemingly impervious to even our best intentions (laughter)—let's just say that's the extreme state of things, held up as a model for thinking about work—and what we've tried to do is to put a strain on the concept of "no referent."

GD: When we first started, we were thinking about authorship. Working with two people starts to dissolve the author. [laughter]

FROM "TALKING ABSTRACT," *ART IN AMERICA*, DECEMBER 1987

PHOTO: BRAD TRENT

The Painting Speaks, 1988
oil on canvas with wood microphones, mixers and amplifier
183 x 243.8 x 91.4 centimeters /
72 x 96 x 36 inches

Pool Ladder Painting, 1985
latex on canvas, stainless-steel pool ladder
251.5 x 152.4 x 81.3 centimeters /
60 x 99 x 32 inches

Nari Ward

Born: Kingston, Jamaica 1963 / Lives and works in New York City

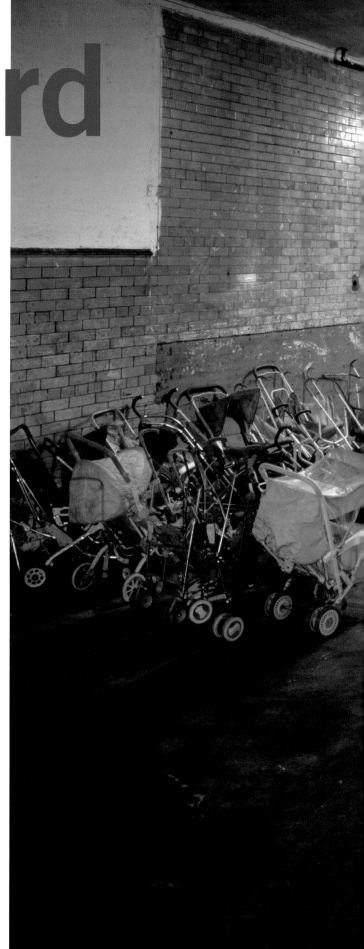

The greatest challenge for me is to enliven my vision to allow the viewer access on numerous levels. Thus I hope to create a work that becomes a vessel for an individual's emotional and spiritual growth. The environment in which the work is presented is an integral axis for its conception.

AMAZING GRACE

was first conceived of and installed in an old firehouse in Harlem, N.Y.C. It conjures many references, personal as well as social, and in doing so affirms the common trust we have between ourselves and others. 1995

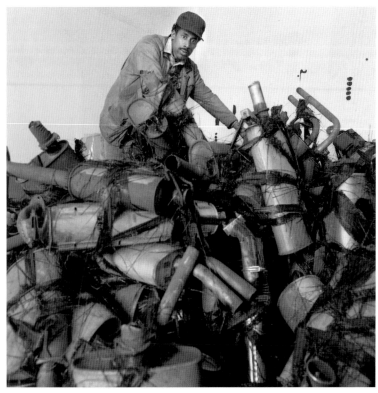

PHOTO: JACK MANNING, NYT PICTURES

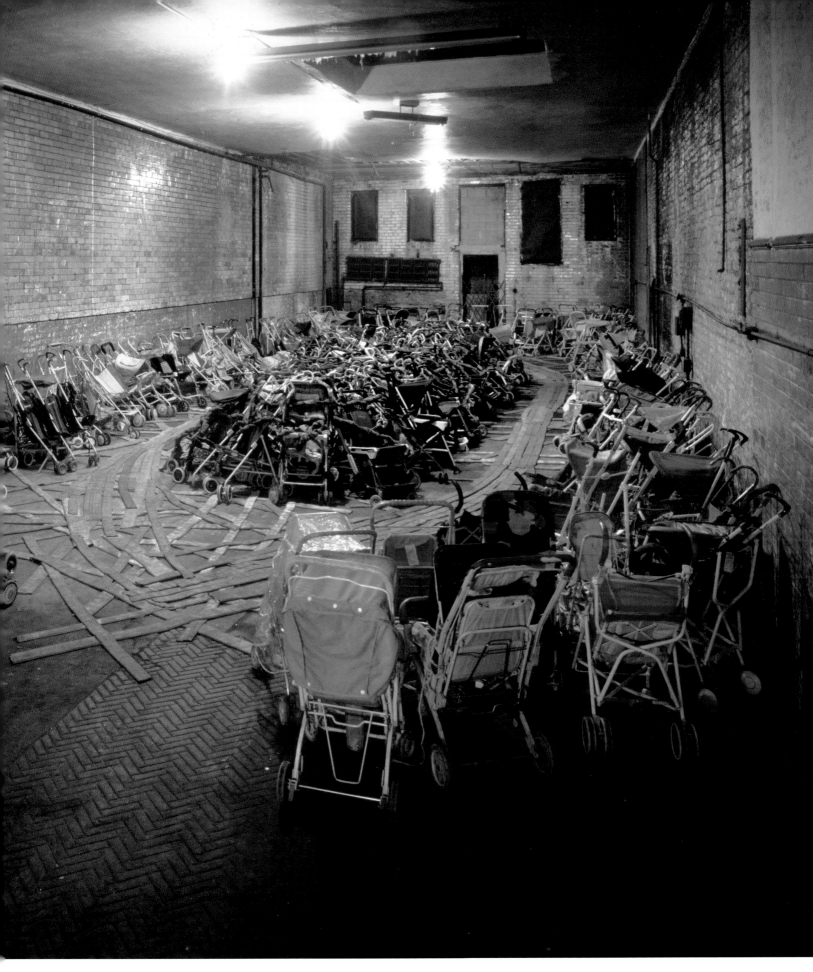

Amazing Grace, 1993, abandoned baby strollers, firehose, audio-recording dimensions variable

Andy Warhol

Born: Pittsburgh, Pennsylvania 1928 / Died: New York City 1987

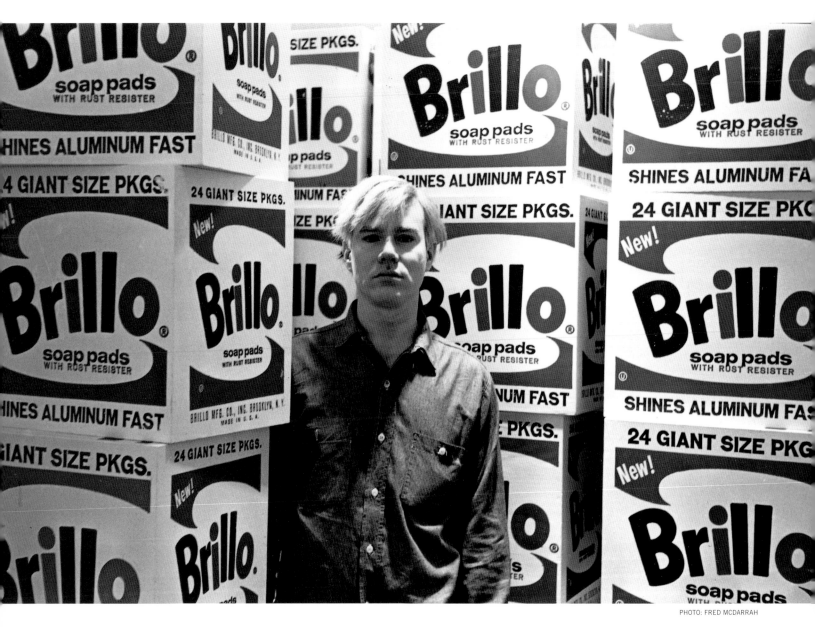

HIGH TIMES: *How did you get the idea to make Brillo boxes?*
ANDY WARHOL: I did all the [Campbell's soup] cans in a row on a canvas, and then I got a box made to do them on a box, and then it looked funny because it didn't look real. I have one of the boxes here.

I did the cans on the box, but it came out looking funny. I had the boxes already made up. They were brown and looked just like boxes, so I thought it would be great just to do an ordinary box.
HIGH TIMES: *Did you ever hear from Campbell's or Brillo or any of the manufacturers whose products you painted?*
ANDY WARHOL: Brillo liked it, but Campbell's Soup, they were really upset . . .

FROM **GLENN O'BRIEN**, "INTERVIEW: ANDY WARHOL," *HIGH TIMES*, AUGUST, 1977

24 GIANT SIZE PKGS.

New!

Brillo®

soap pads
WITH RUST RESISTER

24 GIANT SIZE PKGS.

New!

Brillo®

soap pads
WITH RUST RESISTER

BRILLO MFG. CO., INC. BROOKLYN, N.Y.
MADE IN U. S. A.

SHINES ALUMINUM FAST

Brillo Box, 1964
silkscreen ink on wood
43.2 x 43.2 x 35.6 centimeters /
17 x 17 x 14 inches

Christopher Wool

Born: Boston, Massachusetts 1955 / Lives and works in New York City

What an all-star lineup!

INSOMNIAC,
PESSIMIST,
COMEDIAN,
AMNESIAC,
HYPOCRITE. Of the lot, it's safe to say these works by Christopher Wool best capture the club's trademark atmosphere of clenched-teeth bravado and vampire charm, each an uncanny likeness of howling poverty parading as regal austerity. His is a gangster aesthetic: grim, business-like, poker-faced, blunt. Yet despite their impersonal, all-caps delivery, Wool's flat declarations harbor a trace of insincerity, hesitation, even panic, as if lurking behind their tight-lipped facades were something like a wink, a tip-off to viewers of some colossal unfolding scam. This is art with a gun in its back.

Which only means Wool's paintings address a universal experience—that familiar feeling of being interrogated and blackmailed.

PRANKSTER,
CHAMELEON,
TERRORIST,
SPOKESMAN.

BILLBOARD: GRAZ, AUSTRIA 1992

A portrait of the con artist as a young man. Wool approaches his subjects with a nasty blend of defensiveness and aggression, as if with each painting he were entering into a cutthroat deal, quick to point the finger at suspicious behavior, introducing us to characters we both easily recognize and feel terribly uneasy being around. The resulting body of work evokes a cross between a social gathering and the F.B.I.'s most wanted list. It's a composite picture of human relations in a world organized around exploitation, in which trust and intimacy have all but disappeared, having been hounded into the most remote crevices of private experience, leaving guardedness and paranoia as the leitmotifs of all exchange, in which every conversation follows the course of a petty swindle, as secrets are no longer shared but bought and sold, acts which themselves constitute a form of self-betrayal. Are we having fun yet? FROM **LANE RELYEA**, "976-WOOL," *FRIEZE*, FEBRUARY 1995

opposite page: **Untitled (Comedian)**, 1989
alkyd and acrylic on aluminum 244 x 163 centimeters / 95 1/4 x 63 1/2 inches

A conversat

Dakis Joannou and Jeff Koons with work in progress, *Balloon Dog*, 1996.

on between

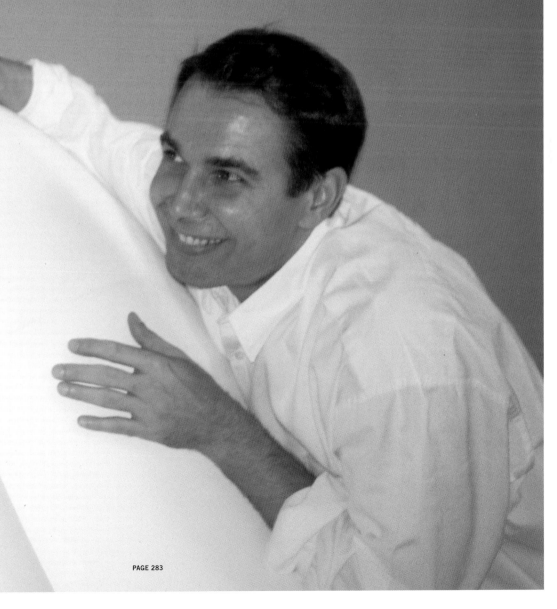

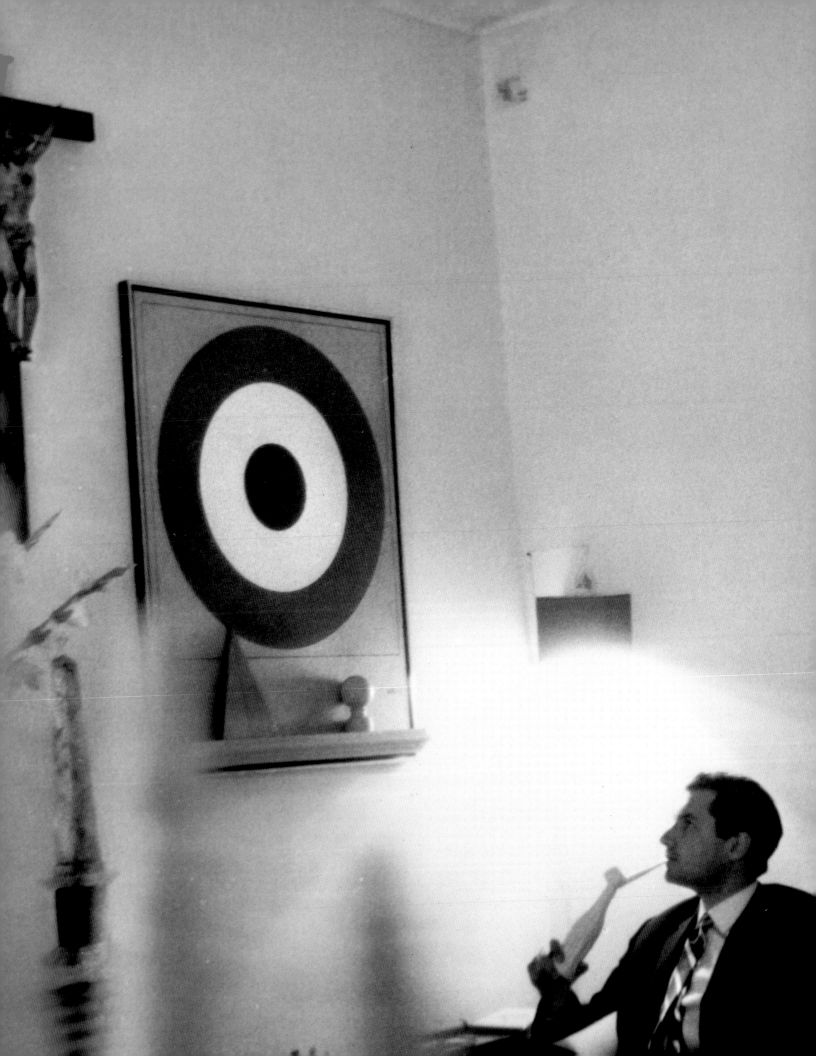

Dakis Joannou and Jeff Koons

DAKIS JOANNOU: What started my collection is your ONE BALL TOTAL EQUILIBRIUM TANK. On my first trip to the East Village in 1985, I must have seen about fifty galleries, but what really stood out was your work. Seeing the EQUILIBRIUM piece for the first time remains one of my strongest art experiences.

JEFF KOONS: It seems a little odd that you got so excited just from a basketball hovering in equilibrium in a tank.

DAKIS JOANNOU: I got a strange feeling from the work. It had a very curious energy. It looked perfect, but at the same time it was odd, as the ball was in a totally unnatural position. It defied logic. The piece even had a classical element to it relating to the classical art of ancient Greece. It was so direct and so strong, yet so unsettling.

JEFF KOONS: So you bought the piece right away.

DAKIS JOANNOU: Yes, that's right. It was the magnetism of that piece that drew me into a totally different world. I found that world very exciting and I went right into it, to collecting.

JEFF KOONS: When did you start to collect? Did you collect when you were younger?

DAKIS JOANNOU: The collection as I understand and define it today—having a structure and a focus—started in 1985. My interest in art has always been there but this collection started the day I saw the EQUILIBRIUM piece.

It was a conscious decision. Before that, I channeled my interest in art through the activity of Deste, a foundation for contemporary art that I established in 1983. Through the foundation I worked on a number of related projects in Greece, Switzerland, and Cyprus.

JEFF KOONS: Contemporary work?

DAKIS JOANNOU: Yes. Two projects were with contemporary Greek artists. Another very ambitious project was to create a new

Left: Joannou in Rome in 1966 with Lucio del Pezzo's *Il Grande Bersaglio Tricolore,* 1964.
Right: cover of the *Cornell Engineer* designed by Joannou in 1962.

concept for a museum of contemporary art. Finally it was something that didn't quite come together. A few more projects. So I started being active in the art scene through the foundation, but not through collecting. After I started collecting, of course, things started to change. The basis of my interest became the collection. But my participation in contemporary art projects continued through the various shows that we have had with the Deste Foundation, which are generally based on the collection.

JEFF KOONS: Do you remember the first work of art that meant enough to you that you purchased it for yourself?

DAKIS JOANNOU: After my graduation from Engineering School at Columbia, when my parents asked me what I wanted for a graduation present, instead of the usual gift, I asked for a work of art.

JEFF KOONS: You studied civil engineering?

DAKIS JOANNOU: Yes. At Cornell from '58 to '62, and then my Masters from Columbia in 1964. After I finished my studies in the United States, I went to Italy where I studied architecture at the University of Rome. So I got my graduation present while I was studying in Italy. It was a work by Lucio del Pezzo, a strange piece with Pop and metaphysical references. I was influenced at the time by the Italian scene, and by Pop art. So I found it very interesting, this combination of Italian metaphysics and American Pop.

JEFF KOONS: So you enjoyed your time in New York?

DAKIS JOANNOU: Oh, yes. My God, it was incredible at that time, 1962 through 1964. Those two years were amazing. The height of Pop art; going to galleries and seeing the great shows of Warhol and Johns. Everything was totally fresh.

JEFF KOONS: So, Dakis, you're originally from Cyprus.

DAKIS JOANNOU: Yes.

JEFF KOONS: There must have been a tremendous difference between the imagery that you would have seen growing up in Cyprus and this type of Pop culture.

DAKIS JOANNOU: In Cyprus, there was really no exposure to contemporary art. We had the war against the English, so we were only thinking about the freedom of the country. There was fighting in the streets. I left Cyprus at age 15 and finished high school at Athens College. It was a great environment and it remains one of the finest educational institutions of its kind.

JEFF KOONS: Did your parents have a visual aesthetic sense? Did they collect works?

DAKIS JOANNOU: Not really. My mother had a good feeling for art. But they were never seriously involved in collecting.

JEFF KOONS: What do you think caused that original spark? I know as an artist myself, my parents encouraged my interest in art, I took lessons when I was young, and that created a little spark. Is there something that you can remember in your childhood, where this interest in aesthetics first presented itself?

DAKIS JOANNOU: As a kid, I had an obsession with designing advertisements. I was designing advertisements of Cadillac convertibles and Parker pens! That's why I keep this pen, the Parker 51. It has a very fifties design.

JEFF KOONS: Going back to our first meeting in 1985, I remember how excited I was to meet you because I had never really had a relationship with many of my collectors. And from the very beginning, right away, you invited me to come to Greece. And I know you've invited many other artists over the years also. It was an absolutely fantastic experience to be able to come over and really to be able to become friends.

DAKIS JOANNOU: Friendship and strong personal relations are central to my approach to art collecting. Collecting is not only about putting together an interesting group of works and making a statement. For me, it's also about involvement. It's about understanding and participation. It's about being involved with the dialogue of what's happening. It's a question of proposing your ideas and putting them out to be challenged, discussed, rejected, or liked.

JEFF KOONS: I know for myself the work kind of defines a reality for me.

DAKIS JOANNOU: Yes.

JEFF KOONS: So it does the same thing for you.

DAKIS JOANNOU: Well, Jeff, I am not sure what reality is anymore. Back to the collection, it is as much an emotional and instinctive process as it is rational and methodical.

JEFF KOONS: Even your boat you use as a platform for art, so that when you get together with your friends and you go out, you have the art right there.

DAKIS JOANNOU: Don't forget the name of the boat. PROTECT ME FROM WHAT I WANT!

JEFF KOONS: The name is, of course, from Jenny Holzer.

DAKIS JOANNOU: Yes.

JEFF KOONS: So when you're with your friends, automatically these ideas or this dialogue about the art is there.

DAKIS JOANNOU: That's right.

JEFF KOONS: They can react to it. How do your friends react to the art?

DAKIS JOANNOU: Well, you've met a lot of them! [LAUGHS] Some of them just rejected it totally, because they feel that the artist should be a craftsman and they don't want to hear about anything else. But others are a little more open and slowly their aesthetic changes. And I find that very interesting. Some, of course, are seriously interested in the work.

JEFF KOONS: So Dakis, the exhibitions you

Opposite page: center, detail of Jeff Koons, *One Ball Total Equilibrium Tank*, 1985; inner circle, Jeff Koons, *The New Jeff Koons*, 1980.

have organized such as Cultural Geometry, Artificial Nature, and Post Human—they have had a tremendous impact. The books that you published to accompany these shows are everywhere.

DAKIS JOANNOU: Jeffrey Deitch's essays and Dan Friedman's extraordinary design made these books great communicative instruments for the exhibitions.

JEFF KOONS: It's always interesting seeing how you live with the work.

DAKIS JOANNOU: My house functions almost like a gallery. I re-install every three to six months and we make changes all the time. So that renews my relationship with the art, the relationship of my family with the art, the relationship of my family with me. Relationships and participation are key words for me. I try to create an environment that induces relationships.

JEFF KOONS: You really enjoy living with the collection.

DAKIS JOANNOU: The work functions best when you live with it, when you're around it all the time, when the kids are around, your family, your friends. That's when the work really comes to life. It gets tired if there is not a daily dialogue with it. The work needs to communicate continuously. And it needs to communicate in an informal way. It's most effective when it's just there and you happen to be near it, and then that attracts your attention. Some works impose on you a little bit more forcefully than other works, but that's fine. So, in the home environment, the work of art almost becomes a living being.

JEFF KOONS: And Dakis, what about living with these objects? Because objects deteriorate and develop patinas.

DAKIS JOANNOU: It's more about looking at how the work grows. Some works become stronger and more interesting over time. Other works become flat. I enjoy watching how my relationship with the works changes.

JEFF KOONS: And you're very much involved with the moment. That's what you're really excited about, to participate.

DAKIS JOANNOU: Absolutely. That has always been the focus of the collection, being involved now and participating in a dialogue that is alive and relevant to our way of life today.

JEFF KOONS: What is exciting in a work of art?

DAKIS JOANNOU: Let me ask *you* that question Jeff. When you look at a work for the first time, how do you respond to it? What makes it work?

JEFF KOONS: When I get excited by a work of art, I feel that I can relate to it. Somehow I'm feeling something that's very objective about that work. And I tend to like works which I feel benefit human kind. I don't like things which are kind of ugly or which have an edge to them that is kind of sinister. I tend to like very optimistic work. So I like to think of it as objective, that the work really can relate, not just to me, but that other people looking at it are feeling the same sensation. It gives me a sense of union with other people. That's what I enjoy.

DAKIS JOANNOU: Yes, I agree. When a work is optimistic it contributes to our lives.

JEFF KOONS: Artists can make paintings and sculptures and present ideas, but through your construction business, you create these huge projects, I mean, you've built towns!

DAKIS JOANNOU: Yes, but that's different. Art is a totally personal issue. The other is business. Some businesses may be a little more creative than other businesses. But that's about it.

JEFF KOONS: As an artist, I feel that I've accomplished something just by making a structure that maybe holds together or that technically I've been able to paint on a certain canvas and it stays on there. But you've been able to engineer huge projects. Don't you find that aesthetic?

DAKIS JOANNOU: I cannot compare the two. Art is something totally personal that's inside you. It's conceptual; it's emotionally very complex.

JEFF KOONS: Dakis, I have to say I have always been amazed, because as an artist, when I look at you, you have a very accomplished life with your work, and your family. You have built a wonderful life for yourself. And then I find myself as this artist, and, well, my life just isn't quite as full. So I've always found it interesting that somebody like you would have an interest in me, when you already have a much more interesting life, in many ways, than the artists who you're working with.

DAKIS JOANNOU: Well, Jeff, I can almost reverse

the question. [LAUGHS] I am wondering . . . why would an artist, with his tremendous talent and his incredible depth and all these ideas be interested in friendship with a businessman?! [LAUGHS] So that's why, as I said before, it's really about relationships and interaction. It's about people communicating. And I value this more than anything else.

JEFF KOONS: When you show the collection in Athens now, will you design how the work will be displayed?

DAKIS JOANNOU: Sure. The design is based on two axes. One is the personal axis, which reflects my own relationship with the art. The other is the context axis, which reflects the conceptual foundation of the collection.

JEFF KOONS: Tell me about the title of the exhibition, EVERYTHING THAT'S INTERESTING IS NEW and how it relates to the collection.

DAKIS JOANNOU: I'm always drawn to the energy of the new, to identify new ideas and new ways of looking at things through the collecting process.

JEFF KOONS: One of my first bodies of work was called The New.

DAKIS JOANNOU: It all connects.

JEFF KOONS: Dakis, the collection keeps getting bigger and bigger. You continue to acquire new works. Now, how are you able to continue to have space to live with a lot of the work?

DAKIS JOANNOU: I will be enlarging my home to accommodate a lot more work than it can now. It is essential to live with the art. Then there is my new office building where I am installing numerous works. Now I am thinking of establishing a space in Athens where we can install works from the collection and do various projects. One thing I know I am not going to do is create a private museum with only works from the collection.

JEFF KOONS: You're always thinking of new ideas for the art. This is a constant process for you.

DAKIS JOANNOU: Yes. You must keep thinking of new options. You can't stop, the train must keep going.

JEFF KOONS: Art seems to me to be a more and more impractical activity, with all the different forms of communication that we have that developed as far as storing information or recording things,

duplicating things, and so on.

DAKIS JOANNOU: There is no substitute for the physical presence of art, how it energizes your senses, your mind, your feelings, your touch. You have to have a personal relationship with a work of art. It has to be physically there and you have to be physically in front of it or around it.

JEFF KOONS: Many of the things that you're interested in, Dakis, are impractical things. It's interesting that you've embraced the impracticality of art. It's impractical to have a sculpture of an elevator that doesn't work, you know.

DAKIS JOANNOU: [LAUGHS] And is too short.

JEFF KOONS: Yes, that is too short. The list could go on and on of these things that are just really . . . impractical.

DAKIS JOANNOU: Or a loom that looms dreams.

JEFF KOONS: Yes, absolutely.

DAKIS JOANNOU: Well, of course. But practicality is the last consideration. A work should communicate, should have something to say, should communicate ideas, and present itself in a way that will give you excitement. Once it does this it doesn't matter how big or how small it is.

JEFF KOONS: I'd like to come back to some of the impracticalities. When I think of Martin Kippenberger's vacuum cleaner, that's this huge, big . . .

DAKIS JOANNOU: Rubber balloon.

JEFF KOONS: Yes, a balloon. It's really quite an impractical piece, but it's optimistic in its impracticality.

DAKIS JOANNOU: The color is not optimistic, the size is not optimistic, the shape is not optimistic; but the work is.

JEFF KOONS: Yes.

DAKIS JOANNOU: Like other optimistic works, it opens some little windows into your mind or into your heart or it takes you somewhere that you have not been. It prompts you to look at issues that you have not dealt with before, and do things in a different way. A successful work of art is about life.

JEFF KOONS: Historically the collection is very much at the cutting edge of art. It's of the moment, but you have included certain historical artists as reference points.

DAKIS JOANNOU: To understand what's happening now, you really have to look at the history and see where it all started.

Duchamp's FOUNTAIN, that's really the beginning.

JEFF KOONS: Is that the oldest work in the collection?

DAKIS JOANNOU: Yes, that's the oldest reference. And then, the presence of artists like Man Ray, Andy Warhol, Vito Acconci, and Bruce Nauman enable the viewer to understand a little bit better what it's all about. I'm trying to provide some historical context. If, one hundred years from now, a museum displays your EQUILIBRIUM piece alone, what messages will it have? The same messages as it does now? It's a big challenge for me to understand how works will function many years from now.

JEFF KOONS: I hope that the works are archetypes, that they convey information that's very profound in everyone that we've been carrying around with us for centuries. So I hope they will continue to communicate what they do now.

DAKIS JOANNOU: But they're using elements that are of today, like the Michael Jackson sculpture. How will that communicate in the future?

JEFF KOONS: I think that MICHAEL JACKSON AND BUBBLES displays itself in a spiritual manner. It has a reference to a Christ-like setting. And I would hope, as with ONE BALL TOTAL EQUILIBRIUM TANK, that it would still come off as an archetype even though the basketball in EQUILIBRIUM is of our time. It's reference would still remain womblike, in this ultimate state of anti-gravity and just floating.

DAKIS JOANNOU: Right.

JEFF KOONS: I think gravity is here to stay.

● ●

JEFF KOONS: So it's 1995 and I've known you now for a decade of collecting. During this time, the things that you've spoken about, what you received from the artwork, is this changing? Is it the same as it was? Or is it different today for you?

DAKIS JOANNOU: By definition, things have changed. I am more interested in going deeper rather than broader to make a statement. But I think that's a sequence that's almost natural. At the beginning I was so

excited about what was happening and about this new world that opened for me. So, I really wanted to define that world as broadly as I could and that involved acquisitions that covered a broad spectrum of artists. I needed to be very open. But now that this statement has been made in this broader context, I want to go deeper, collecting in a more ambitious way. You were talking about scale before. I am a lot more ambitious now. At the same time, artists are doing more ambitious work. Your work is also more ambitious now in terms of scale and size.

JEFF KOONS: **It's gotten larger, not to get larger, but the images I'm working with now, this is what they really want to be.**

JEFF KOONS: **Is there any element of trying to control where new art goes?**

DAKIS JOANNOU: It is not about power and control. It's about dialogue. I don't have an attitude of trying to affect the course of art. What I do is express my ideas, make a few points, say what I have to say, and leave it at that. It's not about power. That's an attitude that I reject.

JEFF KOONS: **I think that your involvement in art gives you another way to be generous.**

DAKIS JOANNOU: Well, that's a nice way of putting it.

JEFF KOONS: **If you look back now to when you first started actively collecting, has the art world come to a point that you envisioned? Do you feel in any way let down by contemporary art, or do you feel pleased with what you've seen in the last decade of art, which you've really participated in?**

DAKIS JOANNOU: It's been more rewarding than I've even imagined.

JEFF KOONS: **Dakis, when you look over the exhibition floor plan, and you have this opportunity to see the whole collection brought together, are you pleased with the growth of it?**

DAKIS JOANNOU: Oh, I'm extremely pleased, Jeff. This idea of laying it out as a landscape rather than in a didactic chronological fashion, the interaction can be more clear and more fluid.

JEFF KOONS: **Dakis, it's a phenomenal accomplishment.**

DAKIS JOANNOU: I have to emphasize, the relationship with you, with Jeffrey, with other artists. I feel like it's more a collective work. I feel my role to be that of an integrator.

JEFF KOONS: **What demands do you feel that the art makes on you?**

DAKIS JOANNOU: To respect it and to understand it.

JEFF KOONS: **Dakis, has there ever been anything that's really been a great disappointment or a frustration that came about through the collection?**

DAKIS JOANNOU: Well, I've had some small disappointments, not big. Sometimes you see some energy there in the work of an artist, and you follow it, and then suddenly you see that things are not going anywhere. That's disappointing. And obviously, I have been disappointed several times by this kind of thing. And there are frustrations. For instance, sometimes there are several artists whose work you really feel would fit the collection, but for some reason or another, you can't get it.

JEFF KOONS: **But you've been able to acquire most things that you had an interest in, just through the excitement of artists to have their works in the collection.**

DAKIS JOANNOU: Oh yes, to a great extent. But there still have been a few frustrations, a few disappointments.

JEFF KOONS: **So Dakis, here we are in the summer of '95. What's exciting to you now?**

DAKIS JOANNOU: The most exciting thing is when you see an exciting new work, for example, seeing your new work in the studio.

JEFF KOONS: **But are there some artists who are really on the edge right now that you are interested in?**

DAKIS JOANNOU: Sure, in the course of developing the exhibition, the collection keeps expanding. I have acquired some very exciting things in the past year including Nari Ward's AMAZING GRACE, Janine Antoni's SLUMBER, and Stan Douglas's EVENING.

JEFF KOONS: **Is there a difference between the European and the American vision? You live with both European and American work.**

DAKIS JOANNOU: There are great differences. Not only between European and American work, but between the east and west coasts of the United States and northern and southern Europe. A few years ago we were all expecting the European Union to become like the United States, with a fairly homogeneous culture. But, increasing globalization has actually made us hold on tighter to our own identities. I feel more Greek now than I felt ten years ago. The more international we become, the closer we get to our roots, cherishing our separate identities.

JEFF KOONS: **If you had to define your aesthetic, Dakis, what would it be?**

DAKIS JOANNOU: Well, first of all, the work must grab you. There must be a magnetism in the work. It must communicate.

JEFF KOONS: **So communication as an aesthetic?**

DAKIS JOANNOU: Yes. That's the first thing. Then, it must have passion. It must have content. It must be charged. I am especially drawn to art that makes a statement that re-lates to our society and the way we live today.

JEFF KOONS: **Most of the works in the collection are "extroverted."**

DAKIS JOANNOU: Yes, but some—such as Robert Gober's—are not, so perhaps "passionate" is a better word than "extroverted."

JEFF KOONS: **Does passion have a color?**

DAKIS JOANNOU: [LAUGHS] Does it?

JEFF KOONS: **Yes.**

DAKIS JOANNOU: White.

Opposite page: **Clegg & Guttmann**
A Contemplation on a Bust, 1987
Cibachrome 165 x 124.5 centimeters / 65 x 49 inches

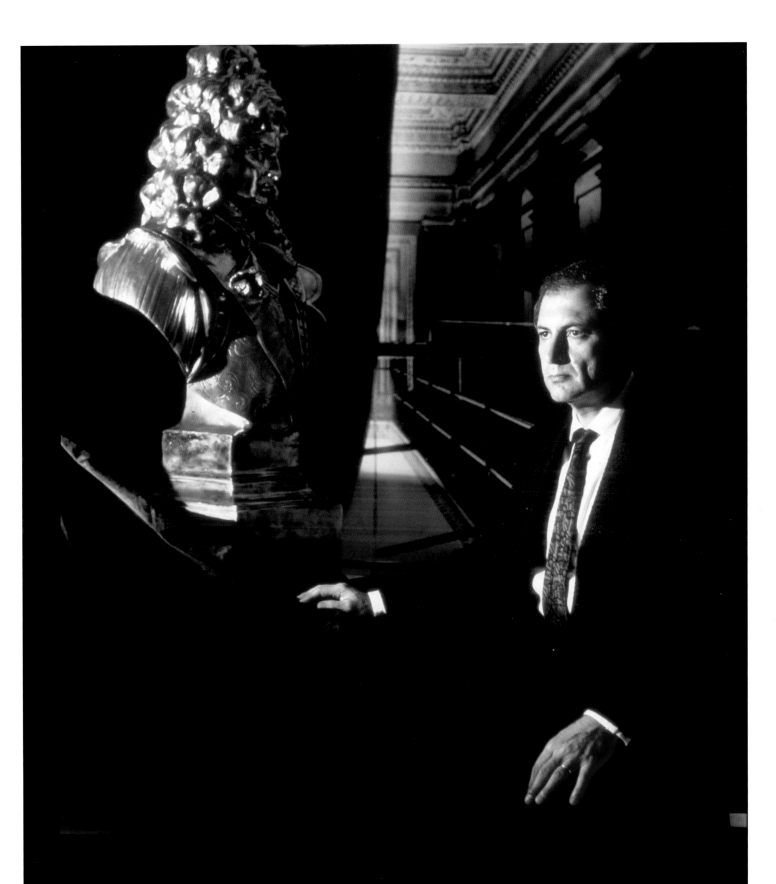

In William Gibson's short story "Burning Chrome,"

published in 1984, the heroes, two robbers called Bobby and Jack, reach a space behind their computer screen where a bank account in the name of Chrome is to become Bobby's. That is the plot. But, even before this moment, the reader has become aware that the focus is on neither the characters nor the narrative but instead on the particular space to be reached by plugging into the keyboard of a computer—that space in which Rikki, Bobby and Jack's mutual partner, performs sex in a virtual brothel. The vertiginous level on which reality becomes heightened potential may offer one key to the 80s, a decade when reality was redefined. Suddenly only virtual reality mattered, and in fields as disparate as fashion, architecture, and economics, reality escalated, as if from that moment on, it could only be flanked by invisible quotation marks. The return of decoration in 80s architecture, the fascination with corporate identity, the theatricality of everyday life, parodied by Bret Easton Ellis in his novel *American Psycho*, are evidence of the sense of heightened reality that affected urban life. This new approach was evident in the recrudescence of conceptual art. For the updated version placed stress differently, harping less on relationships like "something" and "nothing" than on areas of potentiality—in other words, "power." If a single image was needed to sum up the era, when gymnasia were packed from wall to wall, it would be the flexing of a bicep, male or female. ("I want muscles," sang Diana Ross, "all over my body.") Similar metaphors of development and expansion pervaded every aspect of life during a period where power seemed always on the point of being translated into action. In politics incidents occurred such as Margaret Thatcher's order to sink the *Belgrano*, an enemy ship, but one that happened to be sailing in the opposite direction at the time when she gave the order. In business the norm was to invest in the future. And why not? The image of Ronald Reagan, for example, represented stability—his age alone guaranteed that—but also living proof that dreams could come true. The movie-star image he conveyed was indelible; once established, images of stars never change.

Indeed, art altered slowly in the 80s; "hover culture" and "endgame strategy" were only two terms used to describe a widespread need to play endless variations without settling on one. Coinciding with the encroaching millennium,

the anticipation of an ending cannot be ruled out as a factor which contributed to this deceleration, in particular the fossilization of the avant-garde, with all that the term implies. If parody had become a major artistic strategy, the reason was clear; it involved repetition with very slight changes. Yet such changes alter the entire significance of the text, turning it against its original meaning by asserting the exact opposite. By the early 80s, parody might even have been extended as far as the art market—obsessed, or so it seemed, by lies and bad taste. Warhol's own images of himself had become increasingly sinister, so the sense of tension that had always surrounded the issue of reproduction in his work was prolonged, not diffused, by the sheer tastelessness of his late work. By the end of his life, Warhol's theme had become a travesty of the subtlest kind—the most cunning, perhaps, since de Chirico. Entire areas of his output were ignored. Perhaps critics had forgotten his huge hammer and sickle paintings or his giant portrait of Mao Tse Tung—bodiless, beautified, and beatific. Perhaps the only figure in history except God to have successfully outlawed images of himself, Mao was a true Warhol superstar, for, as he grew older, he represented aura without proof of substantiality, to such a degree that (to a Byzantine Catholic like Warhol) he might have been mistaken for an earthly equivalent of the Holy Ghost. Just as the career of a star results in no more than an image or even less, pure potentiality, Warhol's vaunted attempt at self-erasure, a subtle form of suicide, served only to perpetuate the zone of possibility that he had become instead of a person. Warhol was ahead of the game: the conditions for fantasy had changed and he knew it.

In the 80s, art and life were regarded in a new way. From fashion to economics, entertainment to sport, a boundless optimism prevailed, accompanied by a new form of self-aggrandizement. In art, what had been humble was no longer so. Indeed, the growth of corporate identity and the recrudescence of a second generation conceptual art seemed intrinsically linked, one more example of the naive utopianism of the 60s, boosted or corrupted by what could be termed "virtuality." By now, however, the ideal, peaceful, anti-mercantile society adumbrated by 60s conceptualists had become an outdated fantasy but an attractive one. If parameters existed within which art would move, they changed slowly in the 80s. Terms such as "hover culture" or "endgame strategy"

were attempts to describe the widespread desire to play endless variations on the same theme. And as art became more static, in terms of an avant-garde, it seemed to become more self-conscious of its role in relation to what was not art. The model for this was parody of what had happened to art in other periods of history, when conspicuous consumption was the norm. What space did this leave for criticism? "The most provocative American art of the present is situated at . . . a crossing of institutions," wrote Hal Foster in 1982, "of art and political economy, of sexual identity and social life. More, it assumes its purpose to be so sited, to lay in wait for these discourses to riddle and expose them or to seduce and lead them astray. Its primary concern is not with the traditional or modernist proprieties of art, with refinement of style or innovation of form, with aesthetic sublimity or ontological reflection on art as such, but rather seeks out its affiliations with other practices (in the culture industry or elsewhere); it also tends to conceive of its subject differently." The key word here, for the activity the work entails, would be "intervention": to break into a certain social situation, and by doing so to change it. (A representative example would be a Jenny Holzer poster. In the course of her career, Holzer gave up working on walls to installations in large galleries as well as renting billboards in Times Square. There are problems here, but Holzer dealt with these as time went on.) To help explain, Foster revived another, older term which Victor Burgin had coined in the 60s: "situational aesthetics," defined as a "special attention to site, address and audience." For the rest of the decade, this special attention was focused not only on a potentially new audience but also on the audience that had been there all the time: that art-buying, art-selling, market-oriented clan who controlled an art world that was becoming increasingly indurated, conservative, and slow. Despite everything that Hal Foster had said in the early 80s, by the end of the decade parody had become the norm: a parody of prices, of the art market itself, of the mercantilism of New York and of 80s expansion in general. Foster had envisaged a serious attempt at social criticism. In the age of Reagan, however, to read or expose, to seduce or lead astray, could happen in many ways, not all of them what Foster had in mind. Art was developing a rogue identity, apparently counter to what the market wanted yet at the same time finally satisfying its dictates. Perhaps the best example of this was Sherrie Levine's legendary act of appropriation: taking

a Walker Evans photograph and showing it under her own name. There was a logic here, to do with the marketing of photographs themselves and the lack of laws to protect the inventor of a new image. It was also a feminist act, with a number of possible interpretations. To a draftsman, it might be understood as a caricature. To an artist, it might have the same resonance that a urinal achieved when Marcel Duchamp signed it "R. Mutt." Indeed, the resonances of poverty and failed grandeur that must have accompanied Duchamp's wretched non-exhibition, where his work was hidden by a cloth and censored, finds parallels throughout the 80s. For example, Richard Prince managed to steal an image for one night, in the course of which it was copied and returned. It was an early and embarrassing nude portrait of Brooke Shields—"American royalty," in Prince's own words—and it was shown in a gallery in lower Manhattan, named after a famous photograph by Alfred Stieglitz. The result was as tawdry as the portrait itself.

At the opening of an exhibition of his work in Cologne, Meyer Vaisman showed what he called a "Live Sculpture": a local barrel-organ player and Mary, his monkey, who ran around collecting money in a silver mug. In his earlier work, Vaisman had made frequent allusions to money. Now, as if art meant solid profit, he developed a related tactic: accumulation of images, strategies, or mere physical presence. His typically heavy-handed humor relied on an idea of making art that satisfied the requirements of painting as usually defined but which took these a few steps further. The stretcher was thickened pointlessly, the sensuous presence of the canvas was exaggerated by photographing the weave of the fabric, and the idea of truth to materials was flouted by printing it on shiny plastic. And as if a single canvas was not enough, and as if his jokes were not sufficiently gross, the result was called WAD: in English a bundle of separate pieces packed together like a bankroll, but in American English also slang for ejaculation. One permanent subtext in 80s art made by men in the wake of feminism was the dirty joke: a formulaic, repetitive alternative to sincerity or emotional interchange, with the artist/viewer relationship reduced to a financial transaction, unspoken or not, carried out in all-male company where money implies a certain social—and indeed a sexual standing—or in other words respectability. Artists become respectable

to the extent that their works sell, Vaisman proposed—fame is fame; there is no such thing as bad publicity, and old stars remain stars. "Our civilization wants to make artists into clowns," he said in 1987. "It's like a circus act." His own parallel satirical universe was concentrated on low humor: the world according to a borscht-belt comedian. Others have shared his response. The artist as clown features largely in the 80s work of Bruce Nauman, for example. In the early 60s, Nauman was already imagining the perils of creative life. "The true artist is an amazing luminous fountain," he had declared some twenty years before, perhaps ironically. By the early 80s he was reading the memoirs of the newspaper publisher Jacobo Timerman, arrested and tortured by the Argentinian government. Soon afterwards he made his *Clown Torture* works. Of CLOWN TAKING A SHIT, he said, "If you think of times when work is difficult as mental constipation, then the image of a clown taking a shit (not in a household bathroom but in a public restroom—a gas station, an airport, places where privacy is qualified or compromised—can show a useful parallel.)" Early Nauman depicted the artist as hero, a Henry Moore figure. BOUND TO FAIL, as he would be in a Greek tragedy. Later, a petulant, decidedly unheroic figure simply yelling "No, no, no . . ." supplants this as a metaphor for what artists can or cannot do. By this time the surrogate is neither sentimental nor amusing: just a total wreck. Jokes are fascinating in themselves. In 1986 Richard Prince wrote, "A joke shall be printed on the photo of a wave, a wave of such size and shape that it would be referred to as a perfect wave. The final 'look' of the joke and the wave shall be referred to as the perfect joke." For "joke" read "artwork," bound to fail. Or was it? Say instead that it was flexible but only to a degree, like the bicep of a Mapplethorpe nude: a cipher for power, a metaphor for health, a symbol for sexual prowess, but in every case a concept compromised by its obvious uselessness in an era when the avant-garde had been replaced by a parody of its former self.

In one of the strangest artworks of the 80s, a male/female, white/black, man/boy was portrayed wearing golden clothes and cuddling a chimpanzee dressed as himself. The size of a small monument, Jeff Koons's MICHAEL JACKSON AND BUBBLES consists of a single, giant layer of porcelain. In other words, it is simply a shell. By this time, hollowness had become Koons's trademark. From inflatable flowers to pristine vacuum cleaners in dustless transparent cases, from two balls suspended below the surface in a tank of water to a hollow train full of alcohol, Koons's works, made to be collectable as only expensive kitsch can be, had reached a high point of airlessness and, in traditional terms, nonsensicality. Size and "craftsmanship" mattered, but for all the wrong reasons. As opulent as they were repulsive, his pieces resembled toys more than art, with vague references to sport and sex, but also to the spirit that characterized the period. "There is no poverty here," wrote Diana Vreeland in her book *Allure* (1980), a prelude to the coming decade. Those five words proved prophetic. Popular support for Ronald and Nancy Reagan reached its zenith in June 1985, when *Vanity Fair* published a suite of images of the presidential couple locked in each other's arms, dancing at a state dinner, an interlude portrayed in words and images as less an event than the kind of idyll which typified that updated vision of conspicuous consumption the presidential couple both heralded and personified. That he had once been a movie star, albeit an unsuccessful one, only served to confirm the rightness of the people's choice, it seemed. But how much was he the man of the people his pressmen claimed? His social world was exclusive, after all; only the very rich were allowed to enter, together with their entourage of fashion designers. Koons's giant toys kept pace with the spirit of the period by commenting on its collective fantasies. A black man like Michael Jackson could become white, Koons seemed to be observing without comment, just as an old man like Ronald

Reagan could be given the elixir of youth by means of oily lenses and tactful airbrushing. This is the point where comment could have been expected, but no; alternative interpretations of Koons dangle in space, defying the viewer to plump for one or another. Certainly, satire was there if desired—jokes about shedding one's background and age, even color—but such remarks evaporated the moment they collided with the principles of the Declaration of Independence: the belief that Americans have the power to choose what and who to be, and to turn that dream into reality. For Koons's monument to Michael Jackson's capacity for enacting his fantasies was lavish yet hollow, suggesting limited confidence in his decision making. The sculpture remains little more than a hardened canopy, hiding as much as it reveals: a shell without a center, that structure which Koons has repeated throughout his career. Yet imagery in his work is subordinated to other qualities. Finish, for example, the effect of a work literally reflecting on itself, with all that that suggests, and the sheer aestheticism that uninflected, unchangeable objects imply: nothing to do with "objecthood," that relic of minimalist jargon, but rather with its opposite, an untouchability that makes the manufactured object seem precious as a holy relic and that allows the surfaces presented time and time again to tell all we need to know about the response they elicit. For not only are their sleek surfaces im-,portant, a way of holding and redirecting light, but their pristine finish is, too. As Koons stressed in his titling, they are "original." THE NEW JEFF KOONS was the title of an early lightbox, showing a photograph of the artist as a child, making a work of art he implies is his first. In context, it also becomes a play on the idea of advanced art, no longer as powerful at the time he began as it had been earlier in the twentieth century. Koons was determined to make use of that idea of a vanguard while satirizing it, and perhaps reminding viewers of permanent avantgarde manifestations, like the art of the insane or of children.

Oddly, what the viewer is meant to ponder in this and subsequent Koons works is not the theme but its presentation, in particular its surface and its status in terms of manufacture. Uniqueness was under attack. (Koons would eventually present not only works in triplicate but exhibitions in triplicate, too—allowing the same exhibition to be held in three different capitals at the same time, an act of daring that seemed to challenge industry at its own game.) A kind of miracle working was implied, the belief that perfection could be cloned. That the automatic reaction to that would be twofold—nausea and abundance in equal measure—was taken for granted. As our heads swam, the miraculous and the crass, the unique and the commonplace, melded into a term for which no name exists: advertising made real, conspicuous consumption, or at least the fantasy that such consumption evokes. Concentrate too much on this and it becomes hard to concentrate. For that dream of "the new" reveals itself in multiplicity for its own sake: too much to concentrate on. Yet at the same time, every work made at every moment seems exactly the same as every other. The result? A blur: individual identity replaced by a mere sheen that dazzles the eye, short-circuits the brain, and produces a response that resembles awe, the prelude to worship. Other works from the 80s convey something of the same effect: Allan McCollum's floors of dissimilar but ostensibly identical objects; the skin of a black Mapplethorpe model tensing a well-defined arm, with its all-too-obvious associations of automatic tumescence: the slickness of polished metal celebrated in Haim Steinbach's large installation of pristine muscle-building equipment. Indeed, the 80s stress on hardness, slickness, and superficiality, all implied in the concept of a muscular body, the ideal of physical perfection and how it could be used, was also encapsulated in Koons's next move—the attempt to become an artwork in his own right, which involved posing nude. With his Italian wife, Cicciolina, a stripper turned politician, he planned an autobiographical movie titled *Made in Heaven*. Subsequent works seemed to re-

semble sketches for this *Gesamtkunstwerk*, from which only elaborately posed photographs were ever published. Idyllic and gaudily colored, they anticipated a cross between hard sex and kindergarten antics, as manufactured and artificial as any other pornographic movie except for one unusual factor: that there couple in question were man and wife. Aiming for spectacle, satire, and sincerity all at once, *Made in Heaven* might have turned out as one more attempt to grasp that elusive, unnameable essence that eluded Koons: part physical, part spiritual, part natural, part manufactured. Not a truth but an eminently believable untruth was what Koons aspired to, not art as we recognize it but his own deadened version of *tableau vivant:* high spectacle, satire, and sincerity all at once, the essence of salesmanship, persuasion, stardom, and—a difficult concept—perfection, his model for which his model was advertising. "Just yesterday I met some friends," he told an interviewer in 1988. "We were celebrating and I stated to them: 'Here's to good friends!' It was like living in an ad. It was wonderful, a wonderful moment. We were right there living in the reality of our media." The reality of the media—first explored, perhaps, by Daniel Boorstin in his book *The Image*—is something which engaged Koons's attention increasingly as his career continued; for his multiple exhibitions in different capitals, for example, he made photographs that not only advertised himself and his series of worldwide openings but that also existed as photographic works in their own right. Meanwhile through the 80s, media merged with reality in unexpected ways. The cocooned luxury of the private galas of the second inaugural in 1985 and the President's speech—"There are no constraints on the human mind, no walls around the human spirit, no barriers to progress except those we ourselves erect"—coincided with the announcement of the economist Emanuel Tobier's estimate that by 1990 one in every three New Yorkers would be living in poverty. In other words, as the 1980s continued in the United States, truth parted company with reality as never before. In MICHAEL JACKSON AND BUBBLES, Koons's own capacity for wonder—the wonder first of an historical *Wunderkammer*, second of a Disneyesque awe, third of that willing suspension of disbelief that prefaces invention of any kind—ran parallel to that of his subject.

Acting is not simply a profession; it is something that we do naturally in daily life. And as we grow older, it sometimes seems that, as permanent adolescents, we are always growing into and out of our roles, our bodies, our definitions of ourselves. Cindy Sherman plays with that idea, and at the same time with an equally challenging one: the place of women in contemporary life. Sherman's early work, photographed in black and white, consisted of photographs that resembled stills from old movies. Having seen them, the viewer, extrapolating on the evidence, evidence rife with clichés from Hollywood and elsewhere, mistook the photographs as stills, and indeed they were posed to look that way though they were unique items, posed and "acted" by Sherman. Perhaps the photographs she makes exist partly to define women and freedom as their role, as some critics have argued. Yet it is easy to maintain that it is about freedom to adopt any role at all—"roles" in their most stagey definition. After the initial monochromes, Sherman went on, imitating various "characters" the way actors do. And, as with actors, the viewer becomes confused—because that is the point of the exercise for both parties—and is fooled into believing in the guise, however unsubtle it may seem. It matters that Sherman has continued to do what she does, for only by this means could she go one step further than the loss of recognition that strikes every one of her viewers after many different guises have been paraded, each a mask of Sherman, whom gradually we have come to ignore as a person, looking only at her new persona. The word "persona" really means "mask," however, and indeed, the mask is finally all we look at: how well it is made, how difficult it must be to wear. Out of costume it would be impossible to recognize her. Photography is used to identify other people, and to remind us how we seem to them. Paradoxically, if Sherman had wanted to erase all trace of herself, she could hardly have done better than to plan her disappearance in the way she has. That she is a woman has a lot to do with this; traditionally, they worry about their appearance, how they look. Anonymous despite the size of her photographs, belonging to no single period, shifting sex as she does, and even becoming an animal, Sherman seems to have a desire for anonymity, so much so that we finally pay as little attention to her as we might to Edgar Allan Poe's "man in the crowd." If so, what does it mean to be an artist? Does it mean faking feelings, like an actor, or dressing up, like a child? And how does this bear on the place of women in general? Is Sherman a feminist or not? Finally, the problem is too difficult to solve. The complicating factor is the dedication to her task, a task she (masochistically?) chose a long time ago. Should we be admiring Sherman's bid for freedom or pitying her for nunlike submission to a future that we and she can predict without difficulty? For her art seems to involve agreeing to lose much that is most important to people, to do that regularly and often, to get better at her task and to go on performing it forever. People with a vocation are always interesting. And this really is a vocation, isn't it?

The fate of masculinity in 80s America is best described by Richard Prince's bald, cigar-smoking businessmen with busty secretaries on their laps, or David Salle's vast paintings in which women assume "poses" of submission. Salle's second most common theme is commodities such as furniture or tapestries or women. And in Prince and Salle alike, bulk becomes either transparent, bodiless, or reconstituted, as in Prince's parts of car bodies or Salle's attached fabric, or furniture. But while women too become assets in Salle's work, in Prince a free-and-easy take on sexual identity is posited. So free, so easy, that Prince, who worked in a cabaret for a time, remembers strippers who changed their names every few days, altering one letter in an attempt to find a successful combination of image and identity. In Prince, both remain in doubt; the "jokes" he tells and illustrates with borrowed cartoons lose their stability in our minds, partly because all they do is correspond to ideas of what a joke should be and how it sounds, regardless of sense: structure without meaning, a comment on the small change of conversation and its function: phatic, psychological, cathartic, and above all unheard. Like other artists struggling to make sense of the man's world into which they had been thrown, he tries to see it in terms of entertainment: a star system, a set of hierarchies, one above another, a sense of hunting in packs and commenting on male identity. Yet to comment on sexuality, whatever the motive, might be to perpetuate the *status quo*, to do no more than confirm what advertising and bigotry, off-color jokes and loss of self-respect have achieved. The issue is one of power. And with Lisa Lyon and later Madonna lifting weights and playing with visual ideas of androgyny, human musculature started to resemble the design of 50s automobiles—bulk as an unsettling combination of financial reassurance and personal threat. Male-oriented, object-based, morally dubious, photographically inclined, art of the 80s took on problems from outside the art domain, but did so without ever solving them. The idea of art mirroring life can seldom have been so accurate. Above all, artists indulged in "endgame" moves, using delaying tactics, inventing constant variations on a theme that seemed ever smaller, ever more crucial as time passed. Asked why he made comic work, Ashley Bickerton replied, "How could you not laugh at the utter bankruptcy of possibility? . . . I mean, what is left to do?" Tensed, threatening, beautiful, unnecessary, the flexed muscle was a phantom pregnancy, an unprovoked threat, an aesthetic exercise that could be repeated *ad infinitum*, a bubble that would never burst, the outward and visible sign of a society of stasis, which believed in it too much. **—STUART MORGAN**

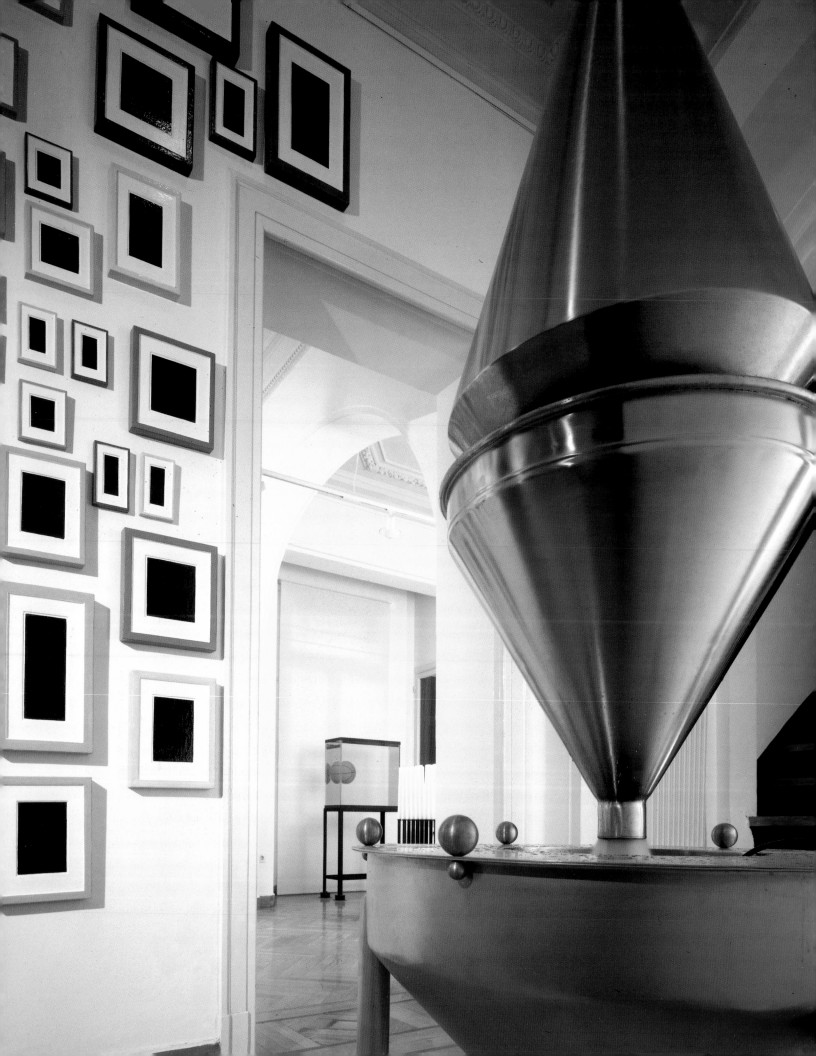

The DESTE Foundation for Contemporary Art

The DESTE Foundation for Contemporary Art sponsors exhibitions, publications and symposia that explore the relationship between contemporary art and contemporary culture. Since its founding by Dakis Joannou in 1983, Deste has organized eleven exhibitions in Greece and Cyprus and has sponsored five exhibitions and symposia at the Centre d'Art Comtemporain in Geneva. In addition, the foundation has sponsored performances and projects by individual artists.

One of the DESTE FOUNDATION's principal interests is helping to develop the audience for contemporary art in Greece and Cyprus and enhancing the opportunities for emerging Greek and Cypriot artists. Through its exhibition program, the Foundation has brought numerous works by major international artists to Athens, Salonica, and Nicosia and has sponsored travel to Greece and Cyprus by important artists, critics, and curators. The Foundation's exhibition program also endeavors to give wider international exposure to young Greek and Cypriot artists.

DESTE FOUNDATION also aims to address the international contemporary art audience, particularly through its publication program, adding to the artistic and critical dialogue through books like Cultural Geometry, Artificial Nature and Post Human which accompanied its exhibitions of the same titles. Through its exhibition and publication programs, the Foundation has taken a particular interest in presenting and interpreting the new conceptually based art that emerged in Europe, America and Japan during the past decade. The Foundation's projects have also explored a more poetic and emotional direction in contemporary art through exhibitions like A Project for Harmony and Inconceptuality, presented in Nicosia in 1990.

EXHIBITIONS
Organized by The DESTE Foundation for Contemporary Art

7 GREEK ARTISTS—A NEW JOURNEY
Nicosia, December 1983
Curator: Efi Strousa

CULTURAL GEOMETRY
Athens, January - April 1988.
Curator: Jeffrey Deitch

TOPOS - TOMES
Athens, April 1989.
Curator: Charis Savopoulos

PSYCHOLOGICAL ABSTRACTION
Athens, July - September 1989.
Curator: Deste Foundation

PANOS KOULERMOS,
Architect. Athens, February - March 1990

ELIMINATING THE ATLANTIC
Salonica, May - June 1990.
Curator: Charis Savopoulos

ARTIFICIAL NATURE
Athens, June - September 1990.
Curator: Jeffrey Deitch

APHRODITE: HARMONY AND INCONCEPTUALITY
Nicosia, September 1990.
Curator: Demosthenes Davvetas

ASSAULT ON THE SENSES
Athens, June - September 1991.
Curator: Catherine Cafopoulos

POST HUMAN,
Athens, December 1992 - February 1993.
(Also presented in Lausanne, Torino, Hamburg and Jerusalem)

EVENTS
Sponsored by The DESTE Foundation for Contemporary art

JOSEPH KOSUTH
Centre D'Art Contemporain Geneva
March 1985

PROMENADES
Centre D'Art Contemporain Geneva
June - September 1985

RECITAL IRENE PAPAS
Teatro Fenice Venice
February 1986

ZORIO
Centre D'Art Contemporain Geneva
April 1986

MARINA ABRAMOVIC & ULAY
Centre D'Art Contemporain Geneva,
April - May 1987

SCULTURA DA CAMERA
Athens, October 1988.
Curator: Galleria Bonomo

SYMPOSIUM
The Possibility of Art;
where does it begin, where does it end
in the world of contemporary art.
Geneva, February 1989

OUT OF TITLE
House of Cyprus, Athens.
April 1992
Curator: Charis Savopoulos

Opposite page: Installation view, *Cultural Geometry*, House of Cyprus, Athens, 1988.

Cafe table, Santorini

Above: Cafe table, Santorini and John M. Armleder, *Untitled (FS79)*, 1985 from *Cultural Geometry*

(Athens: The DESTE Foundation for Contemporary Art, 1988) Jeffrey Deitch, editor, Dan Freidman, designer.

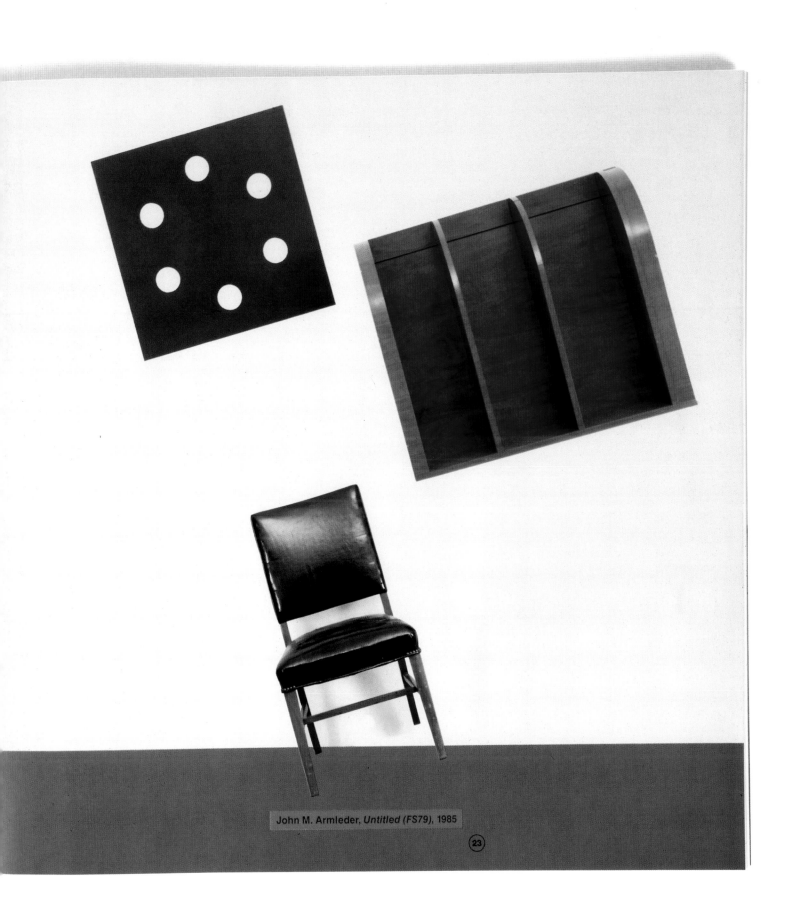

John M. Armleder, *Untitled (FS79)*, 1985

23

credits and information

The photographs reproduced have been provided, in the majority of cases, by the artist or their gallery representative. The following list applies to photographs for which an additional acknowledgment or caption is due.

p.4: courtesy of The New York Public Library Picture Collection p.8, 9, and 11: courtesy of Andreas Gursky and 303 Gallery, New York p.14: film still from *The Wizard of Oz* from Culver Pictures, Inc., New York p.18: film still from *The Wizard of Oz* courtesy of Jerry Ohlinger's Movie Material Store Inc., New York; Marcel Duchamp, *Etant Donnés: 1e La Chute d'Eau, 2e Le Gaz d'Eclairage*, 1946-66, Philadelphia Museum of Art: Gift of the Cassandra Foundation p.20: video stills by Steve Freeman, New York p.23: film still from *The Wizard of Oz* from Everett, New York p.25: film still from *The Wizard of Oz* courtesy of Jerry Ohlinger's Movie Material Store Inc., New York p.28-29: video stills by Steve Freeman p.41: ©1996 Artist Rights Society (ARS), New York/ ADAGP, Paris; photo of *La Poubelle de la Columbe D'Or* by Dimitri Tamviskos p.46-47: ©1996 Richard Artschwager/ Artist Rights Society (ARS), New York; portrait of the artist courtesy of Portikus, Frankfurt p.93 and 95: ©1996 Artists Rights Society (ARS), New York/ ADAGP, Paris p.101: ©1996 Dan Flavin/ Artist Rights Society (ARS), New York p.166-167: ©1996 Joseph Kosuth/ Artists Rights Society (ARS), New York p.169: photo *Untitled*, 1985 by Manolis Baboussis p.172-173: photos of *New Members for the Burghers of Calais*, 1992-1993 by Dimitri Tamviskos p.176: artist with painting, *Obstacle*, 1994 p.187: ©1996 Artist Rights Society (ARS), New York/ ADAGP/ Man Ray Trust, Paris p.212-213: ©1996 Bruce Nauman/ Artist Rights Society (ARS), New York; video stills by Steve Freeman p.223: ©1996 Artist Rights Society (ARS), New York/ ADAGP/ SPADEM, Paris p.279: ©1996 Andy Warhol Foundation for the Visual Arts/ ARS, New York p.282-283: photo by Ricardo De Oliveira p.288: photo of war in Cyprus courtesy of The New York Public Library Picture Collection p.290: photo of PROTECT ME FROM WHAT I WANT by Todd Eberle endpaper: photos by Manolis Baboussis

The editors and the DESTE Foundation gratefully acknowledge the following publishers and authors whose texts have been reproduced for the artists' pages:

Abbeville Press Publishers, New York: excerpt from Jan van der Marck, *Arman*,1984 • *Journal of Contemporary Art*: excerpts from Meg Cranston, "John Baldessari," Fall/Winter 1989; John Zinsser, "Ross Bleckner", Spring 1988; Gerhard Merz, "Statement," Summer 1994; Mattias Winzen," Katharina Fritsch," Summer 1994 • *Shift*: excerpt from Glen Helfand, "Interview with Matthew Barney," Vol.6, No.2, 1993 • Giancarlo Politi Editore, Milan: *Flash Art*: excerpts from Paul Taylor, "Jenny Holzer: I Wanted To Do a Portrait of Society," March/April 1990; Catherine Liu,"Liz Larner: Embodied Tension," January/ February 1991; Jutta Koether, "Interview with Rosemarie Trockel," May 1987: excerpt from Achille Bonito Oliva, *Superart*,1988 • Kunsthalle Bern, Bern: excerpt from Stuart Morgan "Grenville Davey: The Story of the Eye," *Grenville Davey*, 1991• MIT Press, Cambridge: excerpt from *The Definitively Unfinished Marcel Duchamp*, ed.Thierry de Duve, 1991; Barbara Kruger, "Not Nothing," *Remote Control: Power, Cultures, and the World of Appearances*, 1993 • IVAM Centre del Carme, Valencia: excerpt from, Patrick Frey, "Moments of Contented Presence: On Peter Fischli and David Weiss," *Peter Fischli Y David Weiss*, 1990 • Staatliche Kunsthalle Baden-Baden: excerpt from"writing chosen by the artist", in *new uses for fluorescent light with diagrams, drawings and prints from Dan Flavin*, 1989 • MOCA, Los Angeles: excerpt from*"monuments" for V. Tatlin from Dan Flavin, 1964-1982*,1989 • Museum Friedricianum, Kassel: excerpt from Veit Loers, "You Might Think There Was Nothing To See..." *Günther Förg*, 1990 • Museum Boymans van Beuningen, Rotterdam and Kunsthalle Bern, Bern: excerpt from Trevor Fairbrother, "We Are Only as Sick as the Secrets We Keep," *Robert Gober*, 1990 • Hallwalls, Buffalo: excerpt from David Salle, "Jack Goldstein; Distance Equals Control," *Jack Goldstein*, 1978 • Albright-Knox Art Gallery, Buffalo: excerpt from Michael Auping, "Reading Holzer or Speaking in Tongues," *Jenny Holzer: The Venice Installation*, 1990 • The Solomon R. Guggenheim Museum, New York: excerpt from Stuart Morgan,"The Bastille Interviews II, Paris 1993: Rebecca Horn with Stuart Morgan," *Rebecca Horn*, 1993 • Stedelijk Van Abbemuseum, Eindhoven: excerpt from *Donald Judd: Complete Writings, 1975–1986*,1987• ARC/ Musée d'Art Moderne de la Ville de Paris: excerpt from "For the Discovery of Images," *Piero Manzoni*, 1991; Interview with Mike Kelley by Jean-François Chevrier, *Lieux Communs, Figures Singulières*, 1992 • Autoridad Portuaria de Santander, Spain: excerpt from Siri Hustvedt, "The Art of Fascination," *Jon Kessler*,1994 • *Artforum*: excerpt from Joseph Kosuth, "No Exit," March 1988 • Ediciones Poligrafa, S.A, Barcelona: excerpt from Gloria Moure, *Kounellis*, 1990 • Thames and Hudson, London: excerpt from Arturo Schwarz, *Man Ray: The Rigour of Imagination*, 1977 • Daadgalerie, Berlin and Fri-Art Centre d'Art Contemporain Kunsthalle, Fribourg: excerpt from Douglas Kahn, "Christian Marclay's Lucretian Acoustics," *Christian Marclay*, 1994 • Penguin Books, London: excerpt from Edgar Allen Poe, "On Imagination," *The Fall of the House of Usher and Other Writings*, ed. Dave Galloway, 1967 • MIT List Visual Arts Center: excerpt from "Interview: Matt Mullican and Michael Tarantino," *Matt Mullican: The MIT Project*, 1990 • ICA and Serpentine Gallery, London: excerpts from interview with Juan Muñoz by Iwona Blazwick, James Lingwood and Andrea Schlieker, *Possible Worlds: Sculpture from Europe*, 1991 • *The Village Voice*: excerpt from Gary Indiana, "Futurisms: A Conversation with Peter Nagy," April 14, 1987 • *Archis*: excerpt from Camiel van Winkel and Mark Kremer, "Metal Is a Major Thing, and a Major Thing to Waste: An Interview with Cady Noland", January 1994 • Museum of Contemporary Art, Chicago: excerpt from press release for "Options 47: Gabriel Orozco," 1994 • De Donato, Bari: excerpt from *Autoritratto*,1969 • Hanuman Books, Madras/ New York: excerpt from "Cousserances," *Who Knows: Poems and Aphorisms by Francis Picabia*, 1986 • Parkett Verlag AG, Zurich: excerpts from Chris Dercon, "Keep Taking It Apart: A Conversation with Bruce Nauman," *Parkett* #10, 1986; Kathy Acker, "Red Wings: Concerning Richard Prince's Spiritual America," *Parkett* #34, 1992; Peter Schjeldahl, "Ray's Tack," *Parkett* #37, 1993 • *Artnews*: excerpt from an interview with James Rosenquist by G.R. Swenson, February 1964 • Rizzoli, New York: excerpt from "David Salle," *Inside the Art World: Conversations with Barbaralee Diamonstein*, 1994 • Sammlung Goetz, Munich: excerpt from an interview with Cindy Sherman by Matthew Weinstein, *Jürgen Klauke/Cindy Sherman*, 1994 • A.R.T. Press, California: excerpt from an interview with Laurie Simmons by Sarah Charlesworth, *Laurie Simmons*,1994 • ICA Amsterdam and Sdu Publishers, The Hague: excerpt from "An Interview with Kiki Smith," 1990 in *Kiki Smith*, 1990 • New York University Press, New York: excerpt from "Smithson's Non-Site Sights: Interview with Anthony Robbin," *The Writings of Robert Smithson*, ed. Nancy Holt, 1979 • Lenbachhaus Kunstforum, München: excerpt from Ulrich Wilmes, "Androgynous Configurations," *Pia Stadtbäumer*, 1993 • *BOMB*: excerpt from Shirley Kaneda, "Philip Taaffe," Spring 1991 • Palais de Beaux-Arts, Brussels: excerpt from Marianne Brouwer, "Précis de Décomposition," *Jan Vercrussye*, 1988 • *High Times*: excerpt from Glenn O'Brien, "Interview: Andy Warhol," August, 1977 • *Frieze*: excerpt from Lane Relyea, "976-WOOL," February 1995

acknowledgments

We would like to thank the following individuals who have helped provide material for this publication: Caroline and Salvatore Ala • Josh Baer • Jean Bernier, Maria Eliades, and Barbara Feussner, Jean Bernier Gallery • Mary Boone, Adam Sheffer, and Ron Warren, Mary Boone Gallery • Nora Halpern Brougher, Director of Fine Arts, Sotheby's West Coast Division • Gilbert Brownstone and Laura Passetti, Gilbert Brownstone & Cie • Leo Castelli Gallery • Gail Cochrane • Sadie Coles, Anthony d'Offay Gallery • Paula Cooper, Lucien Terras, Natasha Sigmund, and Ona Nowina-Sapinski, Paula Cooper Gallery • Todd Eberle • Hudson, Feature Gallery • Rosamund Felsen • Steve Freeman • Barbara Gladstone, Mark Fletcher, Ivy Shapiro, and Christina Hejtmanek, Barbara Gladstone Gallery • Deborah Goodman • Marian Goodman, Lane Coburn, and Jill Sussman, Marian Goodman Gallery • Jay Gorney Modern Art • Uta Grosenick, Wolfsburg Museum • Barabara Grosshaus, Museum Fridericianum Kassel • Janice Guy • Yves Hayat, *Galleries Magazine* • Max Hetzler • Ghislaine Hussenot • Rafael Jablonka • Sidney Janis Gallery • Michael Joseph • Doug Walla, Kent Gallery • Sarah Morris and Gary McGraw, Jeff Koons Studio • Ursula Krinzinger • Colin de Land • Nicholas Logsdail, James Roberts, and Pilar Corrias, Lisson Gallery • Ullrich Loock, Kunsthalle Bern • Lawrence Luhring, Roland Augustine, Claudia Carson, and Michelle Maccarone, Luhring Augustine Gallery • Elizabeth Cherry, Galerie Philomene Magers • Bettina Marbach, Kunsthalle Zurich • Victoria Miro and Clare Rowe, Victoria Miro Gallery • Helene Winer, Janelle Reiring, Ben Barzune, Jackie Brustein, and David Maupin, Metro Pictures • Karen McCarthy • Juliet Myers • Francis Naumann • Susan Dunne, Marisa Hill, and Noelle Soper, PaceWildenstein • Kostas Pasvantis • Tom Powel • Rebecca Quaytman • Caren Ratzel, Galerie Johnen & Schöttle • Shaun Caley and Stuart Regen, Regen Projects • Andrea Rosen, Michelle Reyes and John Connelly, Andrea Rosen Gallery • Jane and Robert Rosenblum • Alma Ruiz, Exhibitions Coordinator, Museum of Contemporary Art, Los Angeles • Esther Schipper • Ingrid Shaffner • Josh Shore • Cindy Smith • Ileana Sonnabend, Antonio Homem, Lawrence Beck and Nick Sheidy, Sonnabend Gallery • Valentina Pero, Sperone Westwater • Gallery Takagi • Lisa Spellman, 303 Gallery • Despina Vaiopoulou, *The Art Magazine* • Ronny van de Velde • David Zwirner and Angela Choon, David Zwirner Gallery
Special Thanks to: Brian Baltin • Gina Goldman • Jeanne Greenberg • Simone Manwarring • Kate Williams